WOVEN WORLDS

Woven Worlds
Basketry from the Clark Field Collection

edited by

Lydia L. Wyckoff

with contributions by

J. Marshall Gettys

Suzanne Griset

Ann McMullen

Shelby J. Tisdale

Gloria Cramner Webster

Lydia L. Wyckoff

THE PHILBROOK MUSEUM OF ART : TULSA

The Philbrook Museum of Art
2727 South Rockford Road
Tulsa, Oklahoma 74114

ISBN 0-86659-023-4 hardbound
ISBN 0-86659-024-2 softbound

Library of Congress Cataloging-in-Publication-Data
Philbrook Museum of Art.
 Woven worlds : basketry from the Clark Field Collection /
 edited by Lydia L. Wyckoff : with contributions by J. Marshall
 Gettys . . . [et al.].
 p. cm.
 Includes bibliographical references and index.
 ISBN 0-86659-023-4 (hardbound : alk. paper) —
 ISBN 0-86659-024-2 (softbound : alk. paper)
 1. Indian baskets—North America—Exhibitions. 2. Field,
 Clark—Art collections—Exhibitions. 3. Philbrook Museum
 of Art—Exhibitions. I. Wyckoff, Lydia L. II. Title
 E98.B3 P43 2001
 746.41'2'08997—dc21 2001016430

Made possible by grants from:

National Endowment for the Arts

Oklahoma Humanities Council

The Hearst Foundation

Ruth Ann Fate & Martin E. Fate Jr. Charitable Trust

PACERS Auxiliary Inc.

This catalogue was published in conjunction with the
exhibition *Woven Worlds: Basketry from the Clark Field
Collection*, organized by The Philbrook Museum of Art.

Curator: Shelby J. Tisdale

Guest curator and editor: Lydia L. Wyckoff

Copy editor: Hazel Rowena Mills

Publication design and production: Carl Brune

Maps: Carl Brune, Shelby J. Tisdale, Lydia L. Wyckoff

Photography of the collection: Don Wheeler

Distributed in association with
University of New Mexico Press
1720 Lomas Boulevard, N.E.
Albuquerque, New Mexico 87131-1591

505 277 2346

Printed and bound in Belgium

HALF-TITLE PAGE: Cherokee burden basket, 1941 (detail)
FRONTISPIECE: Yucca ring basket, c. 1941 (detail)
COPYRIGHT PAGE: Nez Perce bag, c. 1787 (detail)
SECOND HALF-TITLE PAGE: Jicarilla Apache hamper, c. 1915 (detail)

CONTENTS

LIST OF ILLUSTRATIONS

Maps

Tables

The collection of Native American art at The Philbrook Museum of Art has grown over the years through the generosity of numerous individuals who have shared their treasures, thus enriching the lives of thousands. One such patron was Clark Field, who provided the foundation for the Native American art collection. Within weeks of the September 1938 announcement by Waite Phillips that he was planning to donate his villa for a museum, Clark Field announced that he would donate his collection of Native American basketry and Southwest pueblo pottery to the new museum. Philbrook began under the administration of the Southwest Art Association, which included seven originally appointed trustees who were authorized to appoint four additional members. Clark Field was selected to be part of this exciting and prominent group.

While competing with other collectors and museums, Clark Field's basketry collection continued to grow, and over the years, as he donated his baskets to Philbrook, it became recognized nationally and internationally as one of the more comprehensive basketry collections in the country. For example, the *degikup* by well-known Washoe basketry artist Louisa Keyser (Dat So La Lee) traveled throughout the United States and Europe in the *Sacred Circles* exhibit in the 1970s. Philbrook's collection may be small compared with those of larger institutions; however, the value of the basketry collection lies in the artistic quality of the works and the aesthetic beauty of each individual piece.

It is our mission to provide information on the collections through exhibitions and now with a series of catalogues on different aspects of the Native American art collection. The first in the series, *Visions and Voices: Native American Painting from The Philbrook Museum of Art*, in 1996, was accompanied by an exhibit of paintings from the permanent collection. *Woven Worlds* continues this tradition with an exhibit of more than 250 baskets and a complete catalogue of Philbrook's basketry collection.

Lydia L. Wyckoff's vision for an exhibit and catalogue on the Clark Field basketry collection began in 1996. The daunting task began with the documentation of the collection, assisted by numerous staff members and Native American interns. Shortly after Dr. Wyckoff's retirement in 1998, Shelby J. Tisdale came to Philbrook as the curator of Native American and non-Western art in 1999, bringing the project to completion. To both, I am deeply grateful for a remarkable job.

Our head of graphic design, Carl Brune, deserves much credit for the catalogue's extraordinarily beautiful presentation. It was a particularly challenging project because of the scope and complexities, and the result is a work of art in itself.

This exhibition and catalogue reveal much more than an anthropological exploration of Native American baskets. They are a tribute to a passionate collector who chose to celebrate the artistic endeavors of hundreds of makers. It is a joy and privilege to share these magical contributions.

Marcia Manhart
Executive Director
The Philbrook Museum of Art

ACKNOWLEDGMENTS

I t all began so long ago, when ancestors taught ancestors how to weave baskets. To the makers of the baskets, from sometime between A.D. 1 and 500, when the oldest basket in the Clark Field Collection was made by an unknown weaver, to the weavers Clark Field knew or whose work he purchased, and the weavers of today, I am deeply thankful and honored to have worked with their pieces. I would particularly like to thank the weavers Elsie Battiest (Choctaw), Treva Burton and Bessie Monongye (Hopi), Ruth Sanderson (Kickapoo), and Brenda Thorne (Cowichan), and California Indian Basketmakers Association members Shelly Ammon and Laverne Glaze, who not only have created works of beauty but have also provided information concerning basketmakers in their families and have given their time to help us write this catalogue. The staff members of the Maxwell Museum of Anthropology, University of New Mexico, who came to the aid of the Clark Field Collection in the 1960s by cleaning, conserving, and storing a portion of this collection, deserve our gratitude. In particular, the curator at that time, Jerry Brody, came to assist in packing baskets that went to the Maxwell Museum. He has also given his time and knowledge to help with this publication, as has Marian Rodee.

Thanks to Marsha Anderson, Craig Bates, Claudia Carr, Scott DeHaven, Shan Goshorn, Mark Halverson, Russell Hartman, Ken Hedges, Mary Jepson, Joanne Mack, Helen McCarty, and Christopher Moser for sharing their knowledge and data.

I would also like to thank all of those who gave baskets to The Philbrook Museum of Art, particularly the famed Clark Field, whose friends and family so very kindly assisted me. I especially want to thank David Mitchell, who became fascinated with his great-granduncle's life.

In 1994, The Philbrook Museum of Art began the vast project of entering its collection into an electronic database. As this was done, records were reconciled and baskets were examined. The baskets were also cleaned, measured, appraised, and properly stored, and several received conservation treatment. This costly and intensive effort involved the work of many staff members at the museum, the generosity of docents and volunteers, the support group Friends of Native American Art, and Philbrook supporters, especially Florence Lloyd Jones "Bisser" Barnett.

The Friends of Native American Art established an "adopt-a-basket" program in which different members chose baskets requiring conservation treatment. Friends members Bill and Barbara Boone, Ann Browning, Tom and Sharon Coffman, Cynthia Hale, D. Michael McBride III, Mrs. Ethel G. Roth, Bill and Carol Sheehan, Michael and Suzanne Fitzgerald Wallis, and David B. Waters were sponsors of this program. The Friends of Native American Art also helped with dinners for Bettina Raphael, the excellent object conservator from Santa Fe who not only worked congenially with us all, but also gave of her own time to talk with members about her work. Perhaps most importantly of all, the group provides funds for the Native American internship program. Those interns provided most of the exhaustive labor involved in the completion of the data entry and the cleaning and storage of the baskets. Without the help of Therese Mathews and the late Lisa Blaylock (1961–2000), this project would never have reached completion. Lisa not only worked in the museum's storage vault but, along with Marla Redcorn, also conducted interviews with her tribal members, Choctaw basket weavers. Later, Lisa joined the staff.

I am also indebted to Marshall Gettys, Ann McMullen, and Terry DeWald for their basket appraisals.

Hazel Rowena Mills edited this volume—a demanding task. Don Wheeler photographed the collection. Thank you both very much.

Philbrook Museum of Art registrars David Gabel and Christy Fasano have also contributed to this effort, as has Thomas Young, museum librarian. Tom's patience and assistance have been far above anything anyone could rightfully hope for. Thank you so much, Tom. I would also like to extend a special thank you to Anne Buckner, who has typed—and retyped—this manuscript.

Carl Brune, head of graphics at Philbrook, despite the constant demands of exhibits, *The Philbrook Museum of Art Bulletin*, and other projects, found the time to focus on and design this beautiful book. Thank you, Carl.

In 1998, I retired from Philbrook. By that time, I had already worked on what came to be called "the basket project" for two years. I am deeply grateful to both Marcia Manhart, executive director, and Christine Kallenberger, director of exhibitions and collections, for making it possible for me to complete this work.

On my retirement, Shelby Tisdale was hired as curator of Native American and non-Western art in 1999. She gallantly completed the basket reference list, and her contribution is gratefully appreciated. She continued to work with University of Tulsa interns. I would very much like to thank Laura E. Sullivan, as well as interns Andy Schlavch, Kelly Foshee, Laura Sullivan, and Cynthia Harris, and volunteers Jane Hutchinson and Marilyn Woolsey, who assisted Shelby with data entry and the preparation of the basketry list included in this catalogue.

Lydia L. Wyckoff

FIGURE 1 : OPPOSITE PAGE : **Woody Crumbo (Woodrow Wilson Crumbo) :** *Land of Enchantment,* **c. 1946 : This watercolor by a Potawatomi artist captures the abrasive nature of much of the contact between European-American tourists and indigenous artists in the1940s. As depicted here, the cultural differences are seen in the physical exposure of the potential patron, in marked contrast to the modesty of the Navajo mother and her child, and her public assertiveness over her male companion, which is traditionally unacceptable in Navajo culture. It also captures the European-American fascination with and superior attitude toward "others." In contrast, the irony of the use for the title of a European-American description of the area as "the land of enchantment" cannot be missed. This painting was purchased and given to The Philbrook Museum of Art by Clark Field (1946.45.4).**

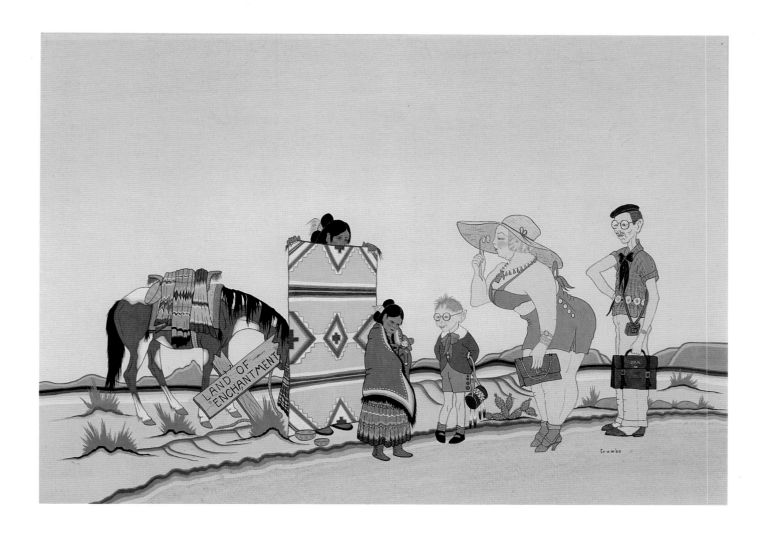

O f the 1,165 baskets at The Philbrook Museum of Art made by native peoples in North America, which includes the United States, Canada, Mexico, and Central America, 1,070 were acquired by a single collector—Clark Field.

The road between the crafting of a native artwork and its place in a museum is a long one. At every stop along the way—from the maker to the Indian agent or missionary to the jobber, dealer, buyer, and finally museum—decisions and choices are made. Thus, when native works are collected by a European-American collector, the object itself becomes an expression of the differences and interconnectedness of two worlds. Once in the museum, although the work will be appreciated on many levels by different people, it cannot be fully understood unless those two worlds meet. For that reason alone, it is critical that tribal peoples are involved in all museums containing their art.

This book is divided into two sections. The first focuses on the collector, his culture, and the nature of the collection, the second on the makers and their world. Obviously, in a book of this length, many people and entire groups have been omitted. However, within the confines of space, a general overview follows.

The first essay, "The Collector and the Collection," focuses on the life of the collector, his motives for collecting, his economic circumstances, his collection goals, and his immediate environment. The essay also discusses academic and commonly held views of the period, and how a few chosen examples from the collection exemplify the weaving of the collector's world with that of the makers.

Clark Field's story is of particular interest because he collected so many of his baskets directly from the makers themselves, primarily during a period, in the 1930s, when few people were collecting and, during the 1940s, when a new wave of European-Americans descended on tribal areas. Fortunately, Field not only catalogued his collection but also frequently added notes stating where or from whom the basket was purchased, the function of the basket, and the name of the maker.

Clark Field, for the most part, followed the cataloging system proposed by Otis Tufton Mason (1904) and George Wharton James (1902). Entries included the type, weave, and materials of the basket; the tribe of the maker, the linguistic family of the tribal language and, occasionally, the location of the tribe; the value of the "specimen" at the time it was purchased and when he purchased it; and the size of the basket and date of manufacture. This information, as well as extensive research, has been used to create the following catalogue. In contrast to Clark Field's categorization, however, the largest organizational unit in this catalogue is not the linguistic family but the cultural area.

The European-American concept of cultural areas is a way to classify, in a general manner, the complex variety of indigenous cultures. Some scholars, such as Clark Wissler (1938), focused on the similarities and differences in material culture. Wissler influenced and was influenced by Alfred Louis Kroeber of the University of California. Although Kroeber considered culture as a unique whole consisting of patterned traits—including language, subsistence, economics, religion, and art—like Wissler, he saw culture areas in the light of ecology. In "Cultural and Natural Areas of Native North America" (1939), Kroeber defines six large areas and eighty-four subareas by a variety of traits which vary in importance, depending on the given area. The six large areas, however, still remain basically vegetation zones because they reflect climate and soil, which in turn provide the subsistence setting. Certainly, hunting and gathering types of culture do contrast with those based on agriculture, but in each instance there is a distinctive kind of adaptation. Environment limits, but does not determine, culture.

As a cataloging device, Harold E. Driver (1969) has perhaps defined the cultural area most succinctly: "A cultural area is a geographical area occupied by a number of peoples whose cultures show a significant degree of similarity with each other and at the same time a significant degree of dissimilarity with the cultures of the peoples of other such areas." Implied for each cultural area is, of course, a common history. The degree to which baskets from the same cultural area are similar varies considerably. Baskets from the Southeast, for example, look remarkably uniform, whereas baskets from the Southwest are most dissimilar, reflecting a relatively recent movement of peoples.

This catalogue has been divided into eight sections: Southwest; California; the Intermontane West, including the Great Basin and Plateau areas; the Northwest Coast; Arctic and Subarctic; Prairie and Plains; Eastern Woodlands, including the Northeast and Great Lakes areas; and, finally, Southeast. The baskets from some of those areas have been all but ignored in recent years, whereas others have been studied extensively.

Within each of these relatively common cultural areas live numerous and diverse groups of peoples designated as "tribes." This is a European-American term and there is no generalization as to what comprises those groups. In some cases, it was a common language, common culture and social organization, common territory and, in some instances, common residence. Some tribes on the periphery of a cultural area have been assigned to one cultural area or another with difficulty. There are few areas of sudden transition.

For the most part, these essays have been written by scholars and native people. Comments and additions by native peoples are clearly noted.

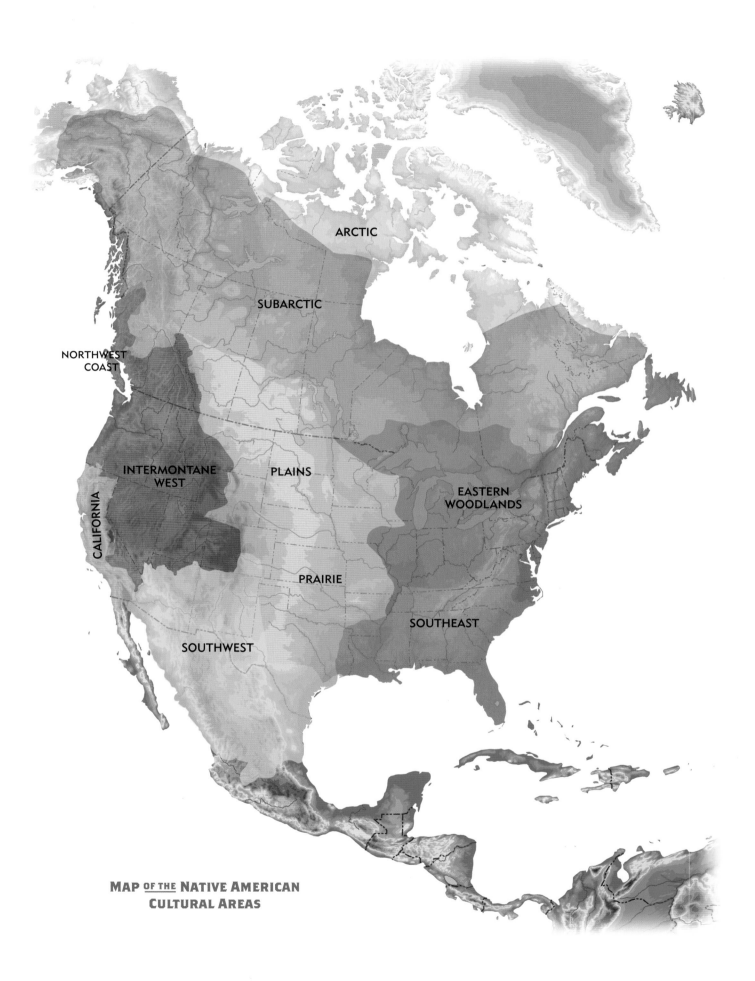

ARCTIC

SUBARCTIC

NORTHWEST
COAST

INTERMONTANE
WEST

CALIFORNIA

PLAINS

EASTERN
WOODLANDS

PRAIRIE

SOUTHEAST

SOUTHWEST

MAP OF THE NATIVE AMERICAN
CULTURAL AREAS

WOVEN
WORLDS

THE COLLECTOR AND THE COLLECTION

Lydia L. Wyckoff

The Philbrook Museum of Art, like other United States museums, including the Smithsonian, was made possible through the generosity of individual donors. Waite Phillips gave Philbrook's original building for a museum in 1938. He also donated important works of Native American art, including an Apache shirt and baskets and Santa Clara pottery. Later, museum purchases and other donations, specifically the Roberta Campbell Lawson, Ellis Soper, and Clark Field Collections, were added to the museum's Native American holdings. Today, Philbrook is well known among scholars for its excellent Native American department.

Clark Field assembled and donated two discrete collections, those of southwestern pueblo pottery and Native American basketry. His motive for forming those collections was certainly different from that of other collectors, but collections are also made in accordance with the European-American cultural values of the time period. These values, therefore, both form a market for the objects collected and are formed by the market, in that the collector is influenced by other collectors and instructed by the art dealers as to what is of value. The impact this market has on individual Native American

artists is profound. Again, although individual artists' motives to create will vary, the presence of a European-American market for Native American works clearly has a considerable impact on the indigenous culture. These changing values in turn are expressed through the pieces themselves.

Clark Field was born on January 6, 1882, in Dallas, Texas.[1] His parents, who were in their thirties, were both from relatively affluent backgrounds. Field's father, Frank Field, was brought up by his uncle, Dr. Robert Durrett, who sent him to boarding school and then to Kemper (1867–1870) and to Washington University in Saint Louis. In Saint Louis, Frank Field met and, in 1878, married Martha Bingham Clark. The following year, they returned to his hometown of Dallas where, in 1881, he became city attorney. At that time and for the next decade, Dallas was growing by leaps and bounds. The first telephone exchange was established, and by the time Clark Field was ten, Dallas boasted a waterworks, an electric plant, and a population of more than ten thousand. Dallas was the headquarters for traveling salesmen, or "drummers," because it was located between Galveston and Chicago, which was only one day away by train (Gaylan Potatti, personal communication November 6, 1997).

During this boom time, the Field family moved from Ross Avenue to the Oak Cliff section of Dallas. In 1884, Frank Field left his position as city attorney and went into real estate as the developer of this residential area. As a child in an affluent Dallas family, Clark Field lacked nothing and enjoyed the cultural amenities that moved westward. In 1893, the Field Museum was established in Chicago with donations from many of its citizens, including American merchant Marshall Field. Although preceded by the Smithsonian Institution (1846), the Peabody Museum at Harvard University (1856), and New York's American Museum of Natural History (1869), it was one of the earliest institutions to establish a great ethnographic collection. The development of this museum would certainly have been the talk of Dallas. The same year the Field Museum opened, the stock market crashed and Frank Field lost everything. It is hard to imagine the impact this must have had on Clark Field, then eleven, and his family. Suddenly penniless, they left Dallas in an attempt to reestablish their fortunes in Eddy County, New Mexico. Within a year, they moved again to homestead in Kildare, in present Oklahoma. This was just one year after the Cherokee Outlet had been opened to white settlers, on September 16, 1893.

The Cherokee Outlet had been conveyed to the Cherokee Nation by treaty in 1835. This treaty provided for the removal of the remaining members of that tribe from Arkansas to Indian Territory, now the state of Oklahoma. The Cherokee Outlet was added to the original seven million acres of land exchanged for the Cherokee homelands in the Southeast to ensure a "perpetual outlet west and a free and unmolested use of all the country west … of said seven million acres." However, after the United States government established reservations for the Osage, Kaw, Oto and Missouri, and Ponca, the Cherokee Nation leased the remaining land of the Cherokee Outlet, approximately 6,345,000 acres, to white ranchers. The ranchers fenced their vast range leases and built corrals and put up shelters for fence-line riders. Apart from that, little had changed prior to 1893, when one hundred thousand white homesteaders rushed into the area.

Information on the Frank Field family for the years between 1894 and 1898, when they resided at Kildare, has not been found. In all likelihood, they farmed their homestead of a quarter section (160 acres). This endeavor failed, and they may have exchanged the land four years later for a fruit farm near Guthrie. It is also possible that Frank Field sought employment in the bustling new frontier town of Kildare, which boasted a population of eight hundred by 1898. One thing was most assuredly the case—life was not easy, especially with the arrival of two more children, making Clark the second oldest of nine living siblings.

[1] All information on the Field family was acquired through David Mitchell, Clark Field's great-grandnephew, who kindly provided me with family records.

THE COLLECTOR AND THE COLLECTION

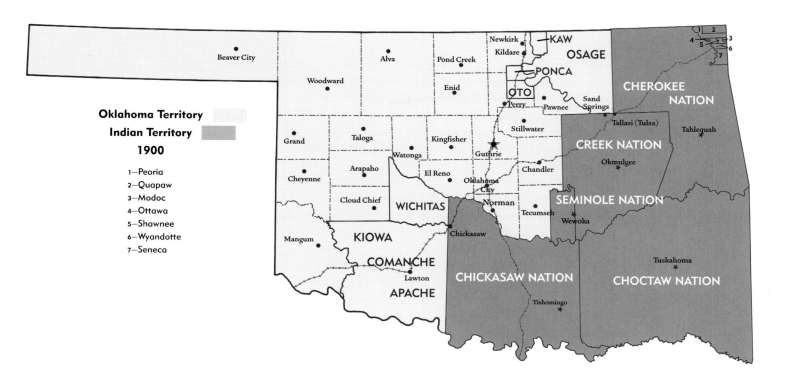

Oklahoma Territory
Indian Territory
1900

1—Peoria
2—Quapaw
3—Modoc
4—Ottawa
5—Shawnee
6—Wyandotte
7—Seneca

From 1894 until his death, Clark Field's life was closely entwined with the history of Oklahoma. When his father's homestead failed at Kildare, the family moved once again. By the time the Field family arrived near Guthrie, that area of the former Creek Nation had been officially opened to European-American settlement for nearly ten years. Even prior to that, towns had begun to develop along the Atchison, Topeka and Santa Fe Railway line, which crossed present Oklahoma, connecting Texas and Kansas. Guthrie soon became one of the largest towns on this railway line and, with the establishment of Oklahoma Territory in 1890, it also became the capital. Oklahoma Territory included all the land west of the then much smaller Indian Territory, which included the lands of southeastern tribes—Chickasaw, Choctaw, Seminole, Creek, and Cherokee—as well as the even smaller lands of the Peoria, Quapaw, Ottawa, Shawnee, Modoc, Wyandotte, and Seneca. By 1900, two years after the Field family arrived near Guthrie, Oklahoma Territory included twenty-three counties and six reservations. The population was estimated at nearly five hundred thousand, having increased sevenfold in ten years.

In 1900, at age eighteen, Clark Field left the family farm and moved to Guthrie. There he worked for the *Oklahoma State Capitol*, which proudly called itself "The first paper published in Oklahoma." Clark Field obviously did well at the newspaper. In 1901, he was "working as a reporter … [and] covered the opening for [European-American] settlement of the Kiowa, Comanche and Apache reservations in southwest Oklahoma" (Field, 1964). Unfortunately, the *Oklahoma State Capitol* records for that period were destroyed by fire, and it is not possible to determine which contributions to the paper were Clark Field's. However, those written by the "Staff Correspondent" and the "Regular Correspondent" are identical in approach (*Oklahoma State Capitol*, July 11, 1901; July 12, 1901). They reported on what forms needed to be completed and how they needed to be completed to register for the homestead lottery; what the conditions were for those registering—water, food, rooms, and dust, and if everything was orderly; and how many people had registered. Nothing was reported on the consequences of this lottery for native peoples themselves. Yet Clark Field (1964) has stated that it was at that time that he "first became interested in the art work of the Indians" and that he made a collection of beadwork and headdresses. Unfortunately, this collection was later destroyed either by moths (Church, 1952) or fire (Indian Pioneer History, 1937) and there is no record of the number of pieces or their quality. At this time, however, few artworks in the conceived "traditional" plains horse/bison cultural style would have remained.

With the near extermination of the buffalo more than twenty years earlier, Clark Field reported on the destruction of the remaining tribal lands as they were divided into individually held allotments, with "excess" land opened for European-American homesteaders. In many instances, Native American allotments were then acquired by European-Americans through fraud, or allottees were forced to sell their land to obtain cash. Many Native Americans were already producing artworks to acquire cash. These were usually copies of earlier pieces, and this was probably the type Clark Field acquired. Less than ten years previously, Smithsonian anthropologist James Mooney had commissioned Oklahoma Arapaho artist Carl Sweezy (Wyckoff, 1996) to record aspects of Arapaho life and Kiowa artists to make small-scale replicas of painted tipis. According to John Ewers (1978), these were based on the memory of elders, because at that time, only one painted tipi remained among the Kiowa.

Mooney, like other early Smithsonian anthropologists, was charged with collecting Native American objects. The oldest, the "most authentic," and "traditional" works were sought. If these were not available, replicas were made. All of this was done in an attempt to preserve what were conceived of as "vanishing primitive cultures." Furthermore, as Janet Berlo (1992) pointed out, efforts by some museums to "preserve" the past actually hastened its "destruction" or, more nearly correctly, the cultural change within those cultures. Between 1880 and 1885, the Smithsonian, for example, removed sixty-five hundred pots from the pueblos of Zuni and Acoma alone. Douglas Cole (1985), in commenting on the "scramble for Northwest Coast artifacts" between 1875 and 1929, states: "By the time it ended there was more Kwakiutl material in Milwaukee than in Mamalillikulla, more Salish pieces in Cambridge than Comox. The city of Washington contained more Northwest Coast material than the state of Washington..." The primary motive for assembling these vast collections of objects also stimulated the recording of the music, beliefs, myths, and social organization of those cultures.

This desire to save what was conceived of as the vestiges of a primitive Native American past for European-American science motivated private collectors as well as scholars. This was certainly true of Clark Field (1964), who sought "to collect authentic specimens of baskets made for actual uses by all basket-making tribes (no tourist specimens are included)." Needless to say, given the fact that his collection was begun in 1915, many "tourist specimens" are indeed included. I suggest, therefore, that at a personal level he was equally motivated by his acute sense of history, his involvement in the turbulence of the times, and his identification with the resulting loss for native peoples.

As a newspaper reporter, Field was actively involved in the rapid changes taking place. The *Oklahoma State Capitol* was the only Associated Press newspaper in Oklahoma Territory, and therefore a primary source for national and international news. Field would clearly have been aware of the development of museums and collections. In fact, on the front page on July 12, 1901, the reporting of the registration for acquiring tribal land is adjacent to the news of the dedication of the university at Rochester, New York, as well as news from Washington, D.C., and London.

During that time, which was the peak of Native American art collecting, I hypothesize that Clark Field, who had seen his family "lose everything," desired to preserve something of the way of life of people who were "losing everything" of monetary value in the form of land in Oklahoma. But why did he initially choose to collect baskets? Clearly, he was interested in things Indian. Along with his daughter, Dorothy, he became interested in collecting southwestern pueblo pottery in 1936. But basketry was his first love.

John M. Gogol (1985) has called the years between 1900 and 1910 "the golden decade of collecting Indian basketry." During that decade, basketry collection was encouraged through advertisements by railroads and steamship companies. Baskets for home decoration were considered most fashionable, and newspapers and magazines featured articles on homes decorated with a "basket corner," "Indian room," or "trophy den." By the early 1900s, nothing symbolized the success of the middle class in the United States more than a fine collection of aboriginal baskets. It was as if the act of

collecting, once the prerogative of the wealthy nobility, now validated the correctness of European-American expansionism.

Furthermore, with the memory of the "vileness of the war-like savage" put forth to fan prejudice and justify westward expansion still fresh in the European-American mind, baskets came to represent the romantic aspect of the "noble savage" because they were usually made by women. In his book *Indian Basketry* (1902), George Wharton James, a collector from Pasadena, California, states:

> Indian basketry is almost entirely the work of Indian women, and, therefore, its study necessarily leads us into the sanctum-sanctorum of feminine Indian life. The thought of the woman, the art development, the acquirement of skill, the appreciation of color, the utilization of crude material for her purposes, the labor of gathering the materials, the objects she had in view in the manufacture of her baskets, the methods she followed to attain those objects, her failures, her successes, her conception of art, her more or less successful attempts to imitate the striking objects of Nature with which she came in contact, the aesthetic qualities of mind that led her to desire to thus reproduce or imitate Nature—all these, and a thousand other things in the Indian woman's life, are discoverable in an intelligent study of Indian basketry.

James then goes on to quote Otis Tufton Mason, curator of the Division of Ethnology at the Smithsonian Institution: "In painting, dyeing, molding, modeling, weaving and embroidering, in the origination first of geometric patterns and then of freehand drawing, savage women, primitive women, have won their title to our highest admiration."

Although basket studies by such academics as Mason (1904) failed to stimulate the imagination of the middle-class European-American buyer, this was not the case for the writings of George Wharton James. According to Paul Arreola (1986), James' book, *Indian Basketry*, published in 1902, sold more than ten thousand copies in its first year of publication. The third edition was published in 1903, a year in which "more important work on Native American basketry was published than in any other year up to the present time" (Gogol, 1985). It was also the year *The Basket* magazine, the publication of the organization founded by James known as the Basket Fraternity, was first published. It is publications of this period, specifically the work of George Wharton James, which most profoundly influenced Clark Field.

In the introduction of *Indian Basketry*, for example, James validates the importance of Native American basketry based on four criteria: (1) it has utility and great antiquity in the Old World; (2) it has utility and great antiquity in the New World; (3) it is made by women; and (4) it is, therefore, an art form and "a striving after the idea; a reverent propitiation of supernatural powers, good or evil... Fine baskets, to the older women, were their poems, their paintings, their sculpture, their cathedrals..." James' romantic thinking is, shall we say, somewhat muddy—confusing art with religion and blindly associating women with art. But it is that thinking which made him also advise his readers to avoid baskets made to sell, because "the basket maker of to-day is dominated by a rude commercialism rather than by the desire to make a basket which shall be her best prized household treasure as the highest expression of which she is capable of the art instinct within her."

More than fifty years later, Clark Field, in his publication *The Clark Field American Indian Pottery and Basket Collections* (1952), uses similar arguments to establish the importance of his collection. As he states:

> The weaving of baskets is almost as old as the history of mankind. Baskets were found among the early Egyptians and are referred to in the Bible in the time of the Pharaohs, and they were found in the prehistoric cave dwellings of Europe.
>
> In this country, since baskets have been found in the caves of Utah, in the cave dwellings of Colorado and New Mexico, and in the Bluff Shelters of Arkansas, it is indicated that baskets were used by prehistoric man in North America—long before the days of Joseph of Biblical times.

Among many primitive races the baskets were a very necessary article of every-day life. Almost the first household article made was a carrying basket. Another was a basket in which to cook liquids. The weaving of baskets among the Indians of our country preceded blanket weaving, beadwork and pottery making. Some Indians never reached beyond the basket stage.

Field also points out the fact that women make most Native American baskets. He does not, however, imply that that is what makes it possible for baskets to be "art works" but rather focuses on the importance of the creativity of the individuals.

The Indian woman (who did all of the basket weaving) has shown herself to be an artist in making baskets. She has shown originality and creative ability. She created the shape and form of a basket and the decorative design. Her skill is shown in the development of the weaving process, and the variations of the weaves. The Indian woman has not only proved herself to be an artist—but a creative artist since she has created, out of the wealth of her imagination, the patterns for her designs and for the patterns of weaving baskets.

It is this sensitivity to the individual basketmaker that led Clark Field to provide us with much of the documentation for the baskets in his collection.

In 1903, when basket collecting was at its peak among European-Americans, Field was in no position to embark on acquiring baskets. In that year, he married Bertha Shearer, who had also moved with her family to Guthrie in 1900 (*Tulsa World*, September 7, 1965). Following his marriage, Clark Field became a student at the University of Oklahoma, where the newlyweds lived in married-student housing. After completing one more year at the university, Field became a traveling salesman. According to Robert M. Church (1952), former director of The Philbrook Museum of Art, it was during that period that Field "toured the Museums of America and found that complete collections of baskets and pottery, properly labeled and catalogued, were singularly lacking." What Church was probably referring to was that most museums did not strive to have baskets from "most of the basket making tribes of North America"(Church, 1952), but rather had collections formed at the time of specific ethnographic fieldwork projects or baskets that were made regionally. It was the comprehensive collection, as put forth by James, that Clark Field wanted. Ironically, with the coming of World War I, the interest of the American public turned away from basketry toward the crisis in Europe, just as Clark Field was in a position to start collecting.

In 1912, Field moved to Tulsa with his wife, Bertha, and their two daughters, Thelma, age six, and Dorothy, four years old. Tulsa in 1912 was very different from the town of Tallasi that the Lochapoka Creeks had known.

In 1836, the people from the Creek town of Lochapoka, in Alabama, were forcibly removed, along with other tribal members, to the Creek Nation in Indian Territory. Perhaps more than any other group, the Creeks suffered most severely during removal. Disease, exposure, and starvation must have taken an almost daily toll. Of the approximately 565 who started the trip from Lochapoka in 1836, the population was still only 274 in 1857, after twenty-one years had passed and many new births had occurred. That was barely half of the pre-exile number. In Indian Territory, the Lochapoka town of Tallasi, meaning "old town," was named after the affiliated mother town in Alabama.

According to Creek oral tradition, as Creeks were leaving the town of Lochapoka, their religious leaders gathered ashes from their sacred fire in the ceremonial square. They carried these ashes from the Southeast—across Alabama, Mississippi, and Arkansas—into Indian Territory. There they followed the Arkansas River until they came to a hill that rose from the sandy banks. On top of the hill was a large oak. Beneath that oak, a council of elders was held, and it was decided that that site, surrounded by rich land to support their crops, was to be their new town. After defining the place for their new ceremonial square, they scattered the sacred ashes they had brought with them

and lit a new fire. Today, the Creek council oak still stands, between Seventeenth and Eighteenth Streets and Cheyenne and Denver Avenues in Tulsa.

Like other native peoples from the Southeast who were removed to Indian Territory, the Civil War brought European-American politics, war, and pressure for land. During the Civil War, the town of Tallasi supported the Union, although some towns and individuals supported and fought for the southern states. The United States government used this action to justify its taking control of the western half of the Creek Nation, where it relocated other tribes and soon opened the area for white homesteads. The town of Tallasi, destroyed during the war, was never reestablished in the traditional Creek manner as a compact village of log cabins built around the ceremonial square, surrounded by fields. Although the ceremonial square was maintained, the people lived in the more dispersed patterns of self-sufficient farms. Some moved downriver to the present town of Sand Springs, and others to Broken Bow.

Beginning in the 1870s, European-Americans began to enter the Creek Nation. At first they came as traders, then as railway shopkeepers. In August 1882, the Saint Louis and San Francisco Railroad reached the Arkansas River two miles from Tallasi's ceremonial ground. This site was to become the city of Tulsa, which was granted an official charter of incorporation sixteen years later. Within six months, Congress passed the Curtis Act, which terminated all tribal governments and stipulated the disposal of tribally held land in Indian Territory. Most of the land was either allotted to Creeks individually or held by existing townsites. However, once again, greed and fraud allowed for the sale of allotments, particularly those surrounding Tulsa. Some Creeks declared many of the sales fraudulent. Others appealed to the federal government to honor the treaty signed on the removal to Indian Territory, which stated that the new country would be theirs forever and that it would be governed by no greater authority than their own. All these attempts for justice failed.

As in Guthrie, the prosperity of Tulsa was founded on the railroad and the opening up of Indian Territory. In contrast to Guthrie, however, Tulsans were soon to discover they had something of great value to offer the nation—oil.

According to historian Danney Goble (1997), after the 1905 oil strike south of Tulsa at the Glenn Pool, ninety-five companies were operating there, and by 1912 Tulsa claimed the title "Oil Capital of the World." The Texas Company, now Texaco, had built a refinery, and the Prairie Company, part of Standard Oil, moved its headquarters to Tulsa and laid pipe to get the oil from Glenn Pool and the Cushing Field to the nation. The ten-story Hotel Tulsa, at Third Street and Cincinnati Avenue, opened in May 1912. There, millions of dollars changed hands in oil deals. Harry Sinclair's suite of offices was on the fifth floor, and according to witnesses, oilman Josh Cosden once wrote a personal check for twelve million dollars over a table in the hotel lobby. Later, in 1914, it was at Hotel Tulsa that J. Paul Getty came to learn the oil business, and he established his company's first headquarters next door. Clearly, in moving to Tulsa, Clark Field had come to the right place at the right time.

In Clark Field's work as a salesman for the office supplier X-Line Rimer Company of Dallas, business was good. It became even better during World War I, when oil prices rose from forty cents a barrel to $2.25. Furthermore, because Field's sales "territory covered from the Panhandle [of Oklahoma] to northeast Indian Territory [now incorporated into the state of Oklahoma] he was often thrown among various Indian tribes, and became interested in their manners and customs" (Indian Pioneer History, 1937). According to his daughter, Dorothy, it was, however, a trip to New Mexico and Arizona that "revived his interest in Indian crafts, especially basketry" (Indian Pioneer History, 1937). Arizona and New Mexico were not in Field's sales territory, so the trip may have been initiated by the fact that his wife, Bertha, had been diagnosed with tuberculosis (David Mitchell, personal communication). At that time, the treatment, apart from rest, was dry mountain air. This trip took place in 1915, at which time Clark Field purchased

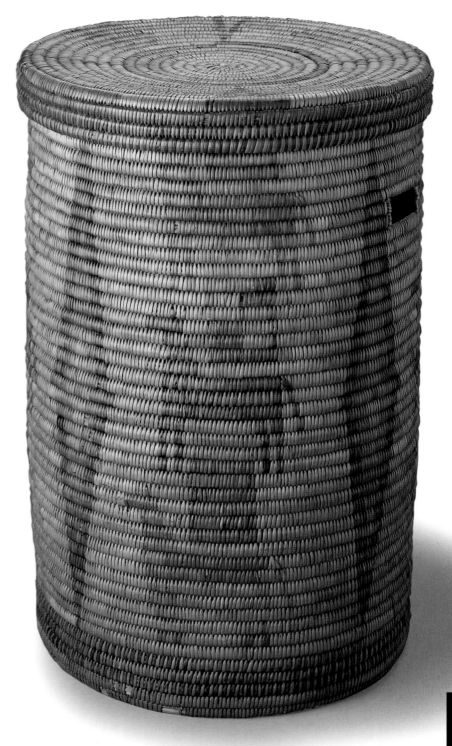

a basket at the Jicarilla Apache Agency, in Dulce, New Mexico. This basket is now at The Philbrook Museum of Art.

In 1915, Dulce was a small agency town with dirt roads in a dry valley beneath pine-covered mountains. Besides the agency buildings, there were a church and the Emmet Wirt trading post. Diseases of all types ravaged the malnourished population which, largely because of deaths from tuberculosis, had declined by nearly two hundred in the preceding fifteen years. When Field visited, only 642 people were on the tribal census roll (Tiller, 1983). Basketry, lumber, a tribal cattle herd, and a few crops barely sustained the population.

The basket that Clark Field purchased (plate 1) was typical of the strong, stout baskets made by the Jicarilla from willow and sumac. Commercial aniline dye was used to create the colors for large, bold designs. The design on Field's basket tells us of the

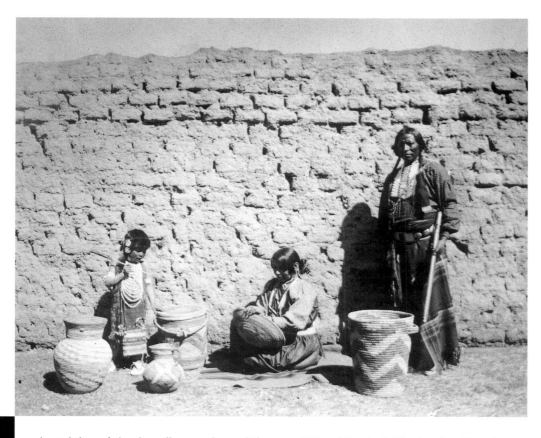

adaptability of the Jicarilla people and the creativity of the individual artist. The design consists of four long vertical triangles alternating with a vertical line of three horses, with three slightly rectangular box-border designs between them. Those are designs associated with the plains, where the Jicarilla hunted buffalo (bison) for part of the year before the Comanche made this impossible, during the first half of the eighteenth century. Prior to that time, the Jicarilla spent only the winter in terraced houses in the mountains, near the pueblos of Taos, Picuris, and Pecos, where they traded dressed skins. It has been suggested that it was from the pueblo peoples that they learned to make baskets. The Clark Field basket is a tall cylindrical-shaped clothes hamper that was made to sell to nonnatives (figure 3).

Did Field realize this basket was "made for sale" and far removed from his later claim that his collection contained "no tourist specimens"? At that point, it is indeed possible that he did not know what the Jicarilla knew, that the form or shape of the basket was desired by European-Americans for use and that the designs appealed to their preconceived notions of "Indianness." Field, however, must have realized that the bright aniline dyes were not traditional. This basket is indeed the first indication that Clark Field did not purchase baskets according to their ethnographic significance only, but also for the beauty of the piece itself. Perhaps as much as anything else, it was his innate appreciation of the beauty of Native American basketry that allowed him to become part of the weaving together of European-American and Native American worlds, as was made manifest in this basket.

As the world of the Jicarilla Apache shrank and they became increasingly dependent on the cash economy, Clark Field's world expanded as a result of his increased income (figure 4). In 1917, he founded Field Office and Supply Company in Tulsa with a bank loan of two thousand dollars (*Tulsa Tribune*, December 19, 1956). Field and his family had moved from 703 South Detroit Avenue to 1423 Carolina Avenue and then to 1126 North Elwood Avenue as Tulsa continued to expand and his income increased. The house on North Elwood was in the heart of the elegant upper-class residential area when Clark Field lived there. (This house was destroyed during construction of the

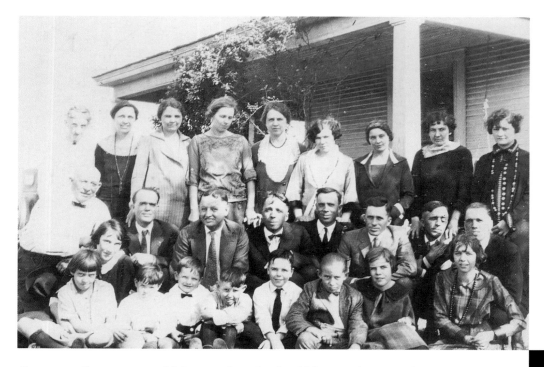

Crosstown Expressway, which served as the final blow to the area, long victimized by racially inspired urban blight.)

After the 1921 destruction by European-American oil workers of the Greenwood neighborhood, a prosperous African and Native American community of more than ten thousand residents, white Tulsans slowly abandoned the area north of downtown. The destruction of Greenwood, with its homes, offices, hotels, theaters, newspapers, schools, hospital, and library, has often been labeled the worst "race riot" in America. At that time, however, Clark Field was probably concerned mostly with developing his new business. In fact, he even had little time to collect baskets. In the early 1920s, the limited number of baskets he collected were primarily from the Southwest cultural area. In 1928, just one year after Waite Phillips had begun his magnificent oilman's manor that later become The Philbrook Museum of Art, Clark Field began his far more modest house five blocks away.

The Field house, at Twenty-two East Twenty-sixth Street, was one of the first houses to be built in the new Riverside residential area, adjacent to the elite millionaire section of Maple Ridge. Like Waite Phillips' mansion, it is made of stucco and roofed with red tile; however, it is not an Italianate villa but is in the somewhat exotic Spanish-revival style often seen in California buildings of that period. The doorway, with its Moorish arch, sets the tone, made "rustic" by the rough slab plaster sections of the exterior wall. By 1955 (*Tulsa World*, December 7, 1955), the house was filled with Clark Field's basketry and pottery and Bertha's Navajo textile and antique glass collections. Although at that time he claimed that the house had been designed to hold their collections, it was not until 1935, seven years after its construction, that Clark Field's collection could be expanded significantly.

The years between 1928 and 1935 must have been difficult for the Field family. Both of Clark Field's daughters, Thelma and Dorothy, had married, but Dorothy became estranged from her husband. Tulsa's economy was declining because of an undisciplined and uncontrolled oil industry (figure 5). With the discovery of the vast pools of oil in Rusk County, Texas, the price of crude oil dropped from $3.36 in 1920 to ten cents a barrel in 1933. By that time, the aftershocks of the collapse of the stock market, in 1929, had added to Tulsa's shrinking economy. The impact was greatest on the European-American oil workers and working class of west Tulsa and the African-Americans of north Tulsa as wealthy European-American families of south and east Tulsa reduced

FIGURE 4 : Field family reunion, Shawnee, Oklahoma, c. 1924 : Compared to the photograph of the Jicarilla Apaches selling their basekts, a different world is revealed. Clark Field is the fifth man from the right in the middle row. Four of his brothers are to the right. Of the three men on the left of the photograph, Field's older brother is sitting between two brothers-in-law. In the back row on the far left is the mother of a brother-in-law; otherwise, wives are standing behind their husbands. The young woman on the far right in the front row is Clark Field's daughter Dorothy.

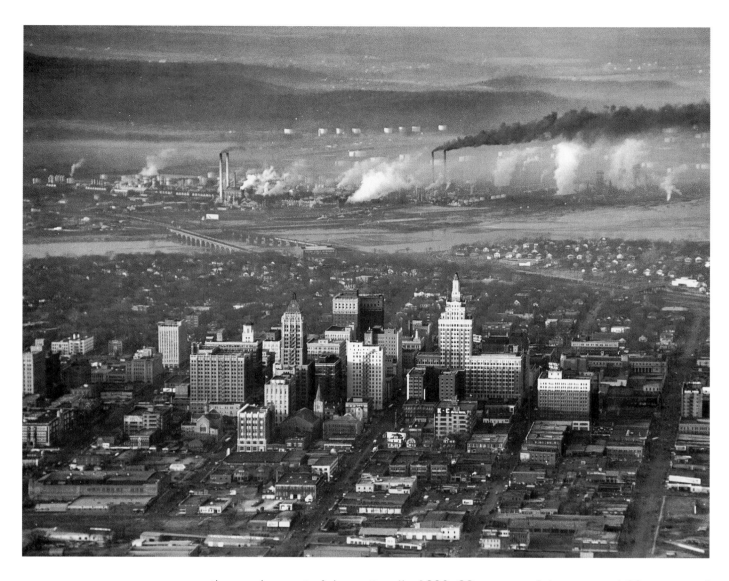

the employment of domestics. (In 1930, 39 percent of the men and 93 percent of women from the north Tulsa area served in that capacity.) For some of Tulsa's wealthiest residents, their finances were such that they merely suffered from inconvenience and anxiety, but for others, the impact was devastating.

Regarding the expeditious sale of the Waite Phillips Company in 1925, Waite Phillips stated, "when I sold out … my accumulated profits [twenty-five million dollars in cash] from oil investments were put into municipal bonds, a new home and two large buildings in Tulsa" (Wallis, 1995.) As a result, Phillips was able to lend support to others who were not doing as well. The Field stationery firm also managed to weather the storm, although profits greatly declined.

Oklahoma and Tulsa benefited as much as any city and state from Franklin Roosevelt's New Deal. Within six months of his inauguration in 1933, paychecks were issued to Tulsans by the Federal Emergency Relief Administration. Thousands of Tulsans were soon back at work on projects sponsored by the Works Progress Administration. Needy people were now treated and paid with more equality. Recipients of jobs through the WPA not only built armories, post offices, and schools but also wrote books, painted murals and, through the Indian Arts and Crafts Board, encouraged and sponsored Native American art.

The Oklahoma chairman of the Public Works of Art Project was the artist Oscar B. Jacobson of the University of Oklahoma, a keen supporter of the early Kiowa painters. Those artists, as well as Creek/Pawnee painter Acee Blue Eagle, received the majority of

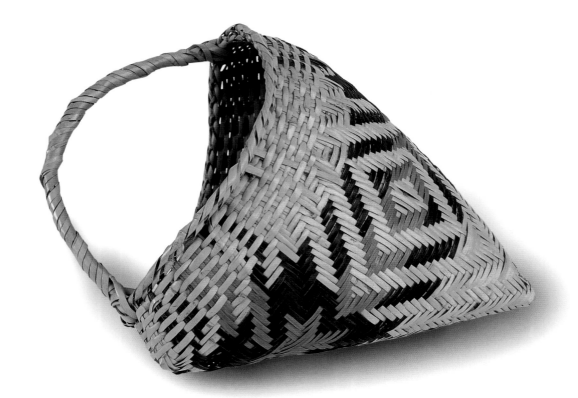

the seventeen Oklahoma commissions under the PWA program, which lasted from December 1933 to June 1934 (Wyckoff, 1996).

Although the project employed only a small percentage of Native American artists—twenty-two when it was terminated—many people argued that, given the lives of poverty among the Native American population, an Indian "Public Works of Art Project" was needed. In 1934, the most active proponent of a federal program was Nina Perera Collier, wife of Charles Collier, son of the commissioner of Indian Affairs, John Collier. President Roosevelt had appointed John Collier to serve under Secretary of the Interior Harold Ickes. Immediately after his appointment, in 1933, Collier denounced the policy of previous administrations, which had set about to destroy Indian identity and force native peoples to comply with European-American beliefs and practices. Thus, Collier's first priority was to promote "cultural self-determination," through encouraging groups to write their own constitutions and to elect councils to govern by majority rule. This was made possible through the Indian Reorganization Act, or Wheeler-Howard Act, of 1934. It is not surprising, therefore, that although Nina Collier's efforts failed, John Collier supported her involvement because it coincided with his efforts to preserve Native American culture. After a year of struggle, Congress passed Senate Bill 2203 in 1936. This bill established the Indian Arts and Crafts Board "to promote the development of Indian Arts and Crafts … and for other purposes" (Schrader, 1983), namely to control the sale of inexpensive, mass-produced copies marketed as "Indian art."

With the increased emphases on quality Native American art and crafts, as well as providing him with "something to do" when in the Southwest for Bertha's health (David Mitchell, personal communication), Clark Field's interest in baskets continued. In 1934, he attended the Gallup Inter-tribal Ceremonial in New Mexico at the same time as the committee to prepare the "Report on Indian Arts and Crafts" for Senate Bill 2203 was there. Field probably met some of the committee members, including chairman James Young, of the University of Chicago, novelist Oliver La Farge, and Kenneth Chapman of the School of American Research in Santa Fe. At that time, Field was proposed as basketry judge for the following year. This he agreed to, and he continued to serve as a judge until 1962.

It is not surprising, however, given the construction of the new house, Dorothy's divorce, and the economic upheaval of the depression, that Clark Field collected few baskets until 1935. In August of that year, he returned to Gallup with his wife, Bertha, and daughter Dorothy. At that time, he acquired three southwestern baskets and one

PLATE 2 : Choctaw elbow basket, c. 1937 : This basket (1948.39.26), made by Fannie Battiest (Mrs. Willis Wesley), was collected by Clark Field in 1937 near Broken Bow, Oklahoma. In 1994, her niece through marriage, Elsie Battiest, was interviewed by Lisa Blaylock of The Philbrook Museum of Art. At that time, Elsie Battiest's daughter, Eveline Steele, translated for Elsie. According to her, when Fannie Battiest made this basket, "they often camped and lived along the riverside . . . they stayed there and gathered their cane and material, [later they] made their baskets and sold what they didn't need to use, as it was a way of making money or trading."

Paiute basket. In 1936, he continued to collect baskets from the Southwest, six in all, but he focused on Oklahoma, where he collected fourteen Cherokee baskets, seven Choctaw, one Chiricahua Apache, and one Seneca basket. Although he had collected a few local baskets previously, the number of purchases he made at that time was probably inspired in part by the Arts and Crafts Board.

After Collier's appointment of René d'Harnoncourt as manager of the Arts and Crafts Board in 1936, d'Harnoncourt's primary concern was to establish what native arts existed and how they could be developed. He believed that the only method possible was to work with each tribe or tribal subdivision as a separate entity. This approach required background research, consideration of past history and, most importantly, close contact and cooperation with local Indian peoples. To do this, d'Harnoncourt began to visit tribal areas as well as contacting local collectors, dealers, and Indian Service staff members. By the beginning of 1937, he had not only visited Oklahoma but while there had "arranged for a modest flow of craft output" (Schrader, 1983). At that time, he also arranged for Alice Marriott, an anthropologist in Oklahoma City with experience among Oklahoma's Kiowa tribe, to become the regional specialist for Oklahoma. Gladys Tantaquidgeon was assigned to North and South Dakota and, in 1938, Gwyneth B. Harrington was assigned to southern Arizona (Schrader, 1983).

By 1937, Clark Field had established the academic goal for his collection and his method for achieving it. His goal, that of acquiring baskets from "every Indian Tribe that made baskets" (Indian Pioneer History, 1937), was to be achieved through purchase (1) when possible, from the makers; (2) dealers, other collectors, and museums; and (3) shops. He actively sought out people knowledgeable in specific areas, and from them learned of makers and vice versa. By then, at age fifty-five, Field had developed an interest in baskets that was no longer a hobby but a vocation, and later became what some people thought of as an obsession. At the beginning of 1937, Field had acquired fewer than fifty baskets; by November of that year, he had two hundred. Forty-eight of those he acquired in Oklahoma by going to various agencies and schools as well as obtaining them from the weavers themselves. He visited the Baptist Native American school, Bacone College, in Muskogee. Through Alice Spink, whose mother was White Mountain Apache, and her husband, who had Karuk kin in California, Field acquired Apache and Karuk baskets. He purchased baskets from the Sequoyah Occupational Trade School, a Bureau of Indian Affairs boarding school near Tahlequah. Through the United States Agency at Shawnee, he acquired both Sac and Fox and Kickapoo baskets (plate 81, p.165). He bought several baskets from Choctaw weavers Fannie Battiest (plate 2) and Jane Brandy as well as from Cherokee weavers Susie Soldier Glory and Eliza Padgett. Then he planned an ambitious collecting trip of more than two months, from Oklahoma to Alaska.[2]

Clark Field left Tulsa at the end of June 1937, before the blistering Oklahoma summer. In those days before air conditioning, Oklahomans who could possibly afford it fled Tulsa's 95- to 110-degree temperature during July and August. Colorado, Wisconsin, and Michigan were the most common retreats, but Clark, Bertha, and Dorothy drove west.

In 1937, Route 66 was paved in its entirety, including the section from Santa Rosa to Albuquerque, thereby eliminating the Santa Fe loop and reducing driving time by four hours (Wallis, 1990). Route 66 was America's primary road linking midwestern cities with California. It was the road along which Clark Field traveled to California and back. Today, to those of us accustomed to four- and six-lane highways, it might seem arduous. In 1937, with new restaurants and motels to serve travelers, not to mention the numer-

[2] The reconstruction of this trip is based on Clark Field's catalogue entries, the general sequence of his numbering system, and references to his various trips (*Tulsa Daily World*, October 2, 1938; October 17, 1954; *Tulsa Tribune*, July 1, 1946; September 17, 1950; July 28, 1955).

ous Indian craft shops which Clark Field would have delighted in, the trip was a delightful adventure. As a middle-aged Tulsa businessman, Field was interested in Native American culture and the exotic. He was somewhat adventurous but was not an explorer. This rather conservative aspect of Field's character, along with his increasing knowledge of Native American cultures, can be traced through his acquisitions and accompanying notes on Hopi basketry.

Hopi women were, and still are, prolific basketmakers. They occupy a somewhat isolated area in northeastern Arizona, living in small villages or pueblos. When Clark Field bought Hopi baskets in 1936, he labeled them as having been made by the "Oraibi Clan" or the "Mishongovi Clan." Oraibi and Mishongovi are pueblos and not clans. When he purchased more Hopi baskets in 1937, he realized that those were places rather than genealogical groups. In 1938, he bought a basket from "near Oraibi." Although it is an Oraibi-style basket, he probably bought it at Leupp, north of Route 66 between Windslow and Flagstaff. It was not, however, until 1943, when a serviceable road crossing the Hopi Reservation from Keams Canyon to Tuba City was constructed, that he traveled through that area. His most extensive trip was in 1952, after the road had been paved.

In 1937, Clark Field's primary focus of basket collecting was California. During the week it took him to drive from Tulsa to Flagstaff, Arizona, he probably stopped along the way and bought more Hopi baskets and may even have requested that J. Verkamp of Flagstaff hold a fine prehistoric Basket Maker II (A.D.1–500) basket for him until his return trip. As the heat began to rise in the first days of July, he continued on Route 66 through the southern section of the Hualapai Reservation to Peach Springs. According to Michael Wallis (1990), the town had been named by early explorers who were surprised and delighted to find peach trees, introduced by the Spaniards, growing there. There, Clark Field bought a Hualapai basket. He and his family possibly spent the night there or may have driven on to Kingman, location of the well-known Beal Hotel, where such celebrities as Greta Garbo and Anne Morrow Lindbergh had stayed less than ten years earlier. It was always important to leave Kingman before the second week in July, because any later, the drive into California and across the Mohave Desert could be intolerable, especially for a middle-aged couple.

In Barstow, California, the Field family turned off Route 66 to go northwestward to Mohave Pass and from there north to Carson City, Nevada. On the way, they stopped at Yosemite National Park. After they reached California and were in the Sierra Nevadas, where the temperature was cooler, Clark Field increased his collecting efforts. He examined the baskets at Yosemite and purchased a Northern Paiute serving bowl. At Bridgeport, he bought what he thought was a Yokuts basket. Suzanne Griset (see this volume) has determined that it is in fact a Tubatulabal piece. (That and the basket he purchased from the Fred Harvey Company on his return trip through Albuquerque are the only Tubatulabal baskets in his collection.) Approaching Carson City, Field may have noticed the Carson Indian Agency on his right in the agency town of Stewart. Perhaps he even stopped there before going on to Carson City to inquire who was weaving the best baskets. Clark Field always sought quality, and he knew about the great Washoe weaver Dat-So-La-Lee, but he probably did not know that her real name was Louisa Keyser.

Louisa Keyser, like other individuals between 1910 and 1920, had been "marketed" along with their baskets. Her "Indianness" was exploited at the same time her skill and artistic ability were admired. The latter qualified her for a "real" Indian name, albeit derogatory—"big hips"—by Carson City traders Amy and Abe Cohn (see Tisdale, this volume). But Clark Field's primary interest was utility baskets. Such workbaskets were what he had collected among the Oklahoma southeastern tribes (see Gettys, this volume). So perhaps, on failing to find that type of basket in Carson City, he later stopped at the agency at Stewart. There he bought a double-handled workbasket.

The Field family probably spent a few days enjoying Carson City and Lake Tahoe. It was also critical to make arrangements to ship back to Tulsa the four Washoe baskets

Field had purchased, including the large basket he had bought at the agency, as well as others he had picked up along the way. Fortunately, during that time, he appears to have had no problem in sending baskets by Railway Express or carrying them in the car. This was not true during World War II. In a letter to Dorothy (August 25, 1967), he reminisced about the problems of transporting artworks to Tulsa, specifically pottery. "Remember you helping me pack the pottery we put in storage until I brought [a] truck from [the] store and went out and hauled it into Tulsa. There was a truck load—our company furniture truck—a full—very full load."

While in the Carson City area or perhaps on his way to Sacramento, Clark Field stopped at Woodfords and bought one of his finest Washoe baskets. It is an exquisite early twentieth-century piece by a master weaver. Unfortunately, Field does not tell us who she was, but he notes that "her work is as famous as Dat-So-La-Le"; she was probably Maggie James (see Tisdale, this volume).

It is often difficult to determine if Clark Field stopped to see a particular collector or collection before visiting a tribal area to gather information or after he had visited a tribal area to acquire baskets but was not able to collect directly from the weaver. The later was clearly the case when he later visited R. B. Cregar in Palm Springs. This may also have been the case when Field purchased baskets from the estate of Henry B. Spencer in Sacramento. If this is the case, Field would have crossed from Carson City via Sacramento on Route 50, either to San Francisco or by turning northwestward to Napa and Petaluma, from whence he continued north on Route 101. There, he was entering Pomo country.

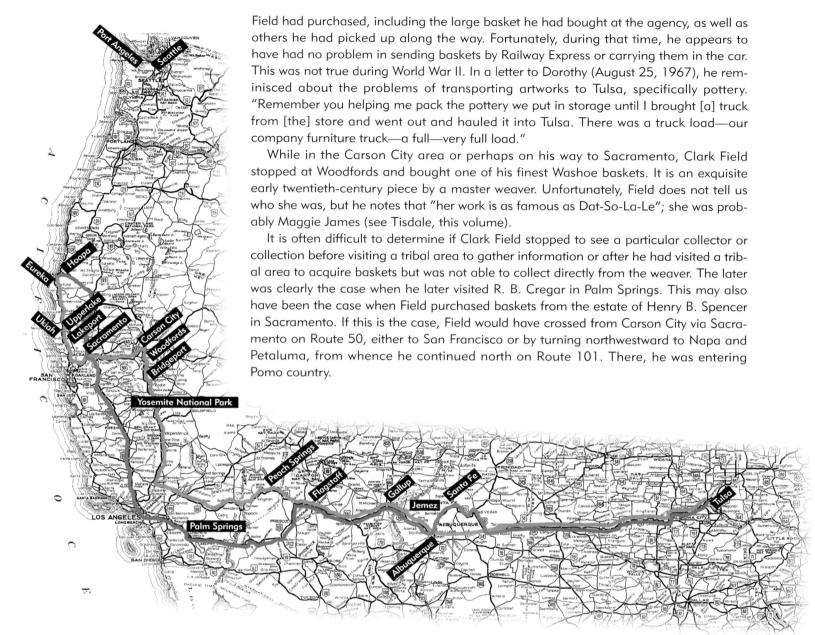

Automobile route of Clark Field's collecting trip, 1937.
1937 map detail courtesy of the Southern California Automobile Club.

In the nineteenth century, the Pomo had been harassed by settlers, their land had been taken, and they had been marched forcibly to the Mendocino Reservation, now Fort Bragg. Some were taken to what was to become the Round Valley Reservation. In the Ukiah area (see Griset, this volume), displaced Pomo joined together to buy back small sections of land, usually less than one hundred acres, on which they could build their own communities, called rancherias. Four of these are clustered about the European-American town of Ukiah, which in 1889 was linked by railroad to San Francisco. Ukiah became the center for the commercial market of Pomo baskets, which flourished between 1890 and 1920. In 1937, Clark Field visited several shops and dealers in Ukiah and bought one basket from what he called Ukiah Rancheria. Turning east from Route 101, he went to Big Valley Rancheria near the town of Lakeport. In the area of the town of Upper Lake he went to what he called the Robinson Rancheria, where he bought an heirloom piece made by Emma Bateman Anderson. At the nearby Upper Lake Rancheria (Habematolel), he bought a basket from Lydia Graves Thompson Sleeper.

As Clark Field continued to travel northward, he could pride him-
self on the nine Pomo baskets he had acquired. Each was a work of
art. But he wanted a collection "of great significance anthropo-
logically as well as artistically" (*Tulsa Daily World*, March 17,
1947). He needed to balance his collection of Pomo art baskets
with Pomo functional workbaskets. Unable to do so, he sought out
the Hupa and Karuk, who were not known for their art baskets, and
so he continued north on Route 101 to the town of Eureka. What a
variety of Hupa baskets he collected—bowls, a tobacco jar, a hat, a
cradle, a carrying basket with tumpline, and two wastepaper bas-
kets made for the European-American market! At the Hoopa Valley
Agency, near the town of Trinidad, he bought a Karuk bowl and
what he thought was a Hupa mortar hopper for grinding acorns,
but it too was Karuk. (To see how a mortar hopper is used, see fig-
ure 15, p. 62.)

It is not known how Clark Field and his wife and daughter trav-
eled north from Eureka. They could have taken a boat from there or
traveled back to San Francisco, from where they took a ship to Alaska.
They could have driven or taken a train to Seattle and then cruised north-
ward, up the Strait of Georgia between Vancouver Island and the British Columbia
mainland into Queen Charlotte Sound. It was the end of July, so the orcas would have
been swimming there. From the ship, Field would have seen abandoned northwest-
coast villages with plank houses and totem poles at the edge of the water (figure 19, p.
111). The Fields stopped at the Queen Charlotte Islands and Hydaburg, Alaska, from
where they crossed to the Aleutian Islands before their return. (In 1948, when Clark
Field returned to Alaska, he added air travel to the three modes of transportation he
had used in 1937.) Their last port of call in the United States would have been either
Seattle or Port Angeles. It was probably at Port Angeles that Clark Field bought both a
Quinault and a Makah basket. Access to both of those tribal areas would have been
extremely difficult in 1937. Today, the two-lane paved road from Port Angeles to Neah
Bay, the town on the Makah Reservation, is still somewhat hazardous, a mere ribbon
between the mountains and the Juan de Fuca Straits. It is frequently blocked by rock
slides. In 1937, it was little more than a track.

When the Fields' ship stopped at Vancouver Island, probably at the port of Nanaimo,
Clark Field bought a Clallam cooking basket. That harbor had originally been occupied
by the Nanaimo. Although the island itself was bought by James Douglas in 1850, by
then the area had also become home to the Clallam. But the nonnative expansion on
the Olympic Peninsula was soon to follow them there, as farms were cut into the interi-
or and sawmills and canneries stole resources. The devastation of lumbering for people
who live by fishing and gathering cannot be overly emphasized. With the cutting of tim-
ber, it is not just the trees that had been used for canoes, fishnets, baskets, and mats
that are destroyed, but once they are removed, secondary shrubs and plants usually die.
Those plants and shrubs had provided berries, roots, and herbs. So the Callam became
wage laborers, working as fishermen and loggers, and they were therefore deeply
affected by the Great Depression. As wage labor decreased, women attempted to
return to gathering where possible, but they were dependent for extra cash on the occa-
sional sale of baskets, for which they had long been famous.

As they cruised northward, Clark Field bought two Haida baskets, one at a stopover
at Queen Charlotte Islands (see Webster and Tisdale, this volume). In Hydaburg, he
bought what he thought was a Haida basket, but it is actually Tlingit. Hydaburg, an
important stop for cruise ships in 1937, was filled with craft shops. Because Field knew
the town was in Haida country, he probably assumed the basket he bought was Haida.
His understanding of the association of place with a given group frequently caused him
confusion. For example, when he returned to Carson City in 1962, he bought three bas-

kets which he assumed were Washoe, when in actuality they were made by their neighbors the Northern Paiute (see Tisdale, this volume). Likewise, when the ship stopped at Attu Island, he labeled the basket he bought there as having been made by the "Attu" instead of Aleut. The two Aleut baskets he bought on this same trip he correctly referred to as Aleut, presumably because he bought them from other islands in the Aleutians.

Clark Field's continued concern for collecting indigenous "workbaskets" as well as exquisite "art baskets" is seen once again in the Aleut baskets he collected. On Attu Island, he collected a well-worn pack bag (see McMullen, "Arctic and Subarctic," this volume) and an exquisite "trinket basket" (plate 3). This finely woven basket, which Field described as looking "as fine as coarse linen" (*Tulsa Tribune*, July 30, 1942), was made for sale. It is decorated with glistening red silk embroidery thread, contrasting in both color and texture with the muted tone of the basket's woven split grasses. In this instance, it is not just the size or the form, with its little knobbed top, that was created for the European-American market, but the materials themselves speak of the meeting of two cultures. Aleut baskets are made from grasses that grow along the shore and streams of this otherwise barren land. Starting in the eighteenth century, contact between the Aleut and Europeans was based preliminarily on trade—an exchange of goods, a sharing. This, as opposed to forced acculturation, allows for a more selective indigenous process in deciding what is acceptable and what is not. The silk thread was bought from traders. When Clark Field visited the Aleut prior to their profound upheaval during World War II, he found that with the decline in whaling as well as the effects of the depression, only "three old ladies" (*Tulsa Tribune*, July 30, 1942) were making baskets in 1937. After the Japanese attack on Alaska in the summer of 1942, the Aleut were evacuated to southeastern Alaska, where they remained until the end of the war.

Returning to the mainland on their 1937 trip, the Field family turned south on Route 99. From Sacramento, where Clark Field purchased baskets from the Henry B. Spencer estate, they continued all the way to Palm Springs. There Field visited R.B. Cregar and purchased Paiute, Yavapai, Chemehuevi, and southern California baskets. In total, Field acquired 27 percent of the California baskets in his collection on that trip.

Clark Field probably met Cregar in New Mexico at the Gallup Inter-tribal Ceremonial in 1936 when Field was judging there. In fact, in 1937 he bought from Cregar a Cahuilla basket from southern California which had been awarded first prize at Gallup in 1936. Clearly, Field was now a member of a web of basket dealers and collectors. It is even possible that from Palm Springs to Gallup, Cregar and Field traveled together, taking Route 89 east and then north to Prescott, Arizona, to rejoin Route 66 at Ash Fork .

Clark Field had arranged to have the baskets he had purchased from Cregar sent back to Tulsa, but at Flagstaff, he stopped at J. Verkamp's and collected or purchased his Ancestral Pueblo (Anasazi) basketry bowl and took it with him to Gallup.

The Gallup Inter-tribal Ceremonial is still held the second weekend in August. Until the late 1950s, it was considered to be superior to the Santa Fe Indian Market, now the most important Native American art competition and market in the United States. In 1937, however, competitive dances were held in Gallup on the ceremonial grounds, with a grandstand for visitors. The exhibit hall had only a single aisle to allow visitors to walk between booths and purchase items—no doubt looking carefully at pieces that had won a prize. Clark Field purchased three prizewinning baskets.

As a judge, Clark Field was instructed to "rule out of competition any article which shows non-Indian characteristics" and "to make certain that only quality arts and crafts are featured" so that "products which are not traditional and do not display Indian trends that one would wish to see developed… [are] put aside" (Hart, 1955). Thus, Field as a collector and a judge was active in influencing the Native American basketry market. As a judge, he was determining what was "traditional," which was frequently based on a preconceived European-American notion of "Indianness." Similarly, because "a recognized trader, dealer, agency, school, guild, mission, or any other recognized organization" (Hart, 1955) could submit chosen "Indian crafts," control of the

Native American art market extended throughout the European-American system, including the Indian Arts and Crafts Board, for whom the Inter-tribal in Gallup became a showcase.

Leaving Gallup, the Clark Field family took Route 66 to Albuquerque and, staying on the old route, went to Santa Fe, stopping on the way at Jemez Pueblo to buy a twill-plaited bowl. In Santa Fe, Field visited the School of American Research, which had been involved in the San Ildefonso black-pottery revival in the 1920s and the resultant fame of Maria and Julian Martinez. Field also went to the associated Laboratory of Anthropology, where the curator, H.P. Mera, classified and appraised the basket Field had just bought at Verkamp's in Flagstaff. Obviously, Field wanted to be reassured as to the authenticity of the piece and possibly whether he had made a financially "good deal." Certainly, it is authentic; however, the cost of twenty dollars may or may not have been in accordance with Mera's appraisal. Two months later, Dorothy noted that the basket was the most valuable in the collection (Indian Pioneer History, 1937).

On later trips to the Southwest, Bertha frequently stayed in Santa Fe to enjoy the mountain air and relatively cool temperature, compared with the heat of Oklahoma at the end of August and the beginning of September. The Fields always stayed at the La Fonda hotel, a grand old adobe on the corner of the Plaza. Bertha liked to sit on the terrace and read and watch people go by while her husband and, in 1937, her daughter went to pueblos and downtown shops to buy baskets and pottery (David Mitchell, personal communication). However, in 1937, Bertha probably returned to Tulsa with her family.

In Tulsa, Clark Field returned to his business but also set about classifying his collection, making "charts representing the different weaves, showing how the crafts of each tribe may be identified" (Indian Pioneer History, 1937). By then, he had collected two hundred baskets and, according to Dorothy, he considered his collection "about two-thirds complete." Clearly, his opinion changed! His desire to continue to collect was probably further stimulated by the Arts and Crafts Board and, two years later, by the establishment of the museum, later to be known as The Philbrook Museum of Art.

Starting in 1937, the first year that regional specialists were employed by the Arts and Crafts Board, Field began to use them to acquire baskets for him. It also appears that initially the Fields were a primary source for information on baskets in northeastern Oklahoma for Alice Marriott, the Oklahoma regional specialist (Marriott, 1937a). Alice and Dorothy soon became friends (Marriott 1937b, 1938a,b; Morgan, 1937, 1938). This is not surprising, considering their similar interests and age. In 1938, Alice and Dorothy, as well as Clark Field, would often travel together on basket-collecting trips. Field was increasingly recognized for his knowledge as well as for being an active participant in this new Indian arts and crafts movement. As a trustee of the Tulsa Art Association and Tulsa's American Indian Foundation, he was actively involved in the exposition at the Tulsa Fairgrounds associated with American Indian Week, which in 1938 was to include a model room. This room, sponsored by the Arts and Crafts Board, was to demonstrate the uses of Native American works in a European-American household, containing everything from rugs to pottery lamps with parfleche (rawhide) shades to furniture to "objets d'art." In other words, it was a marketing "showplace." Clearly, those were "Indian trends that one would wish to see developed." The extensive correspondence (Petty, 1938a,b, c, d; Rowland, 1938a,b) on this project indicates that Clark Field sought a far more elaborate and costly presentation than the Arts and Crafts Board and that "Mr. Field and Mrs. Morgan [Dorothy Field Morgan] have between them about taken over management" (Marriott, 1937a), which at times was probably a source of conflict.

The Arts and Crafts Board also further expanded Clark Field's network of basket enthusiasts. Of particular importance was anthropologist Frank Speck, of the University

PLATE 4 : Naniticoke baskets : Frank Speck was among the few anthropologists who attended to mixed-heritage communities of the northeastern cultural area in the mid-Atlantic region (see McMullen, "Eastern Woodlands," this volume) such as the Nanticoke and Rappahannock. He identified the characteristic rim finish of Nanticoke baskets, shown here on the left (1948.39.259). Speck (1915b) also described Nanticoke fishing technologies, including the use of "eel pots," or traps, like the one shown here on the right, which were baited, set along the shore, and weighted down with stones. The larger "base" of the trap is constructed of an array of sharpened sticks which point inward, leaving an opening through which eels could swim into the trap but not get out. The covered top of the eel pot could be removed for gathering the eels (1948.39.271). This eel pot, made by Topsy Morris in the 1860s, was probably collected in Delaware before 1915 and bought by Field in 1943 as an anthropologically important piece.

Ann McMullen

of Pennsylvania. Alice Marriott had known Speck since the late 1920s, and it was probably at her suggestion that Clark Field contacted him as a source for almost his entire northeastern Native American basket collection. There is no indication that Field ever visited the Northeast himself. His heightened focus on the role of other collectors in the 1940s undoubtedly reflects in part the founding of Philbrook.

On September 21, 1938, Waite Phillips released a statement indicating his desire to donate his villa, Philbrook, for use as a museum and that it was to display "therein works of art, literature, relics and curios including those representative of the native North American peoples" (Wallis, 1995:280–281). Three weeks later, Clark Field announced that he would donate his basket and pottery collections to the new museum. This makes one wonder if he acquired his collections in the hope of donating them to a museum to be established by the Tulsa Art Association, or if he knew from Waite Phillips of this forthcoming announcement (*Tulsa Daily World*, October 2, 1938). As established by Phillips, the museum was to be administered by the Southwest Art

Association. The seven original appointed trustees were authorized to appoint four additional members, of which Clark Field was one. He was on the board of trustees as a knowledgeable collector of Native American art, as was Roberta Campbell Lawson, granddaughter of Charles Journeycake, the last hereditary chief of the Delaware. In 1939, Field was also president of the Oklahoma Archaeological Society (*Tulsa Tribune*, October 13, 1939) and was actively involved in the work of the Arts and Crafts Board. Furthermore, he was a member of the Tulsa Chamber of Commerce which earlier had been dominated by oilmen. It was the challenge of the chamber to pull Tulsa out of its protracted depression, furthered by the virtual depletion of Oklahoma's oil resources.

Since 1919, the Field family had had a cabin at the Tulsa Ozark Club, on Spavinaw Creek (David Mitchell, personal communication). This club, which centered around hunting and fishing, was also a place for children to play and for men—the movers and shakers of Tulsa—to ponder such problems as the Tulsa housing shortage and the war in Europe.

When the United States entered World War II in December 1941, war orders flooded the market. Tulsa, not to be left out, worked directly with the National Housing Board and the War Production Board. The result was that the chamber got the government to agree to hurriedly construct hundreds of new homes (Goble, 1997). Not surprisingly, the War Department then chose Tulsa for its new fifteen-million-dollar Douglas Aircraft Company plant. The plant was joined by J. Paul Getty's Spartan Aircraft Company and its associated program, the Spartan School of Aeronautics. Tulsa was once again expanding, and Clark Field was a man of considerable importance and means. Although he was not an oil multimillionaire, it is apparent that starting in 1940, he was collecting and investing in Native American baskets with the intention of donating them to Philbrook. With this in mind, he started to acquire baskets from Frank Speck.

Frank Speck, who was one year older than Field, had been a student of Franz Boas, the founder of North American anthropology. In the approach of the times, Speck was dedicated to recording, collecting, and measuring what was conceived of as the culture of the disappearing Indian, aiming toward historical reconstruction to create an image of life prior to European contact. Speck wrote his master's thesis and dissertation based on his research among the Yuchi in Oklahoma. In 1908, while still working on his dissertation, he began to teach at the University of Pennsylvania, where he remained until his death, in 1950 (Wiengrad, 1993).

Speck, from the age of about eight to fourteen, had lived with a Mohegan, Fidelia Fielding, from whom he learned the Mohegan language and a deep respect for the natural world. According to Speck's student Loren Eiseley (1975:131), "He was basically an Indian." Others thought of him as "playing Indian," but one thing is apparent; for Speck, like Field, the important thing was active participation. Where Field was a trustee of the American Indian Foundation (Rowland, 1938 a and b), Speck was an adviser for the Nanticoke Indian Association (plate 4, p. 19). In contrast to most academics, Speck disliked the library, and if he had to consult a file of journals, he would send a student (Eiseley, 1975).

It would seem that Speck's active involvement with contemporary New England tribes would be contrary to the concept of the vanishing Indian. Speck never seems to have attempted to explain how the cultures he conceived of as static, pure, but vanishing changed and adapted to be what they were during fieldwork. (For a study of Speck and his relationship with and impact on northeastern tribes, see McMullen, 1996.) This was also true for Clark Field, who at that time was encouraging new "Indian trends" in the arts. I would suspect that for Field and Speck, dedication to the concept of the vanishing Indian was in part a reflection of their romanticism and empathy.

Although the theoretical focus of anthropology had changed considerably by 1941 with new attention on acculturation studies, Speck remained the authority on northeastern tribes, and Field was aware of that. Through Alice Marriott or Eric Douglas of the Denver Art Museum, Field knew that Speck was also a source for northeastern baskets. Speck, like other anthropologists of the period, combined fieldwork with museum collecting. Sponsoring museums would fund his field trips and then choose the items they wanted in return for their sponsorship. Speck would sell the remainder to other museums and collectors (plates 4, 5, and 6.)

Clark Field also read some of Speck's works or at least looked at the illustrations and captions. In fact, quite a few of the pieces in the Philbrook collection are illustrated in Speck's publications. (Many of Speck's works from Clark Field's personal library are now at the Clark Field Library at the University of New Mexico or H.A. and Mary K. Chap-

FIGURE 6 : Letter from Clark Field to Frank G. Speck, May 12, 1947.
Courtesy of the American Philosophical Society. Frank G. Speck Papers (572.97 Sp3)

man Library at Philbrook.) Speck also wrote for popular magazines such as *Home Geographic Monthly*, *Bird Lore*, and *Frontiers*, as well as publications directed at that sector of the public interested in Native American cultures, such as *The Papoose* and *The Red Man* (McMullen, 1996). Given Speck's willingness to write for such publications, it is not surprising that he wrote the foreword for Clark Field's 1943 publication *Fine Root Runner Basketry among the Oklahoma Cherokee Indian*. In this foreword, Speck clearly states his theoretical position:

> The monograph in hand forms a contribution to the series of studies being pursued widely among scholars whose aim is to piece together portions of the picture of culture of the Indians of the Southeast. Our knowledge of the culture properties of native tribes in any area where their development has been going on for centuries in their original seats comes necessarily by gradual steps. These may seem disconnected in the minds of laymen who are in haste to see the whole story completed. Perhaps only the pioneer investigator knows how long and intimately a people must be studied by dwelling in their midst before their ways of life become clear enough to be understood and discussed. Collections of data, historical, descriptive and functional, have to be made and preserved in the form of notes and actual specimens. When these ends are accomplished, the picture of tribal life takes definite shape, and another gap in the history of a people is closed.

What follows in Field's publication is indeed "disconnected," because it includes a page on root-runner baskets in Virginia; a page on Japanese honeysuckle baskets in North Carolina, noting that the use of that material was introduced in about 1880; and then a page on Oklahoma buckbrush baskets, correctly noting their development in Oklahoma, which was clearly not the Cherokees' "original seat" where "development has been going on for centuries." One assumes that the premise of Clark Field's work is that those baskets and therefore their makers are related, but that is not stated. Field leaves theoretical speculation to Speck.

Clark Field's letters (1946, 1947) to Speck, however, do give us a vivid insight into his encyclopedic approach to collecting. Field was concerned with authenticity and detail and had a keen sense of documentation, an almost journalistic concern for facts, unusual for most collectors. He wanted to know, for example, exactly what type of materials were used. He also wrote requesting baskets "to fill a hole in my collection" (Field, 1947, see figure 6) as if he were collecting stamps and wanted to make sure that each country (tribe) was represented.

The relationship between Clark Field and Frank Speck was clearly a friendly but a professional one. It may even be that they met when Clark and Bertha Field visited North Carolina in 1941. Again, this trip to the mountains, where they stayed at the Cherokee Inn, in the town of Cherokee, may have been as much for Bertha's health as for her husband's collection.

In 1942 (Ream, 1943), Clark Field made his promised donation, consisting of 455 baskets, to Philbrook, as well as 265 pieces of southwestern pottery (*Tulsa World*, February 15, 1942). At that time, his baskets were valued at fifteen thousand dollars by three "leading authorities," one of whom was René d'Harnoncourt (*Tulsa Tribune*, July 30, 1942). That autumn, the primary exhibits at Philbrook included not only Clark Field's baskets but also ancient "Cliff Dweller" (pueblo) pottery from the collection of Mr. and Mrs. T. J. Darby, Delaware Big House posts which the Delaware tribe had asked Field to save from being burned (Wyckoff and Zunigha, 1994); and "articles from Spiro Mound," an excavation which Field had supported financially (*Tulsa Daily World*, October 15, 1942). Clark Field was clearly respected by many members of the Native American community. Joe Bartles contacted him regarding the Delaware Big House (Wyckoff and Zuniga, 1994). Acee Blue Eagle had formally given Field a Creek name. The principal chief of the Cherokee Nation wrote an appreciative commentary for Field's bulletin on root-runner basketry (1943), and Field corresponded with basket weavers and tribal members interested in his collection. In part because of this, his contribution to Philbrook and to Tulsa was enormous.

Throughout the 1940s, Clark Field continued his trips to the Southwest and continued to judge baskets at the Inter-tribal Ceremonial at Gallup. By then, however, he was collecting for The Philbrook Museum of Art, despite the fact that his term as a museum trustee had expired in 1943.

In 1938, Clark Field had collected both Akimel O'odham (Pima) and Tohono O'odham (Papago) baskets through Rudy Kassel, superintendent of Indian schools in Tucson, Arizona. Perhaps at that time Field had learned about Bert Robinson, an avid collector of O'odham baskets who, three years previously, had become superintendent of the Pima Indian Agency at Sacaton, Arizona (Pratt, 1954). If Field did not learn of Robinson at that time, he most assuredly did in 1940 when he purchased a basket from the Arts and Crafts Board agent at Sells. By 1942, Field was buying directly from the reservation and with the help of Bert Robinson. As Field stated, "Bert knew all the best weavers" (Field, 1969). It is through him that Clark Field met Susie White and purchased her miniature baskets (see Wyckoff, Southwest, this volume). Robinson considered her the finest weaver of Akimel O'odham miniatures. By the time Field met him, Robinson was blind from a staphylococcal infection (Pratt, 1954). For many years, Robinson continued to be remembered by many people for "his help and encourage-

ment with information and reservation contacts" (Cain, 1991). Although Clark Field bought some baskets from Bert Robinson during his extensive visit in 1948 (plate 7, p. 27), he also bought some from his estate in 1966.

The Fields' travels in the 1940s were extensive. They not only visited North Carolina, as mentioned, but also Wisconsin (1940 and 1942) and Michigan (1941 and 1946). In 1948, they returned to Alaska, where they traveled down the Yukon, returning to British Columbia, Washington, Oregon, and California. In 1949, they traveled to Mexico. By 1956, Clark and Bertha Field had traveled more than two hundred thousand miles, collecting more than one thousand baskets, which had been donated to Philbrook (*Tulsa Tribune*, December 19, 1956; *Tulsa Daily World*, October 8, 1957).

The 1940s were good times for the Fields, for The Philbrook Museum of Art, and for Tulsa. In 1939, artist Eugene Kingman became director at Philbrook. His wife, Elizabeth Yelm, who had studied anthropology and worked at the Ancestral Pueblo site of Mesa Verde, led the "Indian Program." René d'Harnoncourt, who visited Philbrook in 1941 and 1942, had praised both the collections and their presentation. In 1942, Philbrook was open all summer. It had previously been closed during summer, when so many people fled Tulsa's heat (*Tulsa World*, July 18, 1943). By 1944, annual attendance had reached 42,739 (*Tulsa Tribune*, January 19, 1944). In large part because of Clark Field's continued support of the Arts and Crafts Board, coupled with Waite Phillips' gift of "a substantial piece of downtown real estate to the Southwestern Art Association," it was suggested that Alice Mariott determine "what province Philbrook could fulfill" regarding the textile weaving sponsored by the Indian Arts and Crafts Board (Hulings, 1939). In 1942, Philbrook held an exhibit from Sequoyah Training School near Tahlequah of woolens from sheep raised and sheared at the school, where the wool was spun, dyed with native vegetable dyes, and woven (*Tulsa Tribune*, July 20, 1942). In 1946, Philbrook held its first Annual, a national competition for Native American painters (Wyckoff, 1996). Clark Field not only supported the competition financially but also bought paintings from it for the museum (figure 1, p. ix). In 1948, his daughter Dorothy became assistant curator of Indian art (figure 7.) Clark Field was the honorary curator (*Tulsa Daily World*, June 20, 1948).

In 1954, Dorothy became a member of the Indian Arts and Crafts Board staff working with the people of Pine Ridge and Rosebud Reservations in South Dakota and Turtle Mountain and Fort Totten in North Dakota. Clark Field may have taken Dorothy to her new job or visited her later, for at that time, he acquired the two Chippewa baskets for his collection (plate 65, p. 143). Such baskets were widely marketed by the Arts and Crafts Board, so much so that today few people realize that although they were always primarily made for the European-American market, it was originally the market of the 1900s. On that trip, Field also traveled to Wisconsin and to the eastern coast of Canada. It was to be his last extended collecting trip. He was then seventy-two years old. Clark Field did, however, continue his annual trips to the Southwest to judge at the Gallup Inter-tribal Ceremonial.

The Inter-tribal Ceremonial at Gallup in 1955 must have been a joyous occasion for Clark Field. Dorothy was there with an entry from the Arts and Crafts Board from her region. She brought "a small selection of baskets and beadwork from the Turtle Mountain jurisdiction in North Dakota" (Field, 1955:4) and quillwork from the Rosebud Asso-

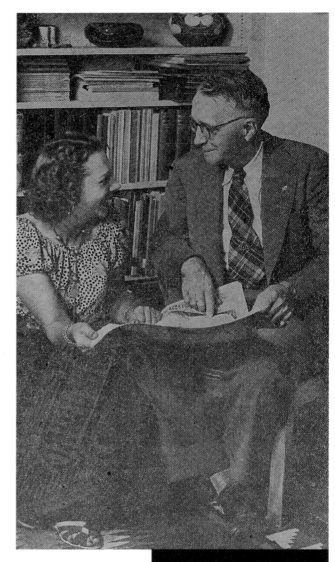

FIGURE 7 : Clark Field and his daughter Dorothy, c. 1948 : This photograph was taken at the Fields' house at Twenty-two East Twenty-sixth Street. At that time, Clark Field was honorary curator and Dorothy Field was assistant curator at The Philbrook Museum of Art. The devotion between Clark Field and Dorothy is readily apparent in this *Tulsa Daily World* photograph, published on June 20, 1948.

—World Staff Photo

Admire Tulsa Collection

American Indian pottery and baskets held the attention of four members of the Indian Arts and Crafts board of the Interior department at Philbrook Art center Saturday afternoon as they admired the Clark Field collection. Left to right are Erich Kohlberg, Denver, Colo.; Field, donor of the collection and honorary curator of the Indian department at Philbrook; Vincent Price, Los Angeles; Rene d'Harnoncourt, board chairman, and Dr. Frederic J. Dockstader, both of New York City.

FIGURE 8 : *Tulsa Daily World, January 26, 1958*

ciation, as well as "Sioux" beadwork. She had also been involved in the production of "Sioux pottery," which had never been made previously, but there is no mention that she took any examples of it to Gallup

That same year, Clark and Bertha Field's eldest daughter, Thelma, died at age forty-nine. Thelma had married William McGinley and had moved to Bartlesville, Oklahoma, where the Fields frequently visited her. While Clark Field gave talks on baskets at the public library, Thelma and her mother enjoyed their time together. Thelma curated the 1938 exhibition of Field's basket collection at the Tulsa Fairgrounds for Indian Week. Later, in 1942, she acted as hostess at Philbrook when her father's collection was officially donated (*Tulsa Daily World*, October 2, 1938). Thelma was the responsible, caring oldest child. She would have been sorely missed.

After Thelma's death, Clark Field kept himself busy writing an occasional article (Field, 1964, 1969) and meeting young basket specialists such as Andrew Whiteford (*Tulsa World*, February 1, 1963). Many of Field's friends from "the old days," such as H.P. Mera, Eric Douglas, Bert Robinson, and Frank Speck, were no longer alive (figure

FIGURE 9 : Clark Field and Cub Scouts, c. 1962 : **In the 1960s, Clark Field seems to have been at his happiest when sharing with others his love of Native American baskets.**

8, p. 25). In 1961, Bertha became ill. Clark Field went to Gallup to judge the Inter-tribal Ceremonial for the last time in 1962. At that time he was awarded a Living Memorial (*Tulsa Tribune*, August 22, 1962). Bertha died a few years later and Clark Field moved into the Utica Square Apartments, an easy four-block walk from Philbrook and his beloved basket collection.

A renewed interest in Native American art was spawned during the 1960s when many people in the United States began to examine alternative world views. During this period, scholars and basket collectors became increasingly aware of the quality of the Clark Field collection. Many people considered the *degikup* (plate 32, p. 79) by Dat-So-La-Lee (Louisa Keyser) the finest piece she ever made (Dockstader, 1962; Haberland, 1964). This basket epitomizes Field's collection. It fills his criteria for aesthetic beauty and workmanship. From Field's point of view, the basket is anthropologically important, because he believed it had a ceremonial function and symbolic designs. Field did not know that that information, quoted by Otis Tufton Mason of the Smithsonian Institution (1904), was a fabrication of Amy Cohn's imagination and the desire to present Dat-So-La-Lee as one of the last "vanishing Indians" knowledgeable in the lore of a pristine past (Cohodas, 1992). This basket was the most costly piece Clark Field acquired and it was "his pride and joy" (*Tulsa Daily Word*, January 7, 1964).

Clark Field gave his baskets to The Philbrook Museum of Art because he wanted to share them with others. Starting in 1945, he volunteered to be at the museum when he was in Tulsa every Sunday afternoon from one o'clock until five to give informal gallery talks. He would also talk to groups such as the Woman's Club or Boy Scouts (figure 7). He loved to work with children and to tell stories of his collecting days and legends about the basketry and pottery (*Southside Times*, July 26, 1962). By 1964, he had sold his company, his wife was bedridden, his remaining daughter, Dorothy, had remarried, and he had no grandchildren.

In 1959, Donald G. Humphrey had come from the University of Oklahoma to be director at Philbrook. According to Jerry Brody (1997 b), Humphrey and Jeanne Snod-

FIGURE 10 : "The Most Complete Collection of Pima Basketry Known," c. 1966 : **Clark Field made this claim following his purchase of the Akimel O'odham (Pima) baskets from Bert Robinson in 1966. This claim was primarily based on Field's having at that time acquired baskets decorated with all of Bert Robinson's design types. The large baskets on the floor from left to right are representative of the fret, "swastika," turtle's back, and butterfly designs. The large basket with lid in the second row on the right is a grain-storage container. The center baskets appear to have whirlwind designs. On the table on the left is a swastika design with coyote tracks, and on the right and in the center is the squash-blossom design with a varying number of petals.**

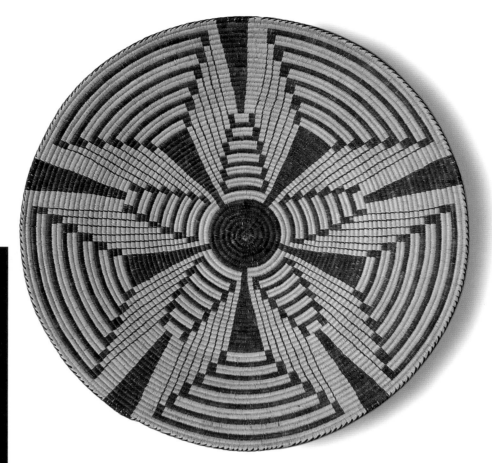

PLATE 7 : Akimel O'odham plaque, c. 1948 : This basket was made by Emma Newman. Clark Field was probably given her name by Bert Robinson, and Field bought it either directly from her or her family near Blackwater, Arizona, on the Gila River Reservation. Robinson called the design a squash blossom (1942.14.2020).

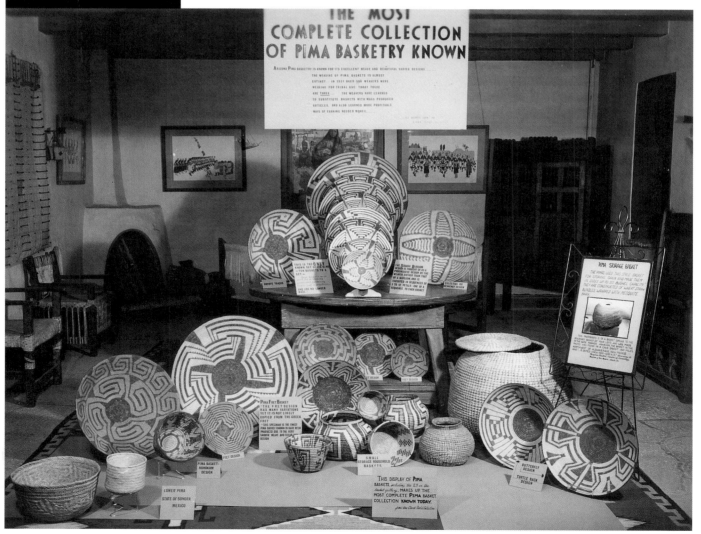

grass were some of the few people at the museum to care about Clark Field's collection in the 1960s. Claudia Baker Carr (personal communication) noted that most people considered him little more than a "boring old man." This may have been true at that point in his life, but Philbrook had also changed its mission.

The seeds of the division that was later to develop at Philbrook were sown in Waite Phillips' initial gift. Phillips, with his love of the West and Native American art, gave a building and some furnishings of European character, chosen by his wife, Genevieve, to the Southwest Art Association for a museum. After Laura A. Clubb's gift of European paintings in 1947 and the loan and later donation of the Samuel H. Kress Collection of Italian Renaissance paintings and sculpture, in 1961, the Philbrook increasingly changed its focus toward Europe while attempting to maintain a balance of "esthetic and spiritual values" (Humphrey, 1963:8). Humphrey tried to accomplish that but recognized that he could no longer preserve the integrity of Clark Field's collection. He deeply regretted this because no funds for adequate storage were appropriated and the board demanded exhibits that were not Native American, thus he had no choice but to keep a large part of Field's collections in the attic and garage at Philbrook or lend them to another museum.

Clark Field could not understand Philbrook's increased fascination for foreign art. He was an American and proud of being an Oklahoman and from Tulsa. His identity was there. It is striking that despite his extensive travels, he wrote to Dorothy in 1966,

> I asked Nancy if she and her husband had not toured Europe twice—and *why again*? She said yes, but she would go every year if she could—*not for me.* Do you know that Albert and Glenn Mitch here have been *seven times* abroad, Europe, Asia, Africa Mediterranean area. That never appealed to me—it surely appeals to some people!

This letter was simply signed "Love, Dad."

When Dorothy visited her father, she was appalled at the condition of the works stored in Philbrook's garage. Jerry Brody (1997), curator of the Maxwell Museum at the University of New Mexico, has described the situation as he found it in 1966:

> The storage conditions were abominable. Every basket that had had anything that the insects or vermin could eat was gone. Feathers and quill work on baskets had been eaten. A magnificent Acoma pot contained a squirrel's nest and the acid from their urine had totally destroyed the bottom four inches of the inside.

Clark Field was both saddened and distressed, but Dorothy was furious. Her relatives in Tulsa have described her as "spoiled, eccentric and strong willed" (personal communication). Brody (1997) also remembers her as "strong willed, and free wheeling, but also honest." Clark Field, at eighty-four, was caught in a dilemma. Despite his love of Tulsa and Philbrook, he felt he and his collection were then considered by them of little importance. His only surviving immediate relative, Dorothy, wanted him to move the collection to New Mexico. His relatives in Tulsa did not want the collection moved. The integrity of the collection which he loved so much was paramount. Field did not want to move the collection from Tulsa, but he also wanted it to be cared for. Field came to the only logical decision that he could. He decided that the baskets, pottery, and Spiro mound artifacts on exhibit would remain in Tulsa. He would lend the majority of the collections in Philbrook's attic and garage, many of which could now be used only for research purposes, to the University of New Mexico, along with most of his books, including Schoolcraft's *History, Condition, and Prospects of the American Indian Tribes of the United States* (1853). What is extraordinary is that at the same time, he acquired baskets from Bert Robinson's estate.

The acquisition of these baskets represents a fundamental change in Clark Field's collecting pattern. Earlier, he had sought baskets "from all basket making tribes," focusing on both "traditional" forms and "artistic" works. Later, he acquired baskets from a

specific group, the Akimel O'odham, in all of the design categories defined by Bert Robinson (1954). With Clark Field's acquisition in 1966, he was filling in the holes within a design system rather than a tribal listing. Robinson's design system included geometric (the fret and "swastika") and symbolic designs (squash blossom, turtle's back, butterfly wings, whirlwind, coyote tracks, and the man in the maze; see figure 9). This approach to collecting was closer to that of Dorothy who, for example, had collected kachina dolls based on Fewkes' (1903) and Colton's (1959) publications. Similar distinction between collections of breadth as opposed to depth can also be seen by contrasting Clark Field's basketry collection with his pottery collection. The pottery collection, begun in 1936 when Dorothy was entering the University of New Mexico, is also much more focused, no doubt reflecting her influence. She in fact acquired some of this pottery for her father.

The change in Clark Field's collecting pattern parallels some of the changes taking place in anthropology and America as a whole. Increasingly, anthropologists were studying adaptation and change. They finally realized that the Indian had not vanished, nor had Native American culture, albeit it had changed. Native American culture was no longer perceived of as pure and frozen in time. European-Americans became aware of the enormous contributions Native Americans had made during World War II and the value of their distinct cultures. After all, the languages of the Comanche and Navajo "code talkers" had never been broken by the enemy. In addition, because of enlistment during the war, more Native Americans were exposed even further to European-American culture, which further increased their cultural change as it did the perception of their culture by European-Americans.

Clark Field, however, was probably far removed from these changes and the Native American art beginning to be produced at that time, as was Dorothy. She now wanted to make a contribution to a museum in her own right. Her husband, Gilbert Maxwell, was a well-known dealer in Farmington, New Mexico. Dorothy used twenty thousand dollars in oil stock she had inherited from her mother for the construction of the Maxwell Museum at the University of New Mexico, named in honor of her and her husband (*Tulsa Tribune*, December 22, 1967). In that museum, she placed the majority of her mother's Navajo textile collection and her own collection of Hopi kachina dolls. Gilbert Maxwell added his rare, comprehensive, and historically important collection of Navajo textiles as well as various baskets and pieces of pottery. It is not surprising, therefore, that Dorothy wanted to add Clark Field's basketry and pottery collection. Also, at that time, the University of New Mexico's Clark Field Library was established.

Clark Field was separated from much of his collection, but it had been saved by the University of New Mexico. Unfortunately, beginning in 1969, Field's health had declined so much that he was living in the Ambassador Manor Convalescent Home, in Tulsa. Clark Field died in Tulsa in 1971 after a long illness, at age eighty-nine (*Tulsa Tribune*, December 3, 1971).

Afterword

In 1979, The Philbrook Museum of Art built a contemporary, fully equipped storage unit. In 1986, the baskets on long-term loan to the Maxwell Museum were returned to Philbrook. Clark Field's basketry collection is exceptional in its breadth, beauty, and outstanding quality. It is also historically important because it is one of the few collections made during the 1930s and 1940s. He deliberately acquired this collection for The Philbrook Museum of Art and the state of Oklahoma. It is hoped that this publication will increase public awareness of the importance of this collection. However, until either a new wing or associated exhibition space for the Native American collections is established, much of Clark Field's collections, today worth well over four million dollars, remains underutilized.

THE COLLECTOR AND THE COLLECTION

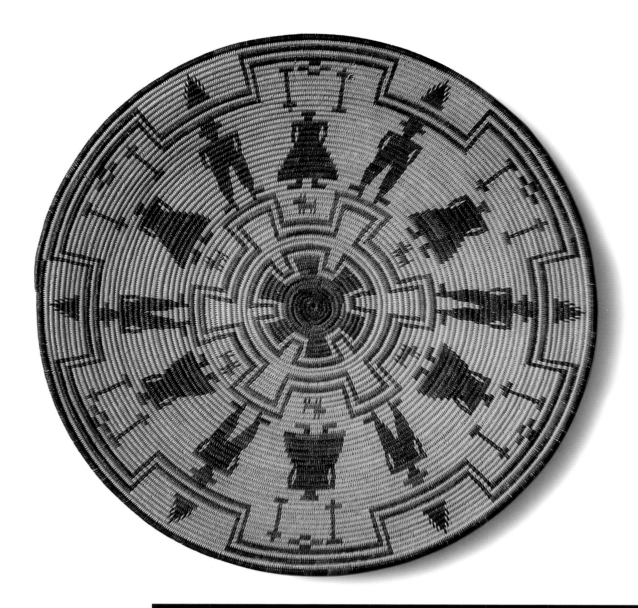

SOUTHWEST
Lydia L. Wyckoff

The dramatic ruins of such archaeological Ancestral Pueblo (Anasazi) sites as Mesa Verde and Chaco Canyon, coupled with the realization that the people who occupied these sites were related to the Native American pueblo or village people in New Mexico and Arizona, have made the Southwest the most intensely studied cultural area in the United States. By 1928, Alfred L. Kroeber had ascertained that the Southwest cultural area included not only Arizona, New Mexico, southern Utah, and southern Colorado, where related prehistoric sites were found, but also extended south and included northern Mexico.

Today, the Southwest, or Greater Southwest, cultural area is generally conceived of as an area extending eastward beyond the Rio Grande to the Plains. Thus, the Southwest includes western Texas and the northwestern tip of Oklahoma. The western boundary of the area generally follows the Colorado River to Lake Mead, in Nevada. The northern boundary extends from the northwestern tip of Oklahoma west to the upper Colorado River in Colorado. This northern boundary generally follows this river until it turns westward. To the north of this boundary are the Great Basin and Plateau cultural

areas. The southern boundary crosses Mexico from the Gulf on the east to the Pacific on the west in the general area of Mazatlán. To the south were the great Mesoamerican civilizations of the Toltec and Aztec.

As previously mentioned, cultural-area "boundaries" are general guidelines, and what groups should or should not be included continues to be a source of academic debate. What is important, however, is that the indigenous people within this area share more with one another than they do with surrounding groups.

Perhaps the single most important unifying characteristic of the Southwest is the importance of agriculture within an arid environment. Maize was introduced from Mexico between 4,000 and 3,000 B.C. Combined with beans and squash, this provided the agricultural basis for permanent villages, where there was enough water. The Southwest is not only an arid region but also one of enormous topographical diversity. This diversity greatly influences variations in rainfall, climate, and vegetation and the degree to which agriculture is possible given the crops available. Generally, at higher altitudes where rainfall is more abundant, it is too cold to allow for the maturation of corn. The impact that topography has on environmental usage and cultural adaptation can be readily seen among the traditional cultures of the Navajo and Hopi of northeastern Arizona. The Navajo, who were semisedentary pastoralists with minimal agriculture, occupy regions at both higher and lower elevations than their neighbors the sedentary Hopi. The Hopi occupy a small environmental niche where it is both warm enough and wet enough for dry farming. Here, their villages are among flattopped hills called mesas.

Adequate water and warm temperature most successfully combine to create strong sedentary communities along rivers. Along the Pacific coast in Mexico, these are the Mayo and Yaqui Rivers, named after the tribes that live there. In the Southwestern cultural area within the United States, the principal rivers are the Gila, Salt, Colorado, and Rio Grande.

Although a very small percentage of the indigenous population of the Southwest area occupies the compact villages or pueblos along the Rio Grande and its tributaries, for many people these villages remain a symbol of the region. This is primarily because they were popularized through the marketing of the Fred Harvey Company and the Santa Fe Railway, which reached Flagstaff, Arizona Territory, in 1882. European-American artists and intellectuals who moved to both Santa Fe and Taos in the first quarter of the twentieth century further popularized these pueblos. At that time, twill–plaited yucca ring baskets were still used for cleaning and winnowing wheat, which had been introduced by the Spanish (figure 11). Wicker–plaited baskets were used for carrying produce or firewood. Clark Field collected three yucca ring baskets from the Rio Grande pueblos—one from San Felipe and two from Jemez (plate 9).

Coiled bowl-shaped baskets were also used to wash wheat. Pottery was used for most other daily activities such as cooking and eating, and for storage.

In the 1930s, when Clark Field collected baskets from the Tewa village of San Juan and the Keres village of Santo Domingo, wicker–plaited baskets made in the shape of wastepaper baskets were produced for sale, as was an Easter-type basket with a handle. Pottery, however, was the medium that attracted European-American interest and the attention of the emerging Indian art market. Today, pottery manufacture remains an important source of cash income, and baskets are only rarely made.

In about 1880, Jicarilla Apache baskets began to influence basketmaking among the southern Rio Grande pueblos, particularly at Jemez (Ellis and Walpole, 1959). The three coiled and decorated Jemez baskets in the Clark Field Collection were made by Manuel Ye Pa, Andres Loretto, and José Gachupin. Today, Rosando Gachupin continues his family's tradition of at least three generations, making coiled bowls, using either a three- or five-rod foundation and commercial dyes.

To the west of the Rio Grande in New Mexico are the pueblos of Acoma, Laguna, and Zuni. Farther west, in Arizona, are the Hopi pueblos. Acoma and Laguna, as well as the Acoma farming community of Acomita, are in the San Jose Valley. The Rio San

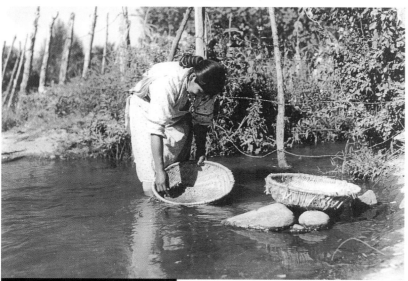

FIGURE 11 : Washing grain with yucca ring baskets at Jemez Pueblo, c. 1930. Photo by Williamson, Courtesy Museum of New Mexico, neg. no. 42075.

Jose joins the Rio Grande approximately forty miles south of Albuquerque. Farther west, the pueblo of Zuni is located along the Zuni River.

Like the Rio Grande pueblos, these New Mexican western pueblos practice floodwater farming along the rivers. In contrast to the Rio Grande pueblos, clans are far more important in the social and religious organization of the western pueblos. These clans are exogamous matrilineal clans, and the women own the houses and garden plots. Also, in contrast to the Rio Grande pueblos, the kachina cult is very important. The kachinas are sacred spirits responsible for bringing moisture to this arid land. Some anthropologists have attributed the importance of the kachina cult west of the Rio Grande to the lack of a secure water supply provided by this river and associated irriga-

tion. Thus, rain and snow, believed to be brought by the kachinas, are more important. Other anthropologists hypothesize that the kachina cult may once have been as important for the people of the Rio Grande pueblos, but it declined as they were more intensively subjected to Spanish missionary policy and colonization than the more isolated western pueblos were.

The two baskets in the Clark Field Collection from Acoma and Acomita are coiled and decorated with black designs. These designs are split, truncated pyramids symbolic of rain clouds among the western pueblos. This symbol, as well as rain itself, is associated with the kachinas. Both of these baskets are made with cornhusks, a nontraditional material, and were clearly intended for sale (plate 10).

In contrast to these "sale items" are the three baskets from Zuni. These baskets are wicker–plaited utility baskets. Two are shallow bowls, also called peach trays, and one is a peach carrying basket. Two of these baskets were made during the last quarter of the nineteenth century and one sometime before 1910. Clark Field bought one shallow bowl (1948.39.149) at C. H. Kelsey's trading post in Zuni in 1939, the same year he acquired one of the Acoma baskets at the Gallup Inter-tribal Ceremonial. Today, most utility baskets such as peach trays or flat piki trays are made by the Hopi.

The Hopi occupy thirteen communities on top of and around three mesas. From east to west, these are called First, Second, and Third Mesa. Today and at the time Clark Field was collecting there, different commercial crafts have been associated with these three mesas.

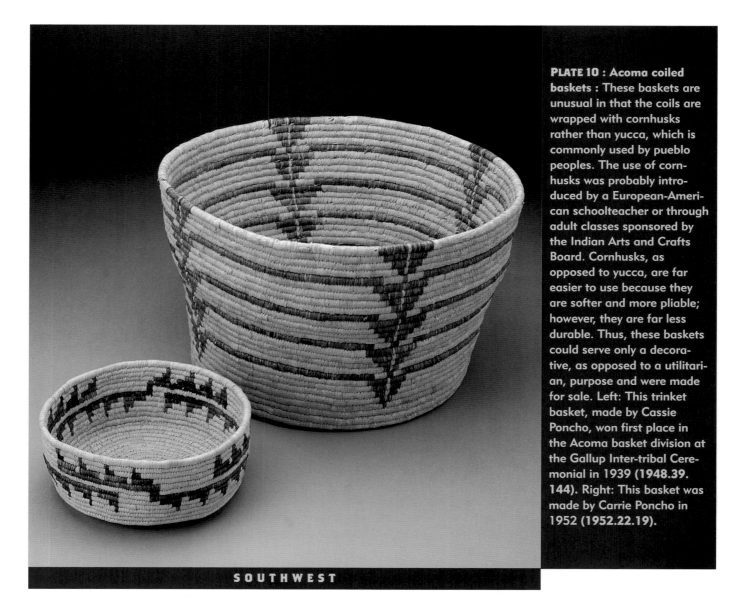

PLATE 10 : Acoma coiled baskets : These baskets are unusual in that the coils are wrapped with cornhusks rather than yucca, which is commonly used by pueblo peoples. The use of cornhusks was probably introduced by a European-American schoolteacher or through adult classes sponsored by the Indian Arts and Crafts Board. Cornhusks, as opposed to yucca, are far easier to use because they are softer and more pliable; however, they are far less durable. Thus, these baskets could serve only a decorative, as opposed to a utilitarian, purpose and were made for sale. Left: This trinket basket, made by Cassie Poncho, won first place in the Acoma basket division at the Gallup Inter-tribal Ceremonial in 1939 (1948.39. 144). Right: This basket was made by Carrie Poncho in 1952 (1952.22.19).

SOUTHWEST

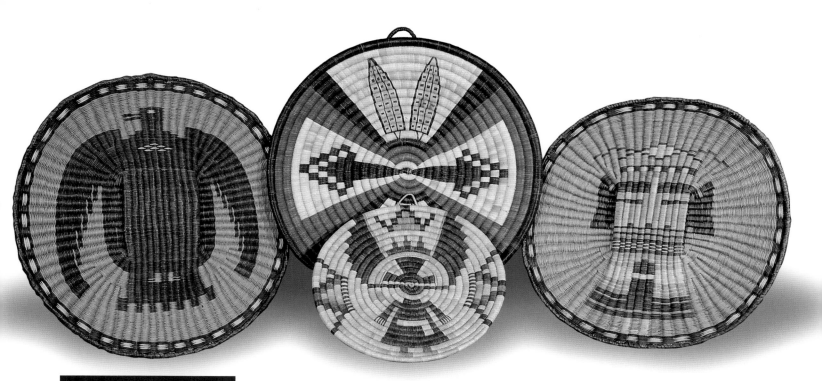

Pottery was marketed as having been made only at First Mesa, specifically by the Nampayo family. Coiled basketry was from Second Mesa, and plaited wickerwork was from Third Mesa. This division was and is reinforced and perpetuated by museums, gal-leries, collectors, and the producers themselves (Wyckoff, 1990). In reality, many utilitar-ian items, such as pottery piki-bread mixing bowls and the flat wicker trays on which the bread is placed, are made on all three mesas. In addition, many items may be either sold or used within a traditional context. Furthermore, it should be understood that just because a particular type of object is made for sale, it is not devoid of cultural meaning for the producers. That this is true for most native peoples is certainly implied in the bas-kets from Acoma, where traditional designs are found associated with a totally nontra-ditional material.

Although seldom articulated by Hopis themselves, piki bread is for them as important an ethnic food as is the oven-baked wheat bread of the Rio Grande pueblos and the fry bread of native peoples of Oklahoma. Piki bread is made from a very thin, almost watery, cornmeal batter. It is cooked on a stone, which is usually oiled with sunflower seeds, over an open wood fire. To cook the bread, a handful of batter is quickly spread on top of the hot stone. In a few seconds, the sheet of paper-thin bread is removed and quickly tucked and rolled to cool on a large, flat wicker tray commonly called a piki tray. This bread is a necessity for important occasions and is commonly given to and/or dis-tributed by kachina dancers.

Along with piki-bread trays, other Hopi utilitarian baskets in the Clark Field Collection include a peach carrying basket and a ring sifter from Third Mesa and, from Second Mesa, a carrying basket with a tumpline and a cradle. Except for ceremonial use, carry-ing baskets have been replaced with buckets and, for large items, the back of a pickup truck, but cradles and sifters are still commonly used. Although twined yucca ring bas-kets are used to hold a variety of items, they are especially important to sift out sand from parched corn.

Perhaps the most important type of Hopi basket made today is a flat plaque (plate 11). These plaques are either coiled yucca or plaited rabbitbrush. They are usually dec-orated and are popular with collectors. (There are twenty-six in the Clark Field Collec-tion.) Although these baskets are sold, they are not "tourist pieces," in the sense that they are not produced just for the art market, but continue to be important social and ceremonial objects.

Plaques are used in a variety of ceremonies. They are carried by the women of the Lakone society during the basket dance and are awarded as prizes to the winners of the

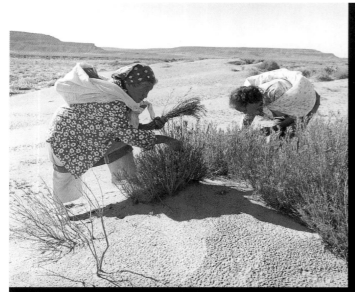

*It takes a long time to
make a [wicker] basket. In
August we collect sivápi
[Chrysothamnus: rabbit-
brush] and sīwi [parryella fil-
ifolia]. We have to get them
when they turn gray and we
have to get them the right
size and height. If you wait
too long [after the beginning
of October] it is hard to take
the peel off [the siváapi].
Then you have to get every-
thing for the dye. I do not
buy my dyes. I make them
from the siváapi flowers, tīmi
[Cleome serrulata: wild
spinach] and sometimes the
kind of clay I decorate my
pottery with.*

**Bessie Monongye
Oraibi, Arizona**

SOUTHWEST

FIGURE 12 : (above left)
Bessie Monongye and her
sister, Treva Burton, collect-
ing rabbitbrush. **Courtesy of
the Arizona State Museum,
University of Arizona (neg.
no. 85856). Helga Teiwes,
photographer.**

FIGURE 13 : (above right)
Bessie Monongye stripping
the rabbitbrush of leaves and
peel. **Courtesy of the Arizona
State Museum, University of
Arizona (neg. no. 85855).
Helga Teiwes, photographer.**

FIGURE 14 : (lower left)
Bessie Monongye holding a
completed vegetal dyed
plaque. **Courtesy of the Ari-
zona State Museum, Univer-
sity of Arizona (neg. no.
85463). Helga Teiwes,
photographer.**

associated footraces. They are given as presents to the captured eagles at the Niman ceremony and later are buried with them. They are used to carry sacred cornmeal and are given to young girls at the Powamu ceremony. They are also a prescribed gift as repayment for a bride's wedding robe woven by the men of the groom's family. The exchange of gifts is the backbone of Hopi society. Reciprocity is what binds one social group to another. In 1979, the two most prolific Third Mesa basketmakers, Bessie Monongye and Treva Burton, from the village of Oraibi, spent three weeks making plaques to repay the groom's family for the wedding robes (figures 12–14). The role of reciprocity applies not only to the social world of the Hopi but also to their spiritual world. Kachinas are the breath of the dead. If the people fail to conduct their cere-monies and ritually feed the kachinas, the kachinas will not send the rain which allows crops to grow to feed the Hopi. On death, the plaque assists one's breath or soul to reach the underworld.

According to traditional Hopi beliefs, the kachinas visit the mesas for six months, from the end of December to July. When the kachinas are present, initiated men con-duct elaborate ceremonies, which also include public dances at which they impersonate kachinas. The power of the kachinas is in the sacred masks. The importance of the kachinas for the Hopi is seen in plaque decoration. Decoration may include images of the kachinas or related objects such as eagles or butterflies, which are associated with water, brought by the kachinas.

Although plaques are found in almost every Hopi home, deep baskets are seldom seen. When present, they are used primarily for decoration and are heirloom gifts, albeit their shapes are clearly historic and reflect the importance of the tourist trade after 1900. Small coiled baskets, however, are known to have been used to carry sacred cornmeal on Second Mesa (Wright, 1979).

Of the twelve deep baskets in the Clark Field Collection, four were clearly made in accordance with the European-American concept of a wastepaper basket. Another (1956.14.1) is of particular interest because it has both a high shoulder and a narrow mouth of a Sikyatki revival polychrome jar (plate 12, p. 38). It is decorated with figures of Crow Mother and Koyemsi (sacred clowns). Thus, even though a basket is made for sale, it is not like a mass-produced commercial object but is filled with meaning at many levels. It may be the objects and symbols used in the decoration, as in this mas-terpiece. It may be the memory of ancestors and the sense of self this evokes. Or it may be a more specific memory of the relative who taught the maker how to find and collect the rabbitbrush, sumac, and yucca used in production, as well as the flowers, kaolin (white clay), pitch, and black beans used for dyes.

Like the Rio Grande, the Colorado River provides an important year-round water source for the agricultural peoples of the Southwest. However, on its journey westward from the Rocky Mountains through northern Arizona, it has cut deep canyons. Although these canyons are used for crops, the Yuman tribes, commonly called the Upland Yuman or "Pai" tribes, that occupy this area were traditionally semisedentary because they used the plateau above the canyons for hunting and gathering. After A.D. 1100, the Yavapai moved westward, inhabiting the middle Verde valley by 1600 (Pilles, 1979; Schroeder, 1952). This move may have been stimulated by hostilities with their northern neighbors the Hualapai (Walapai) and Havasupai.

The Havasupai may have been a band of the Hualapai until 1880, when a reserva-tion for them was established near the Grand Canyon at Havasu Creek, a tributary of the Colorado. Like other Hualapai bands, the Havasupai occupied a distinct area which, prior to the nineteenth century, extended southeastward from the Grand Canyon to the San Francisco Peaks. Only in the winter was this entire area occupied; the Hava-supai spent the summer on their well-watered farmlands.

The expansion of European-American cattle ranching was devastating for both the Hualapai and Havasupai. Following a period of armed resistance to European-Ameri-can incursions, the Hualapai were interned for four years, first at Camp Beale Springs

SOUTHWEST

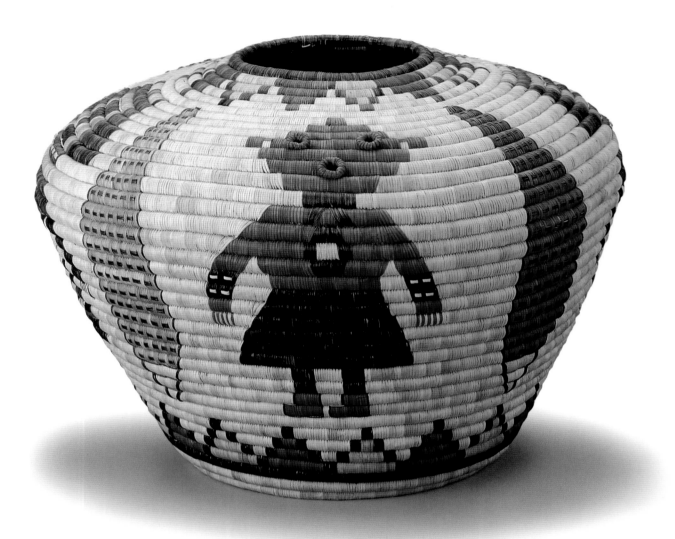

and then at La Paz, on the Colorado River Indian Reservation. In 1875, after having lived in miserable conditions with short rations, many died of disease or fled back to their traditional territory. During their absence, ranchers and miners had colonized the springs and habitable areas and were grazing cattle over large tracts of land. The lack of available water, coupled with the destruction of Hualapai food plants by cattle, made a return to traditional subsistence activities impossible, even after the establishment of a reservation of nine hundred thousand acres in 1883 (McGuire, 1983). Under these conditions, many Hualapai left the reservation to work as wage laborers. Basketry, once utilitarian, became a vital source of cash income.

The majority of the baskets produced for the tourist trade were deep twined bowls with slightly rounded sides and a flat base. These were usually decorated with simple bands with or without zigzags, of either vegetable or commercial dye. Between 1900 and 1930, Hualapai women also produced coiled baskets for sale.

The designs on the coiled trays in the Clark Field collection are on the interior and consist of a simple circle or star surrounded by a petal design reminiscent of shallow Yavapai bowls. These designs, as well as the petal and animals on the interior of a shallow bowl, may indicate that the Hualapai learned this technique from the Yavapai.

After 1930, the Hualapai gave up coiled basketry, and their basketry in their traditional twining technique began to decline, in part because of lack of locally available materials. However, according to Andrew Whiteford (1988:106):

> Toward the end of the 1960s, interest in tribal traditions revived. Basket–making suddenly became a prestigious activity, especially after it was recognized that outsiders approved of and admired Hualapai baskets. The dozen or so elderly ladies who made baskets had long been sustained by their relationships with each other and pride in their creations. One of them, Mrs. Tim McGee, organized a basket-making class in 1968, and several women learned the craft from her.

PLATE 12 : Hopi Second Mesa coiled basket, c. 1956 : This basket is decorated with four alternating figures of the Crow Mother kachina and Koyemsi (sacred clowns). Alternating with these figures are four different-colored ears of corn. Extending down from the rim are truncated pyramids and symbols for rain clouds, and on the chest of the Koyemsi figures is a cross. As Treva Burton explained, this is "how you have the four-corner design on baskets (plaques). It is the Hopi land in the center." This basket, made by Lola Joshongeva, won first place in the Hopi basket division at the Gallup Inter-tribal Ceremonial in 1956. (1956.14.1)

In 1946 or 1947, Clark Field bought a basket made in about 1927 by Mrs. Tim McGee. This basket (1942.14.2001) is a conical carrying basket with the pointed base covered with hide, as was typical for this type of Hualapai basket.

Because of their location, which still can be reached only by an eight-mile trail, the Havasupai remained relatively safe from outside incursions until the twentieth century. As a result, they continued to make and use twined utilitarian baskets, as seen in a twined water bottle (1948.39.417) in the Clark Field Collection. Their location, however, also provided them with the nearby tourist market at the Grand Canyon. There, Clark Field purchased twined shallow bowls, a globular olla-shaped jar with a flat base, and a miniature burden basket. He also bought two coiled baskets (plate 13). Like the Hualapai, the Havasupai also started to make coiled baskets for the tourist trade; however, they also used this technique for some utilitarian pieces.

Today, both Hualapai and Havasupai weavers continue to make small baskets for the tourist trade.

The Yuman tribes along the lower Colorado and in the delta region practiced extensive floodwater farming, and although they were sedentary, they did not live in compact villages. River and Delta Yuman tribes are the Mohave, Quechan, Cocopah, and Maricopa. Mohave, Quechan, and Cocopah baskets are extremely rare and there are none in the collection. The Maricopa, however, continued to make baskets as they gradually moved eastward into the lower Gila from the Colorado River, possibly as early as the fourteenth century (Schroeder, 1961). They are recorded as having been there by the seventeenth century (Spicer, 1962).

Today, the Maricopa live with the Pima, or Akimel O'odham, on the Salt River and Gila River Reservations. The two Maricopa baskets in the Clark Field Collection were acquired here. Both use the open–coil stitch over a foundation of a bundle of grass, similar to Pima wheat-straw storage baskets.

Along the slow-moving Gila and Salt Rivers, the prehistoric Hohokam culture, with its extensive irrigation system, flourished. Today, parts of this area are occupied by their descendents, the Pima, or Akimel O'odham, and Papago, or Tohono O'odham.

When the Spaniards first went through Sonora and western Chihuahua in the sixteenth century, probably about four thousand Pimas lived in Mexico southeast of a coastal group called the Seri. Today, there are but a few hundred Pimas living within one hundred miles south of the United States border in Caborca, Sonora (Fontana, 1983). These people are commonly called the Lower Pima, or Pima Bajo.

Pima and *Papago* are the Spanish names for the O'odham, which means "we the people" in Piman. The Pima and the Papago share similar cultural attributes but have

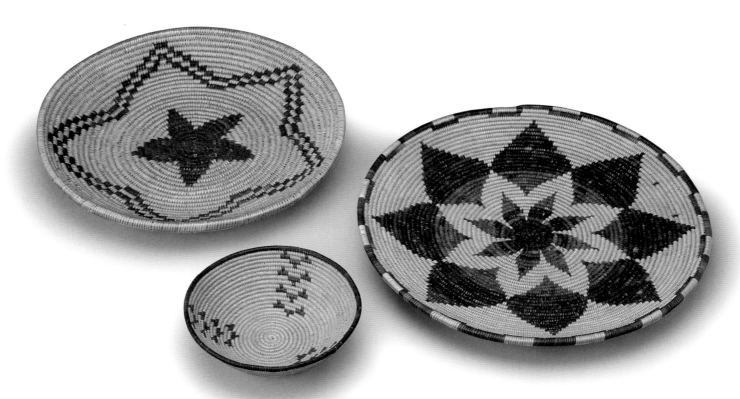

different subsistence strategies. The people European-Americans called Pima are known as Akimel O'odham, or "River People," because they lived along the Gila and Salt Rivers. There they built dams, practiced water diversion for their irrigated fields, and supplemented their agricultural produce with wild foods and meat. Their small, scattered villages had a maximum population of about two thousand people (Hackenberg, 1983). The Tohono O'odham, or "Desert People," were not sedentary because they did not have the advantage of a river water source. These farmers moved between their winter homes in the mountains, near a spring where prickly pears, saguaros, mesquites, and such succulents as barrel cactus grow in profusion, and their summer dwellings, where their fields were watered by washes after the summer rains. For these Desert People, Fontana (1983) estimates harvested goods accounted for about 17 percent of their annual average consumption, in contrast to the Pima, or River People, who, after the introduction of wheat by the Spanish, became exporters of an agricultural surplus. The shallow bowl shape of the winnowing basket is, therefore, in the Clark Field Collection, not as common among the Tohono O'odham as it is among the Akimel O'odham.

Akimel and Tohono O'odham baskets in this collection include winnowing baskets, shallow bowls, a *giho*, or burden basket, wheat-parching baskets, and a Tohono O'odham tiswin, or saguaro wine basket (plate 14). Parching baskets usually have the telltale marks of their use. In parching, hot coals were placed in a pottery bowl over which a thin layer of wheat was poured. When the grain was parched, the bowl was emptied into the basket. Although live coals were partially separated, some lighted coals and ash remained with the wheat. By agitating these contents in the basket, the grain settled at the bottom, allowing the lighter coals and ash to be removed.

I don't know if Clark Field was aware that the Akimel O'odham and Tohono O'odham were, in fact, related peoples speaking different dialects of the same language. By the time he collected his baskets, these people were not only separated because of the different places they lived and, therefore, their different traditional subsistence practices, but also by the United States government. Although they were constantly told that they were either Pima or Papago, they did not change such traditional practices as marrying across this governmental division and maintaining contact with various relatives. In two instances, Clark Field makes notes that baskets in the Pima style were made by Papagos. One of these baskets he listed as Pima (1948.39.100) and the other (1948. 39.317) as Papago, probably because he bought it directly from the Papago Arts and Crafts Board.

A piece that implies marriage with another tribe is a flat tray which Clark Field bought on the Pimas' Gila River Reservation. Although this piece is decorated with the typical Pima squash-blossom design, the coil foundation is neither a cattail nor a willow bundle but three sticks, or rods, typical of an Apache weave.

With the coming of the European-American tourist trade, the Tohono O'odham turned to weaving smaller bowls and novelty forms such as dolls, animals, and saguaro cactus. After 1930, the Pima began to make a variety of baskets by coiling and using elaborate open stitching. The open stitch exposes the bear-grass coil and requires less time than baskets with closed or totally covered coils. A simple open stitch was used by the Maricopa and by the Pima for their grain-storage baskets. Today, both the Tohono and Akimel O'odham make miniature baskets from horsehair for sale.

When Clark Field set out to collect baskets from all the basketmaking tribes that he could, he focused on the United States. He did, however, collect some from Mexico, made by the Tarahumara and the Seri. The Tarahumara live in the Sierra Madre Mountains of Chihuahua. Although it is bitterly cold on the high plateau (eight thousand feet) in winter, the canyons, which drop to three thousand feet above sea level, provide a rich agricultural area watered by mountain streams. The Tarahumara are semisedentary

PLATE 14 : Tohono O'odham (Papago) tiswin basket, c. 1920 : This basket was used to serve tiswin, the intoxicating drink made from the fruit of the saguaro, at the Tohono O'odham summer wine feast. This ceremony was held on sacred ground near the village at the end of June or the beginning of July, just prior to the beginning of the rainy season. It was held to bring the rain necessary to replenish the washes that would water the fields and bring up the planted crops. Although today most Tohono O'odhams are wage laborers, the wine feast is still held, perhaps more to honor their ancestors than to bring rain (1948.39.167).

agriculturists, albeit they live in widely dispersed groups. Their baskets are double-walled twill plaited and are similar to those made by the Lower Pima of Mexico.

To the northwest, along the Pacific Coast of Mexico, are the Seri. At only a few hundred feet above sea level with no real freshwater sources, the Seri live surrounded by desert and sea. They are fishermen who gather wild plants and shellfish. Potable water is very scarce and widely dispersed. Water sources include seasonal accumulations in playas, natural rock tanks, springs, and locations where subsurface groundwater can be trapped by shallow excavation. At these sites, nonsedentary Seris would camp.

Seri baskets are made by wrapping, stitching, and coiling together sticks or bundles of grasses (plate 16, p. 42). Decoration was not used on baskets until after 1900, when baskets were made for the tourist trade. Like most of the baskets in this collection, these baskets were made for sale.

The central Arizona mountain region, at an elevation of seven thousand to twelve thousand feet, is covered by lush aspen and ponderosa-pine forests and small stream-fed mountain valleys. This region is too inclement for stable agriculture. It is occupied by the Western Apaches, whose traditional subsistence economy was based primarily on hunting and gathering.

To quote Keith Basso (1983:462):

> Of the hundreds of peoples that lived and flourished in native North America, few have been so consistently misrepresented as the Apaches of Arizona and New Mexico. Glorified by novelists, sensationalized by historians, and distorted beyond credulity by commercial film makers, the popular image of "the Apache"—a brutish, terrifying semihuman bent upon wanton death and destruction—is almost entirely a product of irresponsible caricature and exaggeration. Indeed, there can be little doubt that the Apache has been transformed from a native American into an American legend, the fanciful and fallacious creation of a non-Indian citizenry whose inability to recognize the massive treachery of ethnic and cultural stereotypes has been matched only by its willingness to sustain and inflate them.

The people commonly known as Apaches were part of the Athabaskan migration from the north between A.D. 1200 and 1500. Apaches can be divided into eight groups. Since 1850, five of those groups have been identified as Western Apache. Those groups are the White Mountain, San Carlos, Cibecue, Southern Tonto, and Northern Tonto. These groups, consisting of various bands, considered themselves distinct, with their own boundaries. However, intermarriage did occur.

Unfortunately, little is known about early Apache baskets prior to the nineteenth century. It can be assumed that baskets were critical for transporting household goods, because these Apaches, like their neighbors the Yavapai, followed a yearly seasonal cycle. After having planted their crops in April, they spent June and July gathering fruit from the saguaro and prickly pears. July and August were spent collecting mesquite, beans, yucca fruits, and acorns. In September, they returned to harvest their fields, after which they settled into their winter camps. One can, therefore, assume that twined burden baskets (plate 17), as well as pitch-covered water bottles, have a long histo-

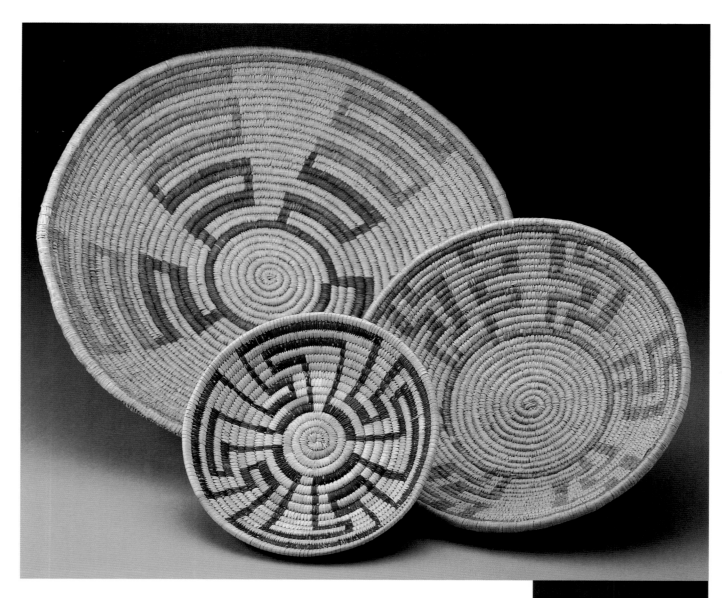

ry. Like the burden basket, water bottles were also twined and frequently had two handles of leather or grass. These baskets were then covered with pine pitch (sap) to make them watertight. The Western Apache also made a small hourglass-shaped water bottle which was plugged with a corncob and worn around the waist.

Because the Western Apaches made very little pottery, it can be assumed that their dishes and bowls were also baskets. These were probably coiled instead of twined, because Apache basket weavers were extraordinarily skilled at this technique by the time they were making baskets for the tourist market.

The importance of the basket trade was a direct result of the loss of land in the wake of European-American expansion. In the mid-nineteenth century, the Western Apache area was approximately ninety thousand acres east and south of the more than eight million acres of Yavapai territory. In 1863, gold was discovered near Prescott, Arizona Territory, in the Yavapai and Tonto area, and settlers began to organize "Indian-hunting parties." Under these conditions, two thousand Yavapai agreed to settle on the Colorado River Reservation in 1865. Camp Goodwin was established in White Mountain country, followed by Camp Ord, later known as Fort Apache. In 1871–1872, four reservations were established for the Apache and Yavapai. Fort Apache became the home for the Cibecue and northern bands of the White Mountain Apache. Camp Verde, in central Arizona, was established for the Northern and Southern Tonto as well as bands

PLATE 16 : Seri and Tohono O'odham (Papago) coiled bowls : The similarity in construction and design between Seri coiled baskets (back: 1942.14.2112; right: 1942.14.2007) and Tohono O'odam baskets, such as the one seen here in the front (1954.15.20), has led some writers (Moser, 1973; Bowen, 1973) to conclude that the Seri may have learned the art of basketry from the Tohono O'odham. But the coils of Seri baskets are usually wrapped with torote rather than yucca. As desert dwellers, however, the Seri most assuredly have a long history of basketmaking.

of Yavapai. Camp Grant was set aside for the San Carlos Apache and the Southern White Mountain bands. In 1874, the federal government set out to "round up" and remove the Chiricahua and the Yavapai, as well as the Tonto and Yavapai from Camp Verde, to a single new reservation—San Carlos, adjacent to Fort Apache. The Tonto and Yavapai from Camp Verde were forced to march 180 miles over partly mountainous terrain; 115 died. Once at San Carlos on a radically reduced land base, Yavapais and Apaches were crowded and poverty stricken. Not surprisingly, by 1880, baskets were being sold to settlers and camp guards to acquire cash. These baskets were usually either shallow bowls or ollas.

Western Apache shallow bowls are finely coiled around rods or splints, as opposed to the grass bundles of the Akimel O'odham. They have a slightly flat base and are frequently curved to a foot or more in diameter. The center and rim of these bowls are usually black devil's claw (*Martynia*). Between these two boundaries, black designs radiate

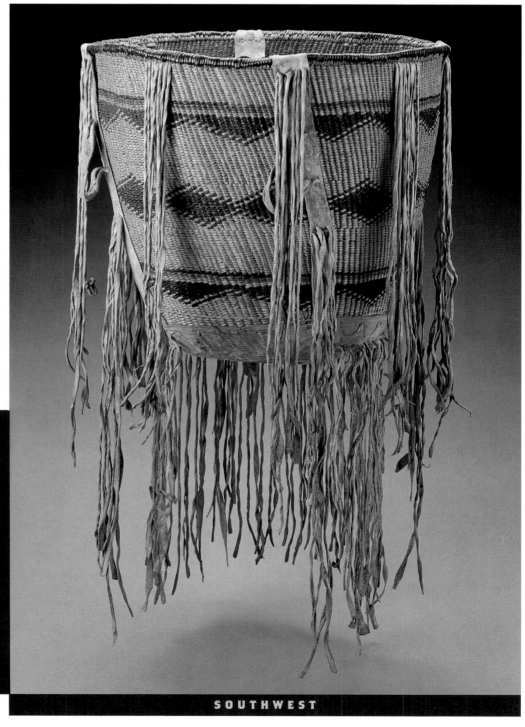

PLATE 17 : White Mountain Apache burden basket, c. 1905 : Clark Field collected this basket in 1947 from Alice Spink, whose mother made the basket. Burden baskets, originally carried on one's back or hung from a saddle, are like deep buckets with slightly rounded bottoms and nearly straight sides. They are almost always decorated with vertical strips of fringed buckskin and a fringe around the base (1947.57.65).

SOUTHWEST

from the center, frequently in large spirals which define smaller areas. Within these areas there may be crosses, checkers, triangles, swastikas, and representations of people, horses, deer, and even flags.

The commercial olla, also coiled around splints, may well have developed from the water jar (plate 18). Two large ollas in the Clark Field Collection were made in about 1900, after which time smaller baskets were made for sale because they were more profitable.

It is often impossible to distinguish between Western Apache and Yavapai baskets. This is partly because of a confusion between these two peoples by European-Americans and partly because of the long and close relationship between the two tribes. Their association was furthered by their enforced proximity on reservations as well as by some intertribal marriage. There appear to be no motifs specific to one tribe or the other, although the Yavapai do seem to use a star motif at the bottom of a bowl more than the Apache (plate 1, p. 8). Perhaps the most commonly seen difference between baskets made by weavers from the two tribes is the degree to which black/brown Yavapai designs appear isolated against the lighter background color of the basket, compared with those made by the Apache. Or, as stated by A.H. Whiteford (1988), "the Apaches tended to include more of them [motifs] on a single basket, sometimes giving their baskets a cluttered appearance, with various elements included simply to fill space." Certainly, more research is needed on the baskets of these different peoples, for it is known that the figure-ground or motif-background relationship is of critical importance in Native American design (Wyckoff, 1990). Research on this topic, however, will be very difficult because many baskets in museums are mislabeled through the collector's inability to differentiate the Yavapai from the Apache.

To the east of the Western Apache were the Mescalero and Chiricahua Apache, and to their north, the Jicarilla Apache. These three groups occupy the eastern boundary of the Southwest. Like the people of the Plains, they too hunted buffalo (bison), used skin tipis and rawhide parfleche, and made fine buckskin clothing, but they were also extensive gatherers and hunted a wide variety of game. In fact, the name *Mescalero* is derived from one of their most important foods, the mescal, or century plant (*Agave americana*). The Jicarilla appear to have practiced more agriculture than the Mescalero and Chiricahua. Initially, their coiled basketry was inspired by their Tewa neighbors. But today, the Jicarilla frequently provide the Tewa with baskets as well as occasionally making "Navajo" wedding baskets and baskets for the European-American tourist trade.

PLATE 18 : White Mountain Apache olla, c. 1900 : This basket is an extraordinary example of a master weaver's art. It is more than two-and-a-half feet in height, and within the diagonal design are barred diamonds, rectangles, crosses, and figures of deer. Like most ollas in various collections from this period, this piece is poorly documented in that we know neither the source, other than its attribution as White Mountain Apache, nor the maker. In fact, in a recent study (Dittmore and Notarnicola, 1999), it has been suggested that ollas from this period, unless the maker is known, be referred to simply as Yavapai-Apache, given the general confusion between these two peoples at that time (1948.39.95).

Although the influence of the sedentary pueblo peoples is most pronounced with the Jicarilla, the masked mountain-god dances among the Mescalero may have also been stimulated by the masked dances held at the pueblos.

The Mescalero and Chiricahua suffered acutely from the westward expansion of the United States. Reduced to a population of only five hundred in 1863, the Mescalero were confined with nine thousand Navajos on forty acres at Fort Sumner, also known as Bosque Redondo. Hail, frost, a lack of wood, crop failure, and alkaline water all led to hunger and deplorable conditions. By 1865, all but nine Mescaleros had fled to their former homeland in the Sacramento Mountains in southeastern New Mexico. In 1871, the Mescalero agreed to stay in the area in the vicinity of Fort Stanton; however, throughout the decade, white ranchers took more and more land. Furthermore, the Jicarilla from New Mexico were forced to move to the area.

To provide for expansion of European-American ranching land, the Chiricahua were ordered to move to the Western Apaches' San Carlos Reservation. Chiricahua resistance to confinement at San Carlos, led by Victorio and Geronimo, is well known. After nine years, with the help of Apache scouts and the Mexican Army, a United States Army contingent of five thousand men took the last of the Chiricahua to Fort Marion, near Saint Augustine, Florida. With all the Chiricahua confined at Fort Marion, including women, children, some who had never attempted to leave San Carlos, and others who had served as army scouts, this became a de facto reservation/prison. The unsanitary, crowded conditions soon took their toll. By the end of 1889, 20 percent of the inmates had died. Finally, in 1894, the tribe was transferred to a reservation in Oklahoma Territory, at Fort Sill. In 1913, freedom was granted to the Chiricahua, who then had the choice of accepting allotments in Oklahoma or returning to New Mexico and sharing the Mescalero Reservation. By that time, the tribe had been reduced to less than half the size it had been on arrival at Fort Marion, twenty-seven years earlier. Of the remaining 271 people, 187 went to live with the Mescalero Apache and 84 remained in Oklahoma (Opler, 1983a).

When the Chiricahua arrived in New Mexico, the Mescalero were under threat of eviction from their land. It was not until 1922 that their title to the land was confirmed and the threat of removal dispelled (Opler, 1983b). The Mescalero Reservation is now the home for these two tribes. Shortly after the removal of the Jicarilla to this area, they left to return to their old reservation. In 1887, the Jicarilla Apache Reservation was established in northern New Mexico.

In light of their history, it is amazing that the Chiricahua and Mescalero have made any baskets in the last 120 years. Originally, baskets were as important to them as they were to any Apaches. Coiling was used to make shallow bowls and vertical sided "boxes," water bottles, and wastepaper baskets. According to Whiteford (1988), all those types of baskets were made for sale. By 1984, none of the women on the reservation was making coiled baskets. The twined burden basket, however, continues to be made. Like the Western Apache burden basket, these are bucket shaped, but instead of being decorated with strips of hide fringe, these baskets have rows of conical tin dangles, or tinklers, at the rim and sometimes along the bottom edge. There are only two Chiricahua baskets in the Clark Field Collection. Both were purchased at the Mescalero Reservation.

The first reference to the Navajo, or Diné, as they call themselves, as distinct from the Athabaskan Apaches, is from 1626. At that time, Father Zarate Salmerón stated that the people of the pueblo of Jemez referred to nearby peoples as "Apaches of Navaju" (Spicer, 1962), or Apaches who have, or take from, fields. This statement implies that Navajo culture was already distinct from that of the Apache and that agriculture was probably more important. What today is known as "traditional" Navajo culture in fact developed between A.D. 1700 and 1750, after the expulsion of the Spaniards in 1680 from what is now New Mexico and Arizona and the reconquest of the area in 1692.

During that time, many pueblo peoples, fearful of reprisals, fled to join the Navajo. These people brought with them pueblo technology such as stonemasonry, weaving, pottery, and animal husbandry, which they had learned from the Spanish. They also brought religious and social concepts, including the use of cornmeal, sand paintings, ceremonial masks, prayer sticks, and a matrilineal clan system. According to Bailey and Bailey (1986:15), it is the fusion of these two distinct Athabaskan and Puebloan cultures that created the Navajo "as biological and cultural hybrids, neither Athabaskan nor Puebloan, but a product of both." This fusion is also evident in their artistic productions.

Although we know little of Navajo basket production prior to the nineteenth century, it can be assumed that baskets were important. Early baskets included carrying baskets, trays, and water bottles. Coiled, pine-pitched water bottles continued to be made as the Navajo gradually shifted their economy from hunting and farming to herding and farming. To provide protection and pasture for their sheep, extended matrilineal families would travel from summer homes to protected winter homes after the corn was harvested. By 1800, wool from Navajo herds was being woven into blankets. Many of the bold band and cross designs are also found on baskets from which they were possibly derived (Kent, 1985). These shallow, coiled bowls clearly establish a Navajo aesthetic distinct from that of Apache and pueblo peoples (plate 19).

Throughout the first half of the nineteenth century, the Navajo had expanded their herds at the expense of Spanish, Mexican, and European-American settlers. In 1862, Brigadier General James H. Carleton became the new military commander of New Mexico Territory and established Fort Sumner. At first, he moved against the Mescalero Apache. He then declared that all Navajo had to turn themselves in to the U.S. military or be considered hostile. When the majority of Navajo, spread throughout an area of approximately thirty thousand square miles, failed to appear, he began to implement a scorched-earth policy. Troops destroyed cornfields, hogans (houses), peach trees, water holes, animals, and people. Between 1864 and 1865, more than nine thousand starving Navajos were forced to march more than three hundred miles to Fort Sumner. From the time they arrived until their departure, in 1868, they were plagued by crop failure, poor rations, and disease. Because of constant crop failure, the cost of annual rations exceeded one million dollars (Thompson, 1976), which many government officials declared prohibitive. To avoid this expense, the Navajo were released and given seeds, farming instruments, and fifteen thousand sheep and goats, which had increased to 1,500,000 by 1885 (Bailey and Bailey, 1986).

Prosperity came to the Navajo through a productive subsistence economy supplemented by the sale of wool, pelts, and blankets, and by silversmithing. With metal kettles and cups as part of their annuity after their confinement at Fort Sumner and with the cash provided by their expanded production to purchase such items, they soon replaced baskets for everyday use. Baskets, however, continue to be important for ceremonies. They are used to hold sacred cornmeal, prayer feathers, colored earth for sand paintings, and numerous sacred objects belonging to medicine men or singers. Baskets were also used as drums or as resonators with a rasp. Originally, baskets for different

PLATE 19 : Navajo shallow bowl, c. 1875 : The decoration on this finely coiled bowl (1942.14.1953) is sometimes referred to as a "Spider Woman" cross. According to Navajo belief, Spider Woman taught humans how to weave and was generally helpful. However, like other Navajo deities, she could also be dangerous. The distinctive rim on this and other Navajo baskets is called a "false-braid" or "herringbone" rim finish. According to Navajo myth, this type of finish is in imitation of the leaf scales on a green juniper sprig.

ceremonies may have had different, ceremonially specific, designs. This is still the case for the basket used in the wedding ceremony (plate 20).

The rapid increase in herd size, which damaged the restricted range, and in population, coupled with the collapse of the wool market in 1893, led to a severe economic depression during the first decade of the twentieth century. Economic recovery was in part possible through the rising price of lamb and the commercialization of Navajo weaving. Navajo women were now weaving rugs for sale to European-Americans. This left little time for basket weaving. It was far more profitable to weave a rug and to purchase a basket made by Utes or Southern Paiutes.

Since the early 1900s, most "Navajo" wedding baskets have been made by the San Juan Southern Paiutes near Tuba City, Arizona, and Navajo Mountain, Utah, and by the Southern Utes in Towaoc, Colorado. The close connection between the San Juan Southern Paiute and the Navajo extends from 1864, when Navajos hid with the Paiute to escape imprisonment at Fort Sumner. Today, although superficially they may appear to be Navajo, the San Juan Southern Paiute continue many traditions associated with the Great Basin cultural area.

PLATE 20 : Navajo wedding basket, c. 1910 : Today, the wedding basket is used in a variety of ceremonies. During ceremonies, the "pathway," or break in the band design, is pointed to the east. In a Navajo wedding, "A small container of water, and a wedding basket containing ceremonial gruel or mush are set out by the bride's father. As part of the ceremony, he draws lines with pollen across the gruel basket—first from east to west with white pollen and then south to north with yellow pollen—and circles the basket. After dipping water from the water bottle over each other's hands, the bride and groom eat gruel from the east, south, west, north, and center of the wedding basket, with remaining portions eaten by the guests" (Witherspoon, 1983:528). **(1942.14.1952)**

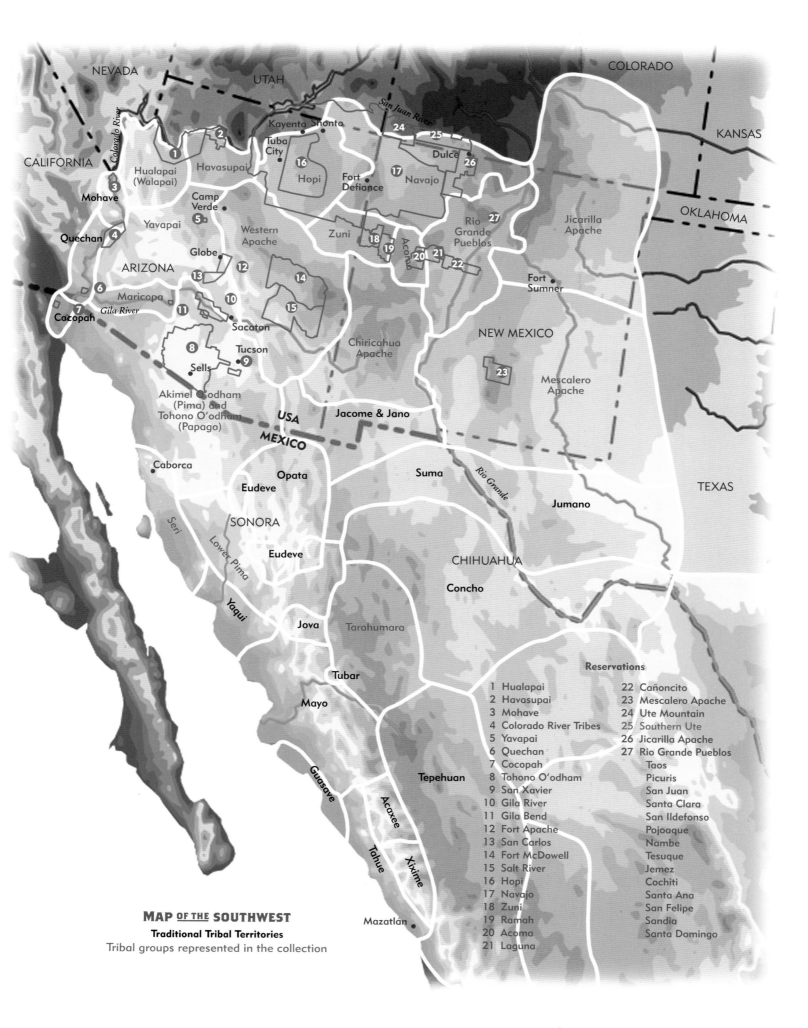

MAP OF THE SOUTHWEST

Traditional Tribal Territories

Tribal groups represented in the collection

Reservations

1 Hualapai	22 Cañoncito
2 Havasupai	23 Mescalero Apache
3 Mohave	24 Ute Mountain
4 Colorado River Tribes	25 Southern Ute
5 Yavapai	26 Jicarilla Apache
6 Quechan	27 Rio Grande Pueblos
7 Cocopah	Taos
8 Tohono O'odham	Picuris
9 San Xavier	San Juan
10 Gila River	Santa Clara
11 Gila Bend	San Ildefonso
12 Fort Apache	Pojoaque
13 San Carlos	Nambe
14 Fort McDowell	Tesuque
15 Salt River	Jemez
16 Hopi	Cochiti
17 Navajo	Santa Ana
18 Zuni	San Felipe
19 Ramah	Sandia
20 Acoma	Santa Domingo
21 Laguna	

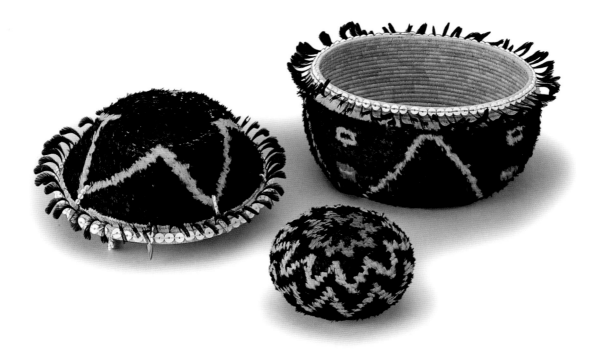

CALIFORNIA

Suzanne Griset

The California culture area (Kroeber, 1939) has long been recognized as distinct from its neighbors, the Northwest Coast, Plateau, Great Basin, and Southwest. That said, the exact boundaries of this area have been the subject of debate (see Heizer, 1978b). Most anthropologists agree that the core of the California culture area extends from the Pacific coast east to the crest of the Sierra Nevada Mountains and the crest of the southern half of the Transverse Ranges, and excludes the eastern side of the Sierras and the easternmost southern California deserts. Some authors also exclude the northwestern and northeastern corners of the state; many still argue over the exact boundary along the eastern deserts. This essay follows Robert Heizer's (1978b) boundaries, as found in the Smithsonian Institution's *Handbook of North American Indians*, Volume 8 (1978a).

Within this overall area, regional divisions are also designated according to general topographic features (Heizer, 1978a). The northwestern region consists of the forested coastal ranges that extend northward into Oregon, Washington, and Canada. The northeastern region is an arid zone similar to both the Great Basin and the Plateau. The central region includes the central coast, the interior Coast Ranges, the Central Valley, and the western slopes of the Sierras, and extends south to the Transverse Ranges. From the Transverse Ranges southward is the southern region. It too includes the coast and interior valleys, but it continues on over the Transverse Ranges into a portion of the interior desert, southward into northern Baja California. It also includes several islands off the Pacific coast. The southern region is arid and does not have the great river systems that characterize the central and northwestern regions, where rivers originate in

the eastern slopes of the Sierras and the Coastal Ranges and drain westward toward the Pacific Ocean. In contrast, much of the southern region relies on ephemeral streams fed by winter rains or springs. Climate is temperate for the most part throughout California, with snow restricted to the higher elevations.

Perhaps the most distinctive feature of the California culture area was and is the diversity of resources and peoples. Within several days' walking distance could be found marine, estuarine, riverine, grassland, woodland, alpine, or desert resources. Extensive trade networks moved these resources within and across the area. Oak woodlands throughout the area provided the principal staple crop, acorns, which was supplemented by gathering a wide variety of other plant foods and hunting small game. Acorns were to California what corn, beans, and squash were to the Southwest or salmon was to the Northwest Coast. With such an abundance of resources, peoples of the California culture area never resorted to full-scale agriculture, but they manipulated the natural resources by careful harvesting and regular burning of underbrush.

The number of distinct languages in the California culture area was equally diverse. At least sixty-four and perhaps as many as eighty mutually unintelligible languages were spoken (Shipley, 1978). Although some scholars have referred to these language groups as "tribes," this is somewhat misleading. Language boundaries did not constitute the geopolitical organization in California. Kroeber (1932) coined the term *tribelet* to describe the political unit of California peoples. Tribelets were small autonomous groups residing in one or more villages within a recognized territory. Trespass across boundaries was grounds for warfare between tribelets. A language group might be composed of one or more tribelets, with a population ranging from fewer than one hundred to several thousand people per tribelet.

Each tribelet had a recognized central leader who consulted with representatives from each of the major families before making decisions. Leaders ruled by consensus rather than decree; if they lost the support of the tribelet members, they were replaced. Leaders were often selected from "chiefly families," but there was no guarantee that their heirs would succeed them. Leaders were responsible for resolving grievances among members, deciding when the group should move to new resource areas, or marshaling forces to war against neighbors. All of these decisions were made after consultation within the tribelet.

The diversity and extent of native language groups indicate that California had long been subjected to many movements of people throughout its rich territory. Europeans also saw California as a land of potential riches, and many European powers sought to claim it for their own. Contacts with European-American sailors began as early as the sixteenth century along the Pacific coast, with sporadic visits by ships needing resupply or safe harbor. Sustained incursions began in the late eighteenth century, when Spain sent missionaries, soldiers, and settlers by land and sea to establish missions, presidios (forts), and pueblos (towns) along the coast to fortify Spain's claim to the land.

A string of twenty-one missions was established from Mission San Diego north to Mission Solano. Each mission enticed or forcibly brought the surrounding native peoples to reside and work at the missions. Often, the residents of a single mission included peoples from formerly hostile tribelets. The reach of the missions extended ever farther inland to find new Indian labor to replace the neophytes who quickly succumbed to European diseases. By the second decade of the nineteenth century, natives from the Central Valley and the interior valleys of southern California were forcibly brought to the coastal missions. With Mexico's independence from Spain, in 1822, and the arrival of ever more Mexican settlers, the mission system's influence began to decline. When the missions were closed, in 1834, the remaining native residents were left to fend for themselves in an area where most native tribelets had been totally decimated.

European-Americans did not have a direct impact on tribelets farthest inland until the onslaught of the California gold rush of 1848–1849. The "forty-niners" swarmed through California, trying to reach the gold fields in the Sierra foothills. Miners forced

natives from their lands, tore up the countryside, and often went Indian hunting for sport. With the miners came the shopkeepers, farmers, and a general influx of Americans who quickly set about acquiring and exploiting the rich lands. In 1850 California became a state.

By the mid-nineteenth century, all but the most remote tribes had been drastically affected. Native peoples were no longer able to gather or hunt in their traditional territories and were forced to seek jobs that would provide cash to buy the food and materials they could no longer collect or create from the land. The latter half of the nineteenth century saw the creation of reservations for the surviving tribelets, either de facto or by congressional decree. Many of these reservations were amalgamations of former tribelets, and some contained peoples who spoke different languages.

Throughout this turbulence, California native peoples preserved as much of the old ways as possible. For many tribes, basketry has proven to be one of the most enduring links with tribal traditions and history. Baskets were the principal tools of daily life, and they also served special ceremonial functions. They were visible representations of images and symbols important to the tribelet. Furthermore, they provided an outlet for the aesthetic creativity of the makers, which brought them special status. Changes in basket forms, materials, and manufacturing techniques often reflect the larger societal changes that affected the basketmakers. These nuances add another layer of appreciation to what is inherently an aesthetically pleasing art form. California baskets are renowned for their beauty; they are also a testimony to the evolving tradition of native peoples.

Basketry constituted the primary form of containers made and used in native California (pottery was manufactured only in the southernmost part of the southern region, along with a full range of basket forms). Baskets were used for gathering, processing, cooking, serving, and storing food. Baskets were used to transport heavy loads such as firewood and smaller burdens such as babies. Baskets were used to store personal treasures or regalia. Basketry techniques were used to manufacture tools such as fish and bird traps, seed beaters, and small animal cages and to construct ceremonial regalia and baskets.

Although fancy coiled baskets, such as those shown in plate 21, (see p. 51), have become the trademark of California basketry, they represent a small portion of the original basketry assemblage. In fact, Lawrence Dawson, former curator at the Phoebe Hearst Museum of Anthropology at the University of California, Berkeley, has speculated that the coiling technique was a relative newcomer to the area and that twining was the original basketry technique used to make the full panoply of basket containers (Dawson, 1983; *Fields of Clover*, n.d.). Most California tribes, however, manufactured a core set of containers for gathering, processing, serving, and storing foodstuffs (plate 22, pp. 54–55):

- *burden/carrying baskets*: for transporting gathered raw foods such as acorns
- *bowls*: in a variety of sizes suited for personal, family, or community servings
- *open-mouth bowls*: for cooking, preparing, and serving foods, made in a range of sizes from small (personal serving size) to large (communal servings)
- *restricted-mouth bowls*: for storing food and other goods, sometimes lidded
- *trays*: open and closed weaves, for sifting, parching, drying, serving
- *tools*: twined forms used to make spoons, seed beaters, traps, etc.

A household required a full set of baskets (coiled and/or twined) for processing the staple food of the majority of California tribes—acorns. First, acorns were collected and transported in a burden basket from the tree to the processing or storage area. A bowlful of acorns was brought to the processing area, where they were prepared for grinding into meal. Each nut was cracked and the outer hull removed. Acorn meats are covered by a thin, bitter "paper" layer that must also be removed after the hulled nuts have been

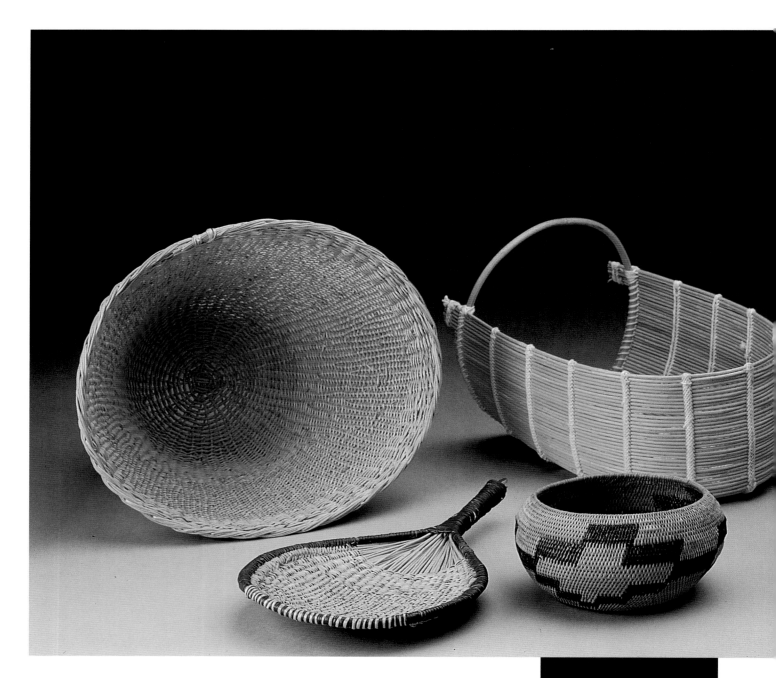

spread on a tray to dry. After the paper layer was rubbed or scraped off, the meat was ground in a stone mortar, either in bedrock or a freestanding boulder to which a basket rim was affixed (mortar hopper basket, figure 14, p. 62). The "flour" was sifted in a tray to separate the larger pieces that had to be reground until a fine meal was produced. The fine meal was accumulated in a basketry bowl, then leached, a portion at a time, in a tray or sand basin and rinsed with water until the tannic acid was removed. The "sweet" meal was then placed into a cook pot (a large bowl, twined or coiled, flat bottomed or rounded), and water was added. The gruel was cooked by adding rocks that were heated, rinsed off in a large bowl of water, then placed into the mush to bring the contents to a boil. When cool, the rocks were rinsed off in yet another large bowl of water before being reheated. The larger the group of people to be fed, the larger the set of basket bowls that was required. Usually, the acorn mush was eaten directly out of the cooking pot; in some areas, small bowls or women's basket hats were used as personal serving bowls.

Pinole, another staple flour, was made from grass and flower seeds that were collected by using a basket fan to beat the seed heads directly into a burden basket. The seeds

PLATE 22 : Pomo household baskets : Many baskets were needed in native California households for gathering, transporting, processing, and serving food. Although this Pomo assemblage is by no means complete, it provides a sample of the different weaves used to make the basket forms that served multiple functions in Pomo society. The seed beater (1942.14.1905) was used to gather seeds into the burden basket (1948.39.129) for transport back to the home. Acorns were carried in

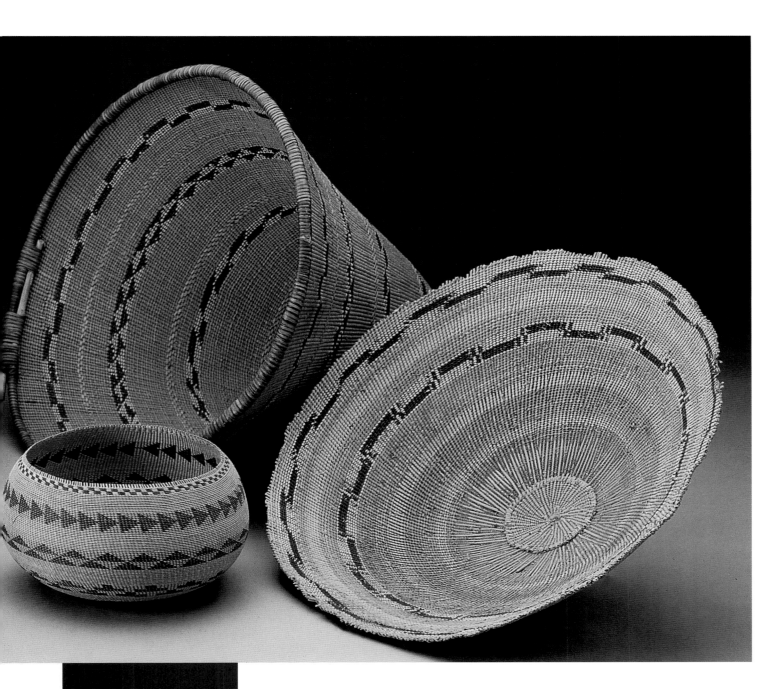

burden baskets to be ground into meal, sometimes in basket mortar hoppers, as seen in figure 15 (p. 62). After the acorns were ground, meal was placed in a tray (1942.14.1885) and leached atop leaves. (1942.14.1882), It was then boiled in mush bowls (1942.14.1908) and served in small bowls (1947.57.58). Open-twined baskets also were used for important tasks such as carrying wood (1942.14.1897) or transporting young children (1942.14.1895).

were toasted by rotating them with live coals on a flat basket tray, then ground and made into meal that was baked or mixed with water in a basket to make a beverage.

Although women made most of the household baskets by twining or coiling strands of split shoots, roots, or grasses, men often made the larger open-twined forms such as fish traps, quail traps, woodpecker traps, and sometimes cradles. These latter were usually made from whole shoots and required great strength to manipulate the materials.

Basketmaking was a household art passed down within families. The techniques and patterns were passed along, but usually the baskets were not. Death rites throughout California required that all the material items owned by the deceased person be buried or cremated with the person or burned at the annual memorial ceremony a year afterward. In fact, many of the fanciest baskets were made specifically to commemorate the passing of a respected tribal member and were destroyed as part of the ceremony.

This tradition began to be altered as nonnatives collected and preserved California baskets. The oldest documented examples are those collected by Russian visitors to the northern California coastal area in 1816 and 1824 (Hudson, 1984). The Wilkes expedition also collected, in 1841, specimens that ultimately were acquired by the Smithson-

ian Institution (Hudson, 1984). Early Spanish and Mexican residents of California also collected baskets in the early nineteenth century, some of which have been incorporated into museum collections.

With the influx of European-Americans into California, many native peoples used baskets to barter for store-bought goods throughout the latter half of the nineteenth century. As more baskets entered the nonnative world, appreciation for them as an art form grew. By the turn of the twentieth century, an "Indian Room" was de rigeur in the best of Victorian homes (Gogol, 1985). This ensured a ready market for California baskets, one that influenced the evolution of traditional basketry into forms "made for sale."

> The golden age of collecting Indian basketry lasted for a few years beyond 1910, but not for many. World War I shifted American interest and resources toward the crisis in Europe. The popular press [was] filled with the problems of the world and labor problems at home. By the 1920s the popular magazines that had once carried all sorts of articles on Indians and Indian culture have changed their design and their contents and become a wasteland for those interested in Native American life and culture. With the onset of the Great Depression the 1930s gave the coup de grace to Indian basket collecting, bringing the art of basketry to the brink of extinction in many areas, a trend reversed only by the onset of a new "golden decade," the 1970s (Gogol, 1985:29).

Along with the revitalization of pride in native cultures that accompanied the American Indian Movement of the 1960s, collecting native art became fashionable once again. This has led to a revival of native basketmaking in California within the past twenty years (Eisenhart, 1990). The California Indian Basketmakers Association was organized in 1992 to provide support and communication among native basketmakers and to address common concerns such as pesticide and herbicide contamination of the native plant materials used to make baskets.

Clark Field's collection of 156 California baskets was made between 1936 and 1965, with the largest number of purchases in 1937. Although Field acquired some baskets from the makers or from Indian agencies, he also bought many of his California baskets from traders and collectors—three from the Fred Harvey Company (purchased in 1937); several choice southern California "Mission" baskets from R. B. Cregar (1937 and 1950), a collector and trader residing in Palm Springs, California; several from a Mr. Spink at Bacone College in Oklahoma (1937); one from C.H. Kelsey (1937); a group of baskets that Mrs. Francis L. Zollinger of Tulsa (1938) had collected from Round Valley, California, at the turn of the twentieth century; two from the Southwest Museum (1949); two from Charles B. Knox of Jamestown, New York (1951); and at least four from the Gottschall Collection of Harrisburg, Pennsylvania (1951). Gottschall's collection was made between 1871 and 1920 and provided some of the oldest specimens that Field collected.

The majority of Field's California baskets (129) come from tribes north of the Transverse Range, which roughly divides northern from southern California (table 1). By regional designations, central California dominates the collection (80 of 157, or more than 50%). Within this region, the baskets can be roughly divided into two groups: (1) those from the northwestern edge of the region (Pomo, Yuki, Wailaki, and northwestern Maidu, who had been removed to Round Valley), and (2) those from the southern end of the Great Central Valley and adjacent eastern Sierra foothills (Sierra Miwok, Mono, Yokuts, and Tubatulabal). Baskets from the southern region represent, albeit sparsely, the southernmost tribes. In total, nineteen of the original sixty-four to eighty California native language groups are represented in the Clark Field Collection.

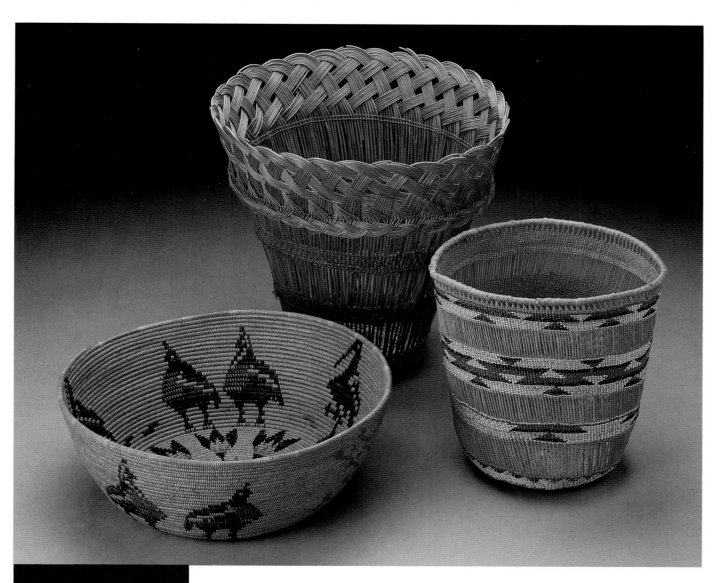

PLATE 23 : New forms for new functions : The two wastebaskets on the right (1948.27.28 and 1948.39.11) were made by Hupa weavers about 1937. Both are made of traditional materials and weaves that have been adapted to functions peculiar to the European-American market. The Kumeyaay bowl on the left (1951.23.14) is finely woven with a sumac weft and juncus design elements, including two quails and a pelican in dyed juncus, and a plant motif woven in undyed juncus. Clark Field remarked on the catalog card: "one of the finest specimens of fine art basketry ever produced." This is an early example of the use of figurative designs that would appeal to European-Americans.

Table 1 . California Baskets by Region of Origin

Northwest		Northeast		Central		Southern	
Hupa	20	Achumawi	5	Pomo	50	Cahuilla	12
Yurok	12			Mono	8	Mission	8
Karuk	10			Yokuts	7	Kumeyaay (Diegueño)	4
Shasta	1			Maidu	5*		
Wiyot	1			Miwok	4	Cupeño	1
				Tubatulabal	2	Luiseño	2
				Yuki	2		
				Wailaki	2		
TOTAL	44		5		80		27

*3 Konkow Maidu and 2 Southern Maidu (Nisenan?)

Many of the baskets in the collection were "made for sale." These baskets made for the European-American market are often in nontraditional forms such as wastebaskets, wash baskets, or rectangular shapes (plate 23). They usually have figurative design elements or were manufactured with non native materials such as feathers from introduced bird species, glass beads, or cloth.

More than nineteen California baskets in the collection are reputed to have been manufactured in the mid- to late nineteenth century. Baskets made between 1900 and

1940 are by far the most numerous, and this accurately reflects the pattern of basket-making in California. Fewer baskets were made after 1940, and most of these come from tribes in which the basketmaking tradition was still strong and resident in more than a single maker (see the discussion of Pomo baskets below).

Northwestern California

Although Heizer (1978b) includes this region within the California culture area, the environment, geography, and native material culture, especially the basketry, belong more properly with the Northwest Coast. The region is dominated by the Klamath, Smith, and Trinity Rivers, which drain rugged mountainous regions of coniferous forests. The economy was based on two primary harvests, salmon and acorns, supplemented by other fish, greens, berries, tubers, and seeds.

Tribes within this region are Tolowa, Yurok, Karuk, Hupa, Chilula, Whilkut, Chimariko, Nongatl, Mattole, Sinkyone, and Lassik. Kroeber (1925, 1936) also included the Shasta. The Clark Field Collection has baskets from the Yurok, Karuk, Hupa, Wiyot, and Shasta.

The northwestern basketry tradition consists of twining to the exclusion of coiling. Warps are generally made from the shoots of young trees. Hazel (*Corylus rostrata californica*) is the preferred material. Others include willow shoots (*Salix sp.*), serviceberry (*Amalanchier alnifsolia Nutt*), and occasionally myrtle (*Myrtus communis*). Tree and plant roots are used for weft. Jeffrey (*Pinus ponderosa jeffreyi*) or Bull pine (*Pinus sabiniana*) are the preferred materials. Others include willow (*Salix sp.*), wild grapevine root (*Vitis californica*), red alder (*Alnus oregana*) and, among the Yurok, redwood roots (*Sequoia sempervirens*). Decorative strands are harvested from white grass (*Xenophuyllus tenax*), maidenhair fern (*Adiantum pedatum*), chain fern (*Woodwardia rodicans*) and, for special accent, porcupine quill (Harrington, 1932; Eisenhart, 1990).

As numerous authors have noted (Kroeber, 1925; O'Neale, 1932; Dawson, 1983; Eisenhart, 1990), despite mutually unintelligible languages, the material culture of the Hupa, Karuk, and Yurok is nearly indistinguishable, and this is particularly true for their basketry. Eisenhart (1990) enumerates eighteen basket types for the Hupa, Karuk, and Yurok, based on the functions they served:

1. **pack (burden) basket**: large, conical shaped, carried on back; openwork to carry wood, close weave to carry smaller, finer contents such as seeds
2. **drying rack**: open weave, flat circular trays, to dry fish, acorns, etc.
3. **food storage**: large openwork, globular with incurving rim, to store dried food
4. **mortar basket**: close weave, strongly reinforced rim, shallow bowls with no base, set atop a stone mortar to catch the acorn flour as it is pounded
5. **flour sifter**: close weave, flat tray, used to winnow out larger pieces of meal for regrinding
6. **mealing tray**: large, close-weave shallow bowl to catch the meal as it is ground in the mortar
7. **dough basket**: large, close-weave bowl to hold the sweet acorn meal prior to cooking; somewhat larger than a family cooking basket
8. **cooking basket**: large close-weave bowl
9. **ladle**: small, shallow, undecorated, closely woven bowl
10. **soup basket**: personal bowl
11. **plates**: open- or close-weave trays
12. **spoon holder**: small, globular handled, open weave, to store horn spoons

13. *treasure/trinket basket*: small, close weave, finely decorated, sometimes lidded

14. *tobacco basket*: minimally decorated, lidded globular basket

15. *gambling tray*: similar to deep mealing tray

16. *woman's hat*: finely woven and traditionally decorated

17. *Jump Dance basket or "purse"*: close weave, begun by women but finished by men, carried by men as part of ceremonial regalia for Spring Jump Dance

18. *cradle*: open weave of hazel sticks, sized to fit the baby

Most of the bowls have rounded bottoms and the basket "start" protrudes upward into the bottom of the bowl. Bowl rims are direct but slightly incurving, with the exception of the straight-sided basket hat, which also has a flatter start. The pack basket is a truncated cone—the bottom is slightly rounded but can usually stand upright.

Of the twenty Hupa baskets, Field purchased one basket from Charles B. Knox of Jamestown, New York, in 1954. The rest were purchased by Field directly. Most of his purchases appear to have been in or near Eureka, and seven of them probably were directly from the makers (table 2).

Table 2. Hupa Basketmakers in the Clark Field Collection

basketmaker	year made	basket no.	form/function
Fred Brown	c. 1943	1948.39.411	eel trap
Emma Frank	c. 1937	1948.27.42	small bowl (personal serving bowl for acorn mush)
Nellie Griffen	c. 1944	1948.39.480	tray ("for soaking babies")
Mrs. Charles Myers	c. 1937	1948.27.43	hat
Howard Quinby	c. 1943	1948.39.409	small bowl (personal serving)
		1948.39.410	small bowl (personal serving)
Mrs. Robinson Shoemaker [1]	c. 1937	1948.27.51	cradle (baby carrier)

(1) Robinson Shoemaker is listed in Heizer and Nissen (1973) as living in 1869. His wife, therefore, would probably have been in her late seventies when Field made his purchase in 1937.

Field recorded Susie Little as a Hupa basketmaker when he purchased a basket from her that was made in 1920. In 1943, he bought four more baskets from Little, but noted her then as a Yurok weaver. Little's great-granddaughter Shelly Ammon confirmed that Little was a Yurok woman who married a Hupa man and moved to Hoopa Valley to raise their family (Shelly Ammon, personal communication, April 2000). Clearly, Field became a more sophisticated collector as he became more familiar with baskets and their makers.

Field purchased a large seed storage bowl (1948.39.396) in 1943 at the Karuk village of Weitchpec, but its materials (hazel warp, conifer root weft, and overlay of bear grass, fern stem, and dyed conifer-root) suggest Hupa manufacture. A flat-bottomed, conical, twined burden basket (1948.39.14) is made of hazel warp, spruce-root weft, and half-twist overlay of bear grass and has an attached leather tumpline. Its exact provenance is unknown, as is the maker; however, the materials suggest that it is of

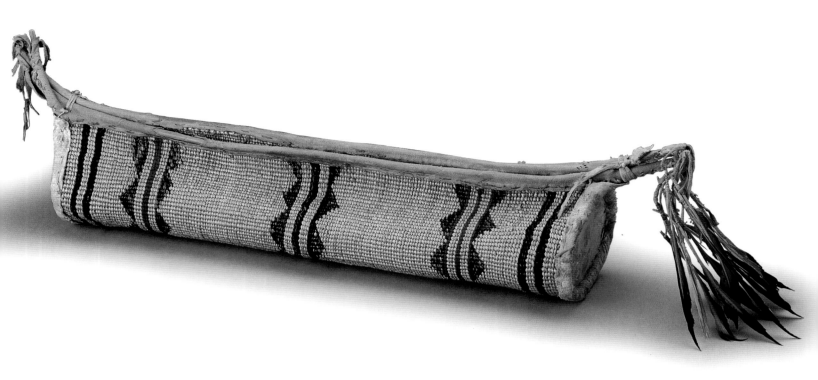

Hupa manufacture. Small to medium-size bowls (1947.57.67 and 1948.27.41) could be used to serve and store a variety of materials and foods. Two wastepaper baskets (1948.27.28 and 1948.39.11) are classic examples of Hupa weavers using traditional materials and techniques to produce a basket designed specifically for the European-American market (plate 23, p. 57).

Also represented in the collection are three examples of a rare basket form known as a "Jump Dance" purse (plate 24). Mason (1904) calls it the Woodpecker Dance because of the redheaded woodpecker headdress worn by the dancers. Clark Field correctly notes that these baskets were considered sacred and were used in a ceremonial dance held each spring as a prayer of supplication for the return of the fertility of the soil to barren land. Another basket form unique to this part of California was the tobacco basket, a lidded jar shape to store tobacco leaves for personal smoking and for ceremonies (plate 25).

The last three Hupa baskets purchased by Field included an open-twined fan which could be used to beat seeds or, as Field noted, to scoop minnows (1956.19.4); a conical burden basket (1954.15.22); and a personal storage jar (1951.23.8). The latter is similar to a smaller version of the large food-storage baskets in that it is conical with a flattened base and a narrow opening at the mouth.

Ten Karuk baskets were purchased through a variety of avenues. Two were bought by Field from Mr. Spink at Bacone College in 1937. Field purchased three directly from the Hoopa Valley Indian Agency and two from an unnamed maker in the town of Happy Camp. The rest are unprovenanced. Makers' names are recorded for four baskets, and Mr. Spink's "relatives" are named as the source of another two baskets.

PLATE 24 : Hupa Jump Dance purse, c. 1900 : This basket is one of three Jump Dance purses purchased by Clark Field. The purse is made from a rectangular segment of twined basketry with a half-twist overlay of bear grass and fern on a conifer-root warp. Hazel rods were attached at the top edges of the purse, and a hide binding secured the end with flicker feathers as ornaments. These baskets were woven by women; men finished the purses and attached ornamentation. The dancers carried empty purses. The Jump Dance was held in the spring in honor of the earth's coming fertility (1948.39.388).

Table 3. Karuk Basketmakers in the Clark Field Collection

basketmaker	year made	basket no.	form/function
Lizzie Jake	c. 1920	1948.39.403	cooking bowl
	c. 1943	1948.39.404	cooking bowl
Mrs. Rafey Jones	c. 1900	1948.27.39	small bowl
Nettie Reuben	c. 1937	1948.27.40	small bowl
Mr. Spink's relatives	c. 1937	1948.27.44	hat
		1947.57.66	small bowl

CALIFORNIA

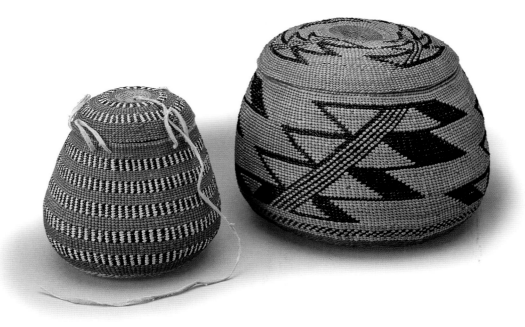

Nettie Reuben supported herself and her children through basketmaking. According to Laverne Glaze (a Karuk/Yurok weaver who, as a child, lived next door to Reuben), Reuben specialized in selling miniature baby baskets (cradleboards) to tourists and full-size baby baskets to natives (Laverne Glaze, personal communication, February 2000). She also reported that the Spink family lived in the area of Happy Camp. Spink was a white man married to Glaze's great-aunt.

Six of the ten Karuk baskets are bowl forms. Two are cooking baskets by Lizzie Jakes (table 3), made of spruce and bear grass. The remaining four bowls, including those made by Mrs. Jones and Mrs. Reuben, are small decorative baskets, woven with half-twist overlay geometric designs that appealed to basket collectors.

Also among the Karuk sample are two mortar baskets (1948.39.44 and 1948. 39.5). These baskets are similar to a large cooking basket but are without a base. This ingenious basket tool was used to grind acorns when suitable granitic bedrock outcrops were not available. Normally, large flat bedrock outcroppings provided areas where several women could sit and grind acorns in basins (mortars) pecked into the bedrock. These conical basins ranged in depth from one-half to twenty inches. In contrast, the hopper basket was portable and could be placed atop a flat rock anywhere, and the basket substituted for the conical sides of the bedrock mortar. The seated woman put her legs on top of the basket to hold it in place, filled the basket with acorn meats, and then pounded them to a meal using a large rock pestle (sometimes twenty inches long) (figure 14, p. 62). Field originally cataloged both mortar hoppers as Hupa, probably based on his having bought them at Hoopa in 1937. However, they are twined on willow warps, suggesting Karuk manufacture.

The most unique Karuk basket is a flattened conical twined basket that Field noted was used to cover the face of the deceased at the time of burial (1951.23.9). There is no evidence, however, that it has ever been used for this purpose. It is approximately 2.5 inches high by 12.5 inches in diameter and has a hole punctured through the center. Field recorded its year of manufacture as 1948. He purchased it in 1951.

All but two of the twelve Yurok baskets were purchased in 1943 in and around Eureka, some specifically from the Hoopa Valley Indian Agency. Makers are recorded for ten of the twelve baskets (table 4).

CALIFORNIA

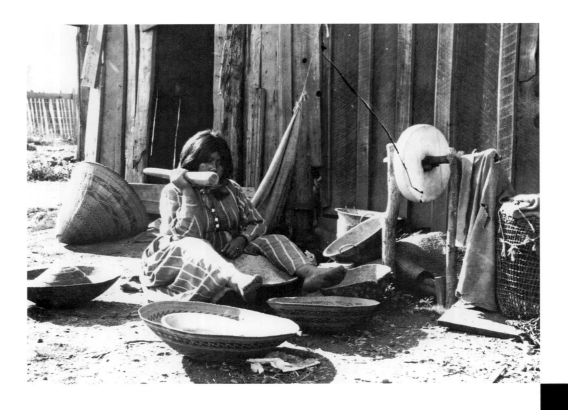

Table 4. Yurok Basketmakers in the Clark Field Collection

basketmaker	year made	basket no..	form/function
Emma Carpenter	c. 1943	1948.39.392	open tray
		1948.39.393	open tray
May Ann Ferry	c. 1943	1948.39.407	small bowl (personal serving)
		1948.39.408	small bowl (personal serving)
Susie Little	c. 1920	1948.27.45 a,b	tobacco jar and lid
	c. 1943	1948.39.383	small bowl (personal serving)
		948.39.384	cooking basket
		1948.39.385	cooking basket
		1948.39.386	cradleboard (baby carrier)
Mrs. Redwood Henry	c. 1943	1948.39.391	burden basket

The two trays made by Emma Carpenter are open-twined trays that were traditionally used for drying and sifting foodstuffs. Mrs. Henry's burden basket is also made by using the open-twined technique with hazel rods. Susie Little's tobacco jar, which Field had originally classified as Hupa, is a small personal size compared with the Hupa example, yet very similar in technique (plate 25, p. 61). Her baby carrier is likewise similar to the Hupa example made by Mrs. Shoemaker in 1937. The remaining baskets are various sizes of bowls for cooking and eating acorn mush. Three individual serving bowls for acorn mush (called soup bowls by Field) were made by Susie Little and Mary Ann Ferry.

FIGURE 15 : Woman grinding acorns, 1893 : When bedrock outcrops suitable for grinding acorns were not available, California women used a portable mortar hopper. In northern and central California, a twined basket with the base cut off and the rim reinforced with a whole shoot was placed atop a large, flat rock. The seated woman placed her legs on top of the basket rim to hold it in place while she pounded the acorns. The basket confined the acorns over the mortar depression so that the meal could be ground until it was fine. This photo, taken in 1893, shows a Pomo woman grinding with a basket mortar hopper. Similar bottomless baskets were used in southern California, but they were affixed with resin to the rim of a freestanding stone mortar bowl. Photograph courtesy of the National Anthropological Archives, Smithsonian Institution, neg. no. 47, 750-A.

Basket production in the Northwest experienced the same ebb and flow seen elsewhere in California. Many of the old weavers passed on in the 1930s and 1940s and few daughters carried on their craft, often because of the forcible removal of Indian children to distant schools where all things native were forbidden and punished. Fortunately, a few people knew the skills. A revival of basketmaking occurred in the late 1960s and 1970s, particularly with the development of tribal museums such as that at Hupa, which supports the teaching of traditional arts to younger tribal members. Contemporary weavers have been instrumental in teaching the craft to a new generation of basketmakers. New basketry forms have been developed, such as the miniature plaque necklace which is popular among modern collectors.

Northeastern California

Kroeber (1925) originally placed the Achumawi (also known as the Pit River tribe) in the central region, then changed his mind and created a northeastern region comprised of the Achumawi and the Modoc, to reflect their affinity with the Plateau and Great Basin areas. Heizer (1978b) also placed the Achumawi within the confines of the California culture area.

The Achumawi territory ranged in elevation from five thousand to fourteen thousand feet above sea level, along the upper stretches of the Pit River, with Mount Shasta and Lassen Peak defining the western boundary and the Warner Range the eastern boundary. This included well-watered valleys, lakes, and areas of barren lava flows. Streams provided salmon and other fish, mussels, and crayfish. Swamps provided the ubiquitous tule that was used for housing, mats, balsa rafts, and food. Marmots and large groundhogs were hunted near the lava flows, and deer, coyote, and badgers could be found in the uplands. Oak riparian zones along the Pit River provided acorns; pines in the eastern part of the territory provided nuts. Tubers such as camas, brodiaea, and wild parsley provided important sources of additional starches. Basketry materials provided by this environment included willow, grasses, maidenhair fern, pine roots, and redbud bark (Olmsted and Stewart, 1978).

Five Achumawi baskets are included in the Clark Field Collection. One, a twined bowl of cedar warps wrapped with grass and redbud decoration (1948.39.4), was purchased from the Fred Harvey Company in 1937. The second is a twined conical burden basket with incurving sides (1951.23.11), much used and with native repairs, bought by Field in 1951. The third is a mortar hopper basket (1948.39.419) recorded as having been made in the 1870s. It is well worn and has the typical hopper breakage pattern in the rim rods. The fourth is a plain-twined bowl (1948.27.63) with a full-twist overlay. The final basket is a large storage basket (1959.2) typical of northern California groups, with sides that tend to bow with age. It has hazel warps and the weft is of hazel, conifer root, and full-twist bear-grass overlay with reinforced three-strand twining on the bottom. A beautiful geometric step design zigzags up the sides of the basket with thin, dark horizontal connecting bands. Unfortunately, no additional provenance is known for any of these baskets.

Central California

One of the features that distinguishes the central California cultural region is the emphasis placed on coiled basketry. Heizer (1949) suggested that coiling was a relatively recent introduction into the area, as evidenced by the appearance of shouldered bone basketry awls in archaeological sites no older than four thousand years. All of the tribes in central California continued to make twined forms, especially for heavy workbaskets that had to be replaced often (twining is faster and requires less material) or for baskets that required open spacing, such as traps, beaters, drying trays, and strainers.

As mentioned previously, the baskets in the Clark Field Collection were purchased

from tribes in two locales at opposite ends of the central region, the northwest and the southeast. At the northwest end, Field collected baskets from the Pomo, Yuki, Maidu, and Wailaki. Many of the baskets appear to have been purchased directly from the makers or from Indian agencies. He purchased four baskets from Round Valley during visits in 1939, 1953, and 1956, presumably at the reservation located there. This reservation had been created in 1858 when the military forcibly relocated Yuki, Wailaki, and Pomo tribes from the surrounding area, as well as Konkow Maidu, Nomlaki, Achumawi, Atsugewi, Lassik, Modoc, and Yana tribal members from east and north of the Coast Ranges. Three additional baskets, all Maidu, were collected in Round Valley in about 1903 by Mrs. Francis L. Zollinger and sold to Field in 1938. Two Pomo baskets were also purchased in 1938 from Mrs. Zollinger, but it is unclear whether they too were bought in Round Valley.

Of the two Yuki baskets purchased by Field in Round Valley, one bowl is recorded as having been made by Peggy Stone in about 1915 (1956.19.1). The other basket is a shouldered bowl (1953.21.2) with no additional documentation. Yuki basketry traditions have been very elusive because few specimens have a known provenance. Most collections contain baskets that are "attributed" to Yuki based on several traits, such as incompletely peeled redbud. The Yuki are thought to be one of the earliest peoples in this area. However, with their removal to the Round Valley reservation, their basketry traditions and choice of materials blended with those of others resident there.

Three Konkow Maidu baskets from Round Valley consist of a shallow bowl (1948.39.128), a bowl (1948.39.127), and a tray (1948.39.126). Two Wailaki baskets, a mortar hopper basket (1948.39.139) and a small bowl (1953.21.1), were purchased by Field in Round Valley in 1939 and 1953, respectively.

Pomo baskets are by far the most numerous of any group within the collection, largely because of the market created for Pomo baskets at the turn of the twentieth century and the active basketmaking community that existed across many Pomo tribelets (called rancherias). Field may have purchased as many as thirty-two of the fifty Pomo baskets directly from the makers on his visits to California. As a result, we know the makers' names for twenty-three of these baskets.

When a basketmaker's name is known, additional information can be gleaned from other researchers and relatives. A fascinating study of the interrelationships among Pomo basketmakers of the late nineteenth century (Abel-Vidor et al., 1996) discusses many of the weavers whose work was collected by Field. It traces the basketmaking tradition of one Pomo woman, Elsie Allen, her relatives, friends, and contemporaries, and provides excellent insight into one of the primary reasons Pomo baskets became and continue to be well known and sought by collectors.

As can be seen in tables 5 and 6, many Pomo basketmakers interacted with one another and passed along basketmaking traditions to relatives and friends. Elsie Allen's mother, Annie Burke, helped establish the Pomo Indian Women's Club to promote an appreciation for Pomo basketry (Abel-Vidor et al., 1996). Annie Burke also went against Pomo tradition and instructed her daughter not to burn or bury her baskets at her death because she wanted them to remain an inspiration for Allen and future weavers (Allen, 1972). Allen states in her autobiography that she came back to basket weaving at the age of sixty-two, just about the time her mother died. Allen's children were grown and she had time to weave again. However, the interest in learning basketmaking was in decline during the 1950s and 1960s, even among the Pomo. Allen decided to teach any and all who indicated an interest, which sparked some opposition among her own people (Allen, 1972).

Table 5 demonstrates how closely intertwined the basketmakers are from whom Clark Field collected. Field collected one basket made by Allen, seven made by her mother, one made by her grandmother, and one made by Evelyn Lake Potter, a distant relative of Allen's father's family. Field collected two baskets from Susie Santiago Billy, a neighbor of Allen's at Hopland, whose daughter Susan Billy later became one of Allen's

Table 5. Elsie Allen's basketmaking relatives and their baskets in the Clark Field Collection

Mary Arnold
(1845–1925)
Elsie's Allen's grandmother
lived in Cloverdale
tray, c. 1890 (1942.14.1885)

Annie Ramon Gomachu Burke
(1876–1962)
Elsie's mother
lived in Cloverdale
seed beater, c. 1930 (1942.14.1905)
fish trap c. 1944 (1942.14.1894)
burden basket, c. 1944 (1949.29.19)
tray, c. 1944 (1942.14.1882)

Susie Santiago (Mrs. Cruz I.) Billy
(1885–1968)
lived in Hopland Rancheria
Elsie's Allen's aunt; Susan Billy's grandmother
feathered bowl, c. 1930 (1953.21.8)
feathered bowl, c. 1952 (1952.22.2)

Elsie Comanche Allen
(1899–1990)
lived in Cloverdale/Hopland/Pinoleville Rancheria
miniature basket, 1952 (1953.1.10)

Evelyn Lake Potter
(c.1908–1952)
lived in Pinoleville
Elsie's Father's relative, Annie Lake's daughter
canoe-shaped bowl, c. 1920 (1942.14.1929)

(Abel-Vidor et. al, 1996)

last students. Field also collected a basket from Clara Williams at Ukiah. Together, these baskets represent weavers from Cloverdale, Ukiah, and Hopland, a blend of central and northern Pomo rancherias.

Other weavers not related to or associated with Elsie Allen who were also active contemporaries are listed in table 6. Field collected several baskets from weavers around Upper Lake—three from Lydia Faught; one from her mother, Emma Bateman Anderson; one from Annie Dick Boone; one from Lydia Sleeper, all of Upper Lake Rancheria; Mary John from Lakeport (probably Upper Lake Rancheria); and Mabel McKay from Clear Lake Oaks. Field recorded McKay as a Wintun weaver, based on her residence and steprelatives; however, she considered herself to be a Pomo weaver, because her parents were Pomo and she was born at Lucerne (Mabel McKay, personal communication, 1983). No location or other information is provided for the baskets collected from "Old Grant."

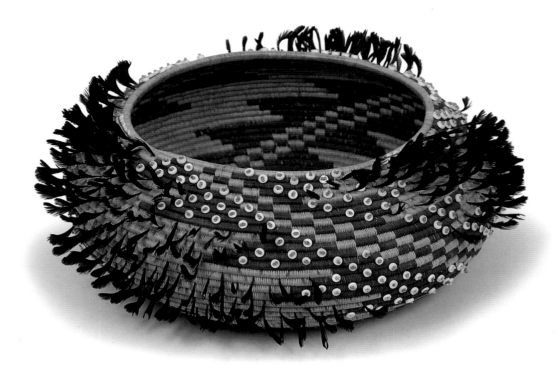

Table 6. Pomo basketmakers in the Clark Field Collection who are
contemporary with Elsie Allen

basketmaker	year made	basket no.	form/function
Emma Bateman Anderson	c. 1920	1948.27.12	feathered bowl
Lydia Anderson Faught	c. 1920s	1942.14.1904	feathered bowl
	c. 1920s	1942.14.1900	feathered bowl
	c. 1944	1949.25.13	feathered bowl
Annie Dick Boone[1]	c. 1930	1942.14.1899	beaded bowl
Lydia Grace Thompson Sleeper	c. 1937	1947.57.68	large bowl
Mary John	c. 1940	1942.14.1928	feathered bowl
Mabel [Mrs. Charlie] McKay[2]	c. 1952	1952.1.13	bowl
Clara Williams	c. 1944	1942.14.1895	cradle
	c. 1945	1942.14.1897	burden basket
Old Grant	c. 1937	1947.57.60	large bowl

[1]Annie Dick Boone is the daughter of William Dick and Laura Burris from Big Valley
Rancheria. She learned basketmaking from three of the finest Lake County weavers—her
mother, her paternal grandmother, Sally, and her aunt Rosa Smith.

[2]Mabel McKay is the stepaunt of Myrtel McKay Chavez.

The Pomo baskets in the Clark Field Collection present a well-rounded example of
the kinds of baskets being made for sale in the twentieth century, and hints of the bas-
ketry made in the previous century. The collection is especially strong in the small feath-
ered gift baskets and miniatures made throughout the twentieth century. The oldest
Pomo basket in the collection, a feathered bowl (1948.39.37) made in 1877, depicts
the traditional use of feathers on fancy or gift baskets (plate 26). The feathers fill the
undecorated area, and shell disk beads are applied atop the design area.

Sally McLendon (1998) observed that Pomo women born at the end of the Span-
ish/Mexican era and the beginning of the American era in California (1830s–1850s)
specialized in making large, functional twined baskets or they made twined as well as
coiled art baskets. Their daughters, born in the 1860s and 1870s, made large coiled art

PLATE 26 : Pomo feather bas-
ket, c. 1877 : Basket weavers
of central California have a
long tradition of decorating
their baskets with feather
inclusions. This basket
(1948.39.37) includes feath-
ers from the native Californ-
ian redheaded woodpecker
(*Melanerpes
erythrocephalus*), inter-
spersed with topknots from
the California quail (*Cal-
lipepla californica*), as well
as clam disk beads. As feath-
ers of introduced bird
species became more preva-
lent and easier to obtain,
feathered baskets evolved to
the fancy "sun baskets" seen
in plate 21.

CALIFORNIA

baskets. Their granddaughters and great-granddaughters, born after the 1880s, made small, exquisite coiled art baskets. This remains the pattern today. Only a few weavers make the large, close-twined forms; most prefer the small coiled art baskets, miniatures, or open-twined forms.

The southeastern end of the Central Valley was a vast grassland with large oak woodlands along all the major rivers draining the Sierra Nevadas. Deer and elk abounded, and it was the migratory pathway for ducks and geese that passed through twice a year. It was also an area of active commerce, lying between the desert to the east and the coastal resources of the Chumash to the west. Given the rich resource base, tribelets in this area, particularly on the valley floor, numbered in the thousands.

Field collected baskets from the Miwok (four), Mono (eight), Yokuts (six), and Tubatulabal (two). Of these tribes, the Yokuts were the first to be affected by European-American intrusions, first by Spanish exploring expeditions (Pedro Fages in 1772 and Francisco Garcés in 1776), then forays by missions searching for additional recruits or runaways and, most disastrously, by the Hudson Bay fur trappers in 1833, with a consequent malarial epidemic that decimated many of the large Yokuts villages along the San Joaquin River. The tribes in the foothills and upper elevations of the Sierras, the Mono (Mono Monache) and Sierra Miwok, were most affected by the intrusions of settlers and the gold rush in the 1840s and 1850s. The Tubatulabal were located south of the Mono and east of the Yokuts in the Kern River area. They too were most affected during the 1850s by incursions of settlers grabbing their land. After a series of conflicts, many joined Yokuts living on the Tule River Reservation or remained scattered throughout the Kern River area and eastward into Owens Valley.

Coiled baskets from the northwestern and southeastern areas of the central California region can be distinguished by the different techniques used. Northwestern groups use rod (stick) foundations and coil leftward; southern groups often use a grass bundle or a bundle-rod combination and coil to the right, as do the tribes in the southern region.

Yokuts used different materials for coiling and twining. For coiling, the weft was most often sedge (*Cladium sp.*) sewn over bundles of bunchgrass (*Epicampus rigens*) with designs in split redbud shoots (*Cercis occidentalis*) and died bracken-fern rhizome (*Pteridium aquilinum*). These latter two materials were obtained in trade from basketmakers who lived in the foothills in exchange for sedge from the valley floor. Twined, or wickerwork was made of warps and wefts from cottonwood shoots and black willow, with redbud decorative elements (Latta, 1977). In the upper elevations of the Sierras, the Miwok used locally available and traded materials: wefts of split willow (*Salix sp.*), maple shoots (*Acer macrophyllum*), and occasionally sedge rhizomes or pine branchlets (*Pinus sabiniana*) for coiled baskets and oak shoots *(Quercus kelloggii*) and buckbrush (*Ceanothus cuneatus*) for twined baskets; foundations of peeled willow shoots, buckbrush, sourberry (*Rhus trilobata*), and bunchgrass (*Muehlenbergia rigens*) for coiled baskets and dogwood (*Cornus californica*), willow, or redbud for twined baskets; decorative elements of bracken fern and split redbud (Bates and Lee, 1990).

Four coiled bowls of sedge represent the Miwok in the Clark Field Collection. Field purchased two of them in 1949 from the Southwest Museum; only one can be traced through its records. It is a three-rod coiled mush bowl (1942.14.2110) given to the Southwest Museum by George Wharton James and said to have come from Tulare County. James dealt in California baskets from the 1890s until his death in 1923. No data could be found on the other Southwest Museum basket (1942.14.2111), a medium-size mush bowl with flared sides, flat bottom, and a traditional herringbone finish on the rim. It is coiled on a grass-bundle foundation. Several inches below the rim is a classic horizontal pattern of alternating trapezoids in bracken fern, coiled on a sedge body and grass foundation. The third Miwok basket (1942.14.1937) is a rectangular bowl obtained by Field in 1946 from the Upper San Joaquin River area. It too has a horizontal band of alternating triangles of redbud on a sedge weft and grass-bundle founda-

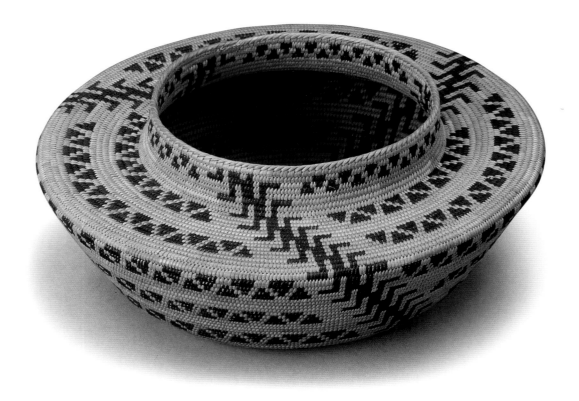

tion. The final Miwok basket (1948.39.12) has a bracken-fern design zigzagging around the walls of the bowl. Miwok basketry had a ready market throughout the twentieth century in the tourist trade at Yosemite National Park. Many local weavers, as well as Mono Lake Paiute weavers from the east side of the Sierras and Chukchansi Yokuts downslope from Yosemite, sold their baskets at the park (Bates and Lee, 1993).

Eight Mono baskets were purchased by Field. The oldest, dating to about 1900, is a bottleneck basket he purchased from the Gottschall Collection. The other seven baskets he acquired from the western Mono, sometimes referred to as Monache. A large bowl (1949.25.9), said by Field to be a "burial basket," is more appropriately called a "washing" basket. These were used at the death rites to wash the clothes of the deceased (Polanich, 1994). Provenance is recorded for three baskets. A coiled bowl (1947.57.62) belonged to Luis and Nellie Dick, who were both born in Auberry, California, a Mono town in the Sierra foothills. This basket was obtained from Bacone College in 1937. Two newly made twined trays were probably bought by Field himself at North Fork in 1943. One is a winnowing tray made in 1943 by Lean Knisma (1948.39.397), and the other is a seed-parching tray made in about 1943 by May Beecher (1948.39.398). North Fork continues to be a center of Mono weaving, with a tribal museum and an annual pow-wow in August at which basketmakers often bring material for sale to other weavers.

Seven baskets in the Clark Field Collection represent Yokuts basketmaking. Field purchased a fine example of a large coiled gambling tray from Mrs. Francis L. Zollinger in 1938, but it probably dates to the turn of the century (1948.39.130). This basket was made specifically for playing the women's gambling game. Dice were made of black-walnut shell halves in which different numbers of abalone chips were embedded in asphaltum. The dice were tossed on the basket tray and scores were tallied. A coiled

PLATE 27 : Yokuts bottleneck jar, c. 1959 : Made of coiled sedge on a grass foundation, this bottleneck basket is decorated with bands of small dark triangles, representing a variation on the rattlesnake motif, broken by three diagonal rows of the quail feather design. These fancy baskets were made to hold personal valuables. This form and design appealed to the European-American market (1959.7.1).

Yokuts bowl with human forms and crosses (1942.14.1980), from the San Joaquin Valley, was purchased in 1947 by Field. Beautiful coiled bottleneck baskets were purchased from the Gottschall Collection in 1951 (1951.18.49), and another jar (1959.7.1) from an unknown source is illustrated in plate 27.

Field recorded the name of only one Yokuts basketmaker, Nancy Rogers, a Chuckchansi Yokuts, who made baskets which Field purchased in 1946 in Yosemite Valley. One is a twined cradle (1942.14.1944), made in 1938, and the other is a twined mush pot (1942.14.1945).

The two Tubatulabal baskets in the collection are beautiful tricolor bowls purchased in 1937. The Tubatulabal live between the Central Valley and the desert areas to the east, and their basketry materials come from both areas. One large bowl (1948.27.30) was made in about 1900 by Mary Ann Brazzanovitch, who resided in Bridgeport, on the eastern side of the Sierras. However, the basket materials are Central Valley and foothill materials—sedge weft with redbud and bracken fern design. This basket was exhibited at the 1935 San Diego Fair. The other large bowl (1948.27.80) was purchased in 1937 from the Fred Harvey Company in Albuquerque and was said to have been fifty years old at that time. It is made of willow weft with martynia and yucca-root designs, materials characteristic of the desert areas east of the Sierras.

Southern California

Prior to contact with European-Americans, the indigenous peoples of the southern region lived in island and coastal villages that relied heavily on marine and estuarine resources; mountain villages where they gathered acorns in the fall and supplemented them with other native seeds and kernels; or eastward, in desert villages where processed agave and mesquite were the major sources of storable carbohydrates. Many southern California peoples followed a seasonal round of gathering plant foods. Their travels brought them close to the other areas and they also traded extensively with their neighbors. By A.D. 1500, many of the peoples in southern California were using and making ceramic vessels. As a result, some basket forms, especially the large acorn cooking basket, were replaced by ceramic cooking pots.

The basket-weaving techniques of the southern region are similar to those of the southern San Joaquin Valley; however, the materials used are quite different and reflect the different environment south of the Transverse Range. Coiled baskets of the Chumash, Gabrieleño, Serrano, Cahuilla, Cupeño, Luiseño, and Kumeyaay (formerly referred to as Diegueño) share the traits of a grass-bundle foundation, sometimes in combination with a rod, with juncus and sumac sewing materials. Designs are created in sumac and dyed juncus and occasionally with yucca root in the interior desert. Baskets of other tribes in this region, the Kitanemuk and Tatavium, are less well documented. With the exception of the Chumash, the basketry of the southernmost tribes is often lumped together as "Mission" because of the apparent homogeneity of the basketry tradition in southern California. It is unclear whether this "homogeneity" is a result of the enforced coresidence of tribes in the Spanish mission system, the similarity of materials, or lack of detailed study. Nevertheless, many collections of California baskets blur the tribal identity of southern California baskets with this nomenclature.

Field collected no Chumash baskets. This is not totally surprising, because they are quite rare and the most valued of all California basketry. Few Chumash baskets have been made since the turn of the twentieth century. The Clark Field Collection contains twelve Cahuilla baskets, one Cupeño, two Luiseño, four Kumeyaay, and eight Mission baskets. Many of Field's southern California baskets were purchased from R.B. Cregar in Palm Springs (three baskets) or from the Gottschall Collection in 1951 (four baskets). Six of the seven oldest baskets in the collection, dating to the 1850s, are from the southern region. The names of only four southern-region basketmakers were recorded, and all but one were Cahuilla (table 7).

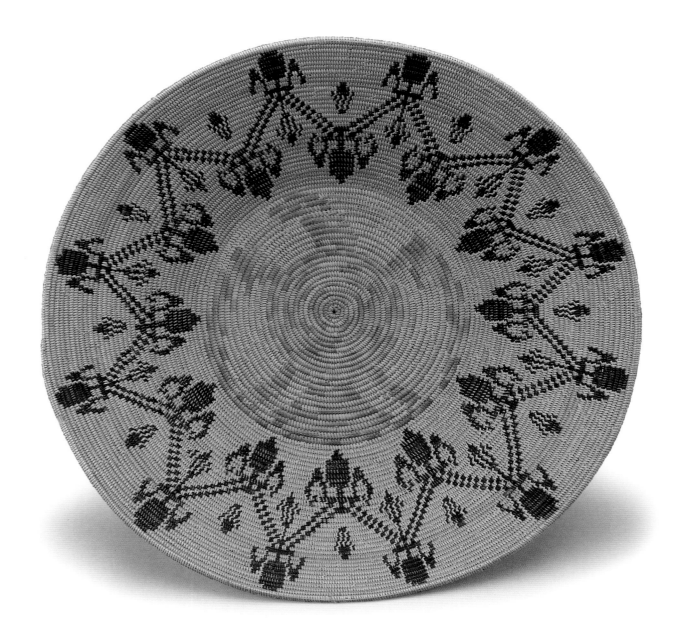

basketmaker	year made	basket no.	form/function
Cahuilla			
Susan Arguello [Argreayo C.F.]	c. 1900	1948.39.138	large bowl
Dolores Patencio	c. 1943	1948.39.405	tray
Casilda Welmas [Mrs. Welmas C.F.]	c. 1936	948.27.52	large bowl
Kumeyaay			
Mary Osuna	c. 1939	1948.39.150	gathering jar
	c. 1952	1953.1.14	clothes basket

The Cahuilla baskets in the collection are six bowls, four trays, one sieve, and one lidded jar. Only one has a specific provenance; Field recorded Susan "Argreayo" as the maker of a beautifully woven bowl (1948.39.138). The surname is likely to be a corrupted version of Arguello. The body of this coiled bowl is made of sumac with four ver-

PLATE 28 : Cahuilla bowl, c. 1850 : This finely woven large bowl is made from sumac with an undyed juncus base. The intricate design of alternating zigzag flowers repeating in a horizontal band is made with dyed juncus (1954.15.16).

tical corn motifs of dyed and undyed juncus bounded by a dyed juncus horizontal band several inches below the rim of the basket. The fag ends (the end of the weaving strand) are tucked on the interior of the basket and trimmed on the exterior, and the rim is self-coiled. These traits of basket weaving are typical of early southern California baskets. Mack (1990) has noted that many of the earliest basket bodies are woven primarily in sumac, which serves as a background for dyed juncus designs. Sumac is a stronger material than juncus but is more difficult to obtain and to prepare. By the early 1900s, as baskets changed from home use to those made for sale, juncus commonly replaced sumac as the material of choice for the body of baskets. Three other Cahuilla baskets date from the 1850s. One is a medium bowl (1942.14.1979) made of sumac decorated with four vertical lines of stacked chevrons in dyed juncus and human figures constructed of undyed juncus. The second basket (1954.15.16) is also a bowl (plate 28). The third basket (1950.17.15 a,b) is a lidded jar in the form of a medium bowl with slightly incurving sides and loop handles and a flat, handled lid. Designs consist of dyed juncus butterfly and dog motifs on an undyed juncus body. Fag ends are trimmed on both surfaces of the bowl and lid.

Another basket (1948.27.52), with a sumac body, is a large coiled bowl woven by Mrs. Welmas, probably Casilda Welmas, a Cahuilla or Cupeño woman who lived at the Cupeño/Luiseño town of Pala (a former mission outpost). Although this basket was woven for sale in 1935–1936, it is a testament to the skills of the maker. It won first prize at the 1936 Gallup Inter-tribal Ceremonial and was sold to Field by R.B. Cregar of Palm Springs. Flower and diamond designs in dyed juncus are distributed on the sumac body. Fag ends are tucked on both faces of the basket.

An oval bowl (1948.27.53), with a flat bottom and slightly incurving sides, has a canoe-basket start made of sumac. The remainder of the basket body is undyed juncus, with four equally spaced swastikas in dyed juncus outlined in sumac. Fag ends are trimmed on both faces. Although this basket was made in 1936, it is unlikely that the design referred to Nazi Germany. The swastika design is native to many tribes in North America and often represents the whirlwind. There is also a small trinket bowl (1948.39.17) woven entirely of undyed juncus, as was the custom prior to the influence of European-American designs. These small bowls were used to store personal belongings.

The acorn sieve (1948.39.42) is an open-twined bowl that could be used for multiple purposes such as collecting, straining, or drying food. Undecorated utilitarian forms such as this basket are often overlooked by most collectors, yet they played a very important part in the overall container assemblage of native California.

The four Cahuilla trays are very distinct. One (1948.39.147) is a coiled, undecorated sumac tray in the traditional form, used for winnowing grains and toasting grasshoppers. Another (1948.39.146) is coiled of sumac with a single horizontal band of frets in dyed juncus. The third (1948.39.405) is also made primarily of sumac. Four vertical dyed and undyed juncus patterns are spaced evenly around the basket and enclosed with a framing horizontal line at the top and bottom. This winnowing tray was made by Dolores Patencio and purchased by Field at Palm Springs in 1943, the year in which Dolores Patencio's husband, Francisco Patencio, the headman of the Agua Caliente Band of Cahuilla at Palm Springs, published his autobiography (Patencio, 1943). The fourth tray (1948.27.55) is coiled in sumac with fag ends of the weaving strands tucked on the interior and trimmed on the exterior. The design consists of a dyed juncus rattlesnake circling the interior and about to consume two rabbits. According to Guy (1976:70), the first rattlesnake design in a southern California basket was woven by Maria Antonia in 1896 at the Mesa Grande Reservation in Santa Ysabel. Prior to that, it was considered bad luck to use the symbol, but soon the rattlesnake became a much sought-after basketry design which obviously spread to the other southern California tribes.

One basket (1950.17.14) purchased by Field in 1950 is identified as Cupeño, a tribe closely related to the Cahuilla. No additional provenance information was provided by

Field, although he noted that the form was rare by 1950. This basket form is also called a *guarita*, which is Spanish for little gourd. This basket is woven of undyed juncus. Arrowhead designs are pendent from the rim and outlined in sumac and dyed juncus; floral design elements are evenly spaced around the base of the bowl. Fag ends are trimmed on both faces of the basket.

The two Luiseño baskets in the collection are a bowl and a tray. The bowl (1942.14.2081) was collected from Pala by Mary Jamison at about the turn of the century and sold to Clark Field in 1948. It has a sumac body and undyed juncus designs. In fact, it appears that the base and beginning walls of the basket were woven with one design in mind, then changed for the remainder of the basket. Clark Field recorded it as being Luiseño; however, the weaving materials (sumac body) and techniques (fag ends tucked under on both work faces) suggest that it might be Gabrieleño or Cahuilla. The food tray (1942.14.1978) was purchased in 1947 and reputed to have been made in about 1850 near San Luis Rey, the site of the Luiseño mission. It has an undyed juncus body with four radiating vertical stepped designs whirling outward from the base of the basket. These are woven in dyed juncus. The final coil at the rim has tick marks of approximately four stitches of dyed juncus in four areas along the rim.

Four baskets have been identified as Kumeyaay (Diegueño), two of which were made by Mary Osuna, or Asuna. The first is a jar (1948.39.150) purchased in 1939 from Mary Osuna, whom Field reported to be Cahuilla. The second (1953.1.14) is a large "clothes basket" made in 1952 by Mary Osuna of Santa Ysabel. It is unclear whether these names refer to the same woman, although both baskets are similarly made of the same materials and have eagles incorporated into their designs. It may well be that the maker of these baskets was the woman photographed while demonstrating how to leach acorns on a bedrock mortar outcrop at Warner's Hot Springs. She is posing in front of an array of her baskets and one pot. Judging from her dress, the photos date to about the 1930s. These photos cite "Mrs. Ossuna" as being Cupeño, probably because Warner's Hot Springs was originally in Cupeño territory (Ken Hedges, personal communication, May 2000). Because artists who make baskets frequently make pottery, it is

PLATE 29 : Large Kumeyaay clothes basket, c. 1952 : This large basket was woven by Mary Osuna to be used as a clothes basket and was probably made for sale (1953.1.14).

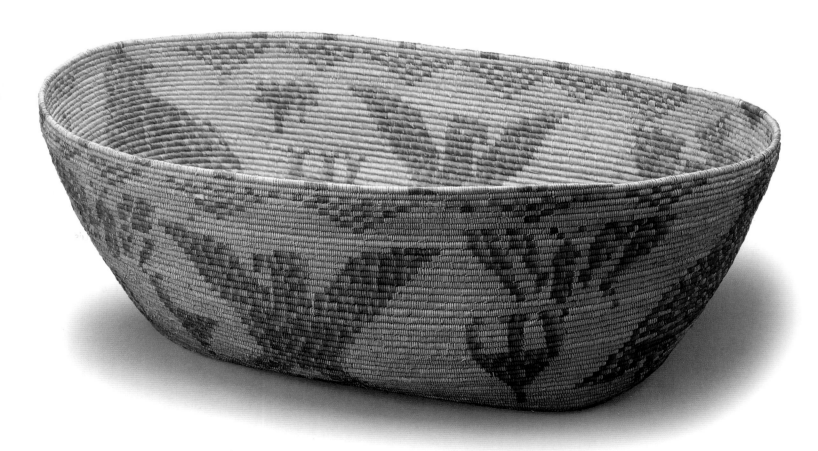

quite possible that the maker of this jar also made Clark Field's baskets. A large pottery jar was made in the mid-1930s by Mrs. Jse [Jose?] Osuna, who had been born in 1876 at the Santa Ysabel Rancheria (Hartman, 2000). Another set of photos taken by E.H. Davis in about 1935 shows "Mrs. Osuna" teaching Susana La Chusa, Christine La Chappa, and Martha Osuna how to make pots (Davis, 1935).

Mary Osuna's jar (1948.39.150) is not a traditional southern California basket form, although it resembles the shape of ceramic vessels made by the Kumeyaay. The form of this basket may also have been influenced by the popularity of southwestern jar baskets among collectors. This basket has a sumac weft with undyed juncus designs of leaves and four eagles interspersed among three large petals that begin at the center of the base of the basket and extend up the sides to intersect with leaves pendent from the rim. Fag ends are tucked on both faces of the basket. The large elliptical clothes basket (1953.1.14) has a sumac body and undyed juncus designs of eagles, butterflies, rabbits, and dogs scattered around the sides of the bowl, and a horizontal band of stepped pendent triangles just beneath the rim (plate 29). Weaving traits include a canoe start, fag ends tucked on both faces, and a self rim.

The weavers of the other two Kumeyaay baskets are unknown. Both of these baskets date from the latter half of the nineteenth century, and both are made from sumac and undyed juncus with dyed juncus design elements.

Eight baskets are identified as "Mission" baskets, a term used to designate the general area of southern California affected by the Spanish missions of San Diego, San Luis Rey, San Juan Capistrano, San Gabriel, and San Fernando. Many of the names applied by the Spanish to the tribes in southern California are direct adaptations of the mission names: Diegueño, Luiseño, Juaneño, Cupeño, and Gabrieleño. The Cahuilla are also considered to be a "Mission" tribe. The term was used widely during the nineteenth century and is a catchall signifying the similarities in the material cultures of this area.

One of the gems of the Clark Field Collection is a mid-nineteenth century burden basket (1942.14.1981) (plate 30). It is undecorated and made entirely of undyed jun-

cus with fag ends tucked on the interior and trimmed on the exterior surface. Travis Hudson (1980) suggested that this might be attributable to Gabrieleño, based on examination of a photograph, but he also noted that similar examples were known among the Luiseño as well. Whatever its origin, this is a superb example of a well-made functional basket whose beauty lies in its classic lines and the natural color variations of the juncus. This piece contrasts sharply with the cup and saucer (1942.14.1744 a,b) a nonfunctional, whimsical piece. It is a classic example of traditional basket materials and weaving techniques used to produce basketry for the European-American tourist of the 1920s and 1930s.

The six remaining mission baskets were also made for the European-American market with intricate uses of multiple nontraditional design elements. Four mission baskets were obtained from the Gottschall Collection in 1951 and two others were purchased in 1950. The Gottschall baskets include two oval bowls, one small bowl, and one rectangular tray. One basket (1951.18.43) is decorated with a whimsical scene of a coyote and birds, woven in juncus, encircling the sides of the sumac body. The other oval bowl (1951.18.47) also has a sense of whimsy, or perhaps it too is a tale of animal foes. It is also woven of sumac, but it has prancing horses and wolves, woven in dyed juncus, around the sides and undyed juncus on the base. The designs and weaving techniques suggest that these two bowls were from the same maker. The small bowl (1951.18.45) is decorated with a row of pronghorn sheep in undyed juncus. The fourth basket is a rectangular tray (plate 31). The two baskets purchased by Field from an unknown source are a tray and a bowl. The tray (1950.17.13) has a juncus body with vertical lightning designs in dyed juncus and sumac which extend downward from a horizontal band of dyed juncus and sumac clouds that circle the basket about an inch below the rim. The bowl (1950.17.11) is a medium sized *guarita* with a sumac base and sides of undyed juncus. It is decorated with stepped designs in sumac that reach from just above the beginning of the side walls up to the final row of the rim

These Mission baskets, like so much of Clark Field's collection, provide us with a

PLATE 31 : Mission basket, c. 1910 : This basket was purchased by Clark Field from the Gottschall Collection in 1951. Amos H. Gottschall, born in Pennsylvania in 1854, collected Native American materials including arrowheads, stonework, baskets, beads, and pottery between 1871 and 1920. He first offered his collection for sale in 1938. This basket is an excellent example of baskets made specifically to suit the tastes of the European-American market, which flourished between 1900 and 1910. The fanciful designs of lizards, butterflies, and plants, possibly corn, which is not native to California, are woven of sumac and dyed juncus on an undyed juncus body. The rectangular shape is also a nontraditional form for California basketry (1951.18.44).

glimpse of the changes that were occurring during the first half of the twentieth century. Although traditional materials and weaving techniques continued to be used, many of the shapes evolved to address the need for speedy production and for forms that were acceptable to the customer. Nonnative designs were adopted and adapted to fit the medium. As materials or the ability to gather them became more and more restricted, substitutions were made. As seen with the Pomo, communities in which multiple weavers resided and interacted were better able to perpetuate the traditions despite periods of low demand for baskets. Many weavers reached out to interested weavers outside their own communities to keep the tradition alive during periods of tribal disinterest. All told, the Clark Field Collection presents a sizable example of many of the weaving traditions of the California culture area.

Today, new regional organizations are bringing together weavers from across the area and even the nation. These organizations promote craft and pride among the weavers. They provide stimulation and encouragement and seek to address specific problems such as access to materials on state and federal lands.

Baskets are still made to serve a variety of functions. Ceremonial baskets are made for use within native communities. The attention to tradition helps perpetuate cultural norms, ideals, and customs. Some basketry techniques are adapted to new forms for public consumption, and some baskets are the purest artistic expressions of weavers' talents. No matter how many new wonder materials are invented in future generations, there is something inherent in basketry that ensures that it will continue to be made for pleasure and for specific purposes, especially in an area with as rich a tradition as that of the native Californians.

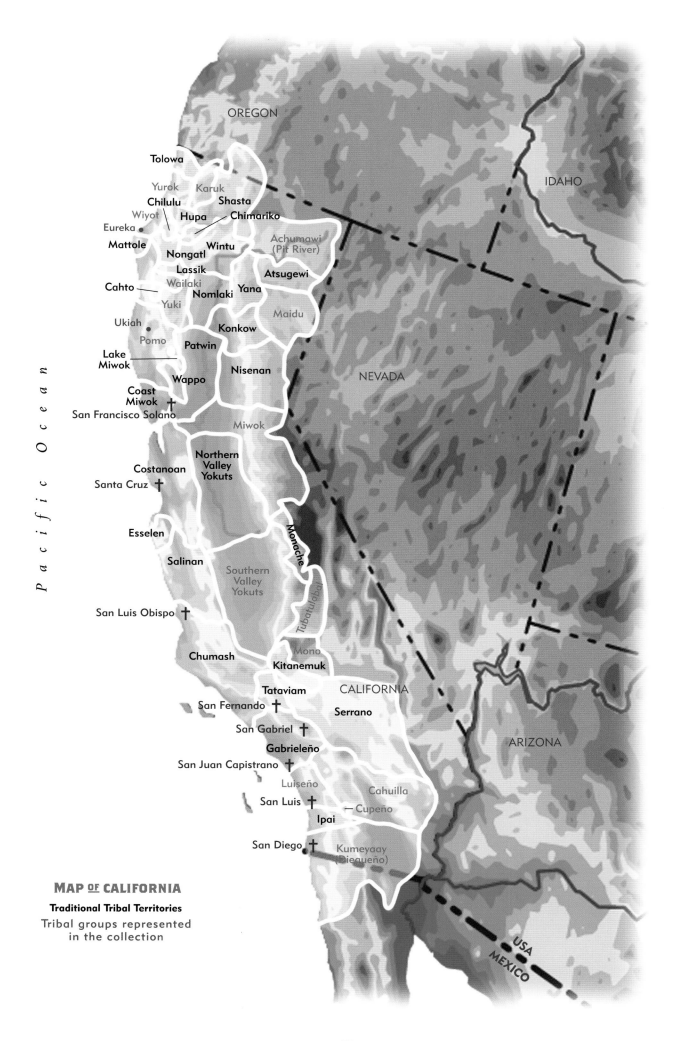

OREGON

IDAHO

Tolowa

Yurok Karuk
Chilulu Shasta
Wiyot Hupa Chimariko
Eureka
Mattole Achumawi
Nongatl Wintu (Pit River)
Lassik Atsugewi
Cahto Wailaki Yana
Nomlaki
Yuki
Konkow
Ukiah
Pomo
Patwin
Lake
Miwok
Nisenan
Wappo
Coast
Miwok ✝
San Francisco Solano
Miwok

NEVADA

Northern
Valley
Yokuts
Costanoan
Santa Cruz ✝

Esselen
Monache
Salinan
Southern
Valley
Yokuts
San Luis Obispo ✝
Tubatulabal
Chumash
Mono
Kitanemuk
CALIFORNIA
Tataviam
San Fernando ✝
Serrano
San Gabriel ✝
ARIZONA
Gabrieleño
San Juan Capistrano ✝
Luiseño Cahuilla
San Luis ✝
Cupeño
Ipai
San Diego ✝ Kumeyaay
(Diegueño)

USA
MEXICO

MAP OF CALIFORNIA

Traditional Tribal Territories
Tribal groups represented
in the collection

Pacific Ocean

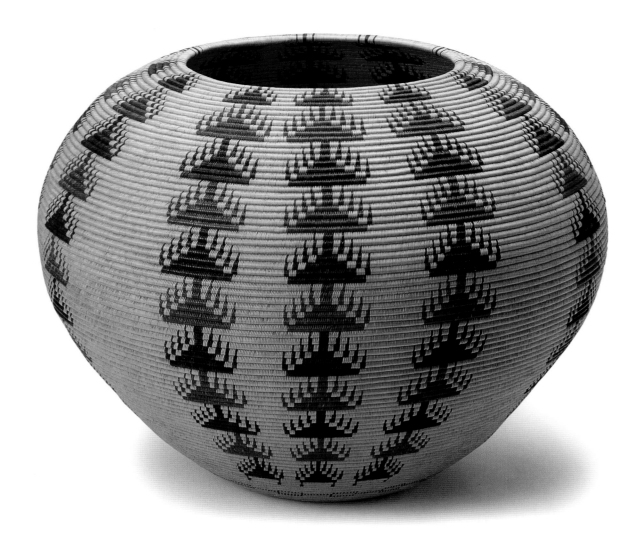

INTERMONTANE WEST

Shelby J. Tisdale

The area known as the Intermontane West encompasses two major cultural areas, the Great Basin to the south and the Plateau to the north. Bounded on the west by the Sierra Nevada and the east by the Rocky Mountains, it has innumerable ridges running roughly parallel to these great mountain walls, with pines on the lower slopes and firs on the upper slopes of the mountain ranges, and streams running downslope into catchment lakes in the flat valleys. Although there are parklike grassy meadows throughout the Intermontane West, it is cut off from the moisture-laden winds of the Pacific Ocean by the Sierra Nevadas, leaving primarily a sagebrush desert to dominate the landscape.

The Great Basin culture area, comprised of approximately 400,000 square miles, grades into the Southwest's Colorado Plateau and western deserts. It includes all of Utah and Nevada and most of western Colorado and northern Arizona and New Mexico, as well as eastern California and the southern portions of Oregon, Wyoming, and Idaho. To the north, the Plateau narrows into the more heavily forested intermontane valleys of British Columbia. The Plateau culture area is bounded by the Great Basin to the south, the Rockies to the east, the Subarctic to the north, and the Northwest Coast to the west. The region is drained by the Columbia and Fraser Rivers. It includes the

lower portion of southeastern British Columbia, eastern Washington, northern Idaho, and western Montana, and the Columbia River area between Washington and Oregon south to the Klamath Mountains in northern California. The shared climate and vegetation of these two physiographic areas facilitated communication and the diffusion of cultural patterns, making the Intermontane West one basic cultural area (Kehoe, 1992).

Basketry has long been regarded as one of the technological hallmarks of the native peoples of the Great Basin (Fowler and Dawson, 1986), and the archaeological record confirms that basketry was made and used by the native peoples of the Plateau centuries before the arrival of Europeans and Americans in the region (Conn and Schlick,1998). Basketry forms and technology were associated with specific functions such as plant processing, cooking, and water or food storage, many of which were altered and even disappeared after contact with European-Americans (plate 33). Clark Field collected 139 baskets from the Great Basin and Plateau culture areas between 1935 and 1964. The most famous basket in the collection, a *degikup* made in about 1918 by Washoe basket weaver Louisa Keyser, popularly known as Dat So La Lee, was collected by Field in 1945 (plate 32, p. 79).

For the purposes of this essay, the Great Basin and Plateau are treated separately. The Great Basin is divided into southern and northern sections and the Plateau into a northern and western section and a southeastern section. Numerous indigenous groups inhabited these areas, however, the following discussion is primarily limited to only those groups represented in the Clark Field basketry collection.

PLATE 33 : Open-twined utilitarian baskets : The open-twined winnowing- parching tray was used for netting minnows, serving or drying meat, and separating chaff from pine nuts and roasting them. Live coals from the fire were placed in the tray with the pine nuts and continually agitated to roast the nuts while preventing the basket from burning. Clark Field collected this fan-shaped Southern Paiute winnowing-parching tray (1948.39.114) in 1938 on the Moapa River Indian Reservation in southern Nevada. Large, openwork baskets were frequently used to collect pinecones or nuts. They also functioned in the transport of household items when a camp was being moved. This large, conical gathering basket made by Washoe weaver Maggie Mayo James was collected by Field in 1944 (1948.39.473).

The Great Basin

High mountains to the east and west, with intervening valleys, characterize the Great Basin culture area. The topographic complexity and environmental diversity profoundly influenced the ecology of the native peoples of the region (Harper, 1986). Alfred Kroeber (1939) noted the close relationship between natural vegetation and cultural attributes, a correspondence that has largely determined the boundaries of the inclusive Great Basin region as the culture area defined here. In addition to these environmental factors, the designation of the Great Basin as a culture area is also based on a synthesis of historic, cultural, and linguistic features characteristic of the native peoples inhabiting the area.

The first contact between the native peoples of the Great Basin and Europeans was in 1776 with the explorations of Escalante, a Spanish missionary. At the time, the Great Basin was inhabited by a number of Numic-speaking groups. Most of the languages of the Great Basin belong to the Uto-Aztecan language family, which stretches as far south as Central America with the most northerly branch being the Numic branch (Miller, 1986). The Numic-speaking groups of the Great Basin include the Ute, the Southern Paiute, the Chemehuevi on the Colorado River, and the Kawaiisu in the Mohave Desert of southernmost California in the southern section; the Shoshone throughout the heart of the basin, including the Gosiute and Panamint dialects, the Northern Paiute, Owens Valley and Mono Lake Paiute; and the Bannock in southern Idaho in the northern section. Kehoe (1992) suggests that these Numic-speaking groups were originally in southern Nevada, along the eastern valleys of the Sierra Nevada and southeastern California. They began to expand north and east in about A.D.1000 over the Great Basin, reaching the southern Plateau by A.D.1300.

The Washoe, who speak a Hokan language, are the only non-Numic-speaking group historically in the Great Basin. Although this language is related to several other groups in California, the Washoe are considered an isolate located in a relatively circumscribed area centering on Lake Tahoe at the western edge of the Great Basin culture area (Jacobsen, 1986). In addition to this linguistic evidence, Kehoe (1992) relates that

Washoe folklore implies a very long residence in their territory around Lake Tahoe; thus, they are more culturally linked to the Great Basin culture area.

Native peoples in the Great Basin were dispersed in small groups along the mountain ranges. They traveled seasonally to a series of ecological niches because single camps rarely had a sufficient quantity of food within walking distance to sustain even one family for more than a few days or weeks. Caves, rock-shelters, and temporary windbreaks usually served as shelters; however, men in some bands constructed more permanent "wickiups" (figure 16, p. 81), or conical mat-covered pole houses. These were often made with parts that could be disassembled and moved from camp to camp (Turnbaugh and Turnbaugh, 1997). To accommodate this movement around the Great Basin, the women wove light, strong basketry containers to carry their belongings, food, and babies the long distances from camp to camp.

Great Basin subsistence practices can be characterized by variety—a variety of foods and a variety of techniques of gathering and processing them (Kehoe, 1992). Women traveled away from camp to gather insects, plants, and seeds. They moved about steadily, beating seeds into carrying baskets, digging up edible roots, picking berries and cactus fruits—gathering whatever food source was ripe, as well as cutting tule, or cattail reeds, to be used for building housing structures. Men fished and hunted mule deer, antelope, jackrabbits, and other small game. Entire families worked together during the autumn harvest of piñon nuts, bending down the branches of the bushy pines, beating off the cones full of soft nuts, and then leaving the older women to clean and roast the nuts and finally grind them into a compact, storable flour. Each family group carried as many basket loads of processed nuts, seeds, and dried meat as it could manage back to camp, caching additional quantities in grass-lined pits covered with brush and stones, for retrieval at a later date (Kehoe, 1992). The women left in camp occupied themselves with weaving baskets and mats, processing food, and other useful stationary tasks as they cared for children and the elderly.

Traditional Great Basin baskets came in a variety of forms and sizes. Open-twined baskets included large conical burden baskets and winnowing-parching trays (plate 33, p. 80), seed beaters, trays, burden baskets, and cradles. Close-twined baskets included small gathering baskets, often attached at the wrist, used to scoop seeds and berries into burden baskets, and winnowing-parching trays, women's hats, and water bottles, often pointed on the bottom and covered with pine pitch. Coiled baskets included shallow circular trays, eating bowls, women's hats, and necked jars. A trait of Great Basin cultures was the basket cap worn by women to protect their heads from the tumpline supporting burden baskets carried on their backs. Both close-twining and coiling techniques were used to make these caps, which were also used for drinking or gathering seeds and berries during travels. Less common, or restricted to a limited area, are fish traps, insect baskets, and scoops (Fowler and Dawson, 1986).

The Great Basin was the last major frontier of North America to be explored and settled by European-Americans. Among the historic events to have far-reaching effects were European contact and the acquisition of horses. The Eastern Shoshone and Southern Ute obtained horses late in the seventeenth century, and by the early eighteenth century most of the Ute, the Eastern and Northern Shoshone, and the Bannock had become deeply influenced by the equestrian cultures of the Plains (D'Azevedo, 1986a). British and American trappers penetrated the northern periphery early in the nineteenth century. After 1845, an increasing number of emigrant parties began to follow the Humboldt or Overland Trail across the central Great Basin to California. Because of the remoteness and the apparent inaccessibility of much of the region, the Mormons ventured in by 1847 and chose the valley of the Great Salt Lake as a place of refuge from religious persecution. It was the Mormons who became the first European-American settlers in the Great Basin.

Two years later, gold was discovered in California and thousands of new emigrants rushed through the corridors of the Great Basin on their way to the Pacific Coast.

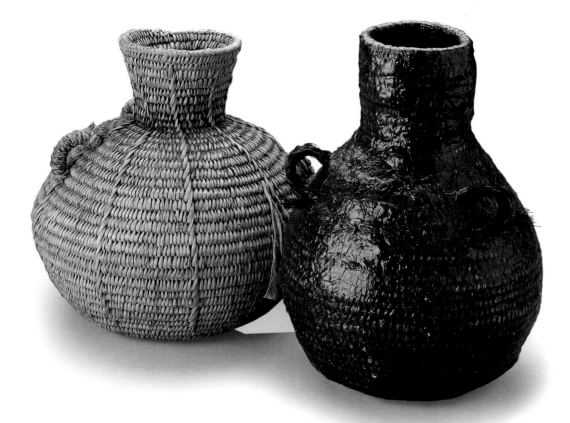

During the following decade, thousands more were attracted to the Comstock mines of western Nevada. Many of them remained to settle as ranchers and townspeople. The tide of emigration transformed the region into new territories and states with networks of American enterprise and settlement.

These new settlers drastically altered the character of the Great Basin. Livestock grazing destroyed grasslands along the rivers and springs, some timbered areas were all but denuded by the needs of the mines and towns, and large game became scarce. The conquest of the new territory was complete, but the impact on the way of life of the native peoples, who had at first cautiously welcomed the intruders and later attempted sporadic resistance, was devastating. Starvation and diseases brought by European-Americans decimated a large portion of the native population. Those who did survive were forced onto reservations that consisted of lands that the new settlers considered to be the least desirable. They were denied access to the wide range of resources that had sustained their traditional economy and society and were forced to become dependents and laborers on ranches and on the fringes of European-American communities (D'Azevedo, 1986a).

This permanent settlement of European-Americans in the Great Basin ushered in a new period of basketry development among most groups. A more settled life on reservations and the introduction of new types of tools, utensils, and metal containers led to the decline in traditional basketry types. Paralleling the decline in certain types of utility wares, however, was an increase in basket types made to trade with European-Americans. Prior to 1900, many European-American households throughout the region used Indian-made laundry baskets, sewing baskets, and small trinket baskets. Native women ordinarily traded these wares for food, clothing, or cloth and also, in many cases, for the metal utensils that were replacing their own baskets (Fowler and Dawson, 1986).

As the end of the nineteenth century approached, weavers began to make baskets to sell in the growing tourist or curio market. Prominent in this trade were the Washoe; Owens Valley, Mono Lake, and Northern Paiute; Panamint Shoshone and Chemehuevi basket weavers (Fowler and Dawson, 1986). As tourism at Lake Tahoe, Yosemite Valley, and Death Valley increased, basket weavers responded by weaving baskets that would appeal to this emerging market.

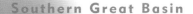

The Ute, particularly those east of the Colorado and Green Rivers, were among the first Great Basin groups to adopt the horse and were instrumental in the spread of equestrian practices from the Spanish settlements to the north. In this process, they were able to hunt buffalo on the western Plains, acquiring many new cultural elements. Nevertheless, they retained their central Great Basin cultural orientation (D'Azevedo, 1986a). Limited grazing in their homeland, however, prevented the Ute from accumulating large herds of horses (Kehoe, 1992).

Composed of about a dozen territorial bands in the early nineteenth century, the Ute inhabited most of the present state of Utah (named after them) and the Colorado Plateau, from the mountains south of the Great Salt Lake eastward to the Front Range of the Rockies. Establishment of reservations in 1861, 1863, and 1868 reduced the Utes to what the Mormon colonists considered a wasteland. In southern Colorado, the Muache and Capote bands live on the Southern Ute Reservation and the Weeminuche band lives on the Ute Mountain Reservation. In northeastern Utah, the combined Uintah-Ouray Reservation is home to eight Ute bands (Kehoe, 1992).

At the close of the war with Mexico, in 1849, the United States made a treaty with the Ute. During the second half of the nineteenth century, they were shunted about, and the lands the Ute had negotiated to retain were whittled away again and again. Between 1864 and 1899, Ute households were allotted homesteads in severalty, and more than half the reservation acreage was opened to European-American ownership. Ute living conditions did not improve until after 1950, when the United States Court of Claims judged that they had indeed been defrauded of much of their decreed territory and were entitled to compensation (Kehoe, 1992).

Ute basket types include twined conical burden baskets, berry baskets, seed beaters, conical fish traps, and cradles, and coiled cooking baskets, eating bowls, berry baskets, winnowing-parching trays, and water bottles (Fowler and Dawson, 1986).

The Ute made their baskets with sumac, willow, or cottonwood, with some devil's claw for decoration (Turnbaugh and Turnbaugh, 1997). Cooking and eating bowls and wares made for sale have geometric design elements (Fowler and Dawson, 1986). Smith (1974) reports that the northern Ute preferred to paint designs on baskets rather than weave in dyed splints. Buckskin was always used for lugs on berry and pack baskets (Turnbaugh and Turnbaugh, 1997).

PLATE 35 : Ute buckskin-covered cradle, c. 1943 : Clark Field collected this cradle (1948.39.429) in Towaoc, Colorado, on the Ute Mountain Reservation, in 1943. Such cradles were still in use at that time. The infant's maternal grandmother usually made the cradle. Female cradles were painted yellow and male cradles white.

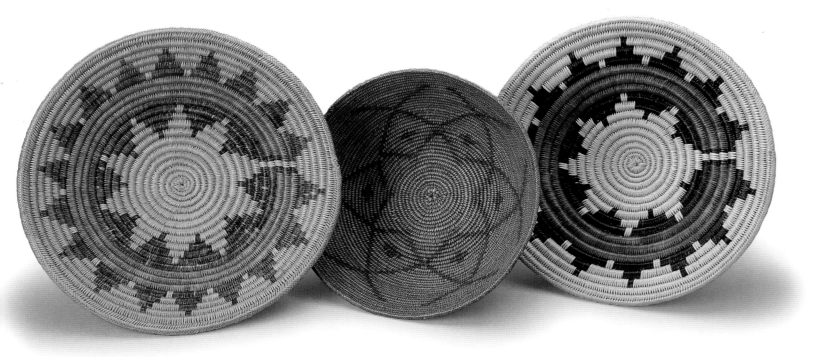

Clark Field collected seventeen Southern Ute baskets. Field collected the first one in 1937, and he identified it as a coiled Jicarilla Apache water bottle (1948.39.2). This was very early in his collecting, and there is no information as to how he acquired this basket other than the year. This water bottle appears to date from about 1900 and to have been used. Field collected another Southern Ute coiled water bottle (1948.39.305) in 1942 from Werner Helms in Towaoc, Colorado. This water bottle is heavily covered with pine pitch and shows no signs of use (plate 34, p. 83). From at least the second half of the nineteenth century, both the Northern and Southern Ute covered their cradles with heavily beaded buckskin (Fowler and Dawson, 1986:727). Clark Field collected a beautiful example of a buckskin-covered cradle made by Clardy Ute when he visited Towaoc, Colorado, in 1943 (plate 35).

When the Navajo stopped making "wedding baskets," the Southern Ute began to make this style of basket to trade with the Navajo (plate 36). Clark Field collected one Navajo-style wedding tray in 1937 that was identified as Navajo (1948.27.24). This was and still is a common mistake among collectors of "Navajo wedding baskets." What is puzzling, however, about Field's identification of this basket is a notation on his cata-logue card in which he notes, "These trays, although used by the Navajo, are made for them by the Paiute Indians of Colorado." Possibly he identified it as Navajo based on which group would be using it instead of who made it. Field collected one Navajo wed-ding-style tray (1948.39.306) from Werner Helms in Towaoc, Colorado, in 1942. Inter-estingly, he collected five similar baskets in Towaoc, on the Ute Mountain Reservation, in 1952 and identified all of them as Paiute (1953.1.1 through 1953.1.5). Another Navajo wedding-style basket made by Medra Wells (1953.1.6), collected at the same time, was correctly identified as Ute. Five miniature Navajo wedding-style baskets (1962.13.6 through 1962.13.10) were collected at Shonto, Arizona, presumably at the Shonto Trading Post, and Field identified them as Navajo. This is an easy misidentifica-tion because Shonto is on the Navajo Reservation, and the trading of baskets by both the Ute and Paiute in the Shonto area is well documented.

The Ute are closely related to the Southern Paiute and, with some Southern Paiute bands, are easily considered Ute as well as Paiute (Kehoe, 1992). The Southern Paiute bands along the Colorado River constitute a firm boundary between speakers of the Southern Numic languages and the Yuman-speaking peoples of the Southwest. The

Navajo began expanding into their territory south of the San Juan River in the nineteenth century. Although there were many influences across the river divides, including the adoption of some horticultural practices, the Southern Paiute maintained an essentially Great Basin pattern of subsistence and general culture (D'Azevedo, 1986a).

The Southern Paiute, like their Ute neighbors, were pushed onto reservations during the 1870s. The Kaibab and Shivwits Reservations, one on each side of the Utah-Arizona border, and the Chemehuevi Reservation on the California side of the Colorado River, remain today. Several Southern Paiute reservations were terminated in 1954 by the United States government, but eventually the Southern Paiute won a land-claims settlement in 1970. However, there was one complication; the San Juan Southern Paiute, the southernmost of the Paiutes, were not recognized as an Indian nation. The Southern Paiute were finally reinstated in 1980, yet it would be another decade before the San Juan Southern Paiute were officially recognized (Kehoe, 1992).

Basketry types common among the Southern Paiute included twined winnowing-parching trays, seed beaters, and basketry cradles; both twined and coiled water jugs, hats, burden baskets, and treasure baskets; and coiled circular parching trays, cooking baskets, and eating bowls. In some areas, the wrapped-stitch carrying frame, the conical twined fish trap, and the bipointed twined pitch container were also made. In historic times, several other varieties of coiled bowls, baskets, and plaques were made for sale to European-Americans or other tribal groups (Fowler and Dawson, 1986). Baskets were made using a yucca foundation with sumac, willow, and devil's claw. Like the Ute, the Southern Paiute also made Navajo wedding-style baskets. Mountain mahogany root was used in Navajo wedding-style baskets and charred or painted splints were used for the dark decorative element. Some Southern Paiute weavers covered their baskets with tiny glass beads (Turnbaugh and Turnbaugh, 1997).

Clark Field visited the Southern Paiute in southern Nevada, southern Utah, and northern Arizona at least three times (1938, 1946, and 1947) and collected ten baskets. On his first trip to Southern Paiute country, he visited the Moapa River Indian Reservation in Nevada and collected a coiled bowl and a winnowing-parching tray. He visited the Moapa River Indian Reservation again in 1947 and collected an open plain-twined baby cradle, a carrying basket made by Polly O. Viette (1942.14.2000), and a large, close twill-twined seed-gathering basket made by Mary Ann People (1942.14.1999). In 1947, Field also visited the Shivwits Reservation near Saint George, Utah, where he collected an open-coiled utility basket made by Mable Yellow Jacket (1942.14.1991) and a coiled utilitarian tray made by Tappie George (1942.14.1992), and the Kaibab Reservation, where he collected a coiled shallow bowl made by the daughter of Mamie "Squaw" (1942.14.1989) and a coiled utility basket (1942.14.1990). He purchased a single coiled shallow bowl in 1946 along the San Juan Paiute Strip in southern Arizona.

The production of baskets by the Navajo declined for a complex set of reasons (Tschopik, 1940). Before 1900, Southern Ute and San Juan Southern Paiute weavers began to make baskets for sale to Navajo Reservation traders or directly to Navajos. In order to conform to Navajo requirements for baskets used in ceremonial contexts (not just weddings), the Ute and Southern Paiute weavers produced the baskets with an interior work surface, a new design, and a new selvage treatment (false braid). In the late 1930s, Utes from Towaoc and Ignacio, Colorado; Southern Paiutes and Utes from Blanding, Utah; and Southern Paiutes from near Tuba City and Navajo Mountain, Arizona, were weaving Navajo wedding-style baskets. In the 1980s, there were some weavers in all areas, but the most active appeared to be the Southern Paiutes near Tuba City (Fowler and Dawson, 1986). These Southern Paiutes also wove other baskets of new and eclectic designs for collectors (McGreevy, 1985).

A distinctive Southern Paiute group, the Chemehuevi, are closely related to other Paiutes living in southern Nevada and southwestern Utah. They are unique among the Southern Paiute peoples because they developed a culture that was both Great Basin

Numic and riverine Yuman. They traveled great distances during their yearly hunting and gathering expeditions and continued to expand their territory both before and after European-American contact. They enjoyed periods of peaceful coexistence mixed with times of hostilities with their neighbors, the Mohave and Quechan (Yumas), along the Colorado River. They adopted many characteristics of their Mohave neighbors; however, they retained many of their own Southern Paiute characteristics (Dalrymple, 2000).

A major transformation in Chemehuevi basketry occurred as a consequence of the 1867 war between the Mohave and the Chemehuevi (Dalrymple, 2000). The Chemehuevi were defeated by the Mohave and were forced to move westward. They found refuge with the Serrano in Victorville and Twentynine Palms, and with the Cahuilla on the Morongo Reservation. Eventually, some returned to the Colorado River while others remained in these western areas (Moser, 1993). As a result of these migrations, Chemehuevi basketry was influenced by new environments, different weaving techniques, and the use of local materials.

Traditional Chemehuevi basketry consisted of open-twined seed beaters and triangular-shaped winnowing trays and coiled shallow bowls, trays, storage containers, necked jars, and caps. Coiled Chemehuevi baskets are made mostly for sale or trade and include bowls, jars, and oval shapes. Bowl forms are the most common and include both deep and shallow bowls with flat bottoms and flaring sides and globular-shaped jars with a well-defined lip flaring outward. Although Chemehuevi weavers have produced a number of larger baskets, their baskets are generally small (Dalrymple, 2000).

The materials used are willow, sumac, devil's claw, and desert willow (Turnbaugh and Turnbaugh, 1997). Some of the materials introduced by the Serrano and Cahuilla included grass for bundle foundations, sumac, and dyed juncus. Willow and devil's claw are the two principal materials used today, along with small amounts of juncus and feathers (Dalrymple, 2000).

Designs on Chemehuevi baskets are either naturalistic or geometric. Naturalistic designs include butterflies, snakes, plants, trees, lizards, birds, and insects. Geometric designs consist of a variety of diamonds, triangles, and squares in a variety of combinations. A black rim or a ticked (black-and-white) rim is characteristic of many Chemehuevi baskets. Both deep and shallow bowls frequently have a single black band encircling them, and it is between this band and the black rim that the design is placed. Clark Field collected five Chemehuevi baskets. Two were collected from R.B. Cregar in Palm Springs, California, on Field's 1937 trip. One is a small globular-shaped jar and the other a large jar made by Mary South Hill (1948.27.56) that was noted as Cregar's number 2.

Field collected two baskets by Mary Snyder, whose weaving demonstrates the influence of the Chemehuevi migrations on basketry techniques and designs (Dalrymple, 2000). Snyder was one of the Colorado River Chemehuevi who moved to Twentynine Palms, California, in the 1870s (Moser, 1993). She later lived on the Morongo Reservation and again on the Colorado River Indian Reservation. Mary Snyder is credited with having originated several designs. Christopher Moser (1993) writes that as early as 1896, she became one of the first known weavers to break with a traditional taboo and used a rattlesnake design on a basket. She also used a pattern of a rattlesnake about to attack a mouse, a design quickly adopted by other weavers west of the Colorado River. Another design Snyder is credited with having originated is a scattered insect design, which was adapted by O'odham basket weavers (plate 37, p. 88).

In addition to Mary Snyder, several Chemehuevi women were weaving during the first half of the twentieth century, and many of their works were collected by Birdie B. Brown who, along with her husband, operated a store in Parker, Arizona, for many years (Dalrymple, 2000). Clark Field collected from Birdie Brown a basket made by Mary Snyder with the stinkbug pattern (plate 37). Most of the active Chemehuevi weavers had died by the 1960s, and the art of basket weaving began to decline. This started to change in 1973 when Mary Lou Brown returned to Parker, Arizona. Much younger than the few

remaining weavers, she started to teach basket weaving to Leroy Fisher, a young, enthusiastic, and capable student. In addition to Brown and Fisher, Sugi Fisher (Leroy's sister) also began to weave baskets (Dalrymple, 2000).

The Panamint Shoshone live in and around Death Valley, California, at the southwestern edge of the Great Basin culture area. They have survived in one of the world's harshest environments. Historically, the Panamint Shoshone lived in small bands with little or no centralized social or political organization. Because their environment would not support a large population in any one area, bands were continually on the move in search of food. To accommodate this movement, they had to carry everything they owned to new campsites. Baskets were the primary containers used for carrying items as well as gathering and preparing foods, and for storage.

The Panamint Shoshone made both coiled and twined baskets typical of the Great Basin, as well as necked treasure jars that were possibly associated with cremation. The materials used included a coiled foundation of grass stems, with sumac and/or willow stitches, and for the decorative elements, bulrush root, devil's claw, yucca, and joshua-tree root. Occasionally the red shafts of flicker feathers, white crow feathers, and an occasional bead were added (Turnbaugh and Turnbaugh, 1997).

Panamint Shoshone baskets made for sale were principally fine-coiled wares with geometric designs, probably an elaborated form of precontact patterns, as well as those with pictorial images. Clark Field collected six Panamint Shoshone baskets during two trips. In 1937, Field collected a coiled bowl made by Rosie Nobles (1948.27.15) at the Gallup Inter-tribal Ceremonial in New Mexico; a coiled, necked jar (1948.27.62) from R.B. Cregar in Palm Springs, California; and a coiled bowl made by Mamie Gregory (1948.27.72). During a trip to Death Valley in 1944, Clark Field purchased two coiled bowls by Mollie Hansen (1949.4.3 and 1948.39.485) and an exquisite large bowl by Sarah Hunter (1949.4.5) made in about 1910. It is a wonderful example of the weaver's imagination (plate 38).

The Owens Valley Paiute once controlled a narrow valley that encompasses the headwaters and terminus of the Owens River and parallels the eastern slope of the southern Sierra Nevadas. Unlike other Great Basin groups, the Owens Valley Paiute lived in hamlet-sized communities on a semipermanent basis. These were "transitory and unstructured settlements temporarily occupied from year to year by the same fami-

PLATE 37 : Chemehuevi shallow bowls : Designs are considered the property of the weaver who created them and are not used by other weavers unless permission in granted. This practice has made it easy to identify a basket with its maker (Dalrymple, 2000). Two Chemehuevi shallow bowls by Mary Snyder are shown, one with stinkbugs (1942.14.1995) and one with rattlesnakes (1942.14.2014).

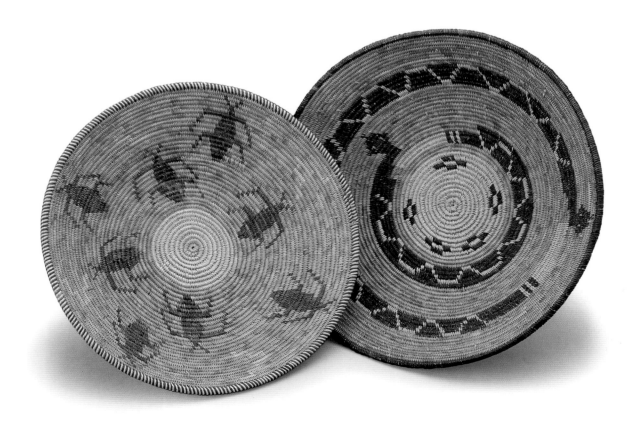

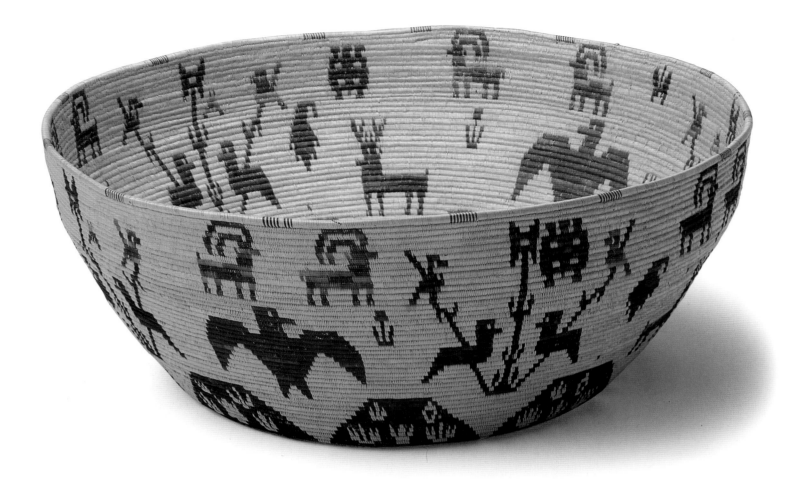

lies, loosely coordinated for social purposes: ceremonial, religious and recreational" (Liljeblad and Fowler, 1986:414). When families did move from one camping place to another, they traveled lightly. Woven baskets, twined and coiled in a rich variety of ways, made up the greater part of the property that they carried with them. The Owens Valley Paiute were influenced by their California neighbors as they intermarried and traded with the Yokuts, Miwok, and Tubatulabal, and this relationship is reflected in their basketry.

In addition to the Great Basin repertoire of basketry forms and techniques, the Owens Valley Paiute made specialized open-twined baskets for harvesting the larvae of the Pandora moth and winnowing trays for tossing basket dice. They also made coiled and necked treasure baskets similar to those of the California Yokuts and Monache (Western Mono).

Although little is known about the development of marketable styles of baskets among the Owens Valley Paiute, it is clear that from 1900 to the late 1930s, Owens Valley weavers were making a number of excellent coiled pieces. However, Clark Field collected only two utilitarian baskets—an open-twined cooking basket made by Maggie Williams (1948.39.471) and a twill-twined boiling basket (1948.39.472), both clearly made for sale.

Northern Great Basin

The Northern Paiute and Western Shoshone shared a similar desert environment and lifestyle. Northern Paiute territory is bounded on the west by the Sierra Nevada Mountains, on the east by Western Shoshone territory, and on the north by present-day southeastern Oregon and southern Idaho. The Northern Paiute lived a more settled existence than their Western Shoshone neighbors, because they occupied several lake and riverine areas with more abundant resources that permitted a greater concentration of people (Dalrymple, 2000). Several northern bands obtained the horse as early as the late 1700s and developed a lifestyle similar to that of the mounted Plains Indians. With the

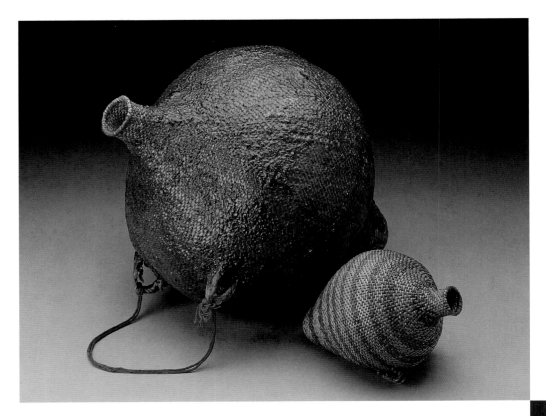

tribal groups living in proximity to one another, the impact of European-Americans affected Northern Paiute and Western Shoshone basketmaking traditions in much the same way.

Northern Paiute history is more checkered than the other Numic-speaking groups in the Great Basin. European-American impingement began with wagon trains carrying thousands of emigrants across the Great Basin on the Oregon Trail and the California Trail. Horses and cattle on the wagon trains consumed grasses and shoots the Northern Paiute would have harvested, and disrupted game habitats, causing the dislocation of the Northern Paiute from their homelands (Kehoe, 1992). Within twenty years of the discovery of gold in California and Nevada, their entire way of life was destroyed. Many Paiute and Shoshone were forced to live in makeshift structures near towns and ranches where wage labor was available. Others combined part-time work with hunting and gathering, and some attempted farming on lands given them by the government, even though they had little experience and the land was poor and without water (Dalrymple, 2000).

Several reservations were established for the Northern Paiute in the 1870s, including the Walker River Reservation, the Pyramid Lake Reservation, the Malheur Reservation (now abolished), and the Duck Valley Reservation, later enlarged to include the Shoshone. Reservations set aside for the Western Shoshone include the Grosiute Reservation (1914), the Duckwater Reservation (1940), and the South Fork Reservation (1941). Many bands from both tribal groups chose to remain in areas they considered home rather than move to reservations. As a result, several smaller reservations and many colonies were established throughout eastern California, Nevada, Utah, southern Idaho, and southeastern Oregon. Battle Mountain, Elko, Wells, Ely, Austin, Reno, Tonapah, and Fallon are but a few of the towns in Nevada that have an Indian colony or reservation nearby, and each locality has a different history (Dalrymple, 2000).

Both the Northern Paiute and Western Shoshone made a variety of different utilitarian baskets before the arrival of European-Americans. These baskets were predominantly twined, although coiled pieces had been produced in the area for thousands of years.

PLATE 39 : Northern Paiute bottles : Water bottles had pointed bases and narrow necks. Loops were added at the shoulder line for attaching a carrying strap. They were often covered with a mixture of red ochre, crushed vegetable material, and pine pitch. The bottoms were often covered with leather or canvas. Northern Paiute water bottles were made in three sizes. Small bottles were for individual use as canteens, medium for carrying water to different localities to be used temporarily by a few people, and large for use at the base camp. Medium and large bottles were bipointed and kept the water from spilling when they rested sideways. Small bottles had a rounded, occasionally indented or flattened, base. Medium-size bottles were of either shape. Small unpitched bottles were used for seed storage (Fowler and Dawson,1986). Left:1948.27.60, right: 1952.22.8

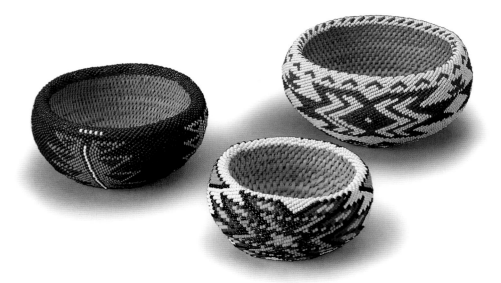

With few exceptions, both groups made twined baskets similar to those found throughout the West and Southwest, including conical burden baskets of various sizes, cooking baskets, eating bowls, seed beaters (also used as sieves), water bottles, and cradles (Dalrymple, 2000; Fowler and Dawson, 1986). Water containers, made with pointed or rounded bases and narrow necks, were waterproofed with pitch (sap) from the piñon pine (plate 39). The predominant material used for both Northern Paiute and Western Shoshone coiled baskets is willow. The Northern Paiute use bracken fern and redbud for their designs on coiled baskets, and the Western Shoshone use both aniline and vegetal dyes (Dalrymple, 2000).

Traditional Western Shoshone basketry seems to be quite variable in technique and function. It included twined conical burden baskets, gathering baskets, and winnowing-parching trays, which also served as gambling trays in the Reese River area (Dalrymple 2000), as well as twined boiling baskets, hats, water bottles, and cradles. Coiled wares include food bowls and boiling baskets from around Beatty, Nevada (Fowler and Dawson, 1986). The only Western Shoshone basket in the Field collection is a baby carrier, or cradle (1964.24.7), made by Marie Tala Hash in 1964.

By the 1880s, the transitional period from precontact utilitarian basketry types, many of them no longer needed, to baskets made for sale to nonnatives was probably under way. Northern Paiute men and women began to work long hours for European- Americans as laborers, ranch hands, domestics, and cooks. It was probably during this time that "Indian women began duplicating worn-out wicker baskets used in frontier households with materials and techniques they were familiar with. In so doing a demand for their work was created and an additional source of income established" (Dalrymple, 2000:34).

Clark Field collected twenty-three Northern Paiute baskets between 1935 and 1962. The first Great Basin basket he collected (1947.57.47) was in the Yosemite Valley of California. On his trip through the Southwest and California in 1937, Field purchased a small beaded bowl at the Gallup Inter-tribal Ceremonial and a coiled jar from R.B. Cregar in Palm Springs. In 1943, he visited the Walker River Reservation and collected a baby carrier made by Maud Allen (1948.39.395) and a pointed-bottom water bottle made by Lorena Thomas (1948.39.406). He visited the Walker River Reservation again in 1946 and 1952 and collected a large carrying basket; a twined seed jar with loops, illustrated in plate 39 (see p. 90); and a twined seed-gathering basket with a handle. In 1944, Field collected a doll cradle made by Ella Patega (1948.39.482) in the Pyramid Lake area.

A new focus of craftsmanship was beadwork items (Dalrymple 2000). By the late 1920s, baskets covered with a thread-sewn net of beads (plate 40, p. 89) were being

produced by Northern Paiute, Washoe, and Western Shoshone weavers in significant numbers (Fowler and Dawson, 1986). The Northern Paiute probably learned the art of beadwork from their neighbors to the north on the Columbia River Plateau (Bates and Lee, 1990). On his last visit to the Great Basin, in 1962, Field went to Carson City, Nevada, where he collected six small coiled and beaded bowls (1962.13.11 through 1962.13.16). He identified these as Washoe; however, based on the designs and colors, they appear to be Northern Paiute. Because we do not know the names of the weavers, this is purely a judgment call, because both the Northern Paiute and the Washoe were making and selling beaded baskets. The remaining seven Northern Paiute baskets Field collected were purchased at different times during the twenty-seven-year period.

Today, there are few active weavers among the Northern Paiute and Western Shoshone. They produce mostly small, single-rod baskets that are either beaded or plain. Although there are some weavers who make twined conical burden baskets and winnowing and sifting trays, cradles are still produced with greater frequency because of the demand within the tribal community. Intermarriage between both groups and the Washoe has produced weavers of mixed blood who weave in the Paiute, Shoshone, or Washoe styles, which are now quite similar (Dalrymple, 2000). The number of weavers making baskets continues to decline. However, some young women are actively pursuing the craft, and they frequently integrate new designs and methods into their work while preserving the art and educating others about basketry.

Like the Western Shoshone and Northern Paiute, the Washoe did not feel the impact of European-Americans until the 1850s, when trading posts sprang up in their territory to supply gold seekers and emigrants headed for California. The discovery of the Comstock Lode on Washoe lands and the founding of Virginia City, Nevada, in 1858, had a devastating effect. The city grew rapidly as European-Americans arrived by the thousands, laying claim to Washoe lands and natural resources. It was not long before Lake Tahoe was discovered, with the resulting exploitation of its natural beauty and resources. Forced to live close to towns and ranches where work was available, the Washoe were prevented from moving to their beloved Lake Tahoe during the hot summer months.

The Washoe were never provided with a reservation of their own, but in 1917, the government supplied funds to purchase a small tract of land near Carson City, Nevada, which became the Carson City Colony. A rancher near Gardnerville donated forty acres to be held in trust for the Washoe the same year which became the Dresslerville Colony (Dalrymple, 2000:48). Finally, they purchased the 795-acre Washoe Ranch in the Carson Valley after the passage of the Indian Reorganization Act in 1935 (D'Azevedo, 1986b).

Traditional Washoe baskets were made in a variety of twined and coiled weaves (Fowler and Dawson, 1986), similar in shape and function to those of other inhabitants of the Great Basin. Willow, bracken fern, and redbud were the materials used in both twined and coiled Washoe basketry. They included parching and winnowing trays and sifting baskets for processing pine nuts and acorns, different sizes of conical carrying baskets, seed-gathering baskets, and fish traps (Dalrymple, 2000). In addition to these utilitarian forms, the Washoe made globular bowls and bowls with flaring walls (Turnbaugh and Turnbaugh, 1997).

By the 1890s, metal containers had replaced the need for utilitarian baskets in Washoe households, and the weavers began to focus their talents on making baskets for sale. Twined baskets with modified shapes and sizes continued to be produced, such as the large conical gathering basket by Maggie James (plate 33, p. 80), while coiled basketry underwent dramatic changes. Some of the finest examples of baskets made for sale were produced by Washoe weavers during the late nineteenth and early twentieth centuries (Dalrymple, 2000), and the people and events that brought about these transformations created a demand for Washoe basketry that continues to the present.

The increasing popularity of Native American baskets with collectors and tourists; the

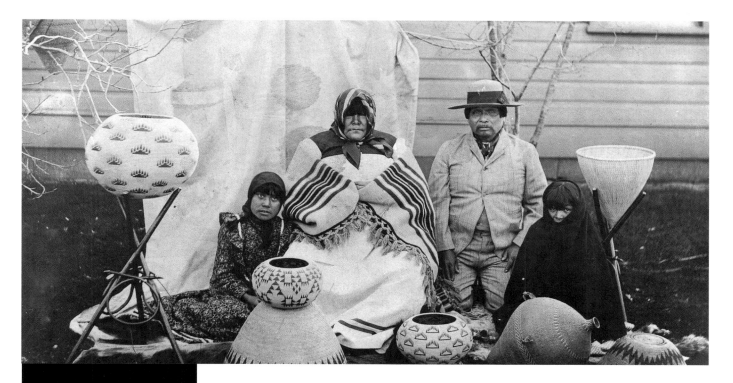

patronage and business skills of Abe and Amy Cohn; and the talented weaver Louisa Keyser, whose Washoe name was Dabduba (Young Willow), combined to create interest in Washoe basketry (figure 17). While working as a domestic for the Cohn family in the 1870s, Louisa Keyser met their son Abe, who would become the most influential person in her career as a basket weaver. Abe Cohn, who owned The Emporium Company in Carson City, bought four basketry covered whiskey flasks from Keyser, and her career was launched at age sixty as the legendary "Dat So La Lee" (Dalrymple, 2000). Cohn and his wife, Amy, created much of the information about Keyser's career, including the symbolism connected with her work and quite possibly her name. Cohn became Keyser's patron and held exclusive rights to her work from 1895 until her death, in 1925 (Cohodas, 1983).

In addition to The Emporium Company in Carson City, Nevada, the Cohns sold Indian arts and crafts in their store in Tahoe City. The Cohns purchased old baskets no longer used and encouraged weavers to make coiled baskets. This provided weavers with a constant outlet for selling their work, and the Cohns accumulated an inventory of baskets to sell to the rapidly growing number of tourists visiting Lake Tahoe. The Cohns kept records of each basket weaver and her work while actively advertising, photographing, and promoting basketry as an art. They assigned number LK–61 to the Louisa Keyser basket collected by Clark Field.

What part, if any, the Cohns played in its creation is not known, but the *degikup* replaced the traditional coiled basket, which had a flat bottom; straight, flaring sides; and predominantly horizontal designs. Louisa Keyser is thought to have introduced the use of redbud in conjunction with bracken fern for creating the designs on Washoe baskets (Dalrymple, 2000). Her success at discovering various types of designs that complement the *degikup* shape turned Keyser's craft into an art (plate 32, p. 79). Although the Cohns advertised Keyser's baskets as having a ceremonial context, her designs were created solely for their aesthetic value. She completed some of her finest work during the last ten years of her life, when she was in her eighties. Publicity about her and her baskets, often fanciful and inaccurate, as well as a careful registry of her baskets and a certificate of authenticity to the buyer, helped to promote Keyser. Through the patronage and publicity of the Cohns, she became famous while elevating basket weaving from a craft to an art.

Some of the finest examples of baskets made for sale were produced by Washoe weavers during the late nineteenth and early twentieth centuries (James,1902; Cohodas, 1976, 1979a, 1979b, 1981, 1983; Dalrymple, 2000). From 1895 to 1935, which Cohodas refers to as the period of Washoe "fancy basketry" (as well as the time of Washoe basketry florescence), several weavers rose to prominence. In addition to Louisa Keyser, other Washoe weavers were Sarah Jim Mayo, Maggie Mayo James, Tootsie Dick, Lena Dick, Scees Bryant, and Tillie Snooks (Cohodas 1976, 1979a, 1979b, 1981). All worked principally in the close-coiled technique over a three-rod foundation, producing bowl-shaped baskets, some with incurving rims (*degikup* style). Before collecting the well-known Louisa Keyser *degikup* (plate 32, p. 79), presumably from Abe Cohn's second wife, Margaret, at The Cohn Emporium in Carson City in 1945, Clark Field collected three other baskets in 1937. The last one (1948.27.33), which has an extremely fine weave, was attributed to Maggie Mayo James by Marvin Cohodas in 1982.

Washoe basketry gradually declined after 1935 with the deaths and advancing ages of these weavers (Fowler and Dawson, 1986; Dalrymple, 2000). Today, most Washoe women no longer depend on basketry as a source of supplemental income to help support their families and instead choose to weave intermittently (Dalrymple, 2000). However, renewed interest in Washoe basket weaving has developed in recent years because of the efforts of Florine Conway, Theresa Smokey Jackson, and Joanne Smokey Martinez. All three women are teaching basketry skills to younger people (Dalrymple, 2000).

Overall, basketry production in the Great Basin has been declining steadily since 1945, with the possible exception of the San Juan Southern Paiute. Periodically, classes are held for children and young adults in an attempt to stimulate interest in basketry, but very few weavers have the time to collect and prepare the materials and then weave baskets for the monetary return.

The Plateau

The Plateau contrasts markedly with the Great Basin in the importance of salmon to traditional tribal economies. Although the northernmost Great Basin groups (the Northern Paiute and Shoshone) had access to salmon runs in southeastern Oregon and Idaho and depended in part on harvesting runs of fish at Pyramid, Walker, and other intermontane lakes, the more localized closed-drainage-system fish runs farther south clearly affected the cultural patterns of the Plateau and Great Basin. Populations on the Plateau are largest downriver and decrease as one moves upriver on the main streams and into their tributaries. This decrease correlates with the overall number of salmon, in number of species of salmon (five in the lower Fraser River, for example, but only two in the upper reaches), and in nutrition as the fish exhaust themselves swimming upriver to spawn (Kehoe, 1992).

The native peoples of the Plateau were dependent on the natural environment to supply all their needs. They lived in semipermanent villages located along plentiful fishing streams and rivers, such as the Fraser, Thompson, and Columbia Rivers. Besides fish, the most important foodstuffs included roots and tubers, especially the camas, or bitterroot. Berries, other plants, and various game supplemented the fish-and-root diet (Turnbaugh and Turnbaugh, 1997). Chatters (1998:29) suggests that the Plateau "can be thought of as an ever-changing mosaic of habitats for human beings and the resources upon which they depended for food, shelter, clothing, implements, medicine and ceremony."

Historically, the Plateau was divided linguistically between two large and territorially extensive language groupings, Sahaptin to the south and Salish to the north (Kinkade et al.,1998). There are three Sahaptin language groups. The first group includes the Nez Perce, Yakima, and Klikitat, and the second group the Walla Walla, and Palouse. The

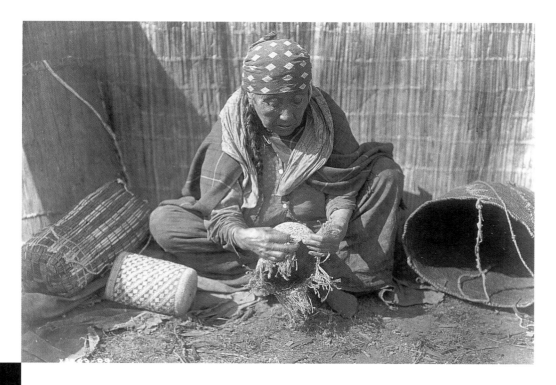

FIGURE 18 : Wishram
woman making basket,
c. 1909 : This Wishram
woman is making a twined
cylindrical "sally" bag. To the
left is a twined basket with
widely spaced wefts and a
large folded cedar container.
At her knee is a completed
sally bag and to the right is a
tightly coiled basket. Photo-
graph by Edward S. Curtis.
National Anthropological
Archives, Smithsonian Insti-
tution, 81-13439.

third group, along the middle Columbia River, includes the Umatilla. The Klamath-Modoc are Penutian-language isolates of the western Plateau, and the Cayuse is another isolate. The other major language stock, the Salish, is spoken by the Kootenai, Lillooet, and the Fraser and Thompson River groups (Kehoe, 1992). Observers have noted that the Nez Perce were frequently bilingual, not only within Plateau Penutian but with Salish, Shoshone, or Crow as well, reflecting the importance of trade.

The Wishram and Wasco, speaking Chinook, a language of the Penutian phylum distinct from Sahaptin, lived in villages on the border of the Plateau at The Dalles, which is at the end of a series of rapids and twisting channels cut by the Columbia River through the Cascade Range. Basically, the Wishram and Wasco belonged to the Plateau culture area, but because they specialized in the large-scale production of dried salmon for sale and hosted trading fairs attended by thousands, their economy was quite different from that of the more typical Plateau peoples upriver. The prominence of the Wishrams' market town led to the development of a pidgin language, Chinook Jargon, based on Chinook but with Nuu-chah-nulth (or Nootka a Wakashan language spoken on Vancouver Island), French, and English borrowings. It became the lingua franca from California to Alaska along the coast and far into the interior (Kehoe, 1992).

The Wishram and their neighbors, the Wasco on the south bank of the Columbia, netted and dried quantities of salmon sufficient to provision thousands of visitors. Plateau peoples came downriver during the summer after gathering and drying camas and roots in the spring; to fish for salmon on the Columbia; as well as to trade. As many as three thousand people would gather at Spedis (the main Wishram village) to gamble, race, eat, and bargain. Bison robes, tobacco, and horses were Plateau products desired by the coastal peoples. Pounded dried salmon, a specialty of the host village at the Dalles, was traded to parties from the coast. In return for these interior products, the coast parties traded their canoes, marine shells and beads, fish oil, and some fish from their regions. Handsome parfleches (rawhide cases) and large flat "root" bags manufactured by the Nez Perce and cylindrical "sally" bags by the Wishram (figure 17) were always good sellers at The Dalles markets. By the end of the eighteenth century, European beads, ornaments, and blankets obtained from trading posts farther north or from ships along the coast were being traded through The Dalles. Furs also moved through this Indian market (Kehoe, 1992).

The Wishram and Wasco viewed European traders as rivals and did not welcome them. European traders severely undermined The Dalles market by drawing Plateau natives to their posts, offering guns and other imported items that were not available or very expensive at The Dalles. The preeminence of The Dalles as the market for the northwestern quarter of North America was lost to European traders as more trading posts were established during the early 1800s (Kehoe, 1992). To complicate matters, missionaries settled at The Dalles in 1838 and introduced European farming methods.

The native peoples of the Plateau used bark and dugout canoes as their primary mode of transportation. Early in the eighteenth century, horses became available to the southern Plateau though trade with the Shoshone but did not come into use in the northern and western Plateau until the nineteenth century. Those groups that began to use horses before European-American domination advanced into the Plateau shifted their cultural patterns, much as did the native peoples of the easternmost Great Basin and the Plains. Becoming more nomadic, they made trips over the mountains in summer to hunt bison herds on the Plains or on their grassland extensions into Idaho. The traditional pit house was abandoned for hide tipis. Many clothed themselves in Plains-style shirts and leggings or buckskin dresses in place of the robe for men and long tunic of mountain-sheep skin or goatskin for women. For protection, groups hunting on the Plains kept together under leaders (Kehoe, 1992).

By the time Lewis and Clark recorded their descriptions of the Plateau and its peoples in 1805, the use of horses had modified the cultural patterns of much of the southern Plateau. In 1811, fur traders from Alberta, Canada, and from Montana and Wyoming entered the Plateau to trade with the Hudson Bay Company. Initially, they were welcomed because the Plateau peoples were accustomed to trade, and the novelty of the strangers' post, with flags and ceremonies, brought the curious from hundreds of miles away (Kehoe, 1992). By 1831, epidemics of measles, whooping cough, smallpox, and other European diseases had severely afflicted the Plateau native population.

The first waves of European-Americans mostly passed through the Plateau to colonize the Willamette Valley in western Oregon or to settle in California. Gradually, the narrow valleys of the Plateau were chosen for settlement by ranchers and farmers. They maintained large horse herds that were sold to them by the native peoples. Emigrants invaded the Dalles area beginning in 1842, the majority en route to the Willamette Valley to the southwest (Kehoe, 1992).

A steady increase in the European-American population led to government-sponsored treaty negotiations in 1855 with the Plateau peoples and the Blackfoot, their neighbors and enemies on the Plains. Peace with the Blackfoot meant more Plateau forays onto the Plains to hunt bison and must have been the reason that many of the Flathead, Nez Perce, and Coeur d'Alene signed the treaty (Kehoe, 1992). The Wishram and Wasco signed the 1855 treaty without protest and avoided entanglement in the Yakima War that followed. Unfortunately, the treaty did not stop the wave of European-American incursions into the richest Indian lands.

In 1858, the Wasco were removed south to the Warm Springs Reservation in central Oregon, and the Wishram north to the Yakima Reservation in Washington. Both reservations were shared by a number of groups, including the Klikitat. After the so-called Bannock War, some Northern Paiutes were settled on the Warm Springs Reservation (Kehoe, 1992). Two years later, in 1860, prospectors for gold overran the Plateau, causing the erosion of stream banks and ruining many of the fishing grounds so vital to the survival of the native peoples. Through the 1860s and 1870s, the native people were pressured and cajoled onto reservations, which were redrawn after Indian occupancy to reduce the boundaries. In 1877, Chief Joseph's band of Nez Perce fled to Canada, only to be forced to surrender before reaching freedom.

The native peoples of the Plateau had been making baskets for centuries before the arrival of European-Americans in the region. As with most native peoples, basketry was traditionally made to be used in tasks related to gathering, storing, and preparing food

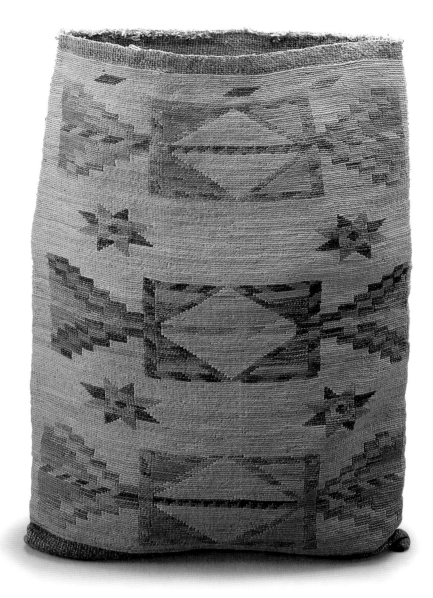

(Miller, 1996). Baskets in the Plateau also played a significant role in the events throughout one's life—such as birth, death, and marriage—when baskets were part of the ritualized exchange of goods. Besides their economic value, baskets also symbolized the woman's role and her contributions to the new family's well-being in marriage exchanges (Miller, 1996).

The principal basketry techniques practiced in the Plateau were coiling and twining. Twined basketry was more prevalent in the central and southern Plateau, and coiled basketry was the dominant type to the north. Although these techniques were used by basket weavers the world over, the methods of decorating Plateau baskets was unique (Conn and Schlick, 1998). All or part of the surface on many coiled baskets, used to collect berries and roots, have a mosaiclike appearance through a folding technique known as imbrication (Mason, 1904). Some of the twined basketry used as hats and bags was decorated with a distinctive method known as false embroidery (Conn and Schlick, 1998).

Coiled basketry was made primarily by the Salishan groups in Canada and west of the Columbia River in Washington state. The Klikitat and adjacent Sahaptian groups also made coiled baskets (Haeberlin et al., 1928). Red-cedar root was the material used for both the foundation splints and sewing elements; bear grass and wild cherry were the primary materials used to create the decorative designs. All the Plateau groups that made coiled basketry used a bundle foundation of fine cedar splints with the exception of the Fraser and Thompson River Salish, who used thin cedar slats combined with splints as a foundation reserved for cradles and covered hampers (Conn and Schlick, 1998).

Fez-shaped twined-basketry hats were made and used by women of all the Middle Columbia River tribes and the neighboring Nez Perce (Schlick, 1994) and were worn daily. However, since European-American settlement, hats have been reserved for use at ceremonials and special social occasions (Conn and Schlick, 1998). A distinctive feature of Plateau hats was the hide tie that the weaver used to gather the warp strands for her basketry start. Feathers, beads, and other decorative items were fastened to the ends of the ties when the weaver finished the hat (Conn and Schlick, 1998). Another type of soft twined basket was the large flat "root bag" used to store dried foods and various other possessions. These were decorated with native grasses in false embroidery to create colorful designs (Gogol, 1980a,b).

Plateau women wove their baskets during the winter months. They used three twining techniques: plain twining, full-turn twining, and false embroidery. These techniques are described by Conn and Schlick (1998:603):

> In plain twining, also known as simple twining, two wefts are crossed only once to engage each warp in turn. In full-turn twining, also known as wrapped or full-twist twining, two wefts of different colors are used. The weaver crosses the wefts once or twice before engaging the next warp, to bring forward the desired color. This two-color technique makes it possible for the weaver to work complex designs into the basket. In false embroidery, or external weft warp, a third element is wrapped around the outside weft strand during the plain twining, creating a surface decoration as the weaving progresses.

The materials most commonly used were Indian hemp or giant dogbane to make a strong string used as the foundation material for soft basketry hats and bags. Twined bags were also made of hazelnut brush, cattail, tule, dogwood root, and a variety of native grasses. Strings of yarn, cotton, and other fibers introduced by European-Americans were utilized by Plateau weavers (Conn and Schlick. 1998). After corn was introduced as a food crop by missionaries and fur traders, the soft inside husks began to replace native grass as a decorative element in the flat bags, which became known as "cornhusk" bags. The cornhusks were pliable, easy to dye, and plentiful, and weavers began to cover the entire bag in false embroidery (Conn and Schlick, 1998).

The designs on the flat bags are interesting in that they were different on each side of the bag and the weaver did not repeat the design on any other bag, thus making each woven bag unique. For the most part, Plateau weavers coordinated geometric designs into a unified design on cornhusk bags, creating a formal design style "featuring symmetry and rhythmic repetition of motifs" (Conn and Schlick, 1998:604). Earlier bags had an overall pattern with a balanced repetition of a singular motif on each side (plate 41, p. 97). Later arrangements of banded designs and central motif or a single motif repeated five times to form a coherent design were popular. A few weavers began to incorporate naturalistic designs of plants, animals, and scenes of daily life into their bags in about 1900 (Conn and Schlick, 1998).

Clark Field collected sixty-six Plateau baskets between 1937 and 1961. Most of the baskets were collected in the late 1930s (1937–38), early 1940s (1942–44), and in 1948. It does not appear that Field traveled into the Plateau until the early 1940s, when he collected baskets on a couple of the reservations, at some of the tribal agencies, and at the Washington State Museum in Seattle.

The Plateau is divided into two sections. First is the northern and western section, including the tribal groups represented in the Clark Field Collection—the Chilcotin, Fraser River Salish, Klikitat, Lillooet, Thompson River Salish, and Yakima. Second is the southeastern section, which includes the Kootenai, Nez Perce, Umatilla, Wishram, and Klamath.

To the north and west of Idaho, the Cascades region, encompassing Washington state and southern British Columbia, is best known for its stiff coiled baskets made of cedar root and bark or spruce root. Most of the coiled baskets are decorated with imbrication using black, white, and red elements to cover the entire surface or to create patterns and motifs against nonimbricated backgrounds. Many of the Cascades peoples used a beading technique, a type of grass overlay related to imbrication, for decoration on their baskets (Turnbaugh and Turnbaugh, 1997).

Different basketry forms were popular in the Cascades region. Although twining and plaiting were done, the prominent weave used throughout the northern and western Plateau was coiling. Watertight rectangular and square boiling baskets were common. The Thompson River Salish created large rectangular storage baskets, and the Klikitat made high, cylindrical baskets that were well adapted for packing on horses (Turnbaugh and Turnbaugh, 1997).

Clark Field collected one Chilcotin pack basket dating to about 1890 from the estate of Henry B. Spencer of Sacramento, California. The Chilcotin made round baskets with knobbed, inset lids, and large rectangular and oval-shaped burden baskets with some imbrication in red and black (Turnbaugh and Turnbaugh, 1997).

The Fraser River Salish coiled baskets have a flat strip or splint of wood as the foundation, with stitches of cedar root. They usually are rectangular forms, with some twisted looped rims and twined flat wallets similar to those of the Nez Perce. Decorative elements of imbricated red-cherry bark and white bear grass are generally found overall (Turnbaugh and Turnbaugh, 1997). Clark Field collected four Salish baskets from the Fraser River area of British Columbia. One carrying basket and a deep bowl are of the traditional form and manufacture. A tray with woven handles (1948.39.45) was clearly made for sale, with both a shape and design that would appeal to European-Americans. In 1945, Field also collected a basketry cradle that is extremely rare (plate 42).

Probably the best-known Plateau coiled basketry is the pail shape made by the Klikitat (Conn and Schlick, 1998). It has a round base with straight, flaring sides and its height exceeds the mouth diameter. They are imbricated with designs of black, white, yellow, and brown, either over the entire surface or the upper part of the basket, in geometric patterns such as large zigzags and/or diagonal, horizontal, and vertical layouts. The Klikitat also do some beaded overlay and at times combine stylized motifs of men and animals with their geometric designs. In addition to coiled basketry, the Klikitat made sewed mats of tule, flexible plaited baskets with rounded bases of maple or willow bark and bear grass, and twined fez-shaped caps and bags of Indian hemp and later of cornhusks (Turnbaugh and Turnbaugh, 1997).

Klikitat burden baskets were tall and narrow for traveling on horses. Pack baskets typically had a compound rim finish. With the exception of one basket that is a jar (1942.14.2070), all the Klikitat baskets that Clark Field collected were berry or gathering baskets. Three were collected on the Yakima Reservation in Washington state in 1948 and another was collected from the Washington State Museum in Seattle in 1943.

In the Canadian Plateau, there were at least three definable local basketry styles, those of the Lillooet and the Thompson and Fraser River Salish. All made baskets with rectangular and square bases, flat spreading sides to a rectangular rim, open coffinlike cradles, and rectangular covered hampers. As mentioned above, these larger forms, especially cradles and hampers, were often made with slats as the foundation (Conn and Schlick,1998). The attribute that distinguishes one group from the other is the placement of decoration and added elements. Lillooet baskets were decorated in zoned compositions in which the upper third of the baskets was fully imbricated with bold figures, and the flat sides of the baskets were imbricated in separated narrow vertical lines or with other small, separated figures. Thompson River groups tended to favor two basic decorative styles—allover imbrication with or without a full background, with one or two repeated figures, or an arrangement of repeated vertical bands. Baskets from the Fraser River groups resemble the Thompson examples, except that hamper lids are usually decorated in a different pattern from the body and are often beaded rather than imbricated (Conn and Schlick, 1998). Decoration was done principally in two methods, imbrication and beading.

Lillooet baskets included rectangular pack baskets with flat bases and slightly flaring sides of western red cedar or spruce root, and large, open, plain-twined utilitarian fish baskets made of cedar twigs (Turnbaugh and Turnbaugh, 1997). Clark Field collected two Lillooet pack baskets in 1937. One was purchased from R.B. Cregar in Palm Springs, California, and the other is documented as having been from the Thompson River area of British Columbia and Washington state. A third Lillooet pack basket was purchased from Cregar in 1938. All three have the typical design layout described by Turnbaugh and Turnbaugh (1997).

The Thompson River Salish made more baskets than any other Salish group (Haeberlin et al., 1928). Their basketry forms include large rectangular coiled storage bas-

kets, conical burden baskets with flat bases, rounded watertight baskets, and smaller forms for trinkets and sewing materials, of cedar, spruce, or juniper root. Some coiled baskets have lids that slide up and down on a string which functions as a handle. The Thompson River Salish also made open-twined fish baskets of cedar twigs or spruce root, and plain twined bags and wallets of tule or bulrush with buckskin rims, as well as plaited mats and coarse flat bags of tule, grasses, or bulrush. Black and red imbricated and beaded overlay on coiled baskets, in geometric and realistic animal designs, is typical. An overlay of colored grasses, wool, and hair is used in twined bags (Turnbaugh and Turnbaugh, 1997). Designs were shared freely among basket weavers and these and adapted designs were passed down to daughters and granddaughters (Wyatt, 1998).

Clark Field collected six Thompson River Salish baskets between 1937 and 1944. These included three storage baskets dating to about 1890 from the estate of Henry B. Spencer of Sacramento, California, purchased in 1938. Another storage basket was collected in 1937. One storage basket (1942.14.2072) dates to about 1750 and was said to have been made by the great-grandmother of the great-aunt of Lois George of Everson, Washington. Field collected a medium-sized berry basket in 1944 on the Warm Springs Reservation in Oregon.

As with the other northern and western peoples of the Plateau, the Yakima basket forms include coiled cylindrical baskets with open loop work around the rim of cedar root or bark, tule sewn mats, and twined caps originally of Indian hemp and decorated with bear grass and later with cornhusks. Although the designs tend to be zigzags and V-shaped motifs, the difference between Yakima coiled baskets and others is in the use of imbrication generally covering the whole basket (Turnbaugh and Turnbaugh, 1997). Field collected seven Yakima baskets in the 1940s. Two excellent examples of gathering baskets with overall imbrication were collected in Toppenish, Washington, on the Yakima Reservation (plate 43). One coiled berry basket (1942.14.2092), collected in Pendleton, Oregon, in 1948, was identified by Field as Umatilla, but it is has all the characteristics of Yakima coiled basketry. Field collected one twined bag in 1942 and two in 1948 on the Yakima Reservation. The only Yakima twined hat in the collection dates to 1848 (1942.14.2054) and was collected by Field in 1948.

The Southeastern Plateau

Prior to the introduction of the horse, the Kootenai and Nez Perce made both deep and shallow coiled utilitarian bowls. Typical of the transitional period for basketry in the southeastern Plateau is the flat, twined wallet or carrying bag. After the Nez Perce and Umatilla adopted the horse, these bags were used as saddlebags (Turnbaugh and Turnbaugh, 1997).

Kootenai basketry forms include coiled bowls, trays, cooking baskets, an inverted truncated cone shape with allover imbricated design, and wicker-plaited cylindrical fish basket-trays and hats (Turnbaugh and Turnbaugh, 1997). The last Plateau basket collected by Clark Field was a Kootenai carrying basket made by Mary Hewankosu in about 1900 (1961.16.1).

Of the Plateau groups, the Nez Perce still make basketry today. They are best known for their plain-twined soft, flexible, flat, rectangular bags of Indian hemp with false-embroidery designs in cornhusks and colored grasses. The designs are usually different on each side. A wrap-twined hat is also recognizable as Nez Perce. It usually has a single black band near the crown and rim, with a zigzag pattern in between (Turnbaugh and Turnbaugh, 1997). Rose Frank, a cornhusk weaver, said:

> This weaving always fascinated me, I just wanted to learn. So one day, Ida Blackeagle decided, I'm going to have to start teaching. If you wanna come, why you're welcome to come, and I'll teach you how. I didn't waste any time getting down there.

While I was learning, I made as many as five bags, and Ida asked me if I wanted to sell them, and I said, Nobody will buy them, go ahead. And by gosh, she sold them for a big price. The highest I got was $25. That was forty-seven years ago (McCormack, 1996b:65).

Clark Field collected seven Nez Perce bags. One that he collected in 1937 was recorded as having been made in about 1787. Given its overall condition, it seems rather doubtful that this bag would be that old; a more practical date would be 1890 (plate 41, p. 97). Three twined bags dating to about 1900 were collected in 1942. In 1948, Field purchased one Nez Perce bag on the Lapwai Reservation near Lewiston, Idaho, and another on the Yakima Reservation in Washington state.

Umatilla basketry includes close plain-twined flexible bags and fez-shaped hats made of Indian hemp, rushes, and cotton twine. The decorative elements of colorful cornhusk, bear grass, and worsted yarn are incorporated through half-twist overlay, false embroidery, full-twist overlay, or wrapping the twined weft (Turnbaugh and Turnbaugh, 1997). Clark Field collected two Umatilla bags in 1937, and one in 1948 that had been made by Anna Wannassee's mother in about 1875 (1942.14.2061).

Round twined bags were found across the Plateau wherever roots were gathered. The most distinctive of these bags were made by the Wishram and Wasco (Conn and Schlick, 1998). Both the Wishram and Wasco, historically located in the strategic Dalles on the Columbia River, made closed-wrapped twined flexible bags, "sally bags," and fez-shaped hats of Indian hemp and rushes, with cornhusks and grasses used as decorative materials. Wrap-twined cornhusks and grasses used to create lifelike figures in brown and black were used to decorate the bags and hats. Although some geometric designs were used, most bags have human and animal figures such as deer, dogs, fish, frogs, and butterflies incorporated into the overall design. Occasionally, glass beads were attached at the rim (Turnbaugh and Turnbaugh, 1997). Field collected a single Wishram bag (1948.39.441) in 1943 from the Washington State Museum in Seattle, which had acquired it in 1929. Instead of the usual lifelike figures of Wishram and Wasco bags, this wrap-twined bag has four decorative bands of diamonds, triangles, and wavy lines.

Klamath basketry includes plain-twined wallets, gambling and winnowing trays, storage and cooking bowls, and cradles made with hazel, cattail, and brown tule rush. Light-colored grasses and poison oak are incorporated in a full-twist overlay in both representational (animals) and geometric designs (Turnbaugh and Turnbaugh, 1997).

Clark Field collected sixteen Klamath baskets between 1937 and 1952. The first Klamath bowl, collected in 1937 (1947.57.61), has quills incorporated as a decorative element and a second, collected in 1942, possibly from Alice M. Robertson (1942.14.1745), has an unusual base with quills incorporated into the design. Two twined wallets were collected from Frank G. Speck, an anthropologist from the University of Pennsylvania who had acquired them from the Gottschall Collection, one in 1941 and the other in 1943. In 1943, Field collected two parching trays made in about 1890 by Sarah Weeks (1948.39.420 and 1948.39.421), a gambling tray by a woman identified only as Wynona (1948.39.445), and a bowl (1948.39.474) and two basketry dolls (1948.39.446-447) made by Carrie Jackson. These were all possibly collected at the Klamath Agency in Oregon. Field collected an unusual basketry quiver made by Lizzie Kirk (1949.4.7), a gambling tray, and an open-twined storage basket in 1944. In 1951, he purchased an open-twined hat with a pointed crown and wide brim (1951.23.10), and in 1952, a baby carrier and an oval-shaped carrying basket with a handle, both of which appear to have been made for sale.

PLATE 44 : Modoc bowls, c. 1940 : These two examples demonstrate the stepped geometric pattern of piled rhomboids in full-twist overlay common to Modoc basketry designs. This is referred to as a block pattern, and it has been in use for a very long time.
Left: 1948.39.475, right 1947.57.44.

Modoc basketry forms include plain-twined winnowing and gambling trays, conical burden baskets, cooking and storage baskets, mortars for grinding meal, hats, and cradles of brown tule rush. They are decorated in a full-twist overlay of light-colored grasses in stepped geometric patterns (plate 44). Occasionally, bird quills dyed yellow are incorporated into the design. With the exception of one woman's cap (1948.39.121), the eight Modoc baskets collected by Clark Field between 1938 and 1944 have documented weavers. In 1938, Field collected a small bowl made by Mary Chiloquin (1947.57.44, see plate 44, p. 100) from Alice Marriott of the Indian Arts and Crafts Board in Oklahoma City, and in 1943 an unfinished bowl by Mary Chiloquin (1948.39.366) from Marriott. He collected a bowl made by Maggie Jacob (1948.39.477) in Chiloquin, Oregon, in 1943. Field returned to Chiloquin in 1944 and purchased a hat made by Jennie Clinton (1948.39.479), an open-twined shallow bowl made by Dollie Lavor (1948.25.5), a storage basket made by Sarah Riddle (1948. 39.476), and a bowl made by Minnie Shiffower (1948.39.475, see plate 44, p.100).

The role of basketry had changed for the people of the Plateau as it had in the Great Basin by the end of the twentieth century; however, the importance of the art form had not. Conn and Schlick (1998:608) point out that "although commercially made products satisfied utilitarian needs, baskets continued to have a ceremonial and sacramental place in Plateau life. The baskets' ties with the distant past offered a satisfying continuity and their fine workmanship and beauty in design continued to be a source of pride."

Very few basket hats were made between the 1800s and 1970s, but with renewed interest in the old ways among the young people and their growing participation in tribal ceremonies and celebrations, there has been an increased demand for these hats. Many weavers in the 1990s were making twined round bags and flat wallets, using commercially made string and yarn, and selling them in tribal gift shops. The last weaver of the distinctive Wishram and Wasco bags with the complex geometric designs died in 1971 (Conn and Schlick, 1998). In the late 1980s and early 1990s, a few young women began to study the Wishram and Wasco twining technique in hopes of reviving the art. At the end of the twentieth century, very few weavers were producing the coiled baskets of the Plateau. The few who have continued to weave have been able to demand a high price from collectors. Even though these basket weavers received a good price for their work, the return did not compare with wages for the amount of time spent gathering and preparing materials and weaving baskets (Gogol, 1980a). Only a few Plateau basket weavers were able to support themselves solely through basketmaking by the end of the twentieth century (Conn and Schlick, 1998)

A small number of weavers have carried on the basketmaking tradition and have earned the respect of the Plateau peoples. There have been attempts by the elders to teach young people who are eager to learn the art of basket weaving, and basketry classes have been offered on the Warm Springs and other reservations. Nevertheless, teaching basketry in a structured institutional style is not easy for weavers who learned the art from their mothers and grandmothers, and there is some resistance to it. Nettie Jackson is probably one of the better-known Klikitat weavers, and she clearly had reservations about teaching anyone else how to weave. In a 1991 interview with Ann McCormack (1996a), Nettie Jackson said, "It took me four years to be satisfied with my work, the way I do it now. But I don't think I could teach somebody in one whole year how to do it, what it took me ten years to do. I told them, 'You're asking me to give you something that is part of me, part of my whole life, my history, my heritage, my whole person, who I am.' "

Basket weaving is an art, and we are fortunate to have women and men willing to carry on the weaving traditions of their native cultures today. As Nettie Jackson and other weavers have said, it takes a very long time to learn to weave baskets, and to be successful, it must become a part of the world that is woven into the weaver's life.

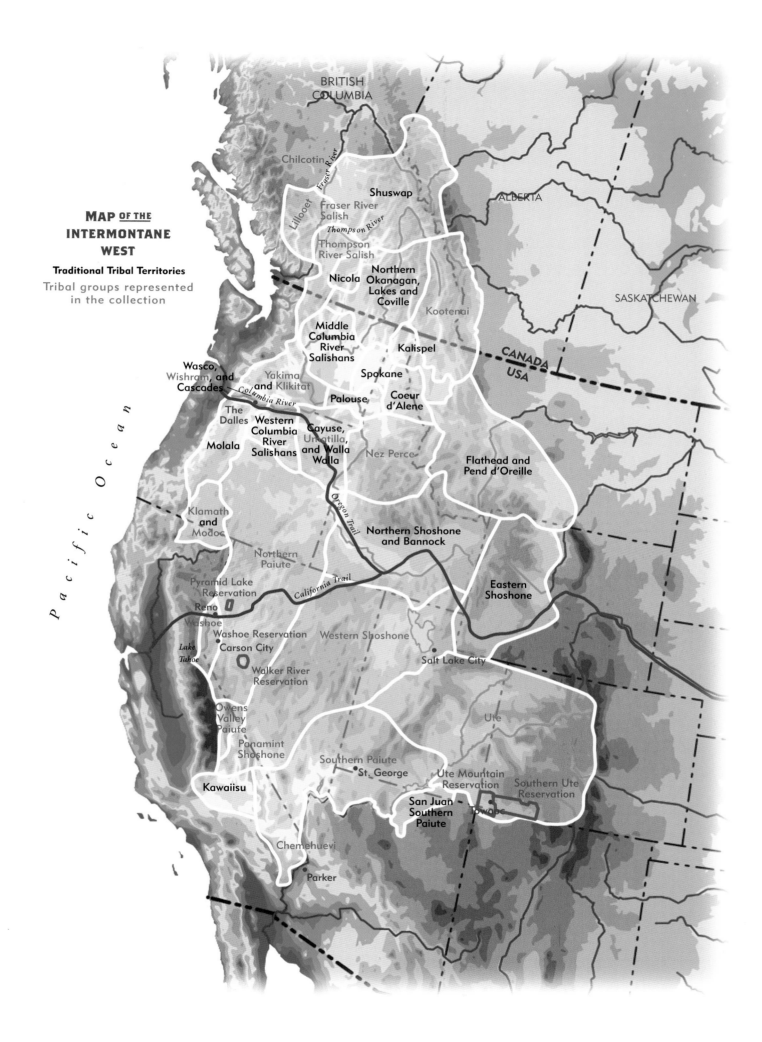

MAP **OF THE**
INTERMONTANE
WEST

Traditional Tribal Territories
Tribal groups represented
in the collection

BRITISH
COLUMBIA

ALBERTA

SASKATCHEWAN

Chilcotin

Fraser River

Lillooet

Shuswap

Fraser River
Salish

Thompson River

Thompson
River Salish

Nicola

Northern
Okanagan,
Lakes and
Coville

Kootenai

CANADA
USA

Middle
Columbia
River
Salishans

Kalispel

Wasco,
Wishram, and
Cascades

Yakima
and Klikitat

Spokane

Columbia River

Palouse

Coeur
d'Alene

The
Dalles

Western
Columbia
River
Salishans

Cayuse,
Umatilla,
and Walla
Walla

Molala

Nez Perce

Flathead and
Pend d'Oreille

Pacific Ocean

Klamath
and
Modoc

Oregon Trail

Northern
Paiute

Northern Shoshone
and Bannock

Pyramid Lake
Reservation

California Trail

Reno

Eastern
Shoshone

Washoe

Washoe Reservation

Western Shoshone

*Lake
Tahoe*

Carson City

Salt Lake City

Walker River
Reservation

Owens
Valley
Paiute

Ute

Panamint
Shoshone

Southern Paiute

Ute Mountain
Reservation

Southern Ute
Reservation

Kawaiisu

St. George

San Juan
Southern
Paiute

Towaoc

Chemehuevi

Parker

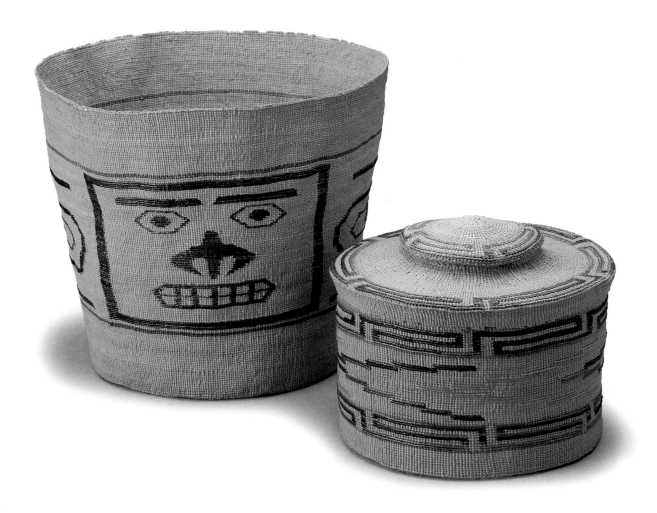

NORTHWEST COAST

Gloria Cramner Webster and Shelby J. Tisdale

PLATE 45: Tlingit baskets : The basket on the left, with the possible crest design of a bear face and elongated eyes (1942.14.2051), is typical of the Northwest Coast "form-line design" technique. The basket on the right (1946.47.15 a,b) is a rattle-top lid basket with a fret design applied with false embroidery.

The Northwest Coast culture area extends from the Copper River delta on the Gulf of Alaska to the Chetco River near the Oregon-California border. The eastern boundary is defined by the Chugach and Saint Elias Mountains in Alaska, the Coast Mountains of British Columbia, and the Cascade Range of Washington and Oregon. The entire area is more than fifteen hundred miles long and includes two international borders, two American states, and one Canadian province. Archaeological evidence indicates occupancy ranging from three thousand to nine thousand years ago, and because of its fragility, basketry is rarely found in archaelogical sites in the area. The Ozette site in Washington state was a massive mudslide that buried several houses and their entire contents. It is the only major archaeological site in which a large variety of basketry remains was preserved.

The Northwest Coast climate is based on its proximity to the Pacific Ocean and the Japanese current, which brings cool summers and mild, wet winters. The area is usually referred to as temperate rain forest. Northwest Coast native peoples lived in permanent villages where weather conditions guided seasonal rounds, with relatively calm weather in late spring, summer, and early fall. During that period, hunting, gathering, and food preservation were most intense. The raw materials necessary for making clothing, uten-

sils, and tools were also collected. Among the nonfood items gathered in season were red-cedar bark and withes, yellow-cedar bark, alder and cherry bark, spruce root, cattail, tule, and a variety of grasses for making basketry. Hardwoods such as yew and alder, and whale, bear, and deer bone for bark lifters, beaters, and awls were also collected while the weather was warm. Dentalium, a highly valued shell, available only in a few locations, was gathered for use in decorating ceremonial clothing and for trading purposes.

The Northwest Coast was heavily populated by different groups with diverse languages and culture. Wilson Duff (1964) describes the British Columbia portion:

> At the time of contact, the Indians of this area were among the world's most distinctive peoples. Fully one-third of the native population of Canada lived here. They were concentrated most heavily along the coastline and the main western rivers, and in these areas they developed their cultures to higher peaks, in many respects, than any other part of the continent north of Mexico. Here, too, was the greatest linguistic diversity in the country, with two dozen languages spoken, belonging to seven of the eleven language families represented in Canada.
>
> Adding the Alaska, Washington and Oregon-California areas of the Northwest Coast to the above description increases the number of languages to over forty, representing a total of one dozen language families. Many of these languages are dying and some have already become extinct.

The native peoples in the northern area are of various linguistic stocks, and the peoples of the southern area speak a Chinookan (or Penutian) language or Salishan. The native peoples in the central area speak a Wakashan dialect and share the cultural attributes of both regions (Turnbaugh and Turnbaugh, 1997).

From their permanent villages, the inhabitants traveled extensively, exploiting the rich maritime resources, including five species of salmon, halibut, several varieties of cod, and herring, primarily for roe. Eulachon, a member of the smelt family, was the source of a valuable oil, commonly called "grease." These were harvested—and still are—in spawning rivers ranging from Bristol Bay in Alaska to the Klamath River in northern California (Drake and Wilson, n.d., 7–8). The grease was an important trade item in traditional times and gave rise to the term "grease trails" to describe the routes followed by people who gathered annually in locations to trade coastal items for those from the interior. In addition to an east-west trading network, there was also trade activity between the north and south, as demonstrated by the acquisition of abalone shell. It originated in California and was not found in the northern areas, where it was highly valued as a symbol of wealth. The excavation of a northern-style hat at the Ozette site in western Washington is also proof of a far-ranging network of trade activities.

Shellfish such as clams, cockles, chitons, mussels, and crabs were gathered, as well as sea urchins. A variety of ducks was used for food, as were their eggs. Harbor seals were hunted for food and sea otters for their pelts, which were used for clothing. The Nuu-chah-nulth (Nootka) and Makah were the only groups to hunt whales, although nonwhaling groups made use of whales stranded on beaches. From the land, elk and deer provided food, and skins of bear and marten were used for clothing. Ermine pelts were used to decorate ceremonial clothing. Mountain-goat wool was used for weaving blankets, the horn for making spoons, and the tallow for face cream.

Because villages were established along waterways, the main mode of transportation was by canoe. Built of a single red-cedar log, the vessel was first shaped, hollowed out, and then filled with hot rocks and water to stretch the fibers to the desired shape. Some of the canoes could carry as many as forty people and large amounts of freight. In some areas, the planks of houses were dismantled and transported by canoe from winter to summer locations, then returned at the end of the harvesting season.

The two main types of basketry made in the Northwest Coast area include (1) twined and plaited bark baskets and matting produced along the coast, and (2) in the interior,

coiled basketry and folded and sewn birchbark basketry. However, differences in basketry techniques are found in each area. These differences were not sharply defined because one group influenced its neighbor, to some degree. For example, basketry produced by the Tsimshian bore significant resemblance to that made by the Tlingit.

In the north, closely twined containers and hats were produced from fine spruce root. After the material was gathered, the strands were roasted over a fire to loosen the outer bark, which was then removed by pulling each strand through a split stake secured in the ground. The stripped roots were soaked in water to soften them, then split into four or more strips, tied into bundles, and stored until ready for use.

Construction requires a warp of upright strands and two wefts of horizontal strands. The wefts are placed on either side of one perpendicular strand and then are switched when they reach the next one. This method produces a distinct slant, either slightly upward to the left (\\\, or Z) or slightly upward to the right (///, or S). By studying the direction of the slant, the provenance of the basket can be determined. Tlingit, Haida, and Kwakwa̲ka'wakw weavers use Z-slant twining, and Coast Tsimshian and Nuu-chah-nulth use S. The Gitksan, a subgroup of the Coast Tsimshian, use a combination of Z and S, alternating direction with each row (Laforet, 1999). The method of constructing a basket differed among these tribal groups. For example, Tlingit weavers worked downward from the base, but Haida women wove upward from the base.

Traditionally, the range of colors used for decoration was limited to black, red, yellow, and blue. These were produced by using organic materials for dyeing. Black came from soaking the fiber in black mud or by boiling the mud with saltwater and hemlock bark. Steeping the fiber in water in which alder bark had been boiled produced red dye. Yellow dye came from lichen, and a bluish-green color was produced by boiling hemlock bark with oxide of copper scraped from old metal or from rock. Shades of purple were produced from the juice of mashed blueberries.

Baskets for gathering were made in different sizes and shapes, depending on what kind of berries or roots were to be collected. For example, for berry picking, three sizes were required. A small basket was made to hang in front of the body by means of a woven strap. A slightly larger one, made in the same way, was carried on the back. The largest one, called a "swallowing" basket, was placed on the ground near the chosen berry patch. After the berry picker filled her front basket, she emptied it into the middle-sized basket. When that was filled, it was transferred to the swallowing basket. The baskets were constructed with a rounded base and with high walls that flared out to a wide opening. This shape was ideal for canoe travel because the baskets fit into the curve of the hull. For wild carrots, the basket was made shallow, and the basket for lily bulbs was low and flat. The exception was the basket made specifically for picking viburnum berries, which had a flat bottom and straight sides with handles. It was of a size to fit into a cooking box, containing hot rocks and water, to steam the berries.

Franz Boas ended his description of the making of a particular type of cedar-bark basket with the statement, "When this has been finished, she continues making baskets, for sometimes she needs as many as ten baskets if she has a large cinquefoil garden" (Boas, 1921:138). The roots of cinquefoil, also called silverweed, were gathered in large quantities, washed, dried, and stored for winter use. The number of baskets required for just one type of food gives some idea of the quantities of different kinds of baskets and containers to be found in a single household. In fact, Mason (1904) states that American Indians used baskets for 116 purposes, many of which were in use on the Northwest Coast. As their world changed, with access to native materials becoming limited and the demand for baskets for the tourist trade increasing, basketmakers replaced traditional dyes with commercial aniline dyes. They also began to use silk thread and colored wool strands to decorate their products.

On the Northwest Coast, the first contact with Europeans was in the late 1700s, with Spanish ships visiting the west coast of Vancouver Island in 1774, followed by the Russians, who established settlements in Alaska. By 1811, European-Americans had

reached the lower Columbia River region. The earliest collections of baskets date from this period (Laforet, 1999). During the first stages of contact, very little changed for the Northwest Coast peoples, because the newcomers were primarily interested in acquiring sea-otter pelts for trade with China. It was not until the arrival of settlers and missionaries that the world changed irrevocably. As some old people have said, "Our world turned upside down," or it was the time "when our world became dark." Yearly cycles were interrupted, and the harvesting of traditional resources faced heavy competition from commercial logging and fishing operations. During that time, missionaries were promoting their own agenda—to civilize the heathen and to save souls for Christ. Children were taken, often forcibly, from their families and placed in church-operated residential schools, where they were forbidden to speak their languages and were taught that everything their parents believed in was evil and heathen. In those institutions, young people learned foreign skills, such as farming. Instead of learning how to weave, girls were taught how to knit and crochet. Their time in residential school meant that they were no longer part of the seasonal round of gathering materials for making baskets and other household items. They lost the opportunity to learn how to harvest and preserve foods to ensure survival during the bleak winter months.

After several decades of European and American settlement, native peoples became involved in a wage economy, working in the commercial fishing industry and in logging camps. The granting of huge tracts of timber to logging companies led to the restriction of traditional native gathering of forest resources necessary for the production of baskets. This resulted in a decline in the knowledge of basketmaking. Baskets that were being made were produced for the European-American market, and some were clearly not traditional in form and function. There are several examples in the Clark Field Collection of such baskets made for sale. In the same way totem poles and canoes were produced in model form to appeal to the tourist market, basketry was miniaturized on the Northwest Coast, as it was elsewhere. Museum collections generally have examples of basketry objects made specifically for the European-American market, such as coiled basketry trays, violin cases, cups and saucers from the Coast Salish, and basketry-covered liquor bottles made by Nuu-chah-nulth women.

The introduction of nontraditional materials, such as aniline dyes and raffia, dates to the beginning of basketry sales to the European-American market. By the 1930s, basketmaking skills had almost been lost (Laforet, 1999). However, until the 1940s, Coast Salish women continued to produce basketry items to trade as they traveled north to work in the canneries. They sold or traded baskets for used clothing in villages along the way. This method of moving goods from one area to another has often been neglected in documenting museum collections. A Coast Salish coiled basket made in Musqueam and collected in Fort Rupert, for example, has often been incorrectly documented as having been made in the latter community.

As one moves from the northern border to the southern boundary of the Northwest, there are distinct characteristics for each language group, including kinship, social organization, and technology. To simplify this discussion, the divisions outlined by Holm (1990) will be used. He describes these as "cultural provinces," with the Tlingit, Haida, Tsimshian, and the northernmost Wakashan-speaking tribes, for example, the Haihais and Haisla, forming the northern province. The central province includes the areas occupied by the Nuxalk, Heiltsuk, Oowekeeno, Kwakwaka'wakw, and Nuu-chah-nulth[1]. The southern province is inhabited by the north, central, and south Coast Salish groups, the lower Columbia River people, and the Oregon Salish.

[1] Since the early 1980s, the people have identified themselves as the Kwakwaka'wakw, meaning all the people who speak the language Kwakwala. The only "Kwakiutl" live in Fort Rupert and were the first people in contact with Europeans, who wrongly assumed that the inhabitants of all other villages were also Kwakiutl. Among other tribes now using their own terms for themselves are the Nuxalk and the Heiltsuk, both formerly Bella Coola, and the Nuu-chah-nulth, formerly the Nootka.

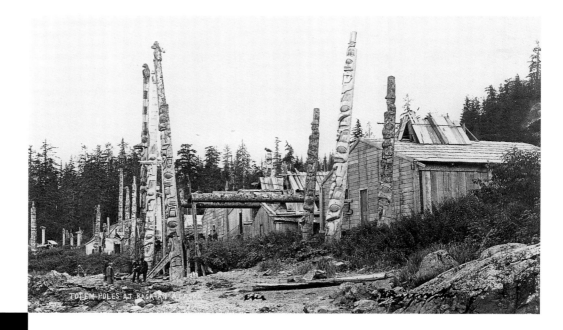

TOTEM POLES AT KASAAN ALASKA

FIGURE 19 : Haida village of
old Kasaan, Alaska, c. 1894 :
During the stormy months of
late fall and winter, people
settled in permanent villages
and were occupied with the
complex ceremonial activities
which have fascinated gener-
ations of anthropologists and
have provided museums with
significant collections of
material culture. Courtesy of
the MSCUA, University of
Washington Libraries, photo
by Frank La Roche, 1894. La
Roche 206

Northern Province

Most of the societies in the northern province were stratified and the native peoples
lived in relatively permanent, semisedentary villages of as many as three hundred peo-
ple (figure 19). An individual's rank depended on heredity and wealth. The upper
Northwest Coast peoples were especially concerned with the accumulation and redistri-
bution of wealth as an indicator of status. They are particularly well known for their cel-
ebrations known as potlatches.

The plain-twined basketry of the Tlingit and Haida was extremely fine and is consid-
ered a cherished collector's item. It is of even workmanship and is painted or decorated
with false-embroidered design elements (plate 46, p. 113). The sophisticated "form-
line" design described by Holm (1965), highly recognized as Northwest Coast art by
artists and collectors, originated in this area and was practiced almost to the exclusion
of any other form of graphic art. This design is found in several forms and is often
woven into or painted onto baskets.

Tlingit country lay between the Copper River in southwestern Alaska and the Dixon
Entrance, an area that includes the thousands of islands named the Alexander Archi-
pelago by early Russian explorers (Lobb, 1990). The Tlingit created superb baskets,
outstanding both technologically and aesthetically. They furnished their homes with
these beautifully dyed, woven, and decorated baskets and used them for many purpos-
es: gathering berries, shellfish, and roots; cooking; and storing trinkets, tobacco, shot,
feathers, and spoons. Baskets with rattle-top lids served as workbaskets. In weaving the
lids, women would fashion a hiding place for loose pebbles (Lobb, 1990).

The importance of basketmaking to the people of the Northwest Coast is illustrated
by a legend of the Tlingit, which described the skill as a gift from Raven, in the time
when humans and nonhumans could change their forms. It is said that a beautiful
young woman was unsuccessfully courted by many human suitors. One day the Sun
saw her, fell in love, assumed human form, and took her for his wife. They had eight
children during their happy years together, but because the children were from the
earth, the mother worried about their future in the sky world. In time, she gathered roots
and began to twist them together into the shape of a small basket. The Sun's powers
made the basket big enough to hold the mother and her children, which were then low-
ered to the earth, where they landed near Yakutat. There, the people developed their
weaving skills (Emmons, 1903).

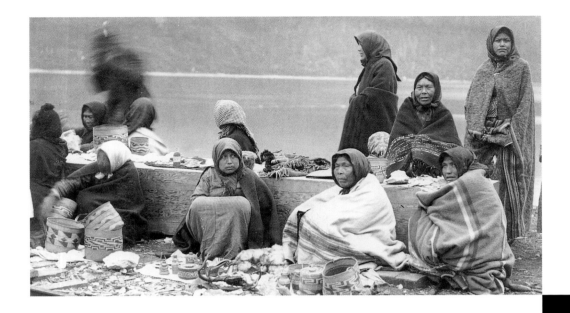

Tlingit basket weavers used young spruce roots, in their natural light color or dyed black or brown. Emmons (1903) lists six distinct techniques of weaving among the Tlingit. Each basket was finished with any one of thirteen types of borders he describes in detail. Emmons also enumerates fifty-one Tlingit basket-design motifs, with the aboriginal names for each one. These include a simple continuous zigzag, either in a single line or in parallel lines separated by a narrow space, which is called the "mouth-track of the woodworm." It refers to the role of the woodworm in Tlingit mythology and is an example of how myths were illustrated and, therefore, remembered in everyday life. Many of the motifs are based on native flora and fauna, including those named "butterfly," "leaves of the fireweed," "teeth of the killer whale," "tail of the halibut," and "raven's tail." Other motifs are named for objects in common use in the Tlingit world, such as "stick fish-weir," "labret," and "crotch," which represents the crotch of a tree, used to construct a salmon-drying frame or tent posts. This gives some sense of the techniques used by the Tlingit for weaving, finishing, and decorating their baskets. Generally, each province had a similar variety of choices, depending on the purpose for which the woven basket was to be used.

False embroidery, using dyed or bleached grasses, is the primary method of decoration. The embroidery is applied to the outside of the basket and is not visible on the inside. Geometric motifs are most common, with nongeometric elements being introduced as the production of baskets became more oriented toward sales. An example of this in the Clark Field Collection is the basket with a crestlike design more commonly found on Chilkat blankets (plate 46). For the most part, Tlingit baskets were of cylindrical shape, with walls that were straight or flared slightly. The lids of straight-sided baskets sometimes contained rattle-top lids.

Tlingit baskets came in different forms and sizes. Some of the most beautiful baskets were pairs of small, slightly tapered cylinders, made so that one slid firmly over the other, completely sealing the contents. These baskets were often totally covered with bands of fine false embroidery. Many Tlingit women were renowned for their skill in weaving baskets, and many of them produced baskets for sale to European-Americans in the late nineteenth and early twentieth centuries. Some baskets types and decorations were developed specifically for this trade (figure 20). They were beautifully made with an extremely fine weave, and many of the baskets now in museum collections were made for sale and never had native use (Holm, 1990).

Clark Field collected twenty-five Tlingit baskets between 1936 and 1951. He made two trips to Alaska, in 1937 and 1948. In 1937, he visited Hydaburg, where he collect-

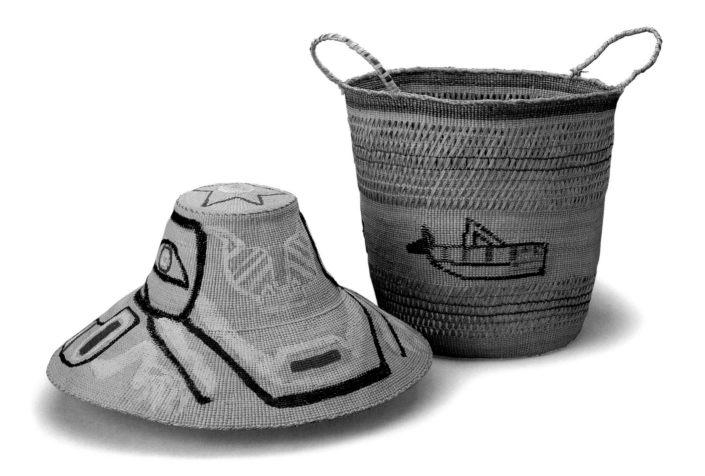

ed a round, plain twined basket with a lid with full-twist overlay (1948.39.57 a,b). It was during his 1948 trip to Ketchikan that he recorded having collected nine Tlingit baskets, including a folding basket, fourteen cylindrical baskets of various sizes, a cooking basket, and a bowl. On that trip, he collected another cylindrical basket at Lynn Canal. He also purchased three baskets from the estate of Henry B. Spencer of Sacramento, California; one from the Washington State Museum in Seattle; a cylindrical-shaped case from Mrs. Henry J. English, granddaughter of missionary Henry Stoever; and several baskets that do not have any collection documentation.

For thousands of years, the Haida people have lived on Alaska's Dall and Prince of Wales Islands and on British Columbia's Queen Charlotte Islands. Haida basketry consisted almost entirely of twined spruce root and primarily took the form of cylindrical storage and gathering baskets and flaring hats (Holm, 1990). Haida plain-twined baskets somewhat resembled those of their neighbors, the Tlingit and Aleut. They differed, however, in that the Haida rarely used false embroidery to decorate their baskets (Lobb, 1990).

Haida baskets came in several sizes, and decoration generally consisted of bands of alternating plain and black-dyed weft, which was visible on the inside and outside of the basket. On the upper margins, the Haida would often use a three-strand twining technique, giving the basket a textured surface. Occasionally they painted designs on the margins (Lobb, 1990). Clark Field collected a plain-twined cylindrical basket with a false-embroidery design (1948.39.49) on his first trip to the Queen Charlotte Islands, in 1937.

It is only in the northern province that painting was used in decorating hats. The twined spruce-root hat of the Haida is readily distinguished from the hats of the other northern province groups. The Haida hat was conical and was either plain or decorated. Field collected two Haida hats, an undecorated hat in 1937 and another in 1946 (plate 46), both originally from Hydaburg, Alaska. The artistic importance of the hat was enhanced through surface decorations of painted or woven patterns. The painting usually depicted crest figures, such as the whale and the beaver, in the classic formline

design described by Holm (1965). Today, Haida women in Ketchikan and on the Queen Charlotte Islands continue to weave baskets in the old way (Lobb, 1990).

Although the weavers of the baskets in museum collections are rarely known, there is one weaver who is recognized for his work. Lobb (1990:35) describes the work of a remarkable Haida artist and hat painter, Charles Edenshaw:

> Edenshaw, now a well-known name among collectors, possessed an innovative and elegant style that apparently took its inspiration from his Haida forerunners. His hats, often finely woven by his wife, Isabella, are easily identifiable by a four-pointed star, each point painted in red and black, on the crown of the hat.

Field acquired an interesting basket with a combination of weaves, including open diagonal and plain twining with false embroidery, in 1946. This bucket with handles has a killer-whale design and was clearly made for sale (plate 46, p. 113). Field did not note from whom or where he purchased this basket.

Basketry was not as important to the Tsimshian as it was to the Tlingit and Haida, and this is reflected in the number of baskets collected by Clark Field. He collected only three Tsimshian baskets, compared with twenty-five Tlingit. Twining was the technique used in the late nineteenth and twentieth centuries. Baskets of cedar bark, with designs in false embroidery, were made by weavers at Metlakatla, Alaska (Holm, 1990). Field collected a twined trinket basket with a lid at Metlakatla in 1948.

Another type of basketry made by the Tsimshian, with a checker weave, is found in utility baskets and mats (Laforet, 1984). Of the two such baskets in the collection, Field purchased a small rectangular basket with handles from the School of American Research in Santa Fe, New Mexico, in 1947, and in 1948, a market basket with handles.

Central Province

Compared with other areas in North America, such as the Southwest, the Northwest Coast village populations were small. For example, on the central coast of British Columbia, the Kwakwaka'wakw occupied thirty villages, with populations ranging from fewer than one hundred to fifteen hundred, for a total population of 10,700 in 1835, when the first official census was taken. By 1929, the population had decreased to 1,854 because of epidemics from introduced diseases such as smallpox and influenza (Duff, 1964). At the present time, the population is 6,360 people in twelve of the original villages (Department of Indian Affairs and Northern Development, 2000).

Only in the northern province was kinship matrilineal and a clan system practiced. On the rest of the coast, kinship was bilateral, and there is no evidence of clans. Those systems were reflected in ceremonies in which children in the north acquired positions, names, and dances through their mother's families, and children in the other two provinces could receive such honors through either parent's lineage. The ceremony common to the entire area was the potlatch, from a Chinook Jargon term meaning "to give." Each language had its own term. For example, among the Kwakwaka'wakw, the term is *pasap*, "to flatten each other," which refers to the efforts of one chief to bury his rival under the weight of wealth being given away. Briefly, the function of the potlatch was to serve as the official record of important events in the lives of the people, naming children, conducting marriages or divorces, mourning the dead, or transferring rights and privileges from parents to the next generation. By accepting his gifts, the guests at a potlatch validated the host chief's claims to display masks, dances, and songs. Rank was extremely important in all aspects of the potlatch, with guests being seated and receiving gifts in order of rank and with dances performed in proper order. From 1884 to 1951, federal legislation in Canada prohibited the potlatch. Thus, contemporary forms of the ceremony have been practiced openly for scarcely fifty years.

In common with indigenous groups around the world, the Northwest Coast peoples had their own methods of conservation, although none of their languages had a word

for such a practice. For example, in gathering cedar bark, women selected young trees, from which they took a limited number of strips, leaving enough bark to grow together to cover the gap or, as the old people said, to make sure the tree would not be naked. The Kwakwaka'wakw believed that if all the bark was stripped from a tree, it would die and other trees nearby would place a curse on the bark stripper and she would also die. These culturally modified trees have been valuable in identifying abandoned traditional sites, many of which are used by nonnative people for logging, mining, and other purposes.

The prayer offered by Kwakwaka'wakw women to a young cedar is typical of the ritual practiced on the Northwest Coast:

Look at me, friend!

I come to ask for your dress, for you have come to take pity on us; for there is nothing for which you cannot be used, because it is your way that there is nothing for which we cannot use you, for you are really willing to give us your dress.

I come to beg you for this, long-life maker, for I am going to make a basket for lily-roots out of you.

I pray you friend, do not feel angry with me on account of what I am going to do to you; and I beg you friend, to tell our friends about what I ask of you. Take care, friend!

Keep sickness away from me, so that I may not be killed by sickness or in war, O friend! (Boas, 1921:619)

Of all the resources to be found on the Northwest Coast, the red cedar was the most extensively used tree. Large oceangoing canoes were built of a single cedar log, sometimes forty feet in length. The posts, beams, and planks of the big houses were made of red cedar. The interior furnishings were of cedar, with bent or kerfed boxes made in different sizes for a wide variety of purposes. The largest boxes, often carved and painted, were used for storing clothing and food. They also served as coffins, in which the deceased were placed in a sitting position. Smaller boxes served as water buckets and for cooking pots. These were filled with water to which hot rocks were added to steam or boil the food. Another use of red cedar was in the construction of cradles and chiefs' seats, often carved and painted.

Red-cedar bark was gathered in early summer, when it was easier to strip, while the sap was beginning to rise. The rough outer bark was removed on site, and the inner bark was coiled loosely and tied into bundles for ease of carrying. What remained was split into three layers by using a splitter of deer bone. The outer layer was used to make coarse matting of a size that would serve to partition sections of the house, providing some privacy. Large sails were also made of coarse matting. Old mats were taken on harvesting trips to use as walls of temporary shelters and as canoe covers, to prevent splitting. Ropes were also twisted from strands of the outer layer of bark. Among the Kwakwaka'wakw, the name for rope is *danam*, "from cedar bark." As native fishermen entered the commercial industry, they adopted the use of hemp or sisal ropes, but the traditional name remained. Even today, ropes made of synthetic fiber, such as propylene, are still called *danam*.

The innermost cedar bark was woven into fine matting and used for serving food. It was also woven to size, as tight-fitting lids for cooking and storage boxes. Finely shredded cedar bark served as diaper material in cradles. Capes were woven of bark, which might have twining of mountain-goat wool and be trimmed with strips of fur. Woven mats were used to wrap the deceased before they were placed in coffins. Dyed red, the bark was worked into head rings, neck rings, anklets, and wristlets and was used as decoration on masks and to cover the body of the dancer wearing the mask.

Withes, the tough, flexible small branches of red cedar, were used for fastening the corners and bottoms of bent boxes and in the construction of coarser baskets, such as

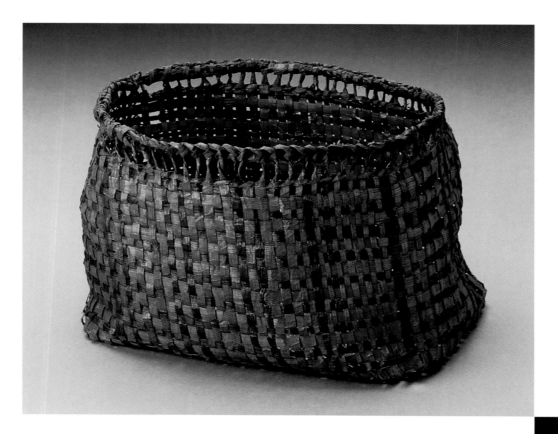

those made for gathering clams. These were of an open-wrap twining, requiring three elements—the warp, the weft, and a flexible strand which held the two together. Each basket was made with handles, so that once the clam digger had filled her basket, she would carry it out into the ocean and move it up and down, to remove the sand clinging to the shells.

Compared with that of the northern groups, basketry took on a minor role among the Kwakwaka'wakw. However, it was believed that if a pregnant woman placed the tools used for weaving under her mattress, she would give birth to a daughter who would grow up to be a good basketmaker and weaver. Another Kwakwaka'wakw belief was that by tying the umbilical cord of a newborn girl around the wrist of an accomplished weaver, the baby would grow up to be skilled at weaving. Among the Kwakwaka'wakw, it was believed that when a woman completed her huckleberry-picking basket, she had to pick the berries right away. Otherwise, she might suffer some misfortune (Boas, 1921).

Almost no elaborately decorated baskets were made, and basketry was confined to utilitarian burden and storage baskets. According to Holm (1990), there were either wrap-twined, openwork burden baskets or plaited cedar-bark containers (plate 47). Basketry filled a utilitarian function, and the Kwakwaka'wakw used the same materials and techniques as their neighbors, the Nuxalk, Heiltsuk, and Nuu-chah-nulth. It is interesting to note that according to Andrea Laforet (1999), the manufacture of basketry for the tourist trade was limited to that of close-twined baskets, and the open-twined containers were not made for sale, but continued to be used for traditional purposes for some years before being replaced by objects of European manufacture. According to her research, the Nuxalk, Heiltsuk, Oowekeeno, and Kwakwaka'wakw of the central province did not produce basketry for sale. This is confirmed in the Clark Field Collection, which contains only two baskets from Kwakwaka'wakw territory and none from the Nuxalk, Heiltsuk, or Oowekeeno. The two small Kwakwaka'wakw clam baskets, dating to about 1890 (1948.39.353 and 1948.39.354), were collected by Clark Field from Frank G. Speck, who had acquired them from the Gottschall Collection. Field originally

PLATE 47: Kwakwaka'wakw rectangular basket, c. 1890 : This small basket, referred to as a clam basket, is typical of the Kwakwaka'wakw. Because they did not make many baskets, it is unusual to see such a delicate basket as this one in a collection (1948.39.353).

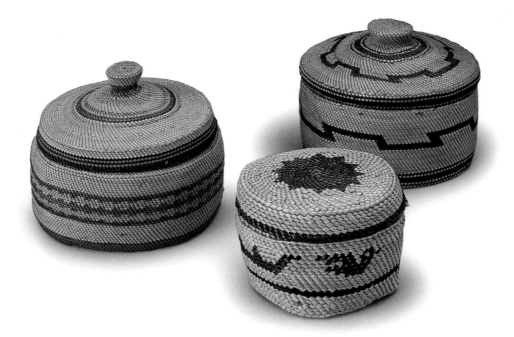

identified both of them as Koskimo, which is a specific tribal name among the Kwak-w<u>a</u>k<u>a</u>'wakw.

The Nuu-chah-nulth, made up of fifteen tribal groups or bands, inhabited the region along the west coast of Vancouver Island and on the northwest extremity of the Olympic Penninsula. Those who lived on Vancouver Island were called the Nootka by Captain James Cook in 1778. According to Lobb (1990), the tribal council has adopted the name Nuu-chah-nulth as the unifying designation for all the tribal groups that share this single culture. He also included the Makah in this group. Among the basketmaking groups of the Nuu-chah-nulth, the Makah and Nootka are recognized for introducing the type of basketry referred to as the "wrapped cross-warp, the birdcage, or fish-trap weaving" (Lobb,1990). This wrap-twined technique is described by Lobb (1990:42):

> The bottom of the Makah and Nootka basket is usually a square constructed of checker-woven cedar bark, but the intersections of each bark strand are embraced by additional rows of twined sedge grass extending to the periphery of the basket's bottom and creating a bird-cage effect. Generally, the wrap material is also cedar bark with a wrapping of bear grass.
>
> The lighter-colored bear grass forming the double weft strand creates a white background for the designs chosen by the weavers. Against this light-colored background, the darker design, created by reversing or twisting the double weft, stand out in dramatic relief.

The Nuu-chah-nulth peoples made their baskets of spruce root and cedar bark and used a variety of twining and plaiting techniques. Conical whalers' hats with the onion-shaped bulb on top, decorated with geometric designs and scenes of whales and whaling canoes or thunderbirds and lightening serpents, are the best-known historic examples of Nuu-chah-nulth basketry. Very few of these have been collected (Holm, 1990). They were typically double woven of split spruce root and black dyed cedar bark with an overlay of chalk-white surfgrass as a background for the pictorial designs. Clark Field collected an undecorated Nuu-chah-nulth hat from the Fred Harvey Company in 1937 and a combination plaited and twined rectangular bowl from Frank Speck in 1941.

In the late nineteenth century, the Nuu-chah-nulth began to weave elaborately decorated baskets using a wrap-twining technique for the nonnative market (Holm, 1990). They were made with a split cedar-bark warp and inner weft, with dyed grass as a twining element. The different colored grasses were used to create a variety of designs and patterns, including geometric bands, swimming birds, whales, and canoes. Many such baskets were made with lids and became popular as trinket baskets for the tourist

PLATE 48 : Makah trinket baskets, c. 1937 : The Makah in Neah Bay, at the northwest tip of the Olympic Peninsula, were known as whalers, and this theme was often depicted on their baskets. Makah trinket baskets made for sale generally have a plaited cedar-bark bottom and twined sides, with grasses used as a decorative element. Left: (1948.39.77 a,b), center: (1948.39.20 a,b), right: (1948.39.79 a,b)

market (Holm, 1990). Clark Field made trips to the Neah Bay area in 1937, 1938, and 1948, where he collected Makah baskets. Of the eighteen Makah baskets Field collected, fifteen were wrap-twined trinket baskets with plaited bottoms (plate 48). Of these, one is an unfinished miniature basket from the Neah Bay that enables us to see the warp strands. The only Makah basket with a documented weaver is a carrying basket made by Ada Markington in about 1900 (1942.14.2091).

Southern Province

The largest and least homogeneous of the three areas of the Northwest Coast is the region from Vancouver Island to the California border, which Holm (1990) designated as the southern province. We limit our discussion of the southern province to those tribal groups represented in the Clark Field Collection, including the Chehalis, Clallam, Clatsop, Lummi, Muckleshoot, Nisqualli, Nooksack, Puyallup, Quileute, Quinault, Siletz, Skagit, Snoqualmie, Suquamish, Swinomish, Tsimshian, and Twana (Skokomish). Field made his first trip to the west Puget Sound area of Washington state in 1937. He went back to Washington in 1938, 1939, 1943, 1948, 1951, and 1952 and collected baskets on several reservations. It is clear from the representation of the different tribal groups in this collection that Field was attempting to acquire representative baskets from each one. In some places, he collected only one, and in others, he acquired several.

In the Olympic Peninsula, Clark Field collected baskets from the Clallam, Quileute, Quinault, and Twana. The Clallam basket weavers, of the Sequim area of Washington, made flexible cylindrical baskets and open-twined pack baskets used for picking hops. Wrap-twined baskets of spruce had a half-twist overlay of bear grass in allover geometric designs. The Clallam also made coiled baskets with imbrication. Some were twill plaited with flat splints of cedar bark or a white wood similar to birch (Turnbaugh and Turnbaugh, 1997). The only Clallam coiled and imbricated basket in the Clark Field Collection is an oval cooking basket (1948.39.39) collected in 1937. On his trip in 1948, Field collected two twined baskets at Sequim, a clam-gathering basket illustrated

PLATE 49 : Gathering baskets : Utilitarian baskets were used for gathering food and materials for the manufacture of clothing and household items. The basket on the right, made by Elsie Payne, has the tumpline still attached. The tumpline went across the woman's forehead to support the basket on her back while she moved around, gathering food and materials. **Left: Quinault clam-gathering basket (1948.39.41), center: Clallam clam-gathering basket (1942.14.2066), right: Quileute gathering basket (1948.39.415)**

in plate 49, and a deep bowl. A twill-plaited, square utility basket made by Julie
Barkhausen and dating to about 1875 (1942.14.2085) was collected in 1948; however,
we do not have a record of where it was acquired.

In 1943, Clark Field stopped at the Quileute Reservation in La Push, Washington,
and collected four baskets, all with the weavers identified. Quileute baskets are similar
to Makah baskets in that they are plain and twill-plaited and twined utilitarian storage
and carrying baskets and wallets of cedar bark and root, with bear-grass overlay as dec-
oration. Field collected two twined baskets, one a plain-twined berry basket and the
other an open-twined carrying basket with woven tumpline made by Elsie Payne (plate
49). In addition to these twined baskets, Field collected a twill-plaited storage basket
made by Mrs. Roy Black (1948.39.413), and a combination twined, checker, and plain-
plaited cradle and bonnet made by Beatrice Hobucket (1948.39.414 a,b).

While on the Olympic Peninsula, Clark Field also collected baskets made by the
Quinault and Twana (Skokomish). The Quinault make close, plain-twined, stiff, deep
bowls and wrap-twined flexible wallets of cedar bark or spruce root. Bear grass is used
in a half-twist overlay in a complex allover geometric design of frets or zigzag patterns
(Turnbaugh and Turnbaugh, 1997). Altogether, Field collected four Quinault baskets.
He purchased an open-twined clam basket in 1937 (plate 49), an open-twined trinket
basket in 1943, and a twined bowl and an imbricated coiled carrying basket in 1948.
The Twana made open- and close-twined soft, flexible, cylindrical bags of cattail and
spruce root with a bear-grass overlay for decoration, as well as coiled baskets with imbri-
cation. The design pattern used by the Twana weavers is an allover geometric pattern
with a horizontal band of stylized animals directly below the rim. Clark Field collected
seven Twana baskets, four of which were soft, flexible wallets. One wallet was collected
in 1939 (plate 50) and three were purchased in 1952. With an eye for something differ-
ent, he collected the other three in 1948. These included two coiled baskets with imbri-

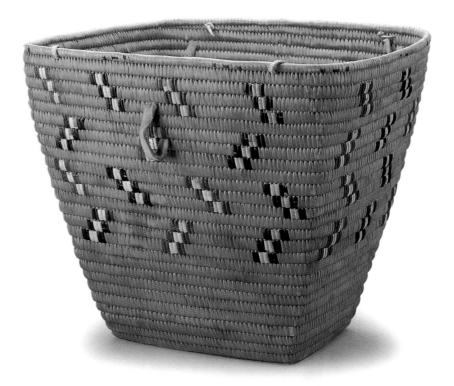

cation, one an oblong bowl and the other a carrying basket made by Sarah Heck in about 1848 (1942.14.2086).

The Lummi people made baskets similar to the Chehalis. Field collected two coiled baskets with imbrication on the Lummi Reservation, near Bellingham, Washington, in 1948. One is a small rectangular basket reportedly made by Mrs. John Salomaen in about 1900 (1942.14.2087), and the other is a wastepaper basket, clearly made for sale (1942.14.2094). He also collected two Nooksack baskets, which are from an area close to the Lummi Reservation. One is a coiled and imbricated carrying basket collected from Northbert Charles in Clearwater, Oklahoma, noted to have been made by his great-grandmother in about 1818 (1942.14.12097). The second, a twined household basket (1942.14.2084) made in about 1910 by Xwienlia-hompkin, mother of Lois George, was collected near Everson, Washington, on Field's trip in 1948.

Clark Field collected Swinomish, Snoqualmie, and Suquamish baskets in 1948. Two Swinomish baskets made by Mrs. Jimmie Jones were collected in La Conner, Washington, one a twill-plaited household basket (1942.14.2090) and the other a rectangular, coiled berry basket with imbrication (plate 51). Two Snoqualmie baskets made by Martha Bagley McDavit were presumably collected directly from her. One is a plain-twined bowl (1942.14.2082) and the other a rectangular coiled berry basket with imbrication, made in about 1900 (1942.14.2077). Field also collected an open-twined and plain-plaited berry basket made by Mollie Bagley in about 1900 (1942.14.2078), and a twined and plain-plaited market basket that he acquired on the Snoqualmie Reservation. On a side trip farther south, Field collected one coiled and imbricated Suquamish berry basket (1942.14.2076) made by Mary George in about 1925 in Marysville.

Several baskets were collected from the Puget Sound area. In 1938, Field collected one Coast Salish basket. In 1948, he collected a Muckleshoot cooking basket (1942. 14.2073) made by Matilda Settle in about 1910, from the Auburn area; a Nisqualli cooking basket made in about 1850, from around Olympia; and a coiled Skagit carrying basket (1942.14.2096) made by Mary Anne Shelton in about 1900. In 1951, he purchased a plain-twined Puyallup storage basket said to have been made in about 1840.

PLATE 51 : Swinomish berry basket, c. 1930 : Berries were a main food item on the Northwest Coast. They were used for several dishes, including pemmican, a small pressed cake made of shredded dried meat mixed with fat and dried fruits and berries. Tightly coiled and imbricated baskets such as this one made by Mrs. Jimmie Jones were used to collect berries (1942.14.2075).

Chehalis basketry forms include stiff, deep bowls of cedar bark and some spruce root, and flexible wrap-twined basketry of cedar bark and cattail. Bear grass is used as decoration in a half-twist overlay in geometric patterns with stylized animals below the rim (Turnbaugh and Turnbaugh, 1997). Clark Field collected four Chehalis baskets made by Susie Williams (1948.39.376 through 1948.39.378 a,b) in 1943 in Montesano, Washington. One basket was coiled with imbrication (1948.39.376), two were plain twined, and the fourth has a combination of twining and plaiting (1948.39.377). He collected another coiled berry basket (1942.14.2080) in 1948 in Oakville, Washington, on the Chehalis Reservation.

The Clatsop in northwestern Oregon made open-twined "clam baskets" and close-twined wallets, small baskets, and flat mats (used as plates and dishes for fish, roots, or berries), cups, caps, and bowls of a truncated conical form. Clam baskets were made of coarse sedge root. Cedar bark was used to make fish baskets, and mats and wallets were made from flags (*Iris sp.*) and cattails. The wallets were often wrap twined with dyed bear grass as a rudimentary decoration. The only Clatsop basket in the collection is a wallet (1951.23.7) made by a "Jennie," collected on the Grande Ronde Indian Reservation (plate 52). The only other basket collected in Oregon is a plain-twined Siletz bowl with half-twist overlay (1948.39.427), which Field purchased from a Mrs. Simmons in Salem, Oregon.

When commercially made metal pots and pans, cardboard boxes, and cloth containers became preferred domestic utensils, it is said that "civilization killed the basket" (Lobb, 1990:7). Although baskets continue to be made today, they generally do not compare with the quality of the older baskets. The monetary return for the time it takes to collect and prepare the materials and then to weave such fine baskets is not an incentive for keeping the art alive. Instead, it is the pride the weaver takes in making a basket that perpetuates its continuation.

When one considers that the identity of individual artists and carvers is often not known by the museums in whose collections their masks, rattles, and other objects are to be found, it is not surprising that the same is true of basketmakers. Additionally, weaving was and still is, to some degree, considered a craft practiced only by women, and it is rarely or only minimally included in discussions or exhibits of "art." *The Legacy* exhibition catalogue published by the Royal British Columbia Museum (Macnair et al., 1980) provides an example. Of the ninety-eight objects in the exhibit, three are basketry hats, two with creators identified. Reference to almost any other museum exhibition catalogue will confirm the difference in the way that objects produced by women, baskets in particular, have been considered less important than those produced by men.

We are fortunate that Clark Field made an effort to recognize the women who wove the ninety-one Northwest Coast baskets he collected. We have the documentation for the weavers of twenty-two baskets. We celebrate and honor the women who wove these baskets, both known and unknown, for their technical skill and aesthetic eye that brought this great art form to the world of collectors and museums.

PLATE 52 : Clatsop wallet, c. 1910 : Unfortunately, we do not know the last name if the weaver, but "Jennie" made this wallet in 1910. Clark Field noted that she was the last weaver in her tribe and that she died in 1920. The animals depicted on this wallet appear to be dogs and deer (1951.23.7).

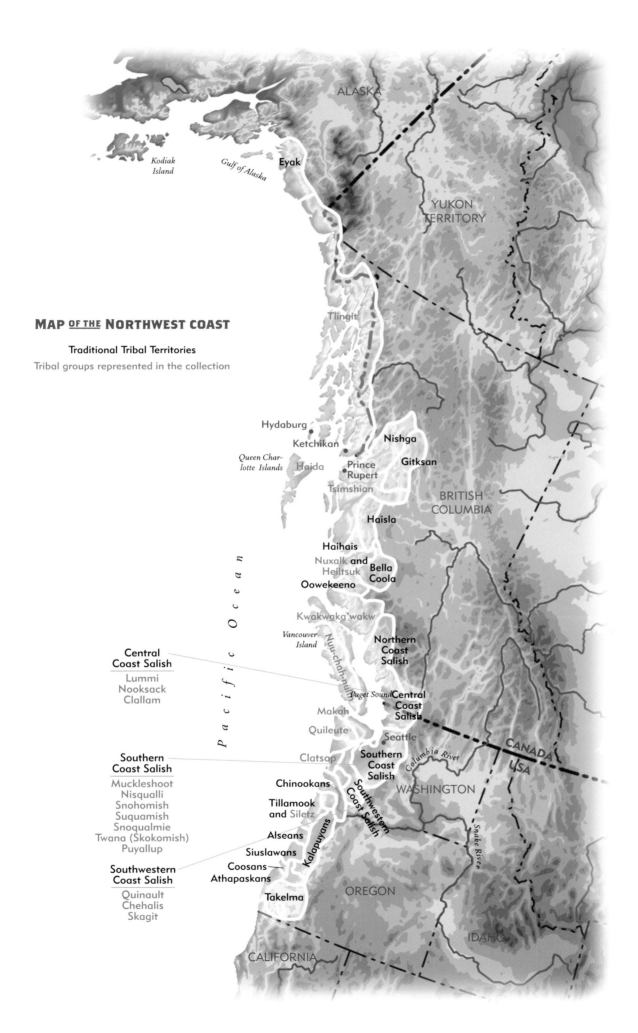

MAP OF THE NORTHWEST COAST

Traditional Tribal Territories
Tribal groups represented in the collection

ALASKA

YUKON
TERRITORY

*Kodiak
Island*

Gulf of Alaska

Eyak

Tlingit

BRITISH
COLUMBIA

Hydaburg

Nishga

Ketchikan

Gitksan

*Queen Char-
lotte Islands*

Haida

**Prince
Rupert**

Tsimshian

Haisla

Haihais

Nuxalk **and**
Heiltsuk

**Bella
Coola**

Oowekeeno

Kwakwaka'wakw

Pacific Ocean

*Vancouver
Island*

**Northern
Coast
Salish**

**Central
Coast Salish**

Lummi
Nooksack
Clallam

Nuu-chah-nulth

Puget Sound **Central
Coast
Salish**

Makah

Quileute

Seattle

CANADA
USA

Clatsop

**Southern
Coast Salish**

Muckleshoot
Nisqualli
Snohomish
Suquamish
Snoqualmie
Twana (Skokomish)
Puyallup

**Southern
Coast
Salish**

Chinookans

Columbia River

WASHINGTON

**Tillamook
and** Siletz

Southwestern
Coast Salish

Snake River

Alseans

Kalapuyans

Siuslawans

Coosans
Athapaskans

OREGON

**Southwestern
Coast Salish**

Quinault
Chehalis
Skagit

Takelma

IDAHO

CALIFORNIA

123

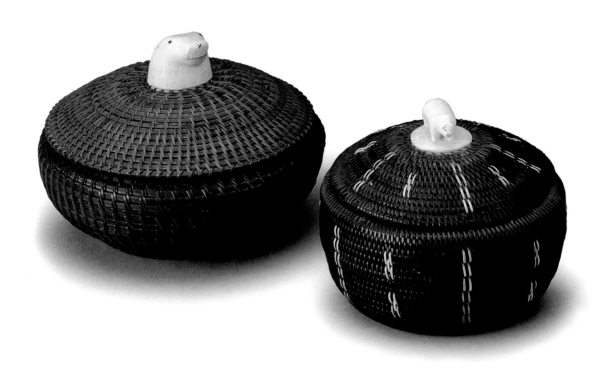

ARCTIC & SUBARCTIC

Ann McMullen

PLATE 53 : Alaskan Inuit baleen baskets : Inupiat men began to create coiled baleen baskets as souvenirs in the early twentieth century. Many of the men worked within characteristic personal styles and signed and dated their baskets before selling them to clients or through craft cooperatives. The basket topped with the complete ivory figure of a polar bear was made by Abe P. Simmonds of Point Barrow, Alaska, in about 1941 (1942.14.1910 a,b). The other is unsigned and its maker is unknown (1942.14.1930 a,b).

The Arctic and Subarctic regions of North America are known for their harsh climates and the challenges those living conditions place on indigenous people living there. However, what is less often recognized is that the adaptive nature of native cultures has allowed people to survive and flourish under circumstances, which can best be described as rigorous. In addition to climate, other mitigating factors include climatic effects on plant life and what this means in terms of resource availability and technology. With regard to basketry, this is particularly significant because in many areas of the Arctic and Subarctic, raw materials which would be suitable for baskets and containers, are rarely found or containers can be produced more easily by using readily available skin or hide. Thus, vast regions of the Arctic and Subarctic will not be discussed here for the simple reason that indigenous people there did not make basketry.

Native people of the Arctic and Subarctic have had a very long history of contact with European-Americans, in some cases because of their proximity to the Atlantic and Pacific coasts and, in others, to the rich fur resources which drew Europeans into the interior to trap and trade. In Quebec and Labrador, contact began in the sixteenth century and moved swiftly into the interior via the Saint Lawrence River. On the west coast,

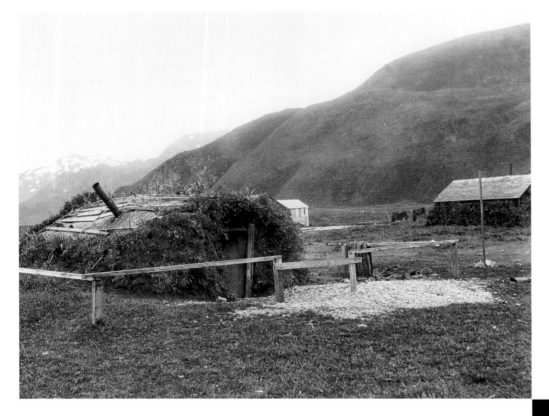

Vitus Bering reached Alaska in 1741, and Captain James Cook followed in 1778, drawing the attention of Russians and others who quickly established trade on the Aleutian Islands and the Alaskan mainland. Because of their size and the history of exploration and colonization, parts of the Arctic and Subarctic have historically been subject to the political and economic influences of France, England, Denmark, Russia, Canada, and the United States, as well as entities such as the Hudson Bay Company, whose economic domination was in some instances more powerful than national attempts at political influence. Despite the extensive expansion of the Hudson Bay Company, some indigenous groups in the Arctic and Subarctic were not in significant contact with European-Americans until the late nineteenth century. In some areas, parts of the Arctic and Subarctic remain predominantly indigenous, including the newly established Canadian province of Nunavut, which has a population that is 80 percent indigenous.

By comparison with other parts of the North American continent, nonnative settlement has had less of a physical impact on the landscape, while still affecting the lives and cultures of native people. Conflicts brought about by the fur trade and other economic developments, including modern construction of dams and hydroelectric power plants, plus missionary efforts and governmental interventions to settle native people in areas where they might receive health and educational services have all significantly affected native people and the ways in which they have pursued traditional lifeways. In many cases, few now "live off the land." Instead, they alternate between spending part of the year in towns and part living "in the bush," accommodating their lives to changes wrought by their inclusion in the modern world system. Others have adapted traditional skills and knowledge to produce art in nontraditional media. Despite these changes, many native people maintain a strong bond with their traditional past and value its continuance.

In this essay, the Arctic and Subarctic are treated as separate areas. Although Clark Field's collections from this massive region seem spotty, they are generally representative. With few exceptions, the regional distribution of his collection mirrors that of basket and bark-container production in the Arctic and Subarctic.

FIGURE 21 : Aleut dwelling at Unalaska, Alaska, July 1899 : This photograph by Edward S. Curtis captures the vast barrenness of Alaska. At that time, Curtis was acting as the official photographer of the Harriman Alaska Expedition. Courtesy of MSCUA, University of Washington Libraries, NA2106.

Environmentally, the Arctic is defined as the region of continuous permafrost north of the tree line, where trees are more stunted and are absent in the areas farthest north (figure 21). With the exception of the mountains in the west, Arctic terrain is relatively flat. In summer, many parts of the treeless tundra remain wet and boggy. Snow comes early and combines with strong winds to create hard-packed surfaces in winter (Stager and McSkimming, 1984). Native people rely greatly on animal life, including whales, walrus, seals, and seabirds in coastal areas, and caribou, musk-ox, arctic hare, bears, and smaller animals inland. In marine and interior environments, fish and bird species are important, including seasonally available waterfowl. Most technologies are based on raw materials available from animals, except in the river deltas, where more vegetation such as grasses and small trees or bushes is available (Freeman, 1984). It is in these locales that native basketry developed in the Arctic.

The indigenous languages spoken in the Arctic belong to the Eskimo-Aleut language family. Aleut, spoken by groups on the Aleutian Islands, consists of one language with two dialects, and Inuit-Inupiat is a series of many dialects spoken from northern Alaska to Labrador. Yupik languages, spoken on the southwestern mainland of Alaska, Nunivak, and other islands, are distinct from Aleut and Inupiaq (Woodbury, 1984). *Eskimo* is a colonial and historic term for Yupik and Inupiat speakers, who generally prefer their own self-designations today. In Canada today, those who were once called *Eskimo* are referred to as *Inuit*, meaning "the people," but in Alaska, the term *Eskimo* still prevails to some degree.

All the Arctic baskets in Clark Field's collection were made by Eskimo/Inuit and Aleut women and men. However, bearing in mind the vast geographic range of these peoples, considerable variation exists within Eskimo basketry and between Aleut and Eskimo basketry. For instance, Labrador Inuit women, living in a largely treeless area, made coiled basketry of wild grasses which closely resembles Eskimo baskets from parts of the Alaskan coast which have similar climates and ecology. Eskimo/Inuit people who make baskets are widely separated, with Inuit people of Canada's northern coast depending on other technologies for the creation of containers.

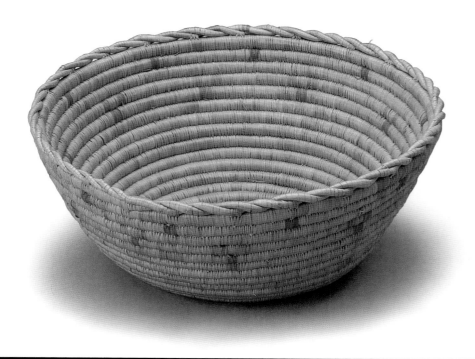

PLATE 54 : Labrador Inuit basket, c. 1920 : This basket is typical of those produced at the Grenfell Mission and which Labrador Inuit women continue to make and sell there today (1948.39.32).

ARCTIC & SUBARCTIC

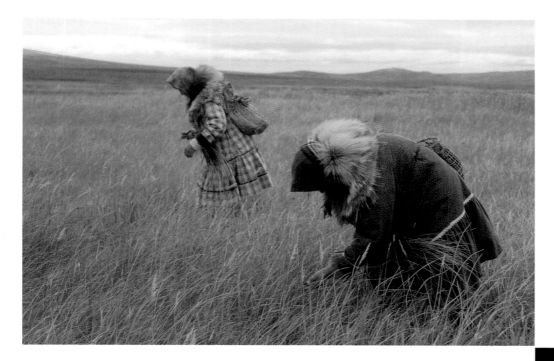

Contact between Labrador Inuit people and Europeans began in the 1500s and continued throughout Canada's French and British colonial periods. In the late eighteenth century, Moravian missionaries from Germany founded several missions in Labrador. In addition to converting the local Inuit populations to Christianity, they opened stores and trading posts, thus making European goods available to the Inuit. In the late nineteenth and early twentieth centuries, the Moravians also encouraged the Labrador Inuit to make crafts for sale, including coiled-grass basketry. When many of the Moravian missions in Labrador closed in the 1920s, the function of selling Labrador Inuit crafts was taken over by the Grenfell Mission of the International Grenfell Association, a philanthropic group which provided medical and other services to the Inuit. In 1905, the Grenfell Mission built a hospital and associated facilities in Saint Anthony, Newfoundland, which served many Labrador Inuit and marketed their basketry (Taylor, 1984).

Clark Field's collection includes four Labrador Inuit baskets, at least two of which were collected by anthropologist Frank G. Speck at the Grenfell Mission in Saint Anthony, in the 1930s and later transferred to Clark Field. All are coiled-grass bowls with small repeated designs woven into the body of the baskets. One basket is more finely made than the others and includes a finely twisted rim finish (plate 54, p. 127). Today, the Labrador Inuit continue to make coiled-grass baskets.

On Alaska's northern coast, basketry was probably introduced from Eskimo populations in more interior locations about the time of increasing historic contact with nonnatives. At that point, basketry was a woman's art, and work in ivory, baleen, and other materials was the province of men. However, in the early twentieth century, when American whaling tapered off sharply, an Alaska trader and whaler, Charles Brower, from the town of Barrow, encouraged a local Eskimo man to copy a traditional coiled basket using baleen, the hard, glossy material which makes up the mouth plates of bowhead whales. From the 1920s onward, the popularity of these baskets grew. Variations in the personal styles of these basketmakers included basket form, type of coiled weave, the inclusion of lighter-colored baleen in the basket's body to create light and dark patterns, and the type of ivory finial used to top the basket lid (Lee, 1983).

Examples with ivory bases and carved ivory finials in the shapes of animal heads were common souvenir items carried by Brower and given to friends or purchased by visitors to Barrow and other towns where the technique spread. From its heyday in the 1930s, baleen basketmaking declined as work opportunities for Inuit men increased,

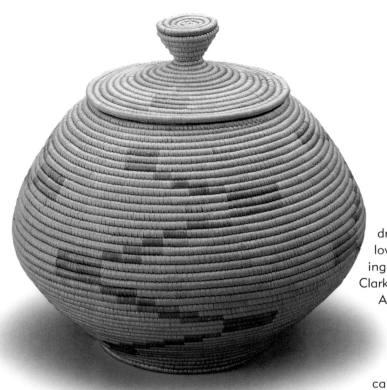

drawing them away from the time-consuming and low-paying process of preparing baleen and weaving small baskets (Lee, 1983). In the early 1940s, Clark Field collected two such baskets in Point Barrow, Alaska. One, made by Abe P. Simmonds (1942.14.1910 a,b), is topped with a carved polar bear and exhibits variation in the basket's body through the addition of lighter-colored baleen. The other unsigned example has a carved seal's head finial (plate 53, p. 125). Although the craft of baleen basketmaking by men has suffered a downturn, it is now being taken up increasingly by Inupiat women in North Slope communities such as Barrow, Point Hope, and Nome, Alaska (Lee, 1983).

Like interior Inupiat peoples of north Alaska, Yupik-speaking peoples of southwest Alaska and its adjacent islands also made coiled and twined baskets, largely of grass (figure 22). Alaskan economies have long been subject to the vagaries of industrial investment there, including the earlier fur trade and the later development of oil and mineral industries. As native employment in these areas has risen and fallen, Alaska's indigenous people have repeatedly reinvested time in the production of crafts for sale, especially to tourists who regularly visit the more southern portions of Alaska which have long been home to the Yupik Eskimo. Although many forms, such as flat bags, mats, and burden baskets, were made, smaller forms decorated with small, colored elements developed as popular souvenirs made for sale to visiting tourists and other travelers.

In the late 1940s, Clark Field collected both traditional and commercial examples of this kind of basketry during his travels to Alaska. During the 1930s, the Indian Arts and Crafts Board, a United States federal agency, assisted in the preservation and expansion of traditional crafts by sponsoring regional craft shops as well as workshops to teach specific crafts, including basketry. In 1938, Clark Field purchased a Yupik basket from the Indian Arts and Crafts Board outlet in Juneau, Alaska (plate 55). In 1948, Field collected three round, coiled baskets at Hooper Town Bay. One was a rather large, un-decorated basket and two were smaller covered examples with knobbed lids, typical of forms made for sale. Lastly, in 1946 Field acquired, probably from someone in the military service, two Yupik baskets on Nelson Island, at the mouth of the Kuskokwim River (plate 56, p. 130). Although the baskets Field collected were typical of that period, they also represent styles which have continued to be made up to the present. Similar coiled-grass baskets continue to be made and sold in local and regional craft and art cooperatives.

Although the Aleutian Islands are considered part of the Arctic, many aspects of Arctic climate and life do not apply; instead, there is no permafrost, and the islands' flora includes many grasses and flowers, but no trees (figure 21, p. 126). As a result, Aleut baskets are twined by using finely split local grasses, and those made on different islands in the Aleutian chain vary slightly in technology and decoration. Some types of traditional baskets have probably been made for thousands of years, but Aleut basket-

PLATE 55 : Yupik basket, c. 1938 : The Indian Arts and Crafts Board shop in Juneau, Alaska, handled native crafts from communities throughout Alaska, including this basket made by a Yupik Eskimo woman from Nunivak Island in the Bering Sea off the coast of Alaska (1948.39.96 a,b).

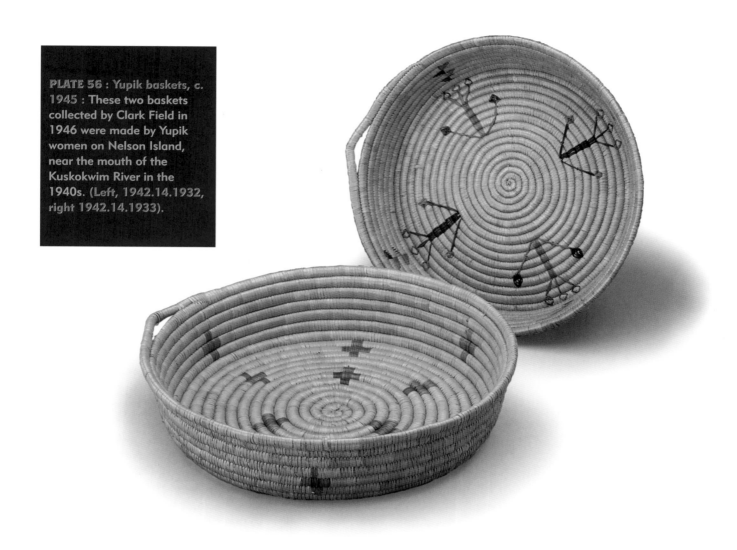

PLATE 56 : Yupik baskets, c. 1945 : These two baskets collected by Clark Field in 1946 were made by Yupik women on Nelson Island, near the mouth of the Kuskokwim River in the 1940s. (Left, 1942.14.1932, right 1942.14.1933).

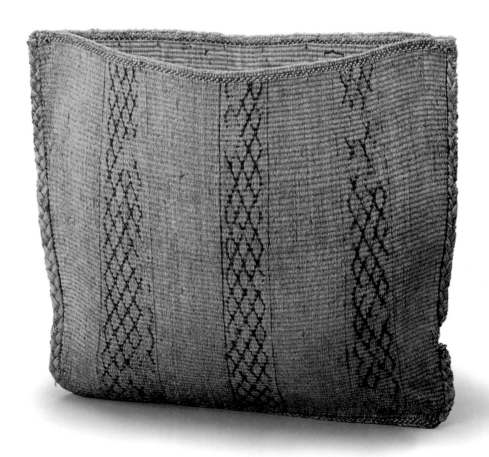

PLATE 57 : Aleut pack bag, c. 1880 : Although Clark Field collected this pack bag in 1937, it probably dates to the late nineteenth century and saw decades of service in an Aleut household. Because of their hard use, few such examples were collected and preserved in museum collections in the continental United States (1948.39.10).

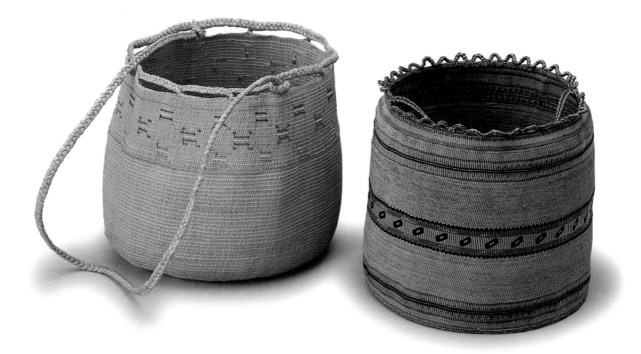

makers developed other forms to suit the desires of buyers who visited the Aleutians as part of whaling, fur-trading, or other trips, especially during the late nineteenth and early twentieth centuries. Many of these baskets were decorated with colored silk and wool yarns in geometric and floral patterns. As contact with Americans increased on the Aleutian Islands, Aleut people made fewer traditional items for their own use.

Declines in whaling and sea-otter hunting for furs, as well as the Great Depression, brought about a decreased market for Aleut baskets, and fewer women wove baskets for their own use or for sale. In addition, during World War II, the Aleutians were subject to Japanese attack. Aleut people were evacuated and housed in southeastern Alaska, thus depriving them of the grasses from their home islands which they would have used to make baskets to sell to American military personnel. By the mid-1940s, when Aleut people returned to the islands, only a few women made baskets (Lantis, 1984; Turnbaugh and Turnbaugh, 1986). In recent decades, some Aleut people have continued to make baskets, but the intensive work required makes the sale prices of baskets so high as to almost prohibit a market for them.

Of all Arctic and Subarctic basket types, Clark Field had the greatest investment in Aleut basketry, with fifteen examples. Aleut baskets are widely admired as artistic works for the fineness of their weave and designs, and this—in combination with the opportunities Field had to collect Aleut baskets during trips to Alaska—may account for their disproportionate representation in his collection. For instance, in 1937, Field collected three baskets made by Aleut basketmakers on Attu Island, including a very old traditional twined pack bag (plate 57) that may have been used to transport personal possessions or foodstuffs, possibly resting in the bottom of a kayak, and a small covered trinket basket (1948.39.51 a,b). Another trinket basket was purchased from the estate of Henry B. Spencer of Sacramento, California. In 1938, Field collected another small covered trinket basket from the Aleutian Islands.

In 1942, Field secured several more Aleut baskets, including two larger examples of tall, cylindrical baskets of the type used by the Aleuts themselves and decorated with false embroidery in silk and wool (plate 58, p. 131), as well as another trinket basket of

the type made for sale to tourists. That same year, Field purchased three larger, traditional Aleut baskets from George Chick of Kelseyville, California, all dating to about 1900 (1948.39.348, 1948.39.349, 1948.39.350). A trip to Alaska in 1948 yielded three more baskets, including a two-piece wallet decorated with silk embroidery (plate 59), and two more examples of traditional forms. Finally, Field rounded out his collection of Aleut baskets in 1955 by purchasing a basketry-covered bottle with a silk-embroidered design (1955.16.7 a,b) from Mr. and Mrs. Melvin T. Boice of Akron, Ohio (plate 59). They had bought it at Dutch Harbor on Unalaska Island in 1902. Taken as a whole, Field's appreciation for Aleut basketry, as well as fine basketry from other parts of North America, speaks volumes about his commitment to preserving these examples of native artistry.

Subarctic

As a region, the "Subarctic" is exactly that—a massive area which lies physically below the North American Arctic and corresponds to the great northern forest which stretches from Alaska's interior to Labrador. The region's topography varies widely, from the lowlands and plains of the Canadian Shield across Quebec, Ontario, Manitoba, Saskat-chewan, and Alberta to the mountains of the Cordillera in British Columbia and the Yukon to the plateaus and river valleys of interior Alaska. Much of the area has a cold but relatively dry climate, with snow cover from 140 to 200 days of the year. Snowmelt contributes to lakes, rivers, and bogs, and these foster open woods of spruce, tamarack, firs, and pines, as well as poplar, aspen, and white birch. Farther north, these species are dwarfed by cold, dry conditions and exist alongside other low-growing flora such as lichens (Gardner, 1981).

Throughout the Subarctic, caribou, moose, and snow-shoe hare were important foods for native peoples, who lived by hunting, trapping, and fishing. Seasonally and year-round, bird and fish species were also important (Gillespie, 1981). Many native groups, organized in multiple related bands, occupied vast territories with boundaries which shifted historically. In many ways, Subarctic peoples were wholly dependent on animals for their livelihood, moving across the landscape to take advantage of seasonally available fish and bird resources or following migrating caribou. At different times of the year, they might live as bands of twenty to fifty people or, during the winter hunting seasons, individual families might travel and live on their own in conical or dome-shaped lodges covered with hides, boughs, or bark. Animals and the forests provided raw materials for clothing, containers, snowshoes, sleds, and canoes (Rogers and Smith, 1981).

The mobile nature of Subarctic Indian life provided a means for French and English access to furs from 1500 onward, with resulting changes in Indian lifeways also brought about by access to trade goods and the activities of missionaries. As a result of the shift to more intensive trapping, many native peoples lived near trading posts for at least part of the year and shifted to consumption of store-bought foods, which had effects both on their health and their independence, because they often remained in debt to the posts. Traditional clothing and implements gave way to cloth and metal tools. After 1945, the

PLATE 59 :
Commercial Aleut forms : Aleut women made a variety of smaller basket forms strictly for commercial sale. One of the most common of these forms was a "wallet" of two parts that slid together (1942.14.2048 a,b) to be used as cigar or glasses cases. Small covered "trinket baskets" were popular as sale items. In many cases, these small baskets are more heavily decorated than larger baskets. Aleut women occasionally covered glass bottles (1955.16.7 a,b) with basketry to sell at ports, such as Juneau. Each of these examples is decorated with designs executed in silk embroidery floss purchased at local trading posts.

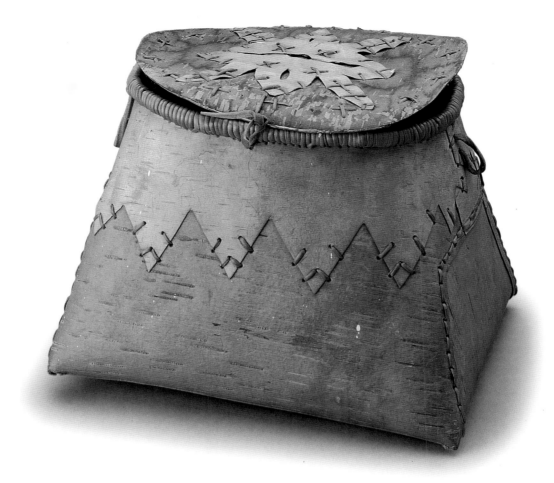

Canadian government took over responsibility for the health and education of its First Nations. This resulted in population recovery and a greater reliance on town life, a decline in the importance of the fur trade, and a concomitant rise in native rights and autonomy (Helm, et al., 1981).

Traditionally, all Subarctic tribes spoke languages of the Algonquian and Athapaskan language families. Algonquian speakers used languages and dialects of the Cree (including Cree, Montagnais, and Naskapi) and Ojibwa (Ojibwa, Chippewa, Saulteaux) language subfamilies. Athapaskan speakers differed broadly and maintained separate Koyukon, Ingalik, Tanana, Tanaina, Tahltan, Chipewyan, Slavey, Dogrib, and other languages. Many of these languages remain viable today.

Traditionally, native peoples of the Subarctic generally fashioned containers of folded and sewn birchbark, called mokoks, rather than woven basketry per se. In the western Subarctic, some groups made netted skin game bags, and others produced coiled baskets of willow twigs and split spruce roots. Creation of basketry has continued to the present in several areas, but in general, baskets are made for sale rather than for traditional uses. Clark Field's collection includes few examples of Subarctic baskets and bark containers, but these range from the Cree in the eastern Arctic to Athapaskan speakers in Alaska's interior.

Although Cree groups in Canada produce no basketry per se, they made and continue to make fine birchbark crafts, including containers. The Attikamek, or Tête de Boule Cree, of Quebec are still well known for their skill with birchbark as a medium, being one of the few Indian communities in Canada where birchbark canoes are still made. Field's collection includes one Attikamek container, a mokok with a lid and leather handle decorated with designs of six-pointed stars and curvilinear forms etched on birchbark. This mokok was collected by anthropologist Frank Speck and sold to Clark Field in 1942 (1948.39.267 a,b).

In addition, Field's collection also includes three baskets identified as Western Woods Cree from Saskatchewan. These were collected by anthropologist Frank G. Speck at Portage la Loche, Saskatchewan, a Chipewyan community, before 1941, when they

PLATE 60 : Chipewyan mokok : Containers called mokoks were made from folded birchbark stitched with spruce root and decorated with etched or incised designs. This mokok (1948.39.230 a,b) was originally identified by Field as Cree, but the mokok itself exhibits an applied piece under the rim as well as rim details which are characteristic of Athapaskan rather than Cree bark containers.

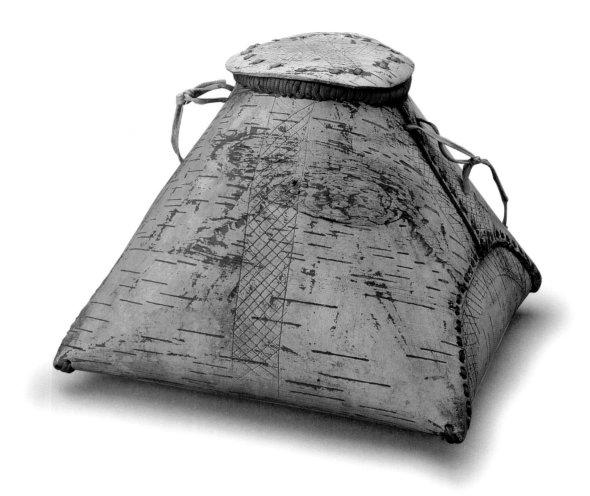

were sold or transferred to Clark Field. These three examples—a bark dish with a hinged cover (1948.39.228 a,b), a covered mokok with an appliqué rim finish of deep jagged diamonds and a floral bark appliqué on the lid (plate 60, p. 133), and a mokok of folded birchbark stitched with spruce root with an inset lid and leather hinge, acquired by Clark Field in 1941 (1948.39.229 a,b) may be Cree or Chipewyan. Portage la Loche was historically a Chipewyan community with some Crees resident there.

Rounding out Clark Field's collection of Subarctic containers from Algonquian-speaking groups, Field also secured a Saulteaux mokok with inset lid, incised design, and leather handle from Frank Speck (plate 61). The Northern Ojibwa, or Saulteaux, were the subject of extensive anthropological research in the early twentieth century. The Saulteaux descend from more southerly Ojibwa people who moved into the area around Lake Winnipeg in about 1800, displacing Cree groups there (Steinbring, 1981). Like their southern Ojibwa kin in Minnesota and Wisconsin, the Saulteaux decorated their birchbark containers by incising designs on the surface, as opposed to the scraped designs more common to the Cree and other tribes farther east.

Birchbark containers were also created by Athapaskan-speaking Subarctic groups. The Gwich'in Dene of Canada's Yukon Territory and interior Alaska—also known as Kutchin and Loucheux—created different types of birchbark crafts. In 1945 and 1951, Clark Field collected two examples from Alaska's Yukon River Valley, including a small birchbark dish and a cradle of folded and sewn birchbark.

In accordance with environmental differences between Subarctic Canada and interior Alaska, the Koyukon and other northern Athapaskans of interior Alaska use different materials and technologies to create containers. In particular, the Koyukons' nearest

LATE 61 : Saulteaux mokok, c. 1910 : Field collected this mokok (1948.39.270 a,b) from Frank G. Speck, who acquired it from its maker, Mrs. John Keefer of Berens River, Manitoba, in 1933.

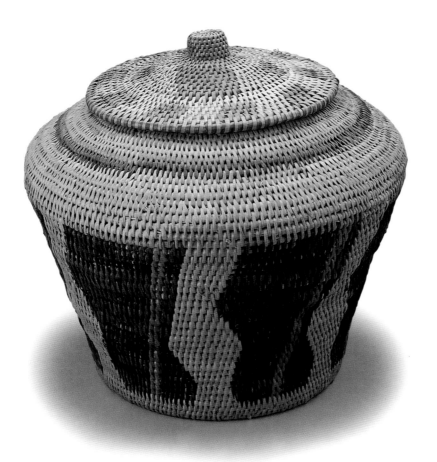

neighbors are the Eskimo peoples of northern Alaska. Like them, the Koyukon make
sturdy coiled baskets of willow, such as the lidded storage basket collected by Clark Field
in Alaska in 1948 (plate 62). In turn, the Koyukon probably taught Eskimos living on
interior rivers how to make folded birchbark containers (Hail and Duncan, 1989).

Taken as a whole, Clark Field's collection of Arctic and Subarctic baskets is a testi-
mony to his respect for the works and lives of native peoples, and his desire to preserve
ongoing traditions. And by collecting both traditional and innovative examples, he
demonstrated his belief that change was a natural part of a basketmaker's life and that
modern Indian people, like their forebears, should be recognized as artists.

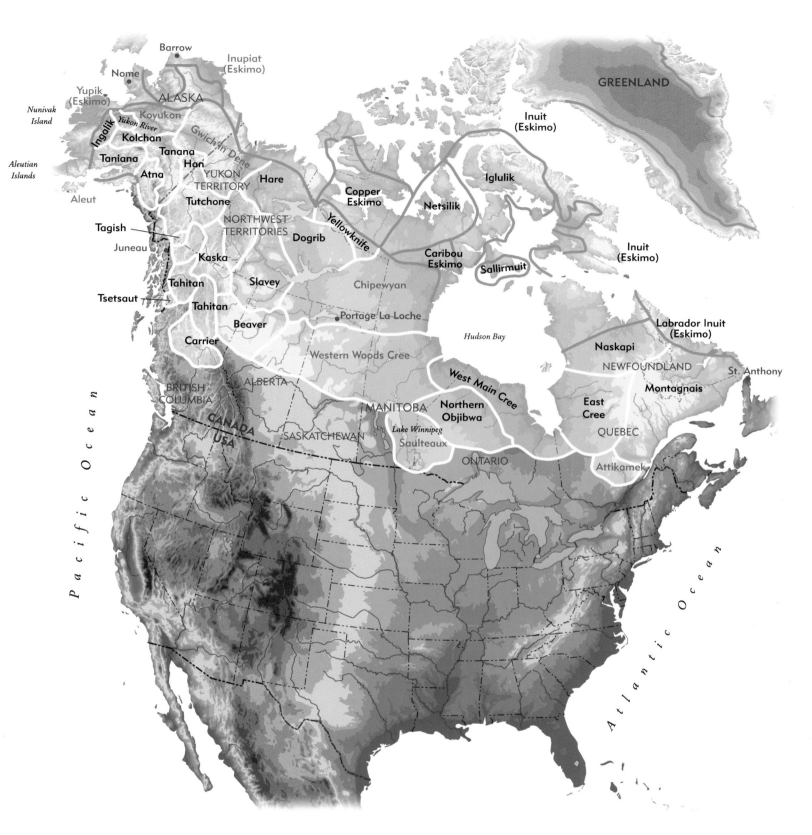

Barrow

Nome

Inupiat
(Eskimo)

Yupik
(Eskimo)

*Nunivak
Island*

ALASKA

Koyukon

Ingalik

Yukon River

Kolchan

Gwich'in Dene

Aleutian
Islands

Taniana

Tanana

Han

Atna

YUKON
TERRITORY

Hare

Aleut

Tutchone

NORTHWEST
TERRITORIES

Copper
Eskimo

GREENLAND

Inuit
(Eskimo)

Iglulik

Netsilik

Tagish

Dogrib

Yellowknife

Juneau

Kaska

Caribou
Eskimo

Inuit
(Eskimo)

Tahitan

Slavey

Chipewyan

Sallirmuit

Tsetsaut

Tahitan

Beaver

Portage La Loche

Hudson Bay

Labrador Inuit
(Eskimo)

Carrier

Western Woods Cree

Naskapi

NEWFOUNDLAND

St. Anthony

BRITISH
COLUMBIA

ALBERTA

West Main Cree

East
Cree

Montagnais

CANADA
USA

MANITOBA

Northern
Objibwa

QUEBEC

SASKATCHEWAN

Lake Winnipeg

Saulteaux

ONTARIO

Attikamek

Pacific Ocean

Atlantic Ocean

MAP OF THE ARCTIC & SUBARCTIC

Traditional Tribal Territories

Tribal groups represented
in the collection

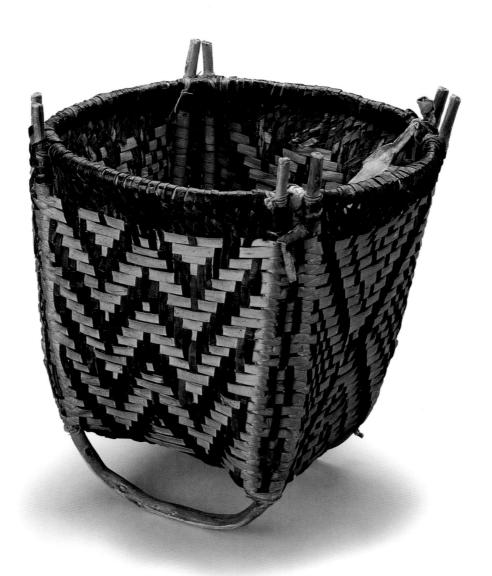

PRAIRIE & PLAINS

Lydia L. Wyckoff

The Plains include the heartland of North America. It is a vast grassland that stretches from northern Alberta and Saskatchewan, in Canada, southward to the Rio Grande border of Texas. Its distinct western margin lies along the foothills of the Rocky Mountains. To the east, the short-grass plains of the West gradually give way to the tallgrass plains or prairie dominated by the Missouri–Mississippi River drainage system.

The contrast in vegetation between the western plains, characterized by sagebrush and yucca, and the eastern prairie, with tallgrass savanna crosscut by streams timbered with oak and elm, is caused by the difference in moisture. In the west, snow and rain will equal approximately ten to fifteen inches of moisture per year, whereas in the east, it is twenty-five to thirty inches. This amount of moisture made agriculture possible on the prairie and along major streams flowing west to east on the plains. Thus, the boundary between the Prairie and Eastern Woodlands cultural areas is defined somewhat poorly. In fact, some anthropologists (Bailey, 1995) consider the Central Algonquin tribes (Illini, Sac, Fox, Miami, Kickapoo, Shawnee) and the Ho-chunk, or Winnebago, a Chiwere Siouan tribe, as sedentary agricultural Prairie peoples.

Prior to the arrival of Europeans, the dry western plains were virtually uninhabited,

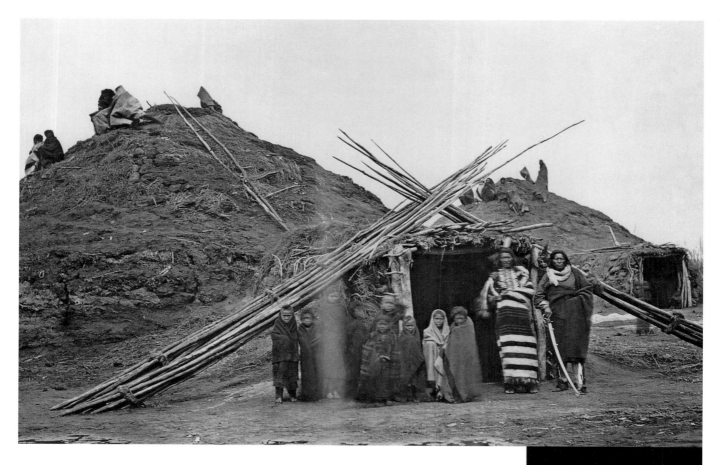

and the northern plains supported only a small nomadic hunter-gatherer population. Although the exploitation of bison, or buffalo, is a characteristic of Plains and later Prairie cultures, the nomadism of the historic period and the development of the bison-horse complex were possible only after European contacts and the reintroduction of the horse.

While Native American culture was radically changed on the plains by the Spanish introduction of the horse, European expansion from the east had a devastating impact on Prairie peoples. In contrast to the Spanish who, for the most part, remained in the villages in the Southwest, trappers and settlers in the east, starting in the seventeenth century, pressed westward, spreading Old World diseases such as smallpox, influenza, measles, malaria, and cholera and killing much, if not most, of the population. Some tribes vanished, others joined together, and small groups of survivors either joined existing tribes or entered the European-American population. As a result, very little is known about the early culture of many groups. By the close of the nineteenth century, the remaining Prairie tribes (Osage, Omaha, Ponca, Kansa, Quapaw, Oto, Missouri, and Ioway) had all been evicted from their lands, in one of the richest agricultural areas in the United States, and had settled in Indian Territory, soon to become Oklahoma.

Traditionally, weaving was an extremely important art for all Prairie peoples. Their permanent villages were composed of mat-covered wigwams along streams or ravines. On the interior, rush mats were used to cover the floor and benches as well as for rolled containers. Bags of twined and knotted Indian hemp, nettle, or the inner bark of elm or cedar were also used as carrying containers and to line storage pits for dried corn, beans, and squash. As Prairie peoples acquired metal and guns from French traders, as well as the horse, prolonged, organized bison hunts into the plains became more economically important than seeking smaller game and the increasingly scarce elk, deer, and bear. With the increased availability of bison hair by the nineteenth century, this

material was added to vegetal fibers for the manufacture of mats and bags. In Oklahoma, Clark Field collected a small (18^1/2 x 21^1/2 inch) Osage mat made of buffalo hair and nettle. This mat probably dates from the 1860s. Its use is not known, but similar, larger mats were used to wrap sacred bundles. This mat was probably a rolled carrying bag, possibly for an article used in a ceremony, such as tattoo needles.

At the time Clark Field was collecting, the Prairie tribes in Oklahoma were probably not making basketry. It is not surprising, however, that the sole Prairie piece he collected was made by the Osage, because they were able to maintain their traditional sociopolitical and religious institutions until the 1880s (Bailey, 1995). This was possible in part because they were more isolated from European-Americans than the tribes located along the Mississippi and Missouri Rivers. Furthermore, the Osage villages along the Osage River in Missouri were nearer to their later reservation land. By the end of the eighteenth century, their present reservation in Oklahoma had become an important part of their bison-hunting area, thereby making the tribe's eventual removal to Indian Territory less disruptive.

By the middle of the eighteenth century, the Osage traveled to the plains to hunt bison in early summer and in fall. This was a time of great anxiety, because the entire village population, except for elderly people and some children, departed to go into contested territory. In 1840, Victor Tixier (McDermott, 1940), a French physician, traveled with the Osage from June to August on their summer hunt. He describes not only the hunt, the butchering, and the drying of the meat, but also the Osages' "eternal enemies"—the Pawnee:

> Dark stormy nights are the ones the Pawnee choose by preference to attack. They can warn one another by imitating the cries of the wild animals, and also create anxiety among the horses and cause them to stampede; so the Osage claim that the Pawnee are sorcerers whose medicine can make nights darker, attract storms, put the warriors to sleep, and stampede the horses. But if all their other means have failed, there remains one last trick for them to do. One of them enters

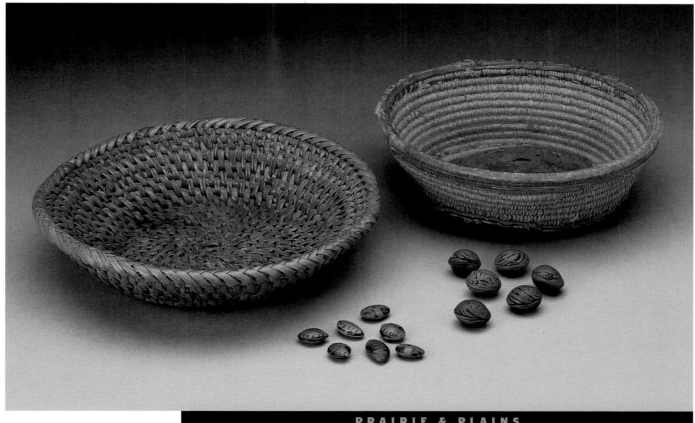

the camp of the enemy alone and without trying to hide his coming into it. He strokes the horses and, of course, does not arouse any suspicion; he cuts the tethers and the reins; then, suddenly jumping on a fast horse, he gallops away, uttering his war cry, while the horses scatter on the prairie, where the Pawnee will soon capture them (McDermott, 1940: 223).

The Pawnee were originally agricultural riverine Plains people living in villages along the Loup, the Platte, and the Republican Rivers, which flow eastward across central and southern Nebraska (figure 23, p.140). Like the people of the prairie, they were agriculturists who hunted the bison. However, they did not have the same complex sociopolitical organization. Shamanism and the vision, so characteristic of the short-grass plains, were important for the Pawnee, as was a religious cycle equally divided between agricultural ceremonies and those for the hunt. By 1840, the Pawnee were hunting southward increasingly in response to Dakota attacks as they were pushed eastward. This brought the Pawnee into conflict with the Osage.

By 1875, the majority of the four Pawnee bands were settled in Indian Territory, having lost their homelands which they had occupied for hundreds of years. Fatal diseases such as measles, smallpox, cholera, and a variety of fevers carried by European traders, as well as Dakota and European-American attacks and, finally, starvation had reduced their numbers from approximately twelve thousand to fifteen thousand to approximately fifteen hundred. According to the United States census of 1910, only 633 Pawnees were living.

In 1939, Clark Field bought, at Pawnee, Oklahoma, the only Pawnee basket in his collection—a round gambling basket (plate 64, p. 141). According to Field, gambling baskets were no longer being made at that time. This probably was true, because in 1929, Gene Weltfish (1930b) interviewed "three old women who had actually made these baskets and still occasionally made them" and who kindly showed her their construction technique.

Like the Pawnee, the Mandan were also agricultural riverine Plains people. By A.D.1100, they had established villages (Wood, 1967) along the Missouri River in present North and South Dakota, on the extreme northern margin of effective agriculture. By the nineteenth century, the Mandan were living in nine separate villages near the confluence of the Heart and Missouri Rivers adjacent to present-day Bismarck, North Dakota. The women cultivated corn, beans, squash, pumpkins, and sunflowers in the soft alluvial soil along the river. Older men grew the sacred crop of tobacco. The villages themselves were compact and consisted of several earth lodges. We know that their neighbors and allies the Hidatsa, for their lodge construction, used matting of willow branches placed over rafters and covered the exterior with layers of packed earth (Wilson, 1934). This is similar to Pawnee lodge construction, as is the use of interior mats. The Skidi Pawnee also used mats as a carrying device, as the Osage did (Weltfish, 1965). Unique to the Mandan, Hidatsa, and Arikara, however, is the twined burden basket.

Like other Mandan burden baskets, the one collected by Clark Field has a frame of four bent U-shaped rods lashed to one another and to a hoop rim (plate 63, p. 139). Two of these rods project outside the weaving and serve as feet for the basket. The bark used for the warp is wrapped around those rods, spiraling downward. The wefts are attached to the hoop rim. Schneider (1984) argues that this form of basket was probably originally covered with hide, because it has a strong resemblance to dishlike hide-covered "bullboats" used for transportation on the river, as well as other hide-covered containers. The bullboat, or coracle, was constructed by sewing green bison hide over a rim of lashed, bent rods. When the rawhide dried, it formed a drum-tight covering. The bison tail was left attached so that when the boat was in use, driftwood could be attached to drag in the water to prevent the boat from revolving and to keep it on course.

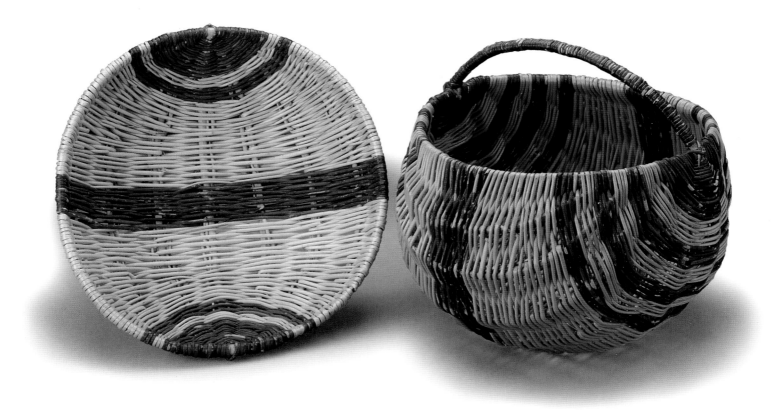

By the close of the eighteenth century, many Ojibwas, pushed west from the Great Lakes region, moved north of the Mandan. These people, commonly referred to as Plains Ojibwa, Salteaux, or Bungi, at the Turtle Mountain Reservation in North Dakota, call themselves Chippewa. Prior to the mid-eighteenth century, they, like their neighbors the Santee Dakota, sometimes referred to as Santee Sioux, collected wild rice, berries, and maple syrup and hunted wild game. By 1800, the Plains Objibwa had moved to the edge of the northeastern parkland and, having acquired the horse, were hunting bison on the Manitoba prairie. However, even though they adopted the bison-hide tipi and the sun dance of Plains culture, they retained their woodland myths and curing ceremonies. After the extinction of the bison herds in the 1880s, the Plains Ojibwa were forced onto reservations in Canada and the Turtle Mountain Reservation in northeastern North Dakota, adjacent to the Canadian border.

In 1954, Clark Field collected a slightly oval handleless red-willow Chippewa basket from the Turtle Mountain Reservation. Also that year, he collected a similar basket from Fort Totten, about sixty-five miles to the southeast (plate 65). Fort Totten served as the fort for the Santee Dakota of Devil's Lake Sioux Reservation, now known as Spirit Lake Reservation, from 1867 until 1890. Shortly afterward, Fort Totten became the boarding school for both the Santee and the Chippewa of Turtle Mountain. Both of those reservations were also served by the Sisters of Charity of Montreal and, during this period, shared a federal agent. Thus, even though the Santee and Chippewa had been rivals when they competed for the same limited resources in the eighteenth century, their lives were now intertwined (Kehoe, 1992). The two baskets collected from these reservations are made with wood spokes and rims. This wood appears to be ash. The frame of the handled basket from Fort Totten appears to be held together with bark, whereas that from Turtle Mountain is tied with string. The weft material is red willow, the majority of which is light, with the bark having been removed. A red band decoration was created with peeled willow. With the similarity in these baskets plus the frequent movement between these reservations—at first by horse, then train, and now roadway—coupled with the fact that, according to Mark Halveison (personnel communication) of the

North Dakota State Historical Society, the Santee never made wicker-plaited baskets, it seems that the Fort Totten basket is not Sioux, as claimed by Clark Field, but rather Chippewa.

When these baskets were first produced by the Chippewa/Ojibwa is unknown, but they are certainly postcontact and were probably made primarily for the European-American market. The earliest written record of these baskets is in the late 1920s, when they were recorded by Frances Densmore (1929). She refers to them as being an "old form" and states "baskets were made of willow at an early date." In the 1930s, red willow baskets were sold to tourists along the shore of Rainy Lake on the Minnesota/Ontario border (Schlick, 1983). Willow baskets continue to be made by both the Chippewa of Turtle Mountain (*Baskets: Red Willow and Birchbark*, 1990) and the Ojibwa of Red Lake (Schlick, 1983).

For the nomadic bison hunters of the central and southern plains, rawhide and tanned hide were used for containers, for dwellings, and for cloths and blankets. The only type of basket made was the coiled gambling basket (plate 64, p. 141). The dice, made from plum or peach pits or bone, were placed in the basket and then tossed into the air. The basket was then placed on a mat on the ground, frequently with a bang, to recapture the dice. This game was most commonly played by women. Clark Field collected two gambling baskets from the Southern Cheyenne in Oklahoma.

The Cheyenne, like so many Plains people, were originally agriculturalists. Their villages were along the Sheyenne River in eastern North Dakota. By the close of the eighteenth century, attacks by the Dakota and Plains Ojibwa, also known as the Chippewa, and the decline in game forced the Cheyenne to abandon their earth lodges and become nomadic tipi dwellers. Although initially they continued some agriculture, this quickly declined, necessitating trading trips to Arikara villages to obtain maize.

Out on the plains, the Cheyenne learned the sun dance from the Sutai, a cognate group later incorporated as a band of the Cheyenne. Because Plains people spent most of the year in bands of twenty-five to one hundred individuals—the optimum number to manage a bison drive, which was the most efficient way to secure food—the sun dance provided a ceremonial occasion for thousands to gather together. With so many people gathered at one place, the sun dance was held in the early summer, when there was lush green pasture for the horses and when the bison began to congregate, but before the bison mating season. For approximately two weeks, the people traded, gambled, held sport competitions, and visited. Individuals sought spouses, and leaders gathered to settle disputes and form policies.

By the mid-nineteenth century, the Cheyenne occupied eastern Colorado and western South Dakota. United States military campaigns and attacks from the Dakota gradually pushed some bands southward. Most of the Black Kettle band was massacred on Sand Creek in 1864 by the Colorado Calvary, a militia formed by Colonel John M. Chivington, who disregarded the fact that the Cheyenne had made peace and were theoretically under the protection of Major Edward W. Wynkoop at Fort Lyon. After the murder of many men, women, and children at Sand Creek, Black Kettle moved southward into Indian Territory. Once again, he sought peace, presenting himself, along with Little Robe of the Cheyenne and Big Mouth and Spotted Wolf of the Arapaho, longtime friends and allies of the Cheyenne, to Major General William B. Hazen at Fort Cobb. Dangerously low on supplies for the Indians who were already there and suffering from the ever increasing decline in the bison herds, Hazen sent them back to their camp on the Washita River. He also warned them not to change camp and move north of the Arkansas, where General William Tecumseh Sherman was waging war. Seven days later, on November 27, 1868, Lieutenant Colonel George Armstrong Custer attacked the sleeping village of fifty-one lodges.

One hundred three Cheyenne were killed, including Black Kettle and his wife. Fifty-three women and children were taken prisoner. After Custer chose a tipi as his souvenir, the village was destroyed. During these activities, Captain Frederich W. Benteen

describes Custer as exhibiting "his close sharp-shooting and terrifying the crowd of frightened, captured squaws and papooses by dropping the straggling ponies to death near them. Oh! he is a clever marksman. Not even do the poor camp dogs of the Indians escape his eye and aim as they drop dead or limp away howling" (Hoig, 1976).

Four members of Custer's Seventh Regiment were killed or mortally wounded. Eighteen men were missing. On December 7, an expedition was launched to recover these men. Their stripped bodies were found, and it was determined that they had set off in pursuit of escaping Cheyenne—men, women, and the "old and infirm"—who were running toward some other camps of Cheyenne, Arapaho, and Kiowa. Warriors from those camps, led by Big Mouth, had rallied to the aid of Black Kettle and had met the pursuing soldiers and killed them.

In the end, however, it was not the United States Cavalry but the decimation of the bison herds that forced the Cheyenne back to Fort Cobb. On December 31, 1868, a delegation of twenty-one Cheyenne and Arapaho chiefs walked into Fort Cobb, their horses too weak to carry them (Hoig, 1976). Their people were starving. In January 1869, Custer and Sheridan negotiated a peace with the Plains peoples of the South at Fort Cobb. Sheridan now sought a more southerly location for his fort, closer to the resettled tribes in western Indian Territory. Sheridan designated the "New Fort Cobb" as Fort Sill in honor of his West Point classmate Joshua W. Sill. The Cheyenne Nation was now divided between the Southern Cheyenne in Indian Territory and the Northern Cheyenne, who were settled on a reservation in Montana in 1884.

Of the two Cheyenne gambling baskets collected by Clark Field, one (1948.39.98 a-k) was made in about 1880 (plate 64, p. 141). According to Field, it was made by "Old Lady Bald Eagle." It is coiled with oil weed on a single willow-stick foundation. The base is made of black leather from what was probably a cavalry boot, complete with a bullet hole. Could this boot have belonged to one of the eighteen men killed and stripped at the Washita? The rim of the basket is bound with mattress ticking of the period. This and the use of fabric on the inner base are characteristic of Arapaho gambling baskets (Turnbaugh and Turnbaugh, 1986). However, by 1880, the Cheyenne and the Arapaho shared their Oklahoma reservation, frequently intermarrying as well as sharing ideas. The second Cheyenne gambling basket was made in 1942 by Laty Osage and purchased from her in Longdale, Oklahoma, by Clark Field. It is coiled coarsely in yucca with split stitches typical of Cheyenne baskets.

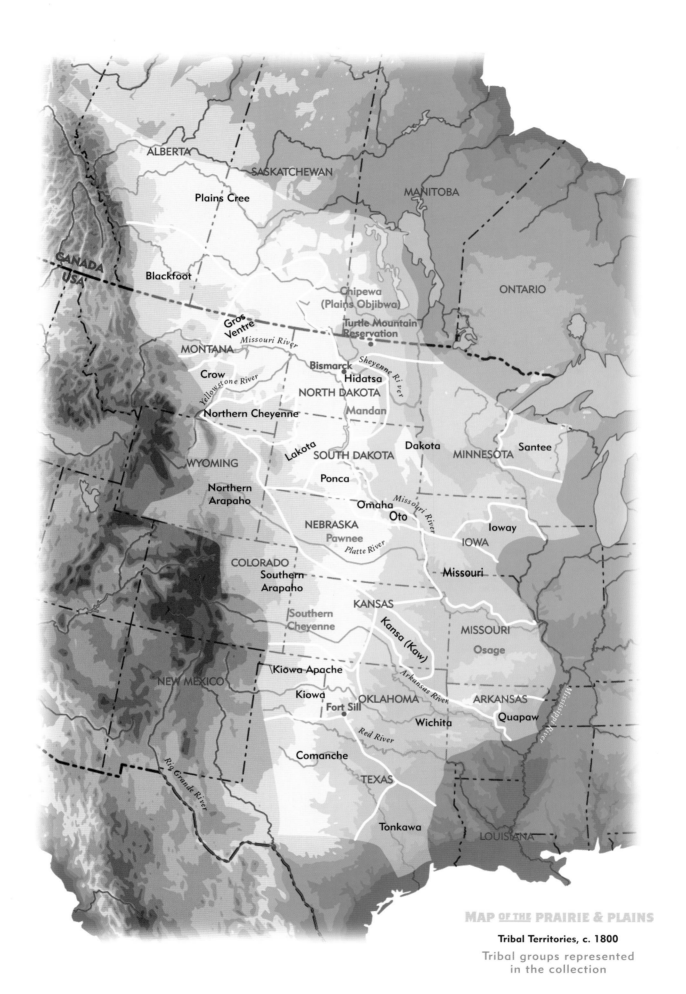

ALBERTA

SASKATCHEWAN

MANITOBA

Plains Cree

ONTARIO

Blackfoot

CANADA
USA

Chipewa
(Plains Objibwa)

Gros
Ventre

Turtle Mountain
Reservation

Missouri River

MONTANA

Sheyenne River

Crow

Bismarck

Yellowstone River

Hidatsa

NORTH DAKOTA

Northern Cheyenne

Mandan

Lakota

Dakota

SOUTH DAKOTA

MINNESOTA

Santee

WYOMING

Ponca

Northern
Arapaho

Omaha

Oto

Missouri River

NEBRASKA

Pawnee

Ioway

IOWA

Platte River

COLORADO

Missouri

Southern
Arapaho

KANSAS

MISSOURI

Southern
Cheyenne

Kansa (Kaw)

Osage

Arkansas River

Kiowa Apache

NEW MEXICO

Kiowa

OKLAHOMA

ARKANSAS

Fort Sill

Wichita

Quapaw

Red River

Mississippi River

Comanche

TEXAS

Rig Grande River

Tonkawa

LOUISIANA

MAP OF THE PRAIRIE & PLAINS

Tribal Territories, c. 1800

Tribal groups represented
in the collection

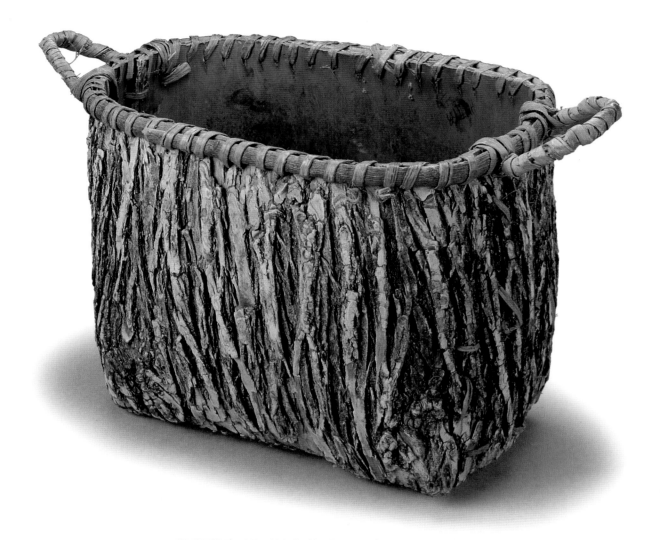

EASTERN WOODLANDS

Ann McMullen

Native Americans of the Woodlands were the first to be affected by Europeans; as a result, they have had the longest period of adaptation and accommodation. In the Woodlands, tribes were exposed to European influences at different stages. From the late fifteenth century onward, native people on the coasts encountered European explorers, exchanging furs and agricultural products for metal tools, beads, and other trade goods. In the Great Lakes, contacts occurred about a century later. Seventeenth-century epidemics decimated native populations and radically altered ways of life, followed by the entry of colonists. These changes occurred later in the Great Lakes, with intensive settlement beginning in the eighteenth century.

Through wars, treaties, and tribal movements, Native Americans often lost political control over much of their land. Some groups adapted to relations with European-Americans, while others sought new lands far from these disruptions. For some, movements brought about major changes in lifeways. In the Great Lakes, tribes which were adapted to forested areas—Sac, Fox, Kickapoo, and Prairie Potawatomi—were driven onto the prairies, where they developed greater reliance on agriculture and the resources of the prairies.

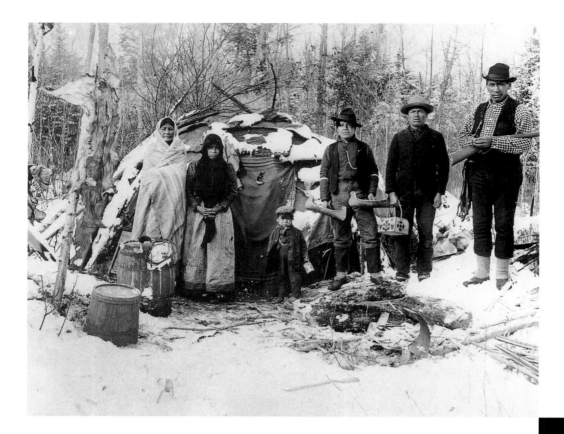

Despite changes, native people maintained a strong sense of traditional life. In the eighteenth and nineteenth centuries, many also found ways of accommodating craft production and lifeways to these newcomers, making decorated baskets, birchbark containers, woodenware, and beadwork both for their own use and for sale (figure 24). In the Great Lakes region, lumbering, maple sugaring, and harvesting wild rice have also remained important as ways to make a living. Although their lives have been very much changed by colonization, Woodland Indian people have retained much of their culture and remain a strong presence in local society.

The Woodlands include the forested areas east of the Mississippi River and north of Cape Hatteras and extending north of the Great Lakes and the Saint Lawrence Seaway into the Canadian Maritimes. Woodland Indian cultures are broadly similar but vary regionally. Traditionally, Woodland Indians were farming, hunting, and fishing people, with lifeways adapted to their environments—forests and parklike woods, waterways, and coastal areas. Eastward from Lake Superior to New England, this landscape included mixed deciduous and coniferous trees. A belt stretching from Illinois through Ohio to southern New England included oak and hickory, with patches of prairie in the western section. North of this belt are northern hardwood forests of birch, beech, maple, hemlock, white pine, oak, basswood, elm, and ash. Wood, bark, and plant fibers were valuable for the arts and artifacts of material culture (plate 66, p. 149). The paper birch was especially useful for creation of native wigwams, canoes, and food and storage containers, and maple was used for its sugar. Ash provided wood for hunting bows and, during historic times, splints for weaving baskets. Hickory, beech, and other nut trees also provided important food sources.

Basswood yielded fibers for string or cordage, which was also used to make bags or soft baskets (plate 67). In spring, bark was peeled from the tree in long strips, and the inner bark was tied in coils. These were boiled with lye, made of wood ashes, until the fibers began to separate. The fibers were separated by rasping the strip through a hole in the pelvic bone of a deer and then rolling them on the thigh until they were twisted

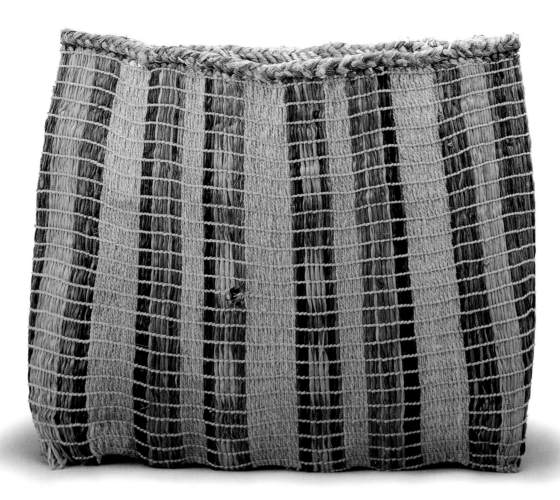

into string. Traditionally, some warp fibers were dyed by using vegetal dyes and grouped in the body of the bags, which were most often open-twined with spaces left between the twined rows to keep the bag flexible. In the mid-nineteenth century, aniline dyes (derived from coal tar) became available and were used to dye basswood fiber for making bags.

Woodland Indians were extremely knowledgeable concerning the properties and uses of trees and other plants, and they exploited that knowledge for foods—wild rice, nuts, berries, and wild vegetables—and for medicines. The forests also provided diverse animal life, and food secured by hunting and trapping formed a considerable part of Woodland Indian diets. Fishing was also a year-round occupation in which Woodland Indians used fishhooks, nets, spears, traps, lures, bait, and trolling lines.

South of a line drawn from central Maine to central Wisconsin, native people relied—at least in part—on agriculture. Women raised corn, beans, and squash. Men hunted deer and moose with bow and arrow and fished on land and from dugout canoes, using nets, hooks, and traps. Women also collected shellfish and wild foods. Their dome-shaped wigwams and longhouses, of saplings covered with bark or woven mats, were furnished with sleeping mats and furs, pottery vessels, wooden spoons and bowls, baskets, bags, and other tools and equipment.

To the north, where the limited growing season made agriculture unreliable, Native Americans depended on hunting with bows, arrows, and spears; fishing on land and from birchbark canoes; and gathering wild foods. In the Northeast, northern people lived in conical wigwams covered with birchbark, and their household goods included containers of folded and stitched birchbark. In the Great Lakes region, dome-shaped wigwams were the norm. In many parts of the Great Lakes—particularly northern Wisconsin—Indian people depended on wild rice as a dietary staple. Where sugar maples grow, Great Lakes Indians established sugar-making camps in early spring and made sugar from tree sap as part of their seasonal round.

Traditionally, most Woodland tribes spoke languages of the Algonquian language family. There are at least thirty Algonquian-speaking tribes in the Woodlands. In the Great Lakes, these include the Ojibwa, Ottawa, Potawatomi, Menominee, Cree, Sac, Fox, Kickapoo, and others. In the Northeast, the Penobscot, Passamaquoddy, Micmac, Mohegan, Pequot, Delaware, and others also spoke Algonquian languages. Besides Algonquian languages, the Woodlands also include languages of the Iroquoian and Siouan language families. The Seneca, Cayuga, Onondaga, Oneida, Mohawk, Huron, and other tribes spoke Iroquoian languages. The Ho-chunk (Winnebago) speak a Siouan language.

For the purposes of this essay, the Woodlands area has been divided into five environmental and cultural subareas: northern New England and the Maritimes; southern New England (including Long Island); the Iroquoian area; the mid-Atlantic region; and the Great Lakes. These areas differ from one another environmentally, culturally, and historically, making separate discussions appropriate.

Northern New England and the Maritimes

Hunting and gathering peoples of northern New England and the Maritimes—including the Penobscot, Passamaquoddy, Abenaki, Maliseet, and Micmac—originally made folded and sewn birchbark containers. Wood-splint basketry—also known as splint, split-wood, checker plaited, ash-splint, and a variety of other names—was the most common basket technology in native New England after European contact. This type of basketry is thought to have been introduced by Swedish settlers in the Delaware River valley in the early 1700s (Brasser, 1975). Although some disagree (Bardwell, 1986; Whitehead, 1980), there is little evidence to suggest that wood-splint baskets were commonly produced except as sieves and corn-processing baskets. However, by the mid-eighteenth century, splint storage and workbaskets were commonly produced

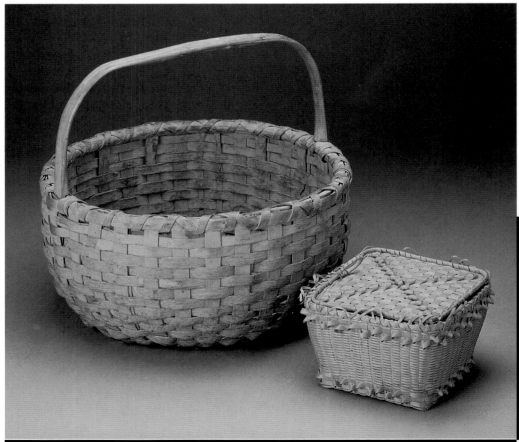

PLATE 68 : Micmac and Maliseet splint baskets : The Micmac example shown here on the left is a small potato basket, made by the Steve Barlow family (1942.14. 2004). The other basket pictured is a Maliseet fancy sewing basket from about 1900, illustrating the use of curled decorative weaves (1948.39.309 a,b).

EASTERN WOODLANDS

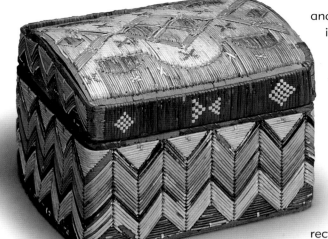

and their sale was an important source of income for Native Americans in many parts of the Northeast. Baskets made with a variety of tools—crooked knife, drawknife and drawhorse, gauge, awl—were checker plaited from a variety of materials, especially black or brown ash (*Fraxinus nigra*) or white oak (*Quercus alba*), and bound with hoops and handles of maple and other materials. Today, splints for making baskets are still pounded from a log by using an ax or mallet, trimmed with a knife or splint gauge to create uniform narrow splints, and woven into baskets.

In the eighteenth century, splint-basketry technology was introduced in northern New England, and native people also developed commercial traditions of making small round and rectangular wood and birchbark boxes elaborately decorated with dyed porcupine quills (Gordon, 1990; Whitehead, 1980). In the nineteenth and twentieth centuries, Native Americans in the Maritime Provinces and Maine made utilitarian and fancy baskets. In general, rougher baskets for home and farm use were made by men, although some families worked together, with men preparing the splints, women weaving baskets, and men attaching the heavy wooden rims and handles. During this period, many Indian families worked seasonally for Canadian and European-American farmers, harvesting potatoes, and the "potato-basket" form developed—a large, round basket with a sturdy rim and bail handle.

In the late nineteenth century, splint basketmakers also adopted the use of curled decorative weaves and used them to create what have been called "fancy baskets" for sale. By the late nineteenth century, Penobscot, Passamaquoddy, and Abenaki people made fancy baskets and—during the summers—often moved to resorts in Maine and New Hampshire to make and sell baskets (Pelletier, 1982). Basket gauges—used to quickly cut large quantities of splints—and molds, used to shape the baskets as they were woven, were keys to uniform production. Traditions of fancy basketmaking coexisted with work by men who made rougher, undecorated workbaskets for their own use and for sale (Lester, 1987b; McMullen, 1990).

After the Great Depression, many Maine Indian basketmakers gave up summer traveling and allowed tourists to come to them instead (Pelletier, 1982). Craft shops on Indian land attracted visitors, and basketmakers were often employed by craft shops. By the 1940s, most people who had depended on basketmaking for a living were gone or had sought other work. Today, many native women and men make baskets for sale and as part of a cultural legacy they feel obligated to pass on. Along with continuing native languages, basketmaking is considered an integral part of native heritage (Coe, 1986; McBride, 1990; Sanipass, 1990).

The Maliseet on the Saint John River in New Brunswick and Quebec made a variety of splint baskets, both for their own use and for sale to white tourists and farms (McFeat, 1987). Clark Field's collection includes three Maliseet baskets, including a small covered basket made by Susan Paul in about 1940, which was said to hold basketmaking tools, including a knife and a splint gauge (1948.39.331). Other forms include a tall cylindrical "feather basket" used to collect and store down and feathers to sell for making feather beds (1942.14.1936) and a fancy splint sewing basket, from about 1900, decorated with twisted decorative weaves (plate 68). Today, Maliseet basketmakers continue to make both fancy baskets and rugged farm baskets.

The Micmac, living in Nova Scotia and New Brunswick, have a long tradition of making quilled birchbark boxes and splint baskets for their own use and for sale (Gordon, 1990; Whitehead, 1982). Plain and decorated birchbark containers were also made for various uses. Field's collection includes examples of sturdy farm baskets and quilled birchbark boxes plus a splint "melon basket." Both workbaskets were made by the family of Steve Barlow of Richibucto, New Brunswick, and were collected by Clark Field

PLATE 69 : Micmac quilled birchbark box : This Micmac quilled birchbark box dates from the late nineteenth century. Earlier boxes were more often round, with white, brown, yellow, and orange curvilinear quillwork designs resulting from the use of vegetal dyes (Whitehead, 1982). Later boxes, such as this one, incorporated porcupine quills boiled with non-colorfast fabric which often yielded dark pastel shades, sometimes with variegation in the overall tone. Diagonal columns of quilling are also typical of this period (1948.39.241 a,b).

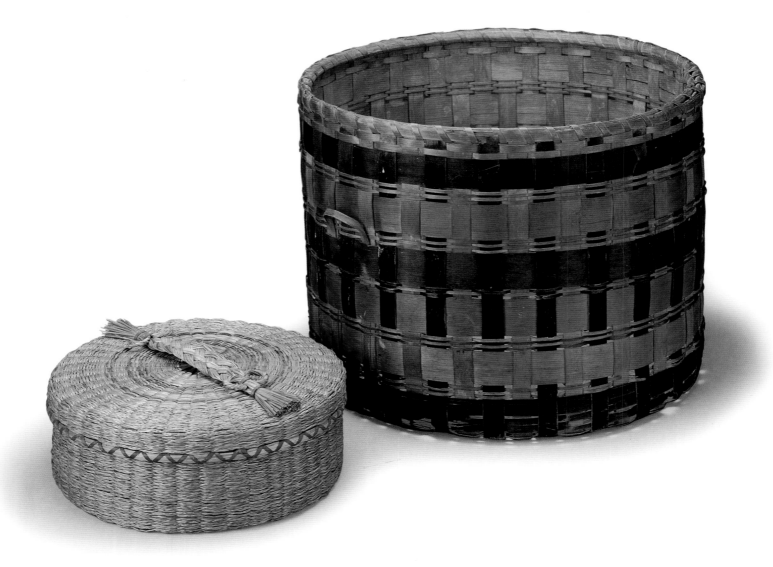

probably in the 1940s. These are similar to what have been called "Yankee-style" baskets, in that they were made of rived rather than beaten splints. By using a froe and mallet, thick splints are split off a quartered log and then smoothed with a drawhorse and drawshave. Yankee baskets were woven with wide warps; uniform, more narrow wefts; and heavy rims and handles, making them suitable for farm and household work. Yankee-style baskets were often round, like bushel baskets. One of the Barlow family baskets, a heavy rectangular basket with a handle, was made for collecting garden produce. The other is a small version of a "potato basket" (plate 68, p. 152), a type made by several tribes and used in seasonal work for harvesting potatoes (McBride, 1990; McFeat, 1987). Field also secured two examples of quilled birchbark boxes. These were made largely for sale in both round and rectangular forms, with wooden bases to give added strength (plate 69, p. 153).

In the late nineteenth century, Abenaki basketmakers began to make fancy splint baskets in quantity, often traveling to resorts in the United States—including Atlantic City and the Adirondacks—to make and sell baskets to vacationing tourists (Pelletier, 1982). Many of these baskets included twisted decorative weaves and the use of flat or braided sweet grass, which added both textural variation and fragrance. Clark Field's collection includes three examples of such baskets, two of which he purchased from anthropologist Frank Speck. These were a plain splint "house basket," or wastepaper basket, made in about 1900 by Joseph Lola (Laurent), formerly chief of the Saint Francis Abenaki at Pierreville, Quebec, and a fancy workbasket with twisted decorative weaves and dyed purple stripes collected in Saint Francis, New Hampshire, in the White Mountains.

Early on, the Passamaquoddy probably made decorated birchbark containers (Lester, 1993), but later adopted production of splint baskets. Passamaquoddy basketmakers

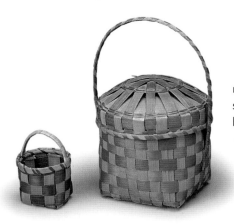

made both fancy baskets and plain workbaskets, including hexagonal-plaited sieves (1942.14.1919), potato baskets, and "melon" baskets (1942.14.1985). Field's collection also includes two early twentieth-century fancy baskets with decorative weaves.

Since the late 1700s, Penobscot and Passamaquoddy basketmakers have made decorated splint baskets for sale (Eckstorm, 1932). Early nineteenth-century examples were large, with square bases, slightly bulging walls, and round rims and covers. They were normally woven of wide and narrow swabbed splints, usually blue, green, and sometimes yellow. After about 1860, the Penobscot shifted to production of tall cylindrical baskets of thinner splints, which were also swabbed with blue, green, and other colors. In some cases, some of the splints were also dyed by immersing them in a solution containing the bark of hemlock trees, which produced a rosy reddish brown.

Penobscot basketmakers were also active in creating fancy baskets for sale, including round sewing baskets with the weft woven entirely of braided sweet grass (plate 70). Along with the use of forms which were made to cater to tourists in Maine, the pleasant scent of the sweet grass gave these smaller baskets more market appeal. Clark Field's collection includes eighteen Penobscot baskets, including a pack basket with leather harness (1942.14.1935), two melon baskets, nineteenth-century hexagonal-plaited open-weave baskets (1948.39.330, 1948.39.335), large covered storage baskets (some woven in twill weaves), and other baskets for use in the home, such as a "pie basket" (1942.14.1942), covered lunch baskets, and open plain and decorated workbaskets.

Today, generations of Penobscots make baskets for sale and for their own use, and basketmaking is seen as a prime marker of Indian identity. Both men and women proudly make baskets and value basketmaking as a marker of their physical and cultural survival (Lester, 1987b; McMullen, 1992).

Southern New England

After earlier Indian wars and epidemic decimation, eighteenth-century Native Americans in southern New England had modified their lifeways to adapt to living among whites. Fragmentary populations often regrouped, joining earlier settlements or creating new communities, which were often known by place names rather than tribal names, such as Mashantucket, Mashpee, and Schaghticoke (Conkey et al., 1978). Those who maintained a land base practiced subsistence farming augmented by hunting, craft commercial production, sale of herbal medicines, wage labor on local farms, and stonemasonry. However, dispersal of native families and individuals also promoted the formation of new types of regional interaction based on traveling craft workers, wage laborers, and Indian doctors. Baskets and basketmaking were focal points of this interaction, as basketmakers traveled the landscape to sell their baskets to nonnatives (Brasser, 1971, 1975; McMullen, 1994).

Eighteenth- and nineteenth-century Wampanoag basketmakers preferred hickory as a basket material and created tall, rectangular covered storage baskets with angular painted designs. In the late nineteenth century, different basket industries were common among different Wampanoag bands (McMullen, 1990). At Mashpee, basketmakers made workbaskets of narrow hickory splints, dyed with commercial dyestuffs or left plain (1942.14.1957, 1949.25.7). Other Wampanoag families living on Cape Cod—specifically the Mitchell family—made miniature baskets of split rye straw, dyed with commercial dyestuffs, and plain splint baskets (plate 71). Rye-straw miniatures were sold to area merchants for tourist sales (Tantaquidgeon, 1930). Unfortunately, none of these basket traditions has survived to the present day. Instead, many Wampanoag now concentrate on reviving manufacture of soft twined bags which were common before European contact (Lester, 1987a).

PLATE 71 : Wampanoag rye-straw miniatures :
The family of Zerviah Gould Mitchell, living near Middleboro, Massachusetts, in the late nineteenth century, developed and marketed a distinctive kind of basket for tourist sale. These baskets, woven of flattened rye straw and dyed purple, green, and red using aniline dyes, were made by the Mitchell daughters and sold to area merchants for sale to tourists (Tantaquidgeon, 1930). Both of these examples were made by Emma Mitchell Safford, probably between 1870 and 1890, and were collected and sold to Clark Field by the anthropologist Frank Speck **(left: 1948.39. 329, right: 1948.39.325).** Because of their fragile nature, few examples of this kind of basketry have survived in museum collections.

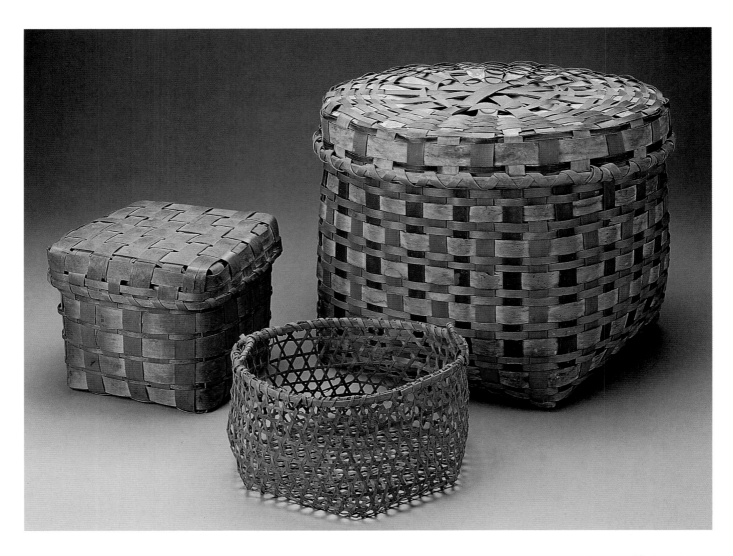

Although scholars suggest that by 1800 the native population of what is now New Hampshire and Vermont had relocated to Canada (Day, 1978), Frank Speck—an early twentieth-century anthropologist—collected several baskets along the Merrimack River in Massachusetts. He suggested that these baskets were made before 1835 by Pennacook, Nipmuc, or Massachuset Indian families which had remained in New Hampshire (Speck, 1947). In the 1940s, Speck sold ten baskets he had collected in Essex County, Massachusetts, to Clark Field, who followed Speck in identifying them as Pennacook and Natick (Natick was the name of a seventeenth-century Christian Indian community). In identifying the ten baskets from Essex County, Speck stated that they were all made in about 1835, which suggests that he bought all of them from a single household. In their technology and decoration, these baskets are similar to basketry of southwestern New England—square- or round-based baskets with round rims and covers which were decorated with swabbing and stamping (plate 72). Recent research (McMullen, 1995) has shown that these probably represent the work of "invisible" communities of native people who lacked reservation lands and spent much of their time traveling and making and selling baskets. Despite the tribes' activity in the nineteenth century, production of baskets by Pennacook and Natick living in Massachusetts and southern New Hampshire does not appear to have continued after 1850.

Although Nipmuc basketmakers were active in the area around Worcester, Massachusetts, Clark Field's collection includes only one basket identified as Nipmuc (1948.39.252), which he may have received from Frank Speck. Unfortunately, early anthropologists and collectors had an antiquarian tendency to correlate New England Indian baskets with whatever tribe originally lived in the towns where they were collected, and such identifications can mask the activity and work of other basketmakers in that area. This so-called Nipmuc basket resembles Penobscot basketry and may actually be the work of a late nineteenth-century Penobscot basketmaker. Troupes of Penob-

scots and other Maine Indians traveled throughout southern New England during that period putting on "Indian entertainments," selling herbal medicines, and making and selling baskets (Johnson, 1861).

During the eighteenth and nineteenth centuries, native basketmakers in southeastern New England—including the Mohegan, Pequot, and Niantic—wove baskets of wide splints and decorated them, after weaving, with hand-painted designs. In addition to large covered storage baskets painted with symbolic designs, smaller decorated storage baskets were also commonly produced (McMullen, 1987). The designs were oriented to the grid of squares created by the weave of the basket, although some were applied by using the basket surface more like an open canvas (McMullen and Handsman, 1987).

Intermarriage among members of different tribes helped to create synthetic styles which make tribal identification of some baskets difficult. In addition, there are relatively few baskets with strong documentation. However, in the early twentieth century, Frank Speck collected baskets from eastern Connecticut which were said to be the work of known basketmakers. For instance, Speck sold Clark Field a basket (1948.39.253) made by Mrs. Henry Matthews (née Mercy Ann Nonesuch), a Niantic woman who had been brought up among the Mohegan and eventually married a Mohegan man (Speck, 1909, 1915a). In addition to several other baskets identified as Mohegan or Pequot, Speck collected two baskets which he said were made by Lucy Tecomwass, a Mohegan woman who lived during the late eighteenth and early nineteenth centuries (Butler, 1947). Both of these are square bottomed with round rims and are painted with brown and reddish brown designs, and may date from about 1800 (plate 73). Clark Field's collection also included other baskets he purchased from Frank Speck. Among these are a hexagonal-plaited basket identified as "Mohegan-Niantic," made in about 1850 (1948.39.251), and two baskets Speck identified as Pequot. However, they strongly resemble those thought to have been made by descendants of native people who dispersed from Christian Indian communities in eastern Massachusetts after the 1700s

PLATE 73 : Early Mohegan baskets, c. 1800 : Few early New England Indian wood-splint baskets have the names of individual makers associated with them, but in the early twentieth century, Frank Speck collected these two baskets. He sold them to Clark Field in 1941, stating that they were made by Lucy Tecomwass. The Tecomwass family was prominent in Mohegan society during the eighteenth century, and Lucy probably was born in about 1750. The simple, centrally placed designs and somewhat convex walls are typical of other Mohegan baskets of the same period **(1948.39.255 a,b; 1948.39.256).**

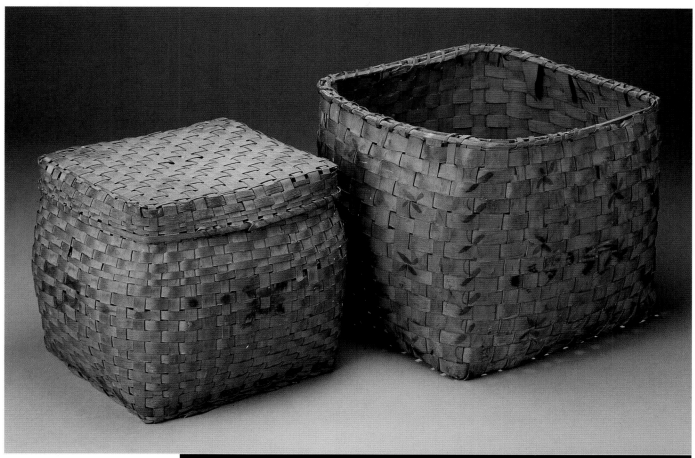

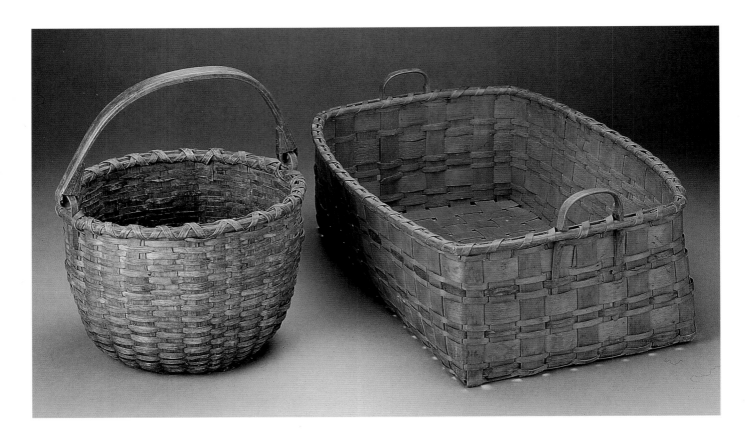

(1948.39.257 a,b, 1948.39.258). After 1900, few Native Americans made baskets in southeastern New England, although Mohegan basketmakers are beginning a resurgence of traditionally decorated baskets today.

Native communities on Long Island have long been known for their production of baskets, scrubs, brooms, and woodenware (Butler, 1947; Feder, 1932; Stone et al., 1983). These included pack baskets and baskets which closely resemble Yankee-style farm baskets woven of sturdy oak splints by European-Americans. However, some traditional wide- and narrow-splint baskets decorated with walnut-stain swabbing were also produced. Clark Field's collection includes nineteen Shinnecock baskets, many of which appear to have been purchased from Frank Speck in the 1940s. Seventeen of these were made by the David Kellis family between 1890 and 1940, including four Yankee-style baskets (1948.39.452, 1948.39.454, 1948.39.459, and 1948.39.463) and a basket with swabbed decorations in green which resembles Iroquois baskets (1948.39.460) (plate 74). The continuation of traditional subsistence practices is also indicated by the Field Collection, which includes a basketry fish trap (1948.39.448) and what is called a "fish basket." It is in the form of a small pack basket and would have been used to bring fish home from the shore (1948.39.461). In addition to a gizzard basket made by Wickham Cuffee, in about 1900 (1948.39.295), the remainder of the Shinnecock baskets are plain workbaskets.

Clark Field's collection also includes three Montauk baskets, including a sweet-grass basket said to have been made by Frances Tokuson (1948.39.293), a Yankee-style workbasket by Naoma Hannabel, from about 1900 (1948.39.347), and an unusual Yankee-style workbasket with a woven compartment in one corner (1948.39.438). Production and sale of baskets continued on Long Island into the twentieth century, but few baskets have been made since the 1940s (Butler, 1947; Stone et al., 1983).

Schaghticoke, in Kent, Connecticut, was founded in the early 1700s by refugees from other New England tribes, including the Pequot, Potatuck, Mahican, and others. Most Schaghticoke baskets combined wide and narrow splints which were swabbed with paint before weaving and were often also stamped afterward (Curtis, 1904). Schaghticoke basketmakers were especially prolific during the nineteenth century, but by the twentieth century, basketmaking was carried on only by a few men (McMullen, 1990). These men considered their baskets and their work traditional and taught reser-

PLATE 74 : Shinnecock baskets : These two baskets, said to have been made by the Kellis family of Shinnecock Indians, illustrate the simultaneous use of two separate basketry traditions. The low rectangular basket **(1948.39.449)** with its wide and narrow swabbed body splints, is typical of eighteenth- and nineteenth-century native baskets in many parts of southern New England. The round workbasket **(1948.39. 439)**, similar to those made by European-American farmers, suggests that those Shinnecock who were, to some extent, influenced by white basketmakers produced "Yankee-style" baskets. Anthropologist Frank Speck collected both baskets and sold them to Clark Field in the 1940s, by which time Shinnecock basketmaking was no longer practiced.

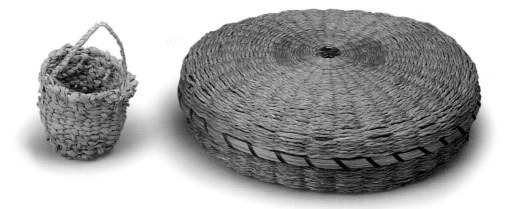

children to make and decorate baskets in an attempt to maintain traditional ways. Clark Field's collection includes a basket made in the early 1940s by one of these basketmakers—Frank Coggswell—which is a miniature workbasket with a bail handle decorated with a band of dyed red splints (1948.39.333). Craft revivals are currently under way among the Schaghticoke.

The Iroquoian Area

Tribes which spoke languages of the Iroquoian family lived in New York state and contiguous parts of Pennsylvania, Ohio, along the Saint Lawrence River, and in Ontario. Within the Woodlands area, other Iroquoian speakers—the Tuscarora, Meherrin, and Nottaway—lived on the coastal plains of Virginia and North Carolina. The Cherokee, in the Southeast and in Oklahoma, also speak an Iroquoian language. In terms of their basketry, the Iroquois differed from northeastern Algonquian-speaking peoples. Besides occasional twined fiber and plaited wood-splint basketry, the Iroquois made cornhusk crafts, including twined salt or tobacco bottles with corncob stoppers, braided and sewn cornhusk mats, and twined or braided and sewn masks used in the curing rituals of the False Face Society (Lismer, 1982; Speck, 1945; Turnbaugh and Turnbaugh, 1986; Waugh, 1973). These cornhusk crafts are still produced (plate 75). Traditional narrow-splint hominy sieves with open-weave bases and twined sides, and twill- and hexagonal-plaited corn-flour sieves were made and used until the mid-1800s (Lismer, 1982). Berry baskets—miniature forms of old-style pack baskets—were also produced.

Members of Iroquois groups probably did not begin production of wood-splint baskets until after the Revolutionary War and perhaps not before 1800 (McMullen, 1990). However, after the Revolutionary War, members of New England tribes joined the Iroquois, introducing the idea of commercial wood-splint basketry (Brasser, 1975). By 1820 or 1830, most Iroquois tribes produced decorated splint baskets in recognizable styles. They continued this until the 1860s, when production of smaller souvenir forms began. During the nineteenth century, Iroquois basketmakers used bright commercial colors when decorating their baskets and often stamped the entire surface with different designs such as concentric ovals, crescents, circles, and squares (McMullen and Handsman, 1987). After the mid-nineteenth century, Iroquois basketmakers no longer decorated their baskets with potato-stamped designs. Men continued to make plain or simply decorated workbaskets, and Iroquois women shifted to the production of smaller baskets embellished with decorative weaves or made plain traditional twill baskets.

During the 1860s, the Mohawk developed decorative weaves and experimented with different forms, including large hampers, smaller baskets, and miniatures, many of which were decorated with sweet grass (*Hierochloe odorata*). These baskets were marketed to tourists in popular resort areas in New York state. Mohawk men also made and sold pack baskets and other utilitarian forms. After the Great Depression, Mohawk

PLATE 75 : Smaller Iroquois basket forms : The small Cayuga cornhusk basket **(1948.39. 272)** illustrated on the left was made in about 1935 in the form of a small bailed workbasket by Kaihnes, a Wolf Clan matron at Sour Springs Longhouse, Six Nations, Brantford, Ontario, for the annual tobacco sacrifice. This basket was collected by Frank Speck during anthropological fieldwork among the Cayuga and later sold to Clark Field. Iroquois women, especially among the Mohawk, also made a wide variety of smaller baskets of thin splints and braided sweet grass, including this "arm basket." Arm baskets were so named because these round, flat baskets could be carried easily under the arm and were popular in the earlier twentieth century among ladies who used them to carry sewing or crafts when they visited one another's homes. Clark Field collected this example in 1954 **(1954.15.9 a,b).**

women continued to make baskets, but few relied solely on sales, and production of pack baskets also dwindled (Carse, 1949). Within the last thirty years, Mohawk basketry has experienced a revival, especially in its recognition as an Indian art. Fancy baskets of plain or dyed splints and decorative weaves and a variety of utilitarian baskets continue to be made at Akwesasne and Caughnawaga (Benedict, 1983; Benedict and Lauersons, 1983; Johanssen and Ferguson, 1983). Clark Field's collection includes five Mohawk baskets, three of which are Yankee-style baskets probably made by men (1948.39.314, 1948.39.315, 1948.39.316; (plate 76).

Along with the Mohawk, the Oneida were probably the first Iroquois to engage in widespread production of wood-splint basketry as a result of the establishment of the Christian New England Indian communities of Brothertown and Stockbridge in Oneida territory in the late 1770s (McMullen, 1990). During the nineteenth century, Oneida basketmakers used a wide variety of decorative techniques and a wide palette, including blue, green, orange, and yellow commercial pigments which they used as paints (McMullen and Handsman, 1987).

In about 1820, many Oneida, along with the Brothertown and Stockbridge Indians who lived among them, moved to Wisconsin and Ontario. About two hundred Oneida stayed in New York, but few continued to make decorated splint baskets. However, in Ontario and Wisconsin, basketry has continued to the present day on a small scale, including both fancy baskets and undecorated utilitarian forms as well as braided and sewn cornhusk mats (Johannsen and Ferguson, 1983). Clark Field's collection includes one Oneida basket, which resembles nineteenth-century examples in other museums. However, unlike its predecessors, the basket is a round bowl decorated with crayon marking rather than hand painting (1948.39.260). The design itself—of small trees—is identical to one used on Oneida baskets a century earlier (McMullen and Handsman, 1987).

After upheavals caused by the Revolutionary War, many Cayuga moved to the Grand River Reserve in Ontario or joined Seneca and Onondaga communities (White et al., 1978). By the early 1800s, when their Seneca and Onondaga neighbors began to make wood-splint baskets, few Cayuga lived in New York state, and it is probable that splint basketmaking never became economically important for the Cayuga (McMullen, 1990). However, they did produce farm baskets, twill-woven splint hominy-washing baskets,

and cornhusk crafts for their own use. Clark Field's collection includes a Cayuga workbasket made by Mary Swamp (1954.15.8), a hulling basket for washing the lye off hominy (1942. 14.1886), and several miniature splint baskets collected from the Six Nations Reserve in Brantford, Ontario, in the 1940s (1942.14.1906, 1942.14.1907, 1942.14.1983).

Clark Field's collection contains no examples of nineteenth-century decorated Seneca baskets, but he did collect one example of a round, bailed basket with swabbed green decoration from the Allegheny Reservation in New York (plate 76), as well as a small Tuscarora basket, probably from one of the Seneca reservations (1948.39.313). Baskets of this type were revived in Seneca communities during the Works Progress Administration (WPA) Seneca Arts Project between 1935 and 1941 (Hauptman, 1981). Field also collected four utilitarian baskets among the Oklahoma Seneca, including a twill-plaited hulling basket (1947.57.37).

During early colonial times, extensive wars with the Iroquois decimated and dispersed the Huron, who originally lived on Georgian Bay on Lake Huron. Many fled to the area near Quebec City and established a community called Lorette (Morissonneau, 1978). Living close to a nonnative population center, many Huron girls went to convent schools in the area and learned needlework techniques (Turnbaugh and Turnbaugh, 1986). During the eighteenth and nineteenth centuries, they turned those skills to the production of birchbark boxes and other small items, which they embroidered with dyed moose hair and sold as souvenirs (plate 77). Clark Field collected several examples of nineteenth-century Huron moose-hair embroidered bark items, including two card cases (1942.14.2009 a,b, 1948.39.243 a,b) used to hold playing cards or visiting cards. The collection also includes a small hexagonal bark box covered with red broadcloth, embroidered with dyed moose hair.

The Mid-Atlantic Region

The mid-Atlantic region has had a long history of colonialism and settlement and, as a result, many tribes there have been badly fragmented. Ted Brasser (1975) has suggested that splint basketry was introduced to the Delaware in the early 1770s. If this is the case, the Delaware (Lenni Lenape) have the oldest tradition of splint basketmaking. Ironically, few old Delaware baskets are known and most are made for farm work and other utilitarian tasks (Harrington, 1908; Newcomb, 1956). Among the dispersed Delaware population in Oklahoma, Clark Field collected one example, a twill-plaited hominy basket made by Eliza Jackson Fall Leaf (plate 78, p. 162). It was said to have been made in the 1860s in Kansas before she was removed to Oklahoma.

In the Field Collection, two other mid-Atlantic tribes are well represented. Through Frank Speck's fieldwork among the Nanticoke in Delaware in the early twentieth century (Speck, 1915b), Clark Field secured six examples of Nanticoke basketry, including two splint eel traps (also called eel pots). One was said to have been made in about 1868 by Topsey Morris (1948.39.271) and the other in about 1900 by Elwood Wright (1948.39.437 a,b). Although Nanticoke baskets had a characteristic rim finish of widely spaced bindings rather than a continuous wrapped binding (plate 4, p. 19), the other examples in Field's collection are typical Yankee-style baskets identifiable only by a Nanticoke rim (1948.39.259, 1948.39.294, 1948.39.346). In addition to those baskets, Speck also sold to Field six examples of Rappahannock basketry which Speck had collected in about 1920 in Virginia (Speck, 1925). What is unusual about these baskets is the wide variety of materials used. One is a knotted bag of slippery elm or mulberry

PLATE 77 : Huron fancies : Huron women living near Quebec City made a wide variety of souvenir items of birchbark embroidered with dyed moose hair. Small boxes and cases such as these were among the most common forms, which were often sold at Niagara Falls. Using only the "cheek hair" of moose, Huron women dyed the hair by boiling it with colored fabric and then used it like embroidery floss. These sewing techniques were said to have been learned in French convent schools in Canada (Turnbaugh and Turnbaugh, 1986). Card cases of this type were used to hold playing cards and visiting cards, and different sizes were made for these two uses. Both of these examples date to about 1880 (1948.39.268 a,b, 1942.14.2009 a,b).

bark made by Susie Nelson (1948.39.262). The others are an egg basket of wicker-plaited peeled and unpeeled honeysuckle by Susie Nelson (1948.39.273), a coiled and sewn cornhusk basket by Lizzie Nelson (1948.39.301), and three oak-splint baskets. One of these, a gizzard basket by Rob Nelson (1948.39.264), dating from about 1900, has a sturdy handle made to hull dried corn and used so that the kernels would fall directly into the basket.

A related example from the Tutelo-Saponi in Staunton, Virginia, also collected by Speck and sold to Field, is a gizzard basket with what is considered a typical Rappahannock rim finish of a single splint wrapped onto a thick vertical splint. Field also collected what he called a "Croatoan" basket of twill-plaited split cane in North Carolina in 1963 (1963.16.11). Because the sixteenth-century Croatoans on Cape Hatteras are thought to have taken on the name Hatteras in the 1700s (Feest, 1978), it is impossible to determine the exact origins of this basket and whether it was made by a person of Indian heritage on Cape Hatteras or elsewhere.

Great Lakes

In the Great Lakes region, the availability of different materials affected basketry and the related arts. Among northern Great Lakes peoples, birch-bark containers were used more extensively than woven baskets, although all Woodland groups had some form of basketry. Birchbark was folded and sewn into a wide variety of forms in addition to being used for house coverings and canoes. Except for making canoes and religious scrolls, gathering birchbark and fabricating items from it were performed by women (Ritzenthaler, 1991).

One traditional type of Great Lakes basket is the coiled basket made of sweet grass, which exudes a sweet fragrance, particularly when dried. The grass, which grows about two feet high, was bundled into coils about an eighth inch to a quarter inch in diameter. One end was knotted, and the coil was wound around the knot and sewn with a fiber thread. When the flat base was completed by sewing several coils together, the sides were built up in a bowl form (plate 79). Small grass baskets of this type were common tourist items in the Great Lakes region in the early twentieth century. Besides round and oval bowl forms, trinket baskets, shallow dishes, and trays were also made (Ritzenthaler, 1991; Turnbaugh and Turnbaugh, 1986).

Plaited black-ash splint baskets were introduced to the Great Lakes tribes by the Oneida, Stockbridge, and Brothertown tribes, which came to Wisconsin in the 1820s (Brasser, 1975). The Ho-chunk (Winnebago), Potawatomi, Menominee, and Ojibwa (Chippewa) all made and used undecorated baskets for household work as well as baskets decorated with colored splints. Today, the Ho-chunk are most active in continuing production of this type of basket.

Birchbark containers were made by heating the bark over a fire or steaming it to make it pliable, then bending and folding it into the desired shape and sewing it with basswood fiber or spruce roots. Bark buckets were used to catch dripping maple sap, which was carried to the boiling site. There also were birchbark vessels, called *makuks*, which would not hold water. Shaped like truncated pyramids, these were used for storing maple sugar and wild rice and for gathering wild fruits and berries. Large, shallow birchbark trays were used for winnowing wild rice. Birchbark containers were decorated by outlining a figure or sketch and then scraping away the background to expose the lighter bark underneath. Beautiful trinket boxes were also made from birchbark and decorated with porcupine quills (Ritzenthaler, 1991; Turnbaugh and Turnbaugh, 1986). Decorated birchbark containers and quilled boxes are still made in some communities.

For embroidery, porcupine quills were moistened in the mouth and flattened by being pulled out between the teeth or with special bone flatteners. Before decorating birchbark boxes, women soaked the quills in water until they were soft, left them unflattened,

PLATE 78 : Delaware hominy basket : Traditionally, hominy was made by soaking dried corn in water with wood-ash lye, and this type of basket was made and used by Iroquois and Delaware women to drain and rinse the hominy afterward. For such baskets, the base was woven in an open checker weave and the sides were twill plaited, allowing the water to flow out easily. This basket—collected by Clark Field before 1938—was said to have been made by Eliza Jackson Fall Leaf, a Munsee Delaware woman living in Lawrence, Kansas, in 1866. She moved to the present state of Oklahoma in 1867. However, the basket shows little sign of use or wear, especially for draining hominy, so it is more likely that it was made shortly before Field collected it (1948.39.131).

used an awl to pierce small holes in the bark, and inserted the points through the holes. The points were trimmed and bent back against the bark to hold them in place. Both floral and geometric designs were worked in this manner (Ritzenthaler, 1991).

A vast number of different types of items was created by weaving with various materials, including fiber and yarn bags, sashes, garters, and rush and bark mats. String and cordage were made from the inner bark of elm, cedar, and especially basswood and were used to sew cattail mats, weave bulrush mats, and weave storage bags. Open-mesh corn-washing bags, tightly woven storage bags, small charm bags, tumplines, and many other items were made by twining. Bags for carrying and storing sacred objects and household goods were twined of basswood and other fibers, including nettle fiber and buffalo wool. In later times, commercial cotton string and wool yarn were also used. On earlier bags, rows of zoomorphic designs were common. On more recent bags made of commercial woolen yarns, designs are composed of bands of geometric and curvilinear designs (plate 80).

Other Great Lakes weaving technologies included plain and decorated open-twined or sewn household mats of bulrushes, red cedar, or cattails. In traditional wigwams, these served as floor coverings and house partitions or were laid on the ground or floor for serving food, especially at feasts. Extensive use of cattails as a weaving material has survived longest among the Kickapoo.

Before European contact, the Kickapoo probably lived in southeastern Michigan, but the centuries since then have driven them to many different locales, including Wiscon-

FIGURE 24, A-D : Kickapoo ceremonial winter house : Traditional Kickapoo women have been maintaining these houses as long as we have been Kickapoo. The summer and winter ceremonial house is the core of our religion. That is what we believe in. It is the woman's role to build this place of worship. Once we have accepted this responsibility you must do it for life. This tradition is passed down from mother to daughter. My central focus as a woman is this house. It makes me feel whole as I am able to do this year after year. All tribal members respect this Kickapoo way of life. We are born to keep this way of life, this tradition, even though we live in modern times. Various ceremonies are held in these houses. Here we pray to the Great Creator for our well-being and strength. I cannot think of anything more important than maintaining this house.

Ruth Wahpepah Sanderson, Kickapoo elder
May 5, 2000

Kickapoo summer houses are made from willow poles with wood planks enclosing three sides and the fourth side an open ramada. Cattail mats are used only for roofing. Winter houses are made by placing cattail mats on a willow frame. Twelve mats and approximately ninety willow poles were required for the winter house illustrated.

In Oklahoma, cattails have become increasingly hard to collect because of destruction by cattle, lack of access to private lands and state parks, and recent droughts. Some Oklahoma Kickapoos now travel as much as two hundred miles to collect cattails to make house mats. The cost of these trips, plus the more than forty hours needed to make each mat, has made it increasingly difficult for today's Kickapoo to participate in the larger cash economy and simultaneously maintain their ceremonial houses. To assist these efforts, a nonprofit organization—Traditional Indian Housing, Inc.—was founded in 1993. The photograph on the upper right illustrates cattails drying in the sun before being woven into mats; the left depicts sewing of the mats themselves. The center right photograph shows the willow frame of the winter house and the lower right photo shows it completed. Photographs courtesy of Ruth Wahpepah Sanderson.

sin, Illinois, Missouri, Kansas, Oklahoma, Texas, and Mexico. Despite this, the Oklahoma and Mexican Kickapoo communities are among the most culturally conservative native people. Many aspects of traditional life which have been lost by other tribes have been retained by the Kickapoo, who are known for their intentional isolation from others (Callender et al., 1978). For instance, cattail mats for the construction of houses are still made by both the Oklahoma and Mexican Kickapoo. These houses are now used almost exclusively for ceremonies (figure 25).

Through his own collecting and that of Alice Marriott, Clark Field accumulated eight examples of Kickapoo basketry for his collection. Although they remain highly conservative in many aspects of their culture, the Kickapoo quickly adopted the use of aniline dyes to decorate their cattail baskets made both for sale and for their own use. Working in Muzquiz in Coahuila, Mexico, in about 1940, Alice Marriott collected three new baskets of aniline-dyed and natural cattails (1942.14.1890, 1942.14.1891, 1942.14.1892), including two large bailed baskets and one miniature. In 1937, among the Oklahoma Kickapoo Clark Field collected four cattail baskets, which also are bailed baskets (plate 80, p. 163). Three of these were made by Mush-Qua-To-Quah (1948.27.47, 1948.27.48, 1948.27.49) and one by Ah-Ko-The (1948.27.50). In 1949, Field collected a final example at Nuevo Laredo, Coahuila, Mexico (1942.14.2114).

Among other Great Lakes people far removed from their original homelands, Clark Field also collected two examples of twined basswood fiber bags from the Sac and Fox in Oklahoma (1948.27.17, 1948.27.38). Both of these bags were made between 1880 and 1900; one utilizes natural dyes and the other commercially available aniline dyes. Like the Kickapoo, the Sac and Fox had been driven from their homes in the Great Lakes but maintained some aspects of traditional culture.

The Ho-chunk—formerly called the Winnebago—are members of a Siouan-speaking tribe living in Wisconsin at the time of French contact in the 1630s. In contrast to their

Wisconsin neighbors the Menominee and Potawatomi, the Ho-chunk relied more on agricultural products for subsistence. They planted large gardens and stored dried corn, beans, and other products in fiber bags and in pits dug in the ground for winter use. After the arrival of Europeans in the Great Lakes region, Ho-chunk populations were decimated by wars and disease. Subsequently, they intermarried with members of other tribes and took on some characteristics from their Algonquian-speaking neighbors. Continued wars and land losses resulted in a scattered population in central Wisconsin with only individually held lands. As an adaptation to this state, many Ho-chunk worked as migrant agricultural laborers during the late 1800s and early 1900s, moving to camp along the Mississippi River in fall and winter to hunt and trap.

Wood-splint basketry was introduced to the Great Lakes tribes by eastern tribes who came to live in Wisconsin in the 1820s, including the Brothertown, Stockbridge, and Oneida. Although many of these tribes made highly decorated storage baskets, Great Lakes tribes such as the Menominee, Ho-chunk, and Potawatomi made strong workbaskets and left them plain or decorated them with simpler bands of swabbed or dyed splints. In the twentieth century, automobile ownership made it possible for many Ho-chunk to increase their income by selling baskets and other crafts at roadside stands, especially at the Wisconsin Dells (Lurie, 1978). Clark Field collected two Ho-chunk baskets in Wisconsin, both sturdy workbaskets with swinging bail handles. One is undecorated (1948.39.182) and may date to 1900, and the other has a characteristic band of brightly dyed splints around the middle of the basket's body (plate 82) and dates to the early 1950s. Today, many Ho-chunk women are still active basketmakers who continue to make baskets such as these as well as a wide variety of miniature forms, in addition to other traditional crafts, including finger weaving.

PLATE 82 : Wisconsin splint baskets : Ho-chunk basketmakers commonly used swinging bail handles, as demonstrated by the round workbasket on the left (1953.1.12). The rectangular basket on the right (1953.1.21), which may have been made by a Potawatomi, exhibits a single wide splint in the middle of the body, characteristic of Iroquois baskets, suggesting that the Oneida living near Green Bay were influential in spreading wood-splint basketry technology in Wisconsin. Both baskets were collected by Clark Field in 1952 near Antigo, Wisconsin.

Traditionally, the Potawatomi and Ottawa relied on hunting, fishing, and gathering food resources in the summer but also maintained substantial gardens of corn, beans, and squash. For many centuries, their population was dispersed in numerous bands which maintained contact with one another through extensive visiting. As these people moved into new areas, they came into contact with and intermarried with other tribes, often learning new adaptations and ways of life. In the nineteenth century, this included learning splint basketry. Potawatomi and Ottawa bands ended up in diverse locations, including Michigan, Canada, Wisconsin, Kansas, and Oklahoma. In some areas, they continued to make splint baskets as well as small coiled grass baskets (1955.16.5) and small decorated birchbark boxes (Turnbaugh and Turnbaugh, 1986).

For some of their baskets, the Potawatomi combined bark and coiled-grass technologies to create small decorated boxes, similar to an example Frank Speck collected in Michigan (1948.39.345). Others made small rectangular birchbark boxes embroidered with porcupine quills and bound with bundles of sweet grass, such as the one collected by Clark Field at Walpole Island, Ontario, in 1942 (1948.39.326). Other Potawatomi in Wisconsin made large swabbed splint baskets similar to those made by their Oneida and Ho-chunk neighbors (plate 82). Only a few Potawatomi continue to make baskets today.

The Ottawa also continued their basketry traditions into the twentieth century. Frank Speck collected two Ottawa baskets in Michigan which eventually became part of Clark Field's collection, including a twill-plaited workbasket made by Charles Shugnaby in about 1900 (plate 83), and a twined basket woven of dyed splints, from about 1930. During trips to Michigan in the 1940s, Clark Field also collected a fancy splint and sweet-grass basket made by Ottina Petosley in about 1930 (1942.14.1964), a small

sweet-grass basket (1942.14.1965 a,b), and a twined basswood bag (plate 83, p. 167). Sometimes braided sweet-grass baskets were decorated with curled fancy weaves. Among the Ottawa, bark industries also remained strong, including creation of quilled birchbark boxes (plate 84); Field collected a new example in Michigan in 1964. Into the twentieth century, Ottawa in Michigan also made containers of folded elm bark (plate 66, p. 149) for collecting and carrying maple sap during sugaring season (1948.39.205, 1948.39.206) and for storing salt in the kitchen (1949.29.16).

The Ojibwa, who originally occupied parts of Canada north of Lakes Superior and Huron, spread to adjacent areas during historic times and now maintain communities from present-day Ontario to Montana and including Michigan, Wisconsin, and Minnesota. The Ojibwa have always lived largely in areas of mixed conifer and deciduous forests, with many lakes and rivers which provided ample fish, wild-rice fields, and means for travel. Collecting wild rice was important for the Ojibwa, for whom it served as a significant stored winter food. Late summer and early fall were the ricing season, and several families worked together to gather and process the rice. In spring, the people moved to the sugar camps to gather maple sap and process it into sugar, which was used as a seasoning throughout the year. For many Ojibwas, reservation life was and is a constant struggle to support families through interaction with European-American society and to maintain aspects of traditional life. Despite considerable contact and intermarriage with whites, many traditional practices survive in the strong use of the Ojibwa language as well as religious practices, oral tradition, knowledge of herbal medicines, traditional crafts (Lyford, 1982), and continued reliance on maple sugaring and collecting wild rice.

The Clark Field Collection contains twenty-two Ojibwa baskets which run the gamut from the most traditional to the most commercial forms. Through his own collecting and that of others, Field acquired a folded and sewn birchbark water bucket, dating from about 1900 (1942.14.1934), a set of birchbark trays for winnowing wild rice (1948.39.180, 1948.39.181), and a birchbark rice-storage container (1948.39.122). In addition to these containers used for collecting and processing wild rice, Field also collected five birchbark containers used in Michigan and Wisconsin to collect and process maple sap to be made into syrup and sugar (plate 85). Through his years of

PLATE 84 : Great Lakes quilled boxes : The tradition of making elaborately quilled birchbark boxes extends back at least to the mid-nineteenth century in the Great Lakes region, and was most common among the Ojibwa and the Ottawa. During Victorian times, boxes and other souvenir pieces were made for sale, and this has continued to the present. The Ottawa box on the left (1964.24.6 a,b), reminiscent of Great Lakes floral beadwork designs, was collected by Clark Field in 1964. The box with the beaver and maple-leaf design (1948.39. 104 a,b) was made before 1938 by Mrs. Sky Eagle, and Field purchased it from R.B. Cregar of Palm Springs, California. The use of the maple leaf and beaver—both Canadian national symbols—suggests that Mrs. Sky Eagle was a member of one of Canada's many Ojibwa communities.

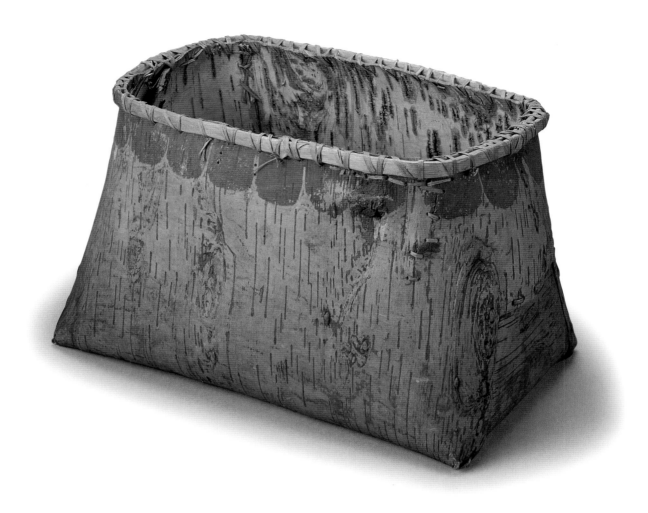

collecting, Field also accumulated several small birchbark boxes decorated with quillwork as well as four traditional coiled sweet-grass baskets. Although splint basketry is not manufactured by all Ojibwa, Field collected two representative examples in 1962.

Like other northern Great Lakes groups, Algonquin bands of Quebec, who lived traditionally by hunting, fishing, and gathering, created containers of folded and sewn birchbark. During the nineteenth century, they also adopted splint basketry from tribes near them, either the Abenaki or the Iroquois (Day and Trigger, 1978). In the twentieth century, birchbark containers were etched with designs or left plain, and splint baskets were sometimes marked using small carved wooden stamps dipped in paint (Speck, 1947) .

The Clark Field Collection includes ten Algonquin bark containers, most of which were probably collected by anthropologist Frank G. Speck during his fieldwork among the River Desert (Speck, 1927) and La Barriere Algonquin bands in the 1920s and the 1940s and sold to Field in the 1940s. Many of these bark vessels are in the form of cylindrical barrels with or without covers and are etched with designs, including flowers, leaves, animals, canoes, and automobiles. Some of these containers were made by two of Speck's primary informants, Mrs. Michele Buckshot (plate 5, p. 20) and Mrs. Pierre Djako. In particular, Mrs. Buckshot was Speck's source for information for his publication on the use of decorative stamping (Speck, 1947). Field's collection also includes two splint baskets, including a large splint feather basket, or hamper, with stamped decorations made by Mrs. Buckshot (1948.39.399). Both birchbark containers and splint baskets were made for native use and for commercial sale.

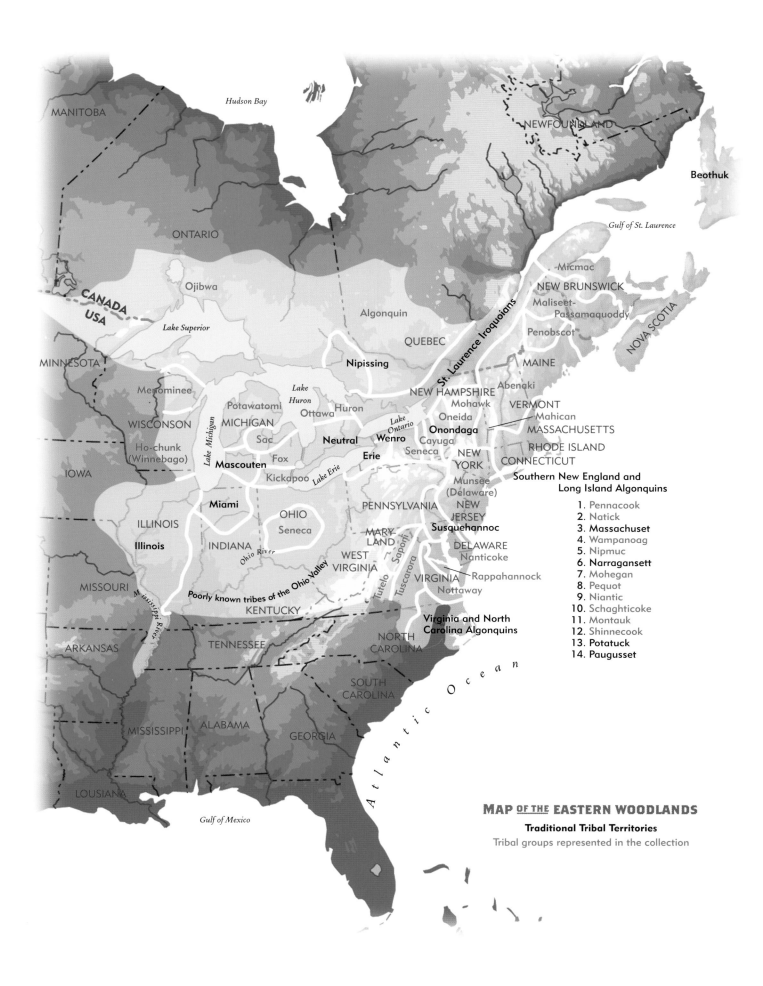

Hudson Bay

MANITOBA

ONTARIO

Beothuk

NEWFOUNDLAND

Gulf of St. Laurence

Ojibwa

CANADA
USA

Lake Superior

Micmac

NEW BRUNSWICK

Maliseet-
Passamaquoddy

NOVA SCOTIA

MINNESOTA

Menominee

Algonquin

QUEBEC

Penobscot

St. Laurence Iroquoians

MAINE

Nipissing

Potawatomi

Lake
Huron

WISCONSON

MICHIGAN

Ottawa

Huron

NEW HAMPSHIRE

Abenaki

VERMONT

Mohawk

Sac

Lake
Ontario

Oneida

Mahican

Ho-chunk
(Winnebago)

Lake Michigan

Neutral

Wenro

Onondaga

MASSACHUSETTS

Fox

Cayuga

RHODE ISLAND

IOWA

Mascouten

Erie

Seneca

NEW
YORK

CONNECTICUT

Kickapoo

Lake Erie

Munsee
(Delaware)

Southern New England and
Long Island Algonquins

Miami

OHIO

PENNSYLVANIA

NEW
JERSEY

1. Pennacook
2. Natick
3. **Massachuset**
4. Wampanoag
5. Nipmuc
6. **Narragansett**
7. Mohegan
8. Pequot
9. Niantic
10. Schaghticoke
11. Montauk
12. Shinnecook
13. **Potatuck**
14. **Paugusset**

ILLINOIS

Seneca

Susquehannoc

Illinois

INDIANA

MARY-
LAND

DELAWARE

Ohio River

WEST
VIRGINIA

Nanticoke

Saponi

MISSOURI

Mississippi River

Poorly known tribes of the Ohio Valley

Tutelo

Tuscarora

VIRGINIA

Rappahannock

Nottaway

KENTUCKY

Virginia and North
Carolina Algonquins

ARKANSAS

TENNESSEE

NORTH
CAROLINA

Atlantic Ocean

SOUTH
CAROLINA

MISSISSIPPI

ALABAMA

GEORGIA

LOUSIANA

Gulf of Mexico

MAP OF THE EASTERN WOODLANDS

Traditional Tribal Territories

Tribal groups represented in the collection

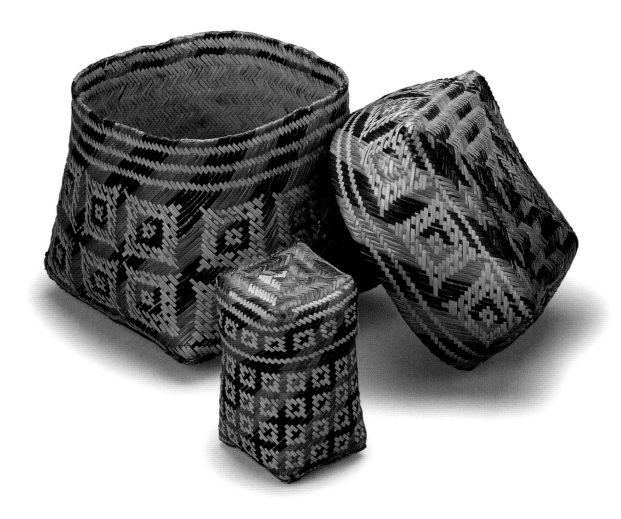

SOUTHEAST

J. Marshall Gettys

Like the people of the Northeast and Great Lakes, those occupying the Southeast have been exposed to European influence since the sixteenth century. In contrast to the Northeast, however, the majority of the remaining Native Americans in the Southeast were removed from their homelands between 1830 and 1860 to Indian Territory, now the state of Oklahoma. There the tribes established independent, self-governing nations. It is, therefore, impossible in any general discussion of the people and their baskets from the Southeast not to include Indian Territory. For this reason, this essay is divided into two sections.

The first section, "The Homeland", discusses the basketmaking people who were not removed to Indian Territory, as well as tribes that appear not to have made baskets after their arrival. The second section focuses on basketmaking tribes that were removed to Indian Territory. Because Clark Field lived in Tulsa, located in the heart of present-day Oklahoma that was occupied by southeastern tribes, his collection has an unusually strong representation in this area, which has largely been ignored by collectors.

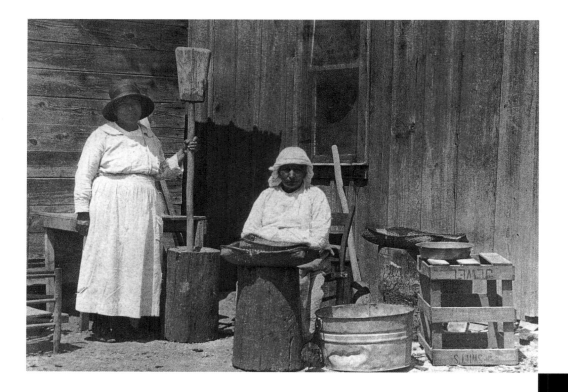

The Homeland

The Southeast culture area includes the warm and moist land of the southern United States between the Atlantic Ocean and the Gulf of Mexico. On the west, it is bounded by the dry country beyond the Trinity River and on the north by the colder climate of the upper Mississippi and Ohio River valleys (Hudson, 1976). Also of importance is the fact that approximately three-quarters of the area is coastal plain, some of the richest agricultural land in North America.

Given the temperature and rainfall of the Southeast, it is not surprising that farming was traditionally the basic economic pursuit across this cultural area. Corn, beans, squash, and pumpkins were the most important, but not the only, crops grown (Swanton, 1946; Hudson, 1976). This complex of crops requires only simple technology for successful production, thrives in southern soil and climate conditions, and does not rapidly exhaust soil nutriments. This agricultural complex is also well suited as a diet, with each crop supplying an essential element the others lack. Southeastern Native American foods are still associated with the Southeast region. Many dishes thought of as southern are, in fact, "Southeast Indian." Grits, hominy, corn bread, hush puppies, corn on the cob, and roasted meat with wood flavors (barbecue) are all part of a food tradition with Native American origins. This is also true for unique aspects of New Orleans cuisine, such as the use of filé to create such dishes as gumbo, and "blackened" meats and fish.

In addition to similar physical environments and a common roster of food crops, tribes of the Southeast also shared food-preparation techniques. The primary crop, corn, was and is consumed across the region at virtually all stages of plant maturity. Ripe corn is roasted and either eaten or cut from the cob and dried for later use. Flint corn, hardened on the stalk and shelled for use, is the basis of many southeastern Native American dishes, including hominy.

Hominy dishes are prepared by first soaking the flint corn, then parching the swollen kernels and pounding them to loosen the husks. The pounded material is then winnowed to remove the husks, and the remaining particles are sifted to size. The resulting product is recombined with liquids and other ingredients to produce dishes ranging from beverages to baked goods.

FIGURE 26 : Southeast food processing, c. 1923 : The uses of the winnowing, sifter, and catch baskets for corn are illustrated by two Creek women, Betty McIntosh on the left and Lydia Larney on the right, ready to pound corn. Notice that one of the three mortars is being used as a work surface on which the catch basket is sitting to receive the pounded corn. Photograph courtesy of the Archives & Manuscripts Division of the Oklahoma Historical Society, Elrod Collection, 15022-G.

Completion of this process requires corn pounders (mortars and pestles), winnowing, sifting, and catch baskets, pots of various sizes, and wooden spoons or paddles. Although there is some variation in size and shape, large flat winnowing baskets, sifters in different degrees of fineness, and catch baskets were made by all the southeastern tribes (figure 26). The maintenance of this traditional form of food preparation resulted in the continued production of corn-processing baskets. Where traditional basketmaking has persisted, the traylike forms associated with food processing usually dominate the basketmakers' production.

De Soto first encountered the Natchez along the rich bottomlands of the lower Mississippi River in 1542. They had lived there since the thirteenth century, in widely dispersed villages of which the "Great Village" was the ceremonial nucleus. There the house of their ruler, the Great Sun, and the temple stood on mounds facing each other across the plaza. The Natchez apparently remained in that area until a combined French/Choctaw force defeated them in 1730–1731. Those who surrendered were sold into slavery. The few who escaped eventually joined the Creek and Cherokee, with whom they later moved to Indian Territory. With an original population estimated at more than four thousand, only two speakers of Nachez lived in the Cherokee Nation in 1940. They were Wat Sam and Nancy Taylor. Wat Sam was the maker of the two Nachez baskets (1947.57.63 and 1947.57.64) collected by Field. One of these baskets (plate 87), was made at about the time it was collected in 1937 near Braggs, Oklahoma. It is made of cane, which was rare in the vicinity and must have taken considerable effort to collect.

De Soto also recorded the Coushatta, also known as the Koasati/Alibamu. At that time they were living on an island in the Tennessee River in what today is northeastern Alabama. By the mid-eighteenth century, part of the tribe had settled in Louisiana. Still later, part of that group settled with the Alabama in Texas (Swanton, 1946). Today, Coushatta settlements are found in Louisiana and Texas.

Coushatta baskets included in the Clark Field Collection are twilled plaited cane or coiled pine needle and raffia. Coiled pine-needle basketry in the Field Collection reflects

SOUTHEAST

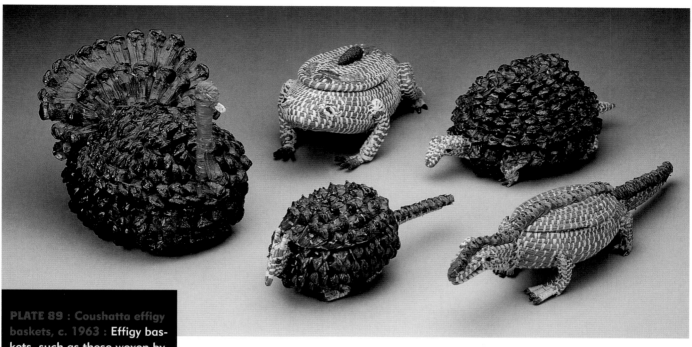

a trend away from cane basketry. Most of the cane baskets were collected in the late 1930s and early 1940s and are similar to specimens in the Rand Collection (Hunter, 1975), assembled beginning in 1930. Clark Field collected a two-pocket basket in 1939 in Livingston, Texas, with the assistance of J.E. Fairly, an Indian agent (plate 88). The later pine-needle and raffia baskets were collected in the 1960s and are forms oriented to the European-American market. Baskets of this type are not found in the Rand Collection (Hunter, 1975).

Maggie Poncho worked in cane (1963.16.12) and pine needles with raffia (plate 89). Clark Field purchased six of her pieces in Livingston, Texas. The Field Collection also contains a basket made by Mrs. Joe Langley (1963.16.14), the Langley family matriarch and well-known as a Texas Coushatta craftsperson.

The Chitimacha, like other southeastern tribes, suffered considerable population loss because of disease and armed conflict.

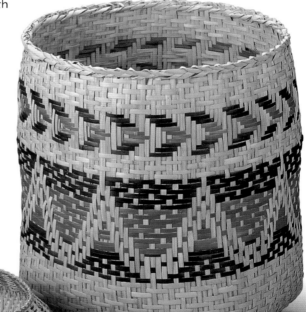

However, the Chitimacha have had the good fortune to remain in southern Louisiana, very close to the area in which Europeans first encountered them, in 1699 (Swanton, 1946).

The baskets of the Chitimacha are considered to be some of the finest produced in the Southeast (plate 86, p. 173). Two baskets were collected by Clark Field in 1938 from a Chitimachan in Charenton, near Grand Lake, Louisiana. The weaving elements are generally smaller than those of other tribes of the region, and the designs are often extremely complex. Only the Chitimacha create designs in plaited baskets that are curvilinear in effect. The names of these designs, such as "Alligator Entrails" and "Worm Tracks," clearly reflect their curvilinear nature (plate 90, p. 177). These highly complex designs have survived by the careful preservation of heirloom "pattern baskets" or pattern books. Reproducing such complex designs from generation to generation requires that the patterns be preserved in some way. Indeed, weavers make an effort to retain pattern sets of their most complex patterns (Gregory and Webb, 1984).

When European-Americans first encountered them in the early eighteenth century, the Catawba occupied parts of present-day western North Carolina and South Carolina. In 1763, they were granted a reservation in South Carolina. In 1841, after a failed treaty and an unsuccessful attempt to establish a reservation in North Carolina, the Catawba settled on an eight-hundred-acre reservation in South Carolina (Swanton, 1946).

Based on his 1931 fieldwork, anthropologist Frank Speck estimated that only 270 people remained in the Catawba tribe, of which only four spoke the traditional language (Speck, 1946). The single Catawba basket in the Field Collection is a large-throated fish trap (1948.39.234) made in about 1890 (plate 91). The white-oak Catawba fish trap differs from that of their non-Indian neighbors by the use of bent splints to close the narrow end of the trap, whereas most non-Indian traps use a wooden plug. Speck acquired this fish trap in North Carolina and Field purchased it from him in 1941.

PLATE 92 (above) : Houma baskets, c. 1941 : The twill-plaited basket on the upper left (1948.39.285) was made by Leona Billiot. Mrs. David Billiot, made the basket on the upper right (1849.39.212), using a "hitch-type" coiling stitch.

PLATE 91 (left) : Catawba fish trap, c. 1890 : The splints on fish traps were loosened or untied when wet and flexible in order to release the catch, after which they were retied. (1948.39.234).

The Houma, or Huma, were first encountered in the late seventeenth century on the east side of the Mississippi River, opposite the mouth of the Red River. After several unsuccessful attempts by the Jesuits to establish a mission in their village in 1700 and a devastating attack by the Tunica in about 1706, the Houma moved southward, toward New Orleans. The Houma later moved to the Gulf Coast in southern Louisiana, where they are found today (Swanton, 1946).

Currently, the Houma make both coiled and plaited baskets of palmetto leaves harvested prior to their opening fully. Palm is also used in the production of braided ribbons that are sewn into basket form. The wide-brimmed hats worn in the region are perhaps the most commonly known form of this type of basketry. The Houma use a unique coiling technique that spaces stitches by looping each around the previous one (Turnbaugh and Turnbaugh, 1986). This technique is represented in the collection by a small basket with a handle (1948.39.212) made by Mrs. David Billiot (plate 92).

The Billiot family accounts for all the known makers of Houma baskets collected by Field. In addition to the coiled palmetto basket noted above, a cypress-splint basket by Anthony Billiot (1948.39.368) and a plaited palmetto basket by Leona Billiot (1948.39.285) are included in the collection. The Billiot family still produces all manner of traditional craftwork, including braided-strip and sewn palmetto baskets and hats, and wood tools and boats made of cypress (Dean and Billiot, 1974).

In 1682, the Tunica occupied a territory along the Yazoo River in Mississippi, but fearing the Chickasaw, they moved south. There they were welcomed by the Houma, whom they later attacked and drove from the area. Prior to 1803, the Tunica abandoned their Mississippi homeland and moved up the Red River, settling near Marksville, Louisiana (Swanton, 1946), where they are located today.

Europeans first encountered the Biloxi in 1699 on the Pascagoula River, but by 1763, they had settled adjacent to the Tunica near Marksville. In response to the pressure of European-American expansion, the Biloxi fragmented, with small groups splitting from the main body to join other tribes. Biloxi peoples joined the Tunica and Choctaw in Louisiana, the Caddo and Pascagoula in eastern Texas, the Choctaw in Oklahoma, and the Coushatta in Texas.

PLATE 93 : (below) Tunica and Biloxi baskets : The Biloxi basket in the center (1964.24.8) was made by Mrs. Joe (Rose Jackson) Pierite in 1964. The makers of the two Tunica baskets are unknown (left: 1953.1.8; right: 1953.1.7). Clark Field collected these from Mr. L. A. Cayer, the superintendent of schools in Marksville, Louisiana.

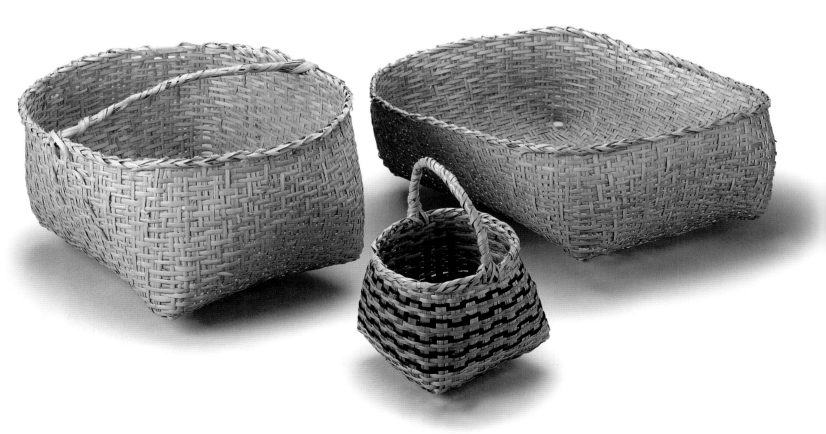

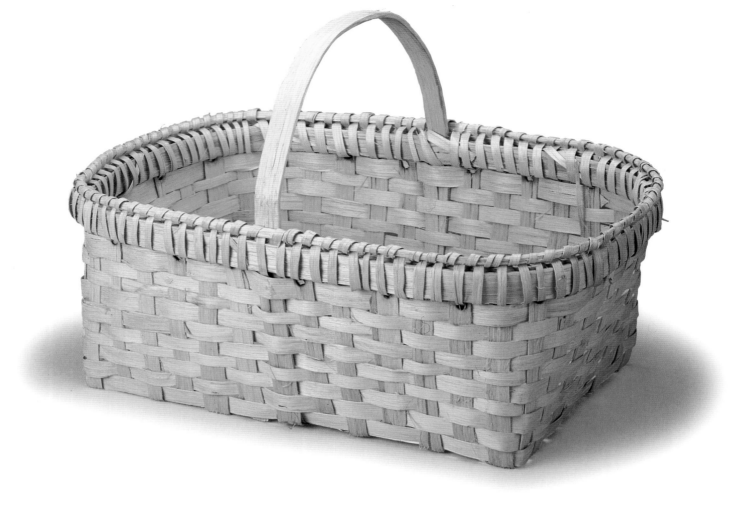

The single Biloxi basket and two Tunica baskets in the Field Collection were acquired near Marksville, Louisiana (plate 93). All three are made of cane. One is a typical tray and the other two are handled utility baskets. The Biloxi basket (1964.24.8) was made by Mrs. Joe (Rose Jackson) Pierite. She continued to produce traditional craftwork through the 1970s. Mrs. Pierite's mother, Emma Dorsey Jackson, was the last Biloxi speaker, and her husband, Joseph A. Pierite, served as chief of the United Tunica, Biloxi, Ofo, and Avowal tribes in Avoyelles Parish, Louisiana (Pierite, 1974).

As recently as the 1990s, the Houma, Tunica, and Biloxi all produced baskets in limited numbers. Many of the weavers are related to those whose work is represented in the Field Collection. Because of this limited production, baskets of these tribes are usually available only at event booths or directly from the weavers in their homes.

The Monacan have survived as a rural population surrounded by European-Americans. Their homeland was on the upper reaches of the James River in Virginia, where they were noted in 1702 by a Swiss traveler. By 1714, they were no longer recognized as a distinct Virginia tribal group (Swanton, 1946), although they continued to live there, away from European-American population centers.

Because of the rapid decline and dispersal of this tribe, it is not surprising that the only Monacan basket (1964.24.4) collected by Clark Field is virtually identical to the European-American wood-splint basketry of rural Virginia. This basket was collected in Amherst, Virginia, within the traditional territory of the Monacan (plate 94). Typical of rural Virginia baskets, this basket is an excellent example of Clark Field's effort to assure that his collection was indeed one that represented all of the basketmaking tribes in the United States. It was made by Virginia Branham (1919–1994), who was a largely self-taught occasional basketmaker all her adult life. When she was confined by poor health late in life, her production increased. She sold her baskets from her house, from Saint Paul's Episcopal Church in Amherst, and at a Lynchburg beauty shop owned by her oldest daughter, Mamie (Mamie J. Branham, October 3, 1999, personal communication).

The Seminole descend from several Creek groups that settled, moved, and resettled in multiple locations before becoming known as "Seminole." The first was a Muskogee-

PLATE 94 : Monocan basket, c. 1964 : Small in number and heavily influenced by their European-American neighbors, Monocan basketry such as this singular, well-documented basket adds greatly to the value of the Clark Field Collection (1964.24.4).

speaking people that became known as the "Cow Creek Indians." The second group was a Hitchiti-speaking people that became known as the "Big Cypress Indians" (Swanton, 1946). Members of the Big Cypress band, or Mikasuki, were originally residents of the Florida Panhandle before being forced south. The Creek War of 1813–1814 pitted the Lower Creeks, allied with European-Americans from Tennessee and Georgia, against the villages of the Upper Creeks. Many defeated Upper Creeks sought refuge in Florida, creating a physical separation between the refugee groups and the other Creeks. This was the beginning of a distinct separation between Creeks and Seminoles.

With the defeat of the Seminole in the First Seminole War of 1817–1818, the geographic separation of Seminoles and Creeks increased as refugees were forced to move farther south and east. In 1842, at the end of the Second Seminole War, only five hundred tribal members remained in Florida (Howard, 1984; Swanton, 1946).

The majority of Seminole baskets collected by Field are tray forms associated with traditional food preparation. Four of the eight baskets, all palmetto food-processing baskets, were acquired through a Mrs. Boehmer, a missionary/educator among the Seminole in Florida. Seminole burden baskets are identical in form to the other southeast burden baskets (plate 95).

Six of the eight Field baskets were made in the early 1940s. The six include the only basket (1950.17.16 a,b) constructed by coiling and made of a material other than palm. Although the collection likely reflects Field's instructions to Mrs. Boehmer as to the types of baskets desired, it also reflects a major shift in production. Prior to the early

PLATE 96 : Yuchi tray-form baskets, c. 1875 : The sifter tray by Fannie Fulsom (1962.13.3) on the right has been well used and repaired, indicating how important these baskets were to the Yuchi household. Of special note is that this sifter has a traditional braided rim while that of George Fulsom, Fannie's husband, on the left (1962.13.2), has a reinforced rim more typical of European-American baskets.

1940s, twill-plaited baskets woven of palmetto for use by tribal members dominated production. After that period, coiled baskets of wire grass, palm fiber, embroidery thread, and raffia, made for sale to European-Americans, became the dominant types. The increased use of coiling as the prevailing basketry technique can be attributed to the growth of the tourist industry in Florida and the accompanying commercialization of basketry (Downs, 1990; Deagan, 1981).

Annie Tommie, the Seminole basketmaker of a palmetto storage basket (1948. 39.358), is a well-known Seminole craftsperson and one of the first to make and market Seminole dolls (Downs, 1995). It is also likely that she is the Annie "Tommy" who contributed information on traditional Seminole food and lifestyle while assisting Frances Densmore during her fieldwork in the early 1930s (Densmore, 1956).

Today, very few tray baskets are produced. Florida Seminole baskets are predominantly easily produced souvenir items with little interest for the serious collector. However, although still far less important as an economic factor or as a cultural symbol than patchwork clothing, some fine coiled baskets, by a limited number of weavers, are being made. Although not a traditional form, these coiled baskets of palm husk, sweet grass, cotton thread, and other minor decorative materials are beginning to acquire a serious following among some collectors (Downs, 1990).

Indian Territory

The Second Seminole War was the last war between European-Americans and the Indians in the Southeast. The tribes that had not succumbed to disease, been eliminated by warfare, or merged with the few remaining larger tribes—frequently at the expense of their own identity—were to be resettled. In 1828, with the support of the southern states, Andrew Jackson, a strong proponent of "Removal," was elected president. By the middle of the 1830s, the major southeastern tribes—Cherokee, Creek, Choctaw, and Chickasaw, along with the majority of the Seminole, as well as the Yuchi and the remaining Natchez—were forced to move west to Indian Territory. The Cherokee and a few Natchez were placed in the northeastern part of Indian Territory. The Choctaw and Chickasaw received the southern third, with the Creek, Yuchi, and Seminole in the central portion, north of the Canadian River.

The new tribal nations in Indian Territory were only a small fraction of the size of their homeland. Not only was the new western territory smaller, but resources were more lim-

ited. Poorer soils, a drier climate, and a different plant community greeted most new arrivals.

Not every member of these tribes was resettled in Indian Territory. What the European-Americans wanted was the rich agricultural land, so most surviving Native American communities in the Southeast are found today in areas where intensive agriculture is not possible. Those Choctaw who refused to be pressured into accepting removal eventually formed communities near Philadelphia, Neshoba County, Mississippi, and near Bayou LaComb, Louisiana. Two bands of Seminole, the Cow Creek Indians and the Big Cypress, remained in the Everglades, the swampy delta region of southern Florida (Swanton, 1946). Some of the Cherokee stayed behind and lived in communities in the mountains of far western North Carolina and adjacent eastern Tennessee. Among

PLATE 97 : Creek corn-processing set, c. 1941 : In addition to the typically large Creek winnowing basket (left back: 1948.39.222), other baskets in the set include a riddle or sifter basket (left front: 1948.39.224), a sieve which has smaller holes (right rear: 1948.39. 225) and a solid-bottom basket for catching the processed materials (right front: 1948.39.223). These baskets were made by Winey Deere.

the Creek and Chickasaw, resettlement in the west seems to have been more complete than among the other tribes. Except for the Creeks who settled with the Seminole in Florida, there are no eastern villages of those tribes.

Of the southeastern tribes moved to Indian Territory, three continued to produce baskets in quantity—the Creek, Choctaw, and Cherokee. In the Field Collection, the number and quality of baskets from those tribes, rarely represented in collections, is extraordinary. Of the remaining three tribes—the Chickasaw, Seminole, and Yuchi—it appears that only the Yuchi continued to make a limited number of baskets.

Yuchi baskets, made in the late nineteenth century, are typical food-processing forms. Clark Field collected two Oklahoma Yuchi baskets, one each by George Fulsom and Fannie Fulsom (plate 96). Both are typical undecorated fine split-wood sifters acquired from the Fulsoms' grandson, Johnson Tiger. Interestingly, no Oklahoma Seminole baskets are in the collection. This tribe is well known for producing baskets in its eastern location in Florida. Field's failure to secure Oklahoma Seminole baskets is a good indication that no Seminole baskets were being produced in Oklahoma. Some-

what less surprising is the lack of Chickasaw baskets. There are no well-documented Chickasaw baskets from the Southeast or Indian Territory.

The Creek, actually a confederacy composed predominantly of Muskogee-speaking peoples, were comprised of the Kasihta and Coweta, the Coosa, and a host of smaller groups, including the Yuchi. The Creek confederacy was well established by the time of first contact with Europeans. For the most part, the confederacy occupied Georgia and northern Alabama. Except for a brief period when part of the tribe moved southwest to be near English trading posts and the part of the tribe that was forced south and became known as the Seminole, the Creek remained in the same area until they were removed to Indian Territory (Swanton, 1946).

The Creek basket industry has remained very consistent throughout the recorded history of the tribe. Descriptions of Creek basket materials include cane and at least one other material. The most commonly mentioned alternate material is hickory; however, dogwood and oak have also been noted. Creek baskets made of hickory frequently exhibit weaving elements of variable widths, a rare occurrence in cane baskets.

Based on a review of Oklahoma baskets, Creek basketry in the late nineteenth century was little different from that collected by Field forty to sixty years later. Utility baskets, including those for food processing, were made from both cane and wood. Elm, hickory, and white oak were used in the construction of utility baskets.

Eight Creek baskets are in the Field Collection, all from Oklahoma. Seven are food-preparation tray forms and are undecorated. Six are made of hickory, including four of the five collected from maker Winey Deere. A single exception is a basket made from dogwood. Although there are baskets made from this material at the Denver Art Museum (Douglas, 1969), it is most unusual.

The baskets made by Winey Deere, the only named Creek weaver in the collection, include a complete food-processing set (plate 97, p. 183). These baskets constitute the Creek version of the basic corn-processing set found across the Southeast. The most complete set in the Clark Field Collection, it was probably commissioned by Field from the weaver, who lived in Cromwell, Oklahoma. The availability of these baskets, collected in 1941, would seem to indicate the importance of traditional food processing in Creek culture and a continuing demand for traditional food-processing baskets.

Neither the Creek nor the Yuchi produced baskets primarily for the larger European-American market. However, the occasional appearance of a newly manufactured hickory tray in the area settled by the Creek and Yuchi would seem to indicate that some traditional basketry is still produced to support a limited practice of traditional food preparation.

The Choctaw homeland of central and north-central Mississippi and adjacent Tennessee and Alabama contained some of the richest farmland in the American Southeast. Although often at war with adjacent tribes, the Choctaw were never at war with the United States. However, the expanding European-American population after the Revolutionary War eventually forced Choctaw removal.

The Choctaw Nation was in the extreme southeastern part of Indian Territory. It is more rugged and significantly less fertile than the homeland. There were few towns in the Choctaw Nation. However, towns had developed across the border in Arkansas and across the Red River in Texas.

In Louisiana, by 1890, the Choctaw had become active participants in the urban European-American economy, as demonstrated by their presence at the New Orleans French Market, selling filé and sassafras roots (Watkins, 1894). In Mississippi and Louisiana, the marketing of baskets in the post–Civil War era had also become an important part in the Choctaw family economy. Choctaw children were often absent from school because they accompanied their parents on winter basketmaking and selling excursions (Halbert, 1896). Bushnell (1909) also noted that "large numbers of small baskets provided with handles are made and exchanged" by the Bayou LaComb Choctaw in nearby towns. These nontraditional baskets were sold as souvenirs to visi-

tors. Thus, by the turn of the twentieth century, although traditional baskets continued to be made, baskets for the European-American market were already influencing the size and form of Choctaw basketry in the tribe's eastern homeland.

In Indian Territory after the Civil War, documentation indicates that traditional food preparation continued to be an important part of Choctaw life. During her childhood, in the 1870s and 1880s, Emma Christian (1931) states that baskets were used in processing corn and nuts. She recounts that sifters were used to separate the husk from the kernel of corn and, once pounded, the meat from the shell of nuts. A rectangular Choctaw winnowing basket was formed with a high wall at one end and no wall at the other. The basket can be held near the high wall and used to toss the pounded material, or it may be held near the open end and used to flip the material back on itself in the manner of an omelet on the edge of a skillet. Referring to the 1870s, Andrew Riley (Indian Pioneer History, 1937) noted the widespread use and manufacture of cane baskets, as well as the log mortar and pestle, or maul, by Choctaws in the Poteau area of Indian Territory.

Although there also appears to have been a local market for baskets in Indian Territory, this did not compare with the European-American market for basketry in the East. It is evident that baskets produced for the local market were traditional forms, sold or traded for use in traditional food processing.

Some baskets were also sold outside the Choctaw Nation. Interestingly, the best account of sales outside the nation is from Harvey Williams, a Choctaw whose mother immigrated into the Choctaw Nation from Louisiana, where selling baskets to European-Americans had a nineteenth-century precedent (Indian Pioneer History, 1937):

> My mother was a basket maker; she would make up baskets, some small ones and some large ones and sell them; she would sell the small ones for twenty-five cents apiece and the large ones for a dollar apiece and she would take some baskets into Texas were she sold them to white people. She would dye these baskets some way with herbs and roots. I do not know what these roots and herbs were but the dye would make these baskets look spotted and striped all over.

Although somewhat vague, this statement would appear to indicate that baskets made for sale in Texas were dyed, in contrast to those sold locally. In addition, this description implies that most of the baskets were sold locally. Thus, while the eastern Choctaw were involved in a seasonal round that included regular basketmaking and exploitation of urban markets, basketmakers in the Choctaw Nation were apparently unable to exploit similar markets. As a result, income from basketry was unavailable to a significant number of families.

The material available on the marketing of Choctaw baskets at the time Field was collecting indicates that tray forms still dominated the basketmakers' repertoire. Clark Field collected twenty-three Choctaw baskets from Oklahoma, six from Mississippi, and four from Bayou LaComb, Louisiana. Of the twenty-three baskets collected by Field in Oklahoma, ten are tray forms with dyed weaving elements, three make up an undecorated corn-processing set, six are simple handled forms with dyed weaving elements, and one each is a heart, elbow, three-sided, and handleless workbasket.

The importance of trade for the Mississippi and Bayou LaComb Choctaw is evident in the basketry forms of the nine baskets Field collected from those areas. Four basket forms are represented in the five baskets collected from the Mississippi Choctaw. These forms include a wall-pocket basket, two bail-handled baskets, a clothes hamper, and a lidded "berry basket" which reportedly was made in Mississippi in 1817 and brought to Oklahoma. Although those forms may not have been produced exclusively for European-American consumption, they are the forms that were commonly sold. The three forms represented in the four Bayou LaComb baskets are more likely commercial forms. Also, there is a distinct lack of the tray form associated with traditional southeastern culture.

Only three Choctaw basketmakers are known from the Field Collection, Marellia Johnson from Bayou LaComb and Jane Brandy and Fannie Battiest from Oklahoma. According to a note on a receipt for baskets sold to Alice Marriott, a field worker for the Indian Arts and Crafts Board in 1937, Fannie Battiest married Willis Wesley at about that time and sold baskets under the name Fannie Wesley. Although the Oklahoma Choctaw baskets collected by Field were made for sale, they do not appear to be forms produced specifically for sale to European-Americans. Decoration with dyed weaving elements is uncommon, and the shapes represented are dominated by tray forms associated with traditional foodways.

Today, Choctaw basketry continues to be produced in Mississippi and Oklahoma. Weavers in both areas produce cane baskets in a variety of shapes and sell directly to the public. Mississippi baskets are readily available in shops in many areas of Mississippi as well as at special events such as the Choctaw Fair in Philadelphia, Mississippi. Oklahoma baskets are seldom available for sale to the public and then only at event booths or directly from the maker.

The traditional homeland of the Cherokee in the early 1700s was western North and South Carolina and parts of northern Georgia and Alabama, southern West Virginia, western Virginia, and eastern Kentucky (Hill, 1997). Unlike the two other basket-producing tribes which were removed to Indian Territory, the Cherokee had a well-developed basket trade with European-Americans in the eighteenth century. Valued by the elite of colonial society, baskets were so well established as a valuable trade item by 1716 that they were included in the goods that could be traded only at government trading posts (Hill, 1997). Nevertheless, private sales persisted.

Spoliation claims submitted by individual Cherokees to request compensation for losses suffered during removal frequently list baskets. Tray forms, including winnowing baskets, riddles (coarse sieves), sifters (fine meshed sieves), and bread trays, were the most common baskets listed (Hill, 1997; Duggan and Riggs, 1991). Forms of southeastern basketry less commonly found in the inventories included pack baskets, lidded storage baskets, and others. Baskets manufactured of split oak or handled forms were rarely noted (Duggan and Riggs, 1991), supporting the contention that white-oak basketry developed in North Carolina largely after the Cherokee removal.

The shift from the dominance of cane to the dominance of oak, which occurred among the Eastern Cherokee, directly reflects the growing influences of European-American settlements in the region. In the 1880s, baskets were an important part of the income of the Eastern Band of Cherokee. By the 1890s, large nets or sacks filled with baskets for sale to European-American visitors were recorded. These baskets were sold or exchanged for necessary items from the larger European-American market. Corn, the principal crop of the Cherokee, was not traded, and it continued to be processed and consumed in the traditional manner.

After the turn of the century, the European-American market continued to be important. Baskets were made by such weavers as Nancy Bradley, who was an accomplished weaver of cane by 1915 (plate 98). According to her daughter, Rowena, she continued to weave until shortly before her death (Hill, 1997). Nancy Bradley's work is represented in the Field Collection by seven cane baskets and one split-oak basket (1948.39.27). Other North Carolina Eastern Band of Cherokee weavers represented in the Field Collection include Sally Toinuta (1948.39.218) and Katie Loossie (Lossiah) (1948.39.220).

The European-American market for Eastern Cherokee baskets, first established in colonial times, fluctuated through time but never completely disappeared. The creation of the Indian Arts and Crafts Board in 1935, the board's subsequent efforts to promote traditional arts and crafts, and the Eastern Band of Cherokees' proximity to a popular resort area greatly influenced the production and availability of basketry. Field assembled most of his Cherokee baskets in the early 1940s, with another brief buying effort in the early 1960s. Field either purchased the Cherokee baskets from the source or from Frank Speck, who also had acquired them during the 1940s.

PLATE 98 : Cherokee burden basket, 1941 : **This basket was made by Nancy Bradley, a name that is synonymous with North Carolina Cherokee weaving. She played a major role in the preservation and revitalization of the burden basket and the technically difficult double-weave basket** (1948.39.196).

White-oak basketry never became as well established in Indian Territory as in the North Carolina homeland. Although various parts of Oklahoma Cherokee baskets were made of a variety of materials, the use of split oak as the primary material never became widespread. However, with a territory at the edge of river cane's natural range, it is not surprising that Cherokee cane weavers struggled to maintain it as a marketable craft. Food-processing baskets continued to be made of cane, but because obtaining cane was difficult, other materials came into use (plate 99).

Regarding Indian Territory basketry of the late nineteenth century, there are few references to any sort of split-wood basketry. In recalling her late-nineteenth-century childhood, Mary Baker remembered that her fellow Cherokees "wove baskets out of buck brush and cane stalks" (Indian Pioneer History, 1937). Buckbrush, found in the western United States, was adapted by the Cherokee for basket construction after their arrival in Indian Territory. The plant is relatively small; however, the lengthy root runners make excellent basket material. More than thirty of the forty-two Oklahoma Cherokee baskets collected by Field are made, at least in part, of buckbrush. Except for a large cradle and several large storage baskets (plate 100) more than eighteen inches tall, most buckbrush baskets are less than ten inches tall and less than fifteen inches in diameter, sizes consistent with decorative use. This may reflect the fact that during the 1930s, WPA (Works Progress Administration) workers had encouraged the production of buckbrush basketry because it sold well in the European-American market (Foreman, 1948).

Another testimony to the importance of basket weaving as a source of cash income among the Oklahoma Cherokee is the number of weavers. Nine Oklahoma weavers are represented in the Field Collection. Twenty-nine weavers' names were noted in Alice Marriott's correspondence and reports. Even allowing for considerable overlap and family name confusion, the number of Cherokee weavers indicates that by the mid-1930s, basket weaving was of considerable economic significance.

Many of the Oklahoma Cherokee baskets in the Field Collection were woven in western Delaware County, near the towns of Kenwood and Eucha. Those baskets were likely acquired because the area was close to Clark Field's Tulsa home and because those weavers had impressed Alice Marriott, who was active in promoting the Native Ameri-

PLATE 99 : Oklahoma Cherokee stick baskets : Among the Oklahoma Cherokee split-hickory tray-form baskets with Cherokee rims, but otherwise much like Creek examples, are known as "stick baskets." The sifter on the left (1946.47.9) was made in 1936. The sifter on the right (1946.47.11) was made in 1890.

can art of Oklahoma. Marriott supplied baskets to Field and considered baskets made
by the Kenwood/Eucha weavers the best woven by Oklahoma Cherokees. Some of the
weavers represented in the Field Collection, such as Sallie Lacy (1948.39.67,
1948.39.173 a,b), share surnames with Cherokee weavers whose names were on a
price list of Kenwood weavers compiled by Alice Marriott.

The focus on the European-American market by Cherokee basketmakers is still the
case in both North Carolina and Oklahoma. In Oklahoma, event booth sales seem to
be the dominant marketing mechanism. Local festivals on major holiday weekends and
Native American art shows in Oklahoma City, Tulsa, and Bartlesville attract a significant
number of weavers and their wares. In the Southeast, basketry is also available at event
and holiday locations. In addition, the Cherokee Fair and the Qualla Arts and Crafts Co-
Op have provided outlets for eastern weavers and a steady supply for buyers.

Southeastern Indian basketry has persisted despite four hundred years of European-
American influences. When necessary, the forms have changed to suit a new function
within the market economy of the European-American society. Where traditional basket
materials have become rare because of modern agricultural practices or a tribe's relo-
cation, new materials have been found and used. Where the influences of the larger
European-American society have been less, basket forms associated with traditional
food processing have persisted. Baskets which served as part of the food-processing
technology and the forms that evolved from them are testimony to the enduring pat-
terns of culture that evolved in the Southeast thousands of years ago.

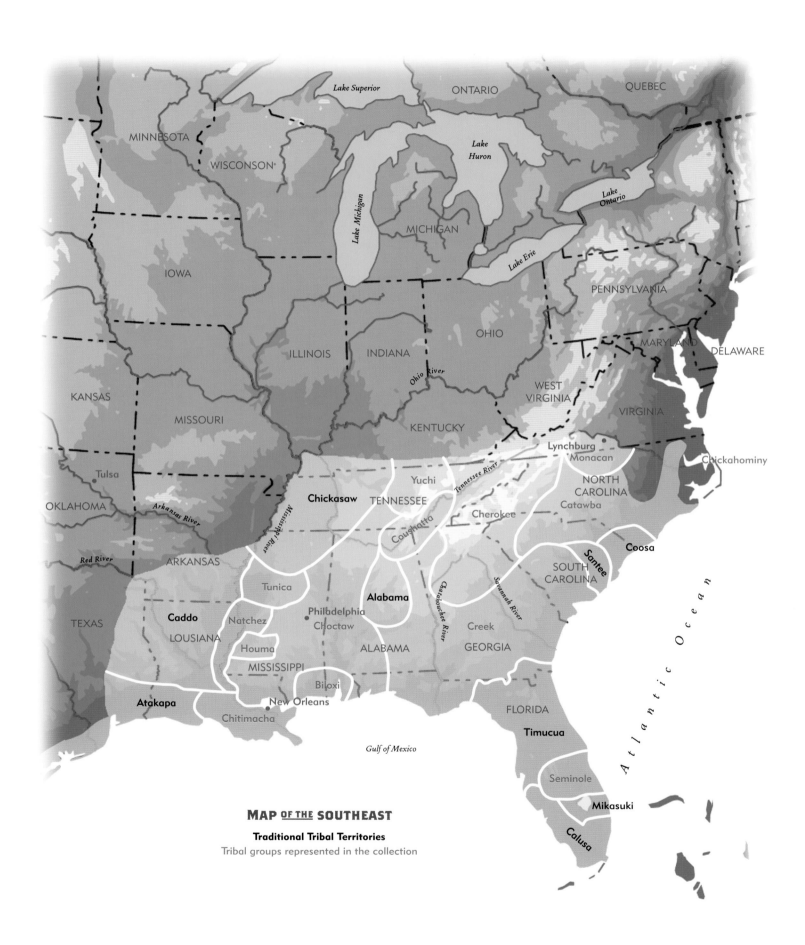

MAP OF THE SOUTHEAST

Traditional Tribal Territories
Tribal groups represented in the collection

The Native American basketry collection consists of 1,165 baskets, the majority of which were collected by Clark Field. A complete list of baskets made by approximately 142 Native American tribes, pueblos, and nations from throughout most of the United States, Canada, part of the Arctic Circle, and northern Mexico is included in this section. Although the essays in this catalogue discuss only baskets in the Clark Field Collection, baskets collected and donated to The Philbrook Museum of Art by others throughout the years are also listed. These are identified by the credit line at the end of each entry. Because the focus of this catalogue is on the native peoples of North America, which was Clark Field's primary concern, baskets collected by Field and others in central Mexico, Central and South America, and the Caribbean are not included.

The list follows the order of the cultural areas discussed in the text of this catalogue. Under each specific cultural area, for example, Southwest, California, and so on, the baskets are listed numerically under each tribal heading. Within those tribal headings, separate bands or linguistic groups may also be listed. For example, under the heading of Apache in the Southwest section, the Chiricahua and Jicarilla Apache are listed as subheadings. In some cases, for example, among the Hopi, where there is a difference in the weaving techniques between the Second and Third Mesas, they are listed as separate subheadings. In a few instances in which Clark Field appears to have been misinformed as to the tribe or in which he has used an archaic term, these are noted in square brackets with a C.F. For example, a Western Apache shallow bowl that Field identified as San Carlos Apache is listed as Western Apache [San Carlos C.F.]. Unless it is clearly an error, tribal affiliations remain as listed by Field.

Under the tribal heading, each basket entry lists the title of the basket and the date made. The title of the basket indicates either the shape, for example, bowl, round basket with handle or lid, olla, or plaque, or the function, for example, hat, cradle, burden basket, winnowing tray, or seed beater. Most of the titles used do not reflect Field's original classification, which was simply "basket." He did, however, frequently indicate the function of the basket. The title is followed by the date, or circa date, that the basket was made.

Next is the name of the weaver, if known. If the weaver is not known but we are able to identify the maker based on stylistic similarities, the weaver's name will have a question mark in brackets after it.

The type of weaving technique used and the dimensions in inches are indicated in the next line. When two dimensions are given, the first number indicates the height and the second the diameter of the basket. For example, ½ x 23 may be the dimensions of a gambling tray. The tray measures ½ inch in height and 23 inches in diameter. Where three dimensions are given, for example, 3 x 4 x 7, the measurements indicate the height, width, and length of the basket.

Philbrook's accession number and the credit line follow this. For all Clark Field baskets, we have noted the available collection information, which often includes the documentation as to when and where he collected the baskets. For all others, the formal credit line for the Philbrook collections is used.

Shelby J. Tisdale
Curator of Native American
and Non-Western Art

Southwest Baskets

Ancestral Pueblo (Anasazi)

Bowl, c. A.D. 1–500
Twined, 5⅝ x 4½
1948.27.73
Collected by Clark Field in 1937 from J. Verkamp, Flagstaff, Arizona. The basket was appraised, valued, and classified by H. P. Mera, curator of anthropology, Laboratory of Anthropology, Santa Fe, New Mexico.

Apache

Chiricahua

Burden basket with jingles, c. 1920
Twined, 10½ x 12
1948.27.19
Collected by Clark Field in 1937.

Water bottle, c. 1940
Made by Dorothy Kawaykula's sister
Twined, 13½ x 9½
1948.39.362
Collected by Clark Field in 1943.

Jicarilla

Water jar, c. 1910
Coiled, 9 x 9½
1942.13.16
Gift of Mr. and Mrs. Waite Phillips

Basket cup with handle, c. 1890
Coiled, 2¾ x 3¾
1947.19.222
Roberta Campbell Lawson Collection, gift of Mr. and Mrs. Edward C. Lawson

Basket with two handles, 1936
Coiled, 11 x 11¾
1947.57.50
Collected by Clark Field in 1936.

Bowl, c. 1888
Coiled, 6 x 15½
1948.39.123
Collected by Clark Field in 1938, Jicarilla Indian Agency, Dulce, New Mexico.

Hamper with lid, c. 1915
Coiled, 22¾ x 14¾
1948.39.124 a,b
Collected by Clark Field in 1915, Jicarilla Indian Agency, Dulce, New Mexico.

Shallow bowl, c. 1920
Coiled, 6½ x 19¾
1953.21.10
Collected by Clark Field in 1953 near Dulce, New Mexico.

Shallow bowl, c. 1920
Coiled, 4 x 13½
1953.21.11
Collected by Clark Field in 1953 near Dulce, New Mexico.

Bowl, 1954
Coiled, 6 x 16
1954.15.10
Collected by Clark Field in 1954.

Bowl, 1954
Made by Tanzanita Pesata
Coiled, 6¼ x 16¾
1954.15.11
Collected by Clark Field in 1954 at Dulce, New Mexico.

Mescalero

Shallow bowl, c. 1937
Coiled, 3⅞ x 20
1948.27.25
Collected by Clark Field in 1937.

Bowl, c. 1938
Coiled, 8½ x 8
1948.39.115
Collected by Clark Field in 1938.

Basket with handle, c. 1938
Twined, 12½ x 9¾
1948.39.116
Collected by Clark Field in 1938.

Straight-sided basket, c. 1938
Coiled, 8 x 9½
1948.39.117
Collected by Clark Field in 1938.

Burden basket, c. 1939
Twined, 11¾ x 13½
1948.39.132
Collected by Clark Field in 1939.

San Carlos

Bowl, c. 1920s
Coiled, 3 x 14
1942.14.1888
Collected by Clark Field in 1944 in Whiteriver, Arizona.

Burden basket, c. 1920
Twined, 10 x 12½
1942.14.1993
Collected by Clark Field in 1947, San Carlos Apache Reservation near Globe, Arizona.

Shallow bowl, c. 1938
Coiled, 4½ x 18½
1948.39.103
Collected by Clark Field in 1938 from Ada T. Tiffany, San Carlos Apache Reservation, Arizona.

Water bottle with two loops and strap, c. 1900
Twined, 17 x 8½ ; strap: 15
1948.39.337
Collected by Clark Field in 1942.

Tonto

Shallow bowl, c. 1940
Coiled, 2¾ x 13
1942.14.1951
Collected by Clark Field in 1946.

Flat-based gambling tray, c. 1845
Coiled, 5 x 24½
1942.14.1977
Collected by Clark Field in 1947, Camp Verde Reservation, Camp Verde, Arizona.

Olla, c. 1900
Coiled, 28 x 19
1942.14.1982
Collected by Clark Field in 1947, Camp Verde Reservation, Camp Verde, Arizona.

Tray, c. 1890
Coiled, 3¼ x 22
1950.17.2
Collected by Clark Field in 1950.

Western

Water bottle, 1890
Twined, 22 x 16
1942.13.15
Gift of Mr. and Mrs. Waite Phillips

Burden basket, c. 1900
Twined, 14¾ x 16
1942.13.47
Gift of Mr. and Mrs. Waite Phillips

Bowl, c. 1900
Coiled, 4½ x 16
1947.19.542
Roberta Campbell Lawson Collection, gift of Mr. and Mrs. Edward C. Lawson

Shallow bowl, c. 1930
Coiled, 2½ x 11¼
1947.29.3
Gift of H. P. Bowen

Shallow bowl, 1920
Coiled, 3½ x 13½
1947.29.4
Gift of H. P. Bowen

Bowl, c. 1900
Coiled, 3¼ x 12¾
1947.29.5
Gift of H. P. Bowen

Bowl, 1910
Coiled, 3 x 12
1947.29.6
Gift of H. P. Bowen

Shallow bowl, 1890
Coiled, 4¼ x 13½
1947.29.7
Gift of H. P. Bowen

Shallow bowl, c. 1940
Coiled, 4 x 13
1947.29.8
Gift of H. P. Bowen

Shallow bowl, c. 1900
Coiled, 3½ x 14½
1947.29.9
Gift of H. P. Bowen

Shallow bowl, c. 1900
Coiled, 4¼ x 17½
1947.29.11
Gift of H. P. Bowen

Olla, c. 1900
Coiled, 13¾ x 11
1947.29.12
Gift of H. P. Bowen

[San Carlos C.F.]
Shallow bowl, c. 1937
Coiled, 2⅞ x 15½
1948.27.70
Collected by Clark Field in 1937.

Western/San Carlos
Tray, c. 1900
Coiled, 4½ x 23½
1953.21.9
Collected by Clark Field in 1953.

Shallow bowl, c. 1954
Coiled, 4 x 16
1954.15.3
Collected by Clark Field in 1954 in
Arizona.

Shallow bowl, c. 1954
Coiled, 4½ x 16½
1954.15.4
Collected by Clark Field in 1954 in
Arizona.

Olla, c. 1940
Coiled, 15½ x 13½
1954.15.6
Collected by Clark Field in 1954 in
Arizona.

Shallow bowl, c. 1900
Coiled, 4¾ x 18¼
1954.15.13
Collected by Clark Field in 1954 in
Arizona.

Shallow bowl, c. 1900
Coiled, 4 x 19¼
1954.15.14
Collected by Clark Field in 1954 in
Arizona.

Shallow bowl, c. 1900
Coiled, 4½ x 20¼
1954.15.17
Collected by Clark Field in 1954 in
Arizona.

Olla, c. 1910
Coiled, 13½ x 12
1995.25.29
Gift of the University of Tulsa,
Ellis Soper Collection

White Mountain
Burden basket, c. 1900
Twined, 3¾ x 14¾
1942.11.79
Gift of Mrs. C. C. Bovey

Burden basket, c. 1940
Made by Mrs. William Fall
Twined, 13½ x 13
1942.14.1887
Collected by Clark Field in 1944, Fort
Apache Reservation, Whiteriver, Arizona.

Hourglass water bottle, c. 1900
Twined, 7¼ x 5½
1942.14.1889
Collected by Clark Field in 1944, Fort
Apache Reservation, Whiteriver, Arizona.

Burden basket, c. 1905
Made by Alice Spink's mother
Twined, 15 x 15¼
1947.57.65
Collected by Clark Field in 1937 from
Alice Spink, whose mother made the
basket. Field collected it from Alice at
Bacone College, Muskogee, Oklahoma.

Olla, c. 1900
Coiled, 30½ x 21¼
1948.39.95
Collected by Clark Field in 1938.

Navajo

Wedding basket, c. 1910
Coiled, 3¾ x 11¼
1942.14.1952
Collected by Clark Field in 1946.

Shallow bowl, c. 1875
Coiled, 3¾ x 13
1942.14.1953
Collected by Clark Field in 1946, Navajo
Reservation, Arizona.

Water bottle with two handles, c. 1940
Coiled, 10¾ x 7
1942.14.2005
Collected by Clark Field in 1947, Navajo
Canyon (Navajo National Monument),
near Kayenta, Arizona.

Water bottle with two handles, c. 1910
Coiled, 18¾ x 14
1942.14.2006
Collected by Clark Field in 1947, Paiute
Canyon, near Tuba City, Arizona.

Wedding basket, c. 1890
Coiled, 3¼ x 12
1948.39.47
Collected by Clark Field in 1937.

Shallow bowl, c. 1900
Coiled, 3½ x 13¼
1953.1.22
Collected by Clark Field in 1952, Navajo
Reservation, Arizona.

Bowl, c. 1960
Coiled, 3½ x 9¼
1960.7.5
Collected by Clark Field in 1960, Navajo
Reservation, Nakaai Mesa, New Mexico.

Shallow bowl, 1961
Coiled, 2¾ x 10¾
1961.16.2
Collected by Clark Field in 1961, Shonto,
Arizona.

Shallow bowl, 1961
Coiled, 3½ x 16
1961.16.3
Collected by Clark Field in 1961, Shonto,
Arizona.

Northern Mexico

Lower Pima (Pima Bajo)

[Papago C.F.]
Syrup strainer, 1938
Twill plaited, 6 x 5
1948.39.119
Collected by Clark Field in 1938, Papago
Indian Reservation, west of Tucson,
Arizona.

Deep bowl, c. 1956
Twill plaited, 7¼ x 13½
1956.19.2
Collected by Clark Field in 1956,
Maicaba, Sonora, Mexico.

Straight-sided basket, c. 1956
Twill plaited, 6 x 7
1956.19.3
Collected by Clark Field in 1956,
Maicaba, Sonora, Mexico.

Seri

Shallow bowl, c. 1947
Coiled, 4¼ x 15½
1942.14.2007
Collected by Clark Field in 1947 from
William Neal Smith II in Tucson, Arizona.

Jar, c. 1947
Coiled, 6½ x 7
1942.14.2010
Collected by Clark Field in 1947 from
William Neal Smith II in Tucson, Arizona.

Shallow bowl, c. 1947
Coiled, 4 x 16¾
1942.14.2011
Collected by Clark Field in 1947 from
William Neal Smith II in Tucson, Arizona.

Shallow bowl, c. 1949
Made by Maria Villalobos
Coiled, 5¼ x 23½
1942.14.2112
Collected by Clark Field in 1949.

Shallow bowl, 1949
Made by Maria Jesus Molino
Coiled, 3½ x 20¼
1942.14.2113
Collected by Clark Field in 1949 from Don
Spence of Tulsa, who obtained it on
Tiburón Island, Gulf of California, Mexico.

Tarahumara

Storage basket, c. 1950
Twill plaited, 5½ x 11 x 11
1942.14.2115
Collected by Clark Field in 1950 from A.
Tappolet in Chihuahua, Mexico.

Southwest Baskets (cont.)

Basket with lid, c. 1940
Twill plaited, 7¾ x 12
1948.39.179 a,b
Collected by Clark Field in 1940.

O'odham

Akimel O'odham (Pima)
Miniature shallow bowl, c. 1930
Coiled, 1⅜ x 7
1942.11.77
Gift of Mrs. C. C. Bovey

Shallow bowl, c. 1900
Coiled, 3⅝ x 30¼
1942.14.1939
Collected by Clark Field in 1946.

Winnowing tray, c. 1930
Coiled, 1¼ x 16¼
1942.14.1948
Collected by Clark Field in 1946, Gila
River Reservation, Arizona.

Grain storage basket with lid, c. 1946
Made by Lucy Chiago
Coiled, 22 x 24
1942.14.1966 a,b
Collected by Clark Field in 1946, Gila
River Reservation, Sacaton, Arizona.

Household basket with lid, 1946
Made by Lucy Chiago
Coiled, 10½ x 11 x 17½
1942.14.1967 a,b
Collected by Clark Field in 1946, Gila
River Reservation, Sacaton, Arizona.

Miniature basket, 1946
Made by Luchial
Coiled, ¼ x ⁷⁄₁₆
1942.14.1968
Collected by Clark Field in 1946, Gila
River Reservation, Sacaton, Arizona.

Miniature basket, c. 1942
Made by Luchial
Coiled, hood x ⅜
1942.14.1969
Collected by Clark Field in 1946, Gila
River Reservation, Sacaton, Arizona.

Miniature basket with lid, c. 1940
Made by Luchial
Coiled, ¾ x ⅞
1942.14.1970 a,b
Collected by Clark Field in 1946, Gila
River Reservation, Sacaton, Arizona.

Miniature basket, c. 1940
Made by Luchial
Coiled, ¼ x ⅜
1942.14.1971
Collected by Clark Field in 1946, Gila
River Reservation, Sacaton, Arizona.

Shallow bowl, c. 1925
Coiled, 2¾ x 8¾
1942.14.1973
Collected by Clark Field in 1946, Gila
River Reservation, Sacaton, Arizona.

Decorative plaque, c. 1948
Made by Emma Newman
Coiled, 3 x 24½
1942.14.2020
Collected by Clark Field in 1948, Gila
River Reservation, Blackwater, Arizona.

Olla-shaped basket, c. 1948
Made by Anastasia Zachary
Coiled, 8¼ x 10¼
1942.14.2025
Collected by Clark Field in 1948, Gila
River Agency, Sacaton, Arizona.

Olla-shaped basket, c. 1948
Made by Anastasia Zachary
Coiled, 8½ x 9½
1942.14.2026
Collected by Clark Field in 1948 from Bert
Robinson at the Gila River Agency,
Sacaton, Arizona.

Miniature basket with lid, c. 1948
Made by Mrs. [Emma?] Newman
Coiled, ¾ x ⅝
1942.14.2031 a,b
Collected by Clark Field in 1948, Gila
River Reservation near Sacaton, Arizona,
from the weaver or the weaver's family.

Miniature basket with lid, c. 1940
Made by Mrs. [Emma?] Newman
Coiled, ¾ x ⅝
1942.14.2032 a,b
Presumed collected by Clark Field in
1948, Gila River Reservation near
Sacaton, Arizona, from the weaver or the
weaver's family.

Miniature basket with lid, c. 1940
Made by Mrs. [Emma?] Newman
Coiled, 1 x ¾
1942.14.2033 a,b
Collected by Clark Field in 1948, Gila
River Reservation near Sacaton, Arizona,
from the weaver or the weaver's family.

Miniature basket with lid, c. 1940
Made by Mrs. [Emma?] Newman
Coiled, ¾ x ⅞
1942.14.2034 a,b
Collected by Clark Field in 1948, Gila
River Reservation near Sacaton, Arizona,
from the weaver or the weaver's family.

Miniature basket with lid, c. 1930
Made by Mrs. [Emma?] Newman
Coiled, 1 x ¾
1942.14.2035 a,b
Collected by Clark Field in 1948, Gila
River Reservation near Sacaton, Arizona,
from the weaver or the weaver's family.

Miniature basket with lid, c. 1930
Made by Mrs. [Emma?] Newman
Coiled, 1⅛ x 1⅝
1942.14.2036 a,b
Collected by Clark Field in 1948, Gila
River Reservation near Sacaton, Arizona,
from the weaver or the weaver's family.

Miniature basket with lid, c. 1930
Made by Mrs. [Emma?] Newman
Coiled, ⅞ x 1⅛
1942.14.2037 a,b
Collected by Clark Field in 1948, Gila
River Reservation near Sacaton, Arizona,
from the weaver or the weaver's family.

Miniature basket with lid, c. 1948
Made by Mrs. [Emma?] Newman
Coiled, 1⅛ x 1
1942.14.2038 a,b
Collected by Clark Field in 1948, Gila
River Reservation near Sacaton, Arizona,
from the weaver or the weaver's family.

Miniature basket with lid, c. 1948
Made by Mrs. [Emma ?] Newman
Coiled, 1⅛ x 1¼
1942.14.2039 a,b
Collected by Clark Field in 1948, Gila
River Reservation near Sacaton, Arizona,
from the weaver or the weaver's family.

Miniature basket with lid, c. 1948
Made by Mrs. [Emma?] Newman
Coiled, 1¼ x 1⅞
1942.14.2040 a,b
Collected by Clark Field in 1948, Gila
River Reservation near Sacaton, Arizona,
from the weaver or the weaver's family.

Miniature tray, c. 1948
Made by Susan White
Coiled, ⅛ x 2¾
1942.14.2041
Collected by Clark Field in 1948, Gila
River Reservation near Sacaton, Arizona.

Miniature tray, c. 1948
Made by Francis Blackwater
Coiled, ⅝ x 4½
1942.14.2042
Collected by Clark Field in 1948, Gila
River Reservation near Sacaton, Arizona.

Miniature olla, 1948
Made by Francis Blackwater
Coiled, 2½ x 3¼
1942.14.2043
Collected by Clark Field in 1948, Gila
River Reservation near Sacaton, Arizona.

Shallow bowl, c. 1948
Made by Mrs. John
Coiled, 2¼ x 27¼
1942.14.2067
Collected by Clark Field in 1948, Gila
River Reservation near Sacaton, Arizona.

Trinket basket, c. 1949
Coiled, 2⅝ x 4¼
1942.14.2107
Collected by Clark Field in 1949, Gila
River Reservation, Arizona.

Straight-sided basket, c. 1935
Coiled, 5 x 9
1946.47.19
Collected by Clark Field in 1935.

Bowl, c. 1920
Coiled, 3¾ x 14⅜
1947.19.238
Roberta Campbell Lawson Collection,
gift of Mr. and Mrs. Edward C. Lawson

Straight-sided basket, c. 1935
Coiled, 5¾ x 8¾
1947.57.34
Collected by Clark Field in 1935.

Straight-sided basket, c. 1935
Coiled, 5½ x 9¼
1947.57.36
Collected by Clark Field in 1936.

Shallow bowl, c. 1936
Coiled, 6¼ x 16½
1947.57.49
Collected by Clark Field in 1936.

Shallow bowl, c. 1937
Coiled, 3 x 13
1948.27.27
Collected by Clark Field in 1937.

Olla-shaped basket, c. 1937
Coiled, 8½ x 9½
1948.27.81
Collected by Clark Field in 1937.

Shallow bowl, c. 1920
Coiled, 5 x 16⅜
1948.39.6
Collected by Clark Field in 1937.

Olla-shaped basket, c. 1937
Coiled, 12 x 10½
1948.39.13
Collected by Clark Field in 1937.

Trinket basket, c. 1937
Coiled, 3½ x 6⅛
1948.39.19
Collected by Clark Field in 1937.

Shallow bowl, c. 1930
Coiled, 4 x 14½
1948.39.66
Collected by Clark Field in 1938.

Shallow bowl, c. 1938
Coiled, 3 x 12½
1948.39.100
Collected by Clark Field in 1938 from
Rudy Kassel, superintendent of Indian
schools, Tucson, Arizona, who had
collected it at Santa Rosa, Papago Indian
Reservation, Arizona.

Burden basket, c. 1890
Made by Mary Poso
Twill plaited, 12 x 25½ x 20½
1948.39.394
Collected by Clark Field in 1943,
Covered Wells, Papago Indian
Reservation, Arizona.

Miniature basket, c. 1950
Coiled, 2¼
1951.18.1
Collected by Clark Field in 1950.

Miniature basket, c. 1950
Coiled, 2⁵⁄₁₆
1951.18.2
Collected by Clark Field in 1950.

Miniature basket, c. 1950
Coiled, 2¼
1951.18.3
Collected by Clark Field in 1950.

Miniature tray, c. 1950
Coiled, 2⅛
1951.18.4
Collected by Clark Field in 1950.

[Western Apache C.F.]
Tray, c. 1920
Coiled, 2¼ x 9
1952.22.6
Collected by Clark Field in 1952.

Bowl, c. 1900
Coiled, 6⅜ x 21
1953.21.12
Collected by Clark Field in 1954 from
Nellie Swamp, Tulsa, Oklahoma.

Squash blossom plaque or tray, c. 1954
Coiled, 2 x 14
1954.15.1
Collected by Clark Field in 1954, Gila
River Reservation, Arizona.

Squash blossom plaque or tray, c. 1954
Coiled, 2¼ x 15¼
1954.15.2
Collected by Clark Field in 1954, Gila
River Reservation, Arizona.

Bowl, c. 1930
Coiled, 7⅝ x 19
1954.15.15
Collected by Clark Field in 1954, Gila
River Reservation, Arizona.

Plaque, c. 1910
Made by Susie White
Coiled, 7¾
1955.16.3
Collected by Clark Field in 1954.

Shallow bowl, 1955
Coiled, 3 x 16¼
1955.16.4
Collected by Clark Field in 1955, Gila
River Reservation, Arizona.

Flat tray, c. 1957
Coiled, 1½ x 16¼
1957.20.21
Collected by Clark Field in 1957, Gila
River Reservation, Arizona.

Shallow bowl, c. 1945
Coiled, 2¼ x 15
1957.20.22
Collected by Clark Field in 1957.

Olla, c. 1910
Coiled, 21½ x 20
1960.7.4
Collected by Clark Field in 1960, Gila
River Reservation, Arizona.

Shallow bowl, c. 1930
Coiled, 4⅞ x 18¾
1966.18.1
Collected by Clark Field in 1966 from
the Bert Robinson estate.

Bowl, 1930
Coiled, 4⅜ x 17
1966.18.2
Collected by Clark Field in 1966 from
the Bert Robinson estate.

Bowl, c. 1930
Coiled, 5¼ x 19
1966.18.3
Collected by Clark Field in 1966 from
the Bert Robinson estate.

Bowl, c. 1930
Coiled, 4¾ x 17½
1966.18.4
Collected by Clark Field in 1966 from
the Bert Robinson estate.

Shallow bowl, c. 1920
Coiled, 6 x 27½
1966.18.5
Collected by Clark Field in 1966 from
the Bert Robinson estate.

Deep bowl, c. 1920–1930
Coiled, 7 x 8½
1976.9.3
Museum purchase

Bowl, c. 1900
Coiled, 5¾ x 19¾
1995.24.224
Gift of the University of Tulsa,
Ellis Soper Collection

Tohono O'odham (Papago)

Cylindrical-shaped basket, c. 1935
Coiled, 14¾ x 12
1946.47.7
Collected by Clark Field in 1935.

Bowl, c. 1920
Coiled, 6 x 8¼
1947.29.1
Gift of H. P. Bowen

Southwest Baskets (cont.)

Straight-sided basket, c. 1936
Coiled, 5 x 11½
1947.57.45
Collected by Clark Field in 1936.

Shallow bowl, c. 1938
Coiled, 4 x 15½
1948.39.101
Collected by Clark Field in 1938 from
Ruby Kassel, superintendent of Indian
schools, Tucson, Arizona, who had
collected it on the Papago Reservation,
Santa Rosa, Arizona.

Olla-shaped basket, c. 1938
Coiled, 16 x 15½
1948.39.105
Collected by Clark Field in 1938 from a
Tohono O'odham at the agency, Papago
Reservation, Sells, Arizona.

Straight-sided bowl, c. 1938
Coiled, 3½ x 5¾
1948.39.118
Collected by Clark Field in 1938, Papago
Reservation, near Tucson, Arizona.

Tiswin basket, c. 1920
Made by Chalola
Coiled, 7½ x 15½
1948.39.167
Collected by Clark Field in 1940 from
Cecilia Antone Skulhimatk, an Indian Arts
and Crafts Board agent, Sells, Arizona.

Shallow bowl, c. 1942
Made by Mary Thomas
Coiled, 3¼ x 14¼
1948.39.317
Collected by Clark Field in 1942 from the
Papago Arts and Crafts Board, Papago
Reservation, Sells, Arizona.

Straight-sided basket, c. 1942
Made by Lena Thomas
Coiled, 7¼ x 7¼
1948.39.318
Collected by Clark Field in 1942 from the
Papago Arts and Crafts Board, Papago
Reservation, Sells, Arizona.

Bowl, c. 1952
Made by Inez Ramon
Coiled, 2 x 7¾
1952.22.18
Collected by Clark Field in 1952.

Shallow bowl, c. 1910
Coiled, 2 x 11½
1954.15.19
Collected by Clark Field in 1954, Gila
River Reservation, Arizona.

Shallow bowl, c. 1954
Coiled, 2 x 11
1954.15.20
Collected by Clark Field in 1954, Papago
Reservation, Arizona.

Seeding basket, c. 1954
Coiled, 11 x 15½ x 17
1954.15.21
Collected by Clark Field in 1954, Papago
Reservation, Arizona.

Tray with hanging loop, c. 1956
Coiled, 1/4 x 12½
1956.19.6
Collected by Clark Field in 1956, Papago
Reservation, Arizona.

Owl effigy basket with lid, c. 1963
Made by Sarah Ramon
Coiled, 9 x 5½
1963.16.21 a,b
Collected by Clark Field in 1963 from the
Gallup Inter-tribal Ceremonial, Gallup,
New Mexico.

Dog effigy basket, c. 1964
Made by Gloria Ramon
Coiled, 8½ x 3 x 6½
1966.4.1 a,b
Gift to Clark Field from Jeanne Snodgrass
in 1964, who collected it at Sells, Arizona.

Tray, 1964
Made by Dorothy Lupes
Coiled, 2 x 10
1966.4.2
Gift to Clark Field from Jeanne Snodgrass
in 1964, who collected it at Sells, Arizona.

Shallow bowl, c. 1965
Made by Jessie Garcia
Coiled, 2 x 7¾
1966.4.5
Collected by Clark Field in 1965.

Olla, c. 1930
Coiled. 8½ x 8
1995.24.229
Gift of the University of Tulsa,
Ellis Soper Collection

Trinket basket with lid, c. 1997
Made by Jinny Miles
Coiled, 6 x 8
1997.12 a,b
Museum purchase.

Pueblo (Eastern)

Cochiti

Bird cage, c. 1900
Twined, 18 x 11½
1948.39.436
Collected by Clark Field in 1943 from
the Museum of New Mexico, Santa Fe.

Jemez

Bowl, 1937
Twill plaited, 3¾ x 9½
1948.27.74
Collected by Clark Field in 1937.

Sifter-ring basket, 1941
Twill plaited, 6¼ x 26
1948.39.194
Collected by Clark Field in 1941.

Bowl, c. 1941
Made by José Gachupin
Coiled, 4 x 13¼
1948.39.213
Collected by Clark Field in 1941,
Jemez Pueblo, New Mexico.

Bowl, c. 1895
Made by Manuel Ye Pa
Coiled, 3⅜ x 11¼
1948.39.214
Collected by Clark Field in 1941,
Jemez Pueblo, New Mexico.

Shallow bowl, c. 1880
Made by Andres Loretto
Coiled, 3 x 12
1948.39.215
Collected by Clark Field in 1941 from
Leonore Baca, granddaughter of Andres
Loretto, Jemez Pueblo, New Mexico.

Sifter-ring basket, c. 1950
Twill plaited, 5 x 14
1951.23.13
Given to Clark Field in 1951 by Mrs.
Quigley of Santa Fe, N.M.

San Felipe

Sifter-ring basket, c. 1937
Twill plaited, 5¾ x 13¼
1948.39.25
Collected by Clark Field in 1937.

San Juan

Wastepaper basket, c. 1930
Made by Jose Ortiz
Wicker plaited, 10½ x 12½
1948.39.140
Collected by Clark Field in 1939.

Basket with handle, c. 1930
Made by Jose Ortiz
Wicker plaited, 20 x 16
1948.39.141
Collected by Clark Field in 1939.

Fruit tray, 1920
Made by Jose Ortiz
Wicker plaited, 8 x 21
1948.39.142
Collected by Clark Field in 1939, San
Juan, New Mexico.

Bowl, c. 1950
Wicker plaited, 4½ x dia 11¾
1951.23.12
Given to Clark Field in 1951 by Mrs.
Quigley of Santa Fe, New Mexico, who
had acquired it at San Juan Pueblo.

Santo Domingo

Wastepaper basket, 1935
Wicker plaited, 14 x 13½
1948.39.24
Collected by Clark Field in 1937.

Taos

Fruit tray, c. 1919
Made by Fermin Vargas
Wicker plaited, 7¼ x 21¾
1948.39.143
Collected by Clark Field in 1939,
Taos, New Mexico.

Pueblo (Western)

Acoma

Trinket basket, c. 1939
Made by Cassie Poncho
Coiled, 3 x 8
1948.39.144
Collected by Clark Field in 1939, Gallup
Inter-tribal Ceremonial, Gallup, New
Mexico.

Straight-sided basket, 1952
Made by Carrie Pancho
Coiled, 9 x 15
1952.22.19
Collected by Clark Field in 1952, Acomita,
New Mexico.

Hopi

Piki bread tray, c. 1940
Twill and wicker plaited, 2 x 21½ x 22
1942.14.1950
Collected by Clark Field in 1946.

(Second Mesa)

Plaque, c. 1920
Coiled, 1 x 15
1942.13.17
Gift of Mr. and Mrs. Waite Phillips

Plaque, c. 1910
Coiled, 1⅛ x 14¾
1942.13.18
Gift of Mr. and Mrs. Waite Phillips

Bowl, c. 1940
Coiled, 10 x 13½
1942.13.19
Gift of Mr. and Mrs. Waite Phillips

Plaque, c. 1900
Coiled, 1 x 17
1942.14.1701
Collected by Clark Field in 1942.

Bowl, c. 1945
Coiled, 6 x 7½
1942.14.1921
Collected by Clark Field in 1945.

Deep, straight-sided bowl, 1940
Coiled, 8 x 10
1942.14.1922
Collected by Clark Field in 1945.

Deep basket with two handles, c. 1940
Made by Polly Nuvamsa
Coiled, 14¼ x 15½
1942.14.1938
Collected by Clark Field in 1946.

Plaque, 1946
Made by Helen Lomaheftewa
Coiled, 1¼ x 15½
1942.14.1994
Collected by Clark Field in 1946.

Bowl, 1936
Coiled, 5¼ x 7
1947.57.52
Collected by Clark Field in 1936.

Plaque, c. 1937
Coiled, 1¼ x 15
1948.27.26
Collected by Clark Field in 1937.

Deep straight-sided basket, c. 1920
Coiled, 18½ x 19
1948.39.106
Collected by Clark Field in 1939.

Plaque, c. 1938
Coiled, 1 x 10½
1948.39.111
Collected by Clark Field in 1938.

Sifter-ring basket, 1941
Made by Helen Lomaheftewa
Twill plaited, 3½ x 19
1948.39.199
Collected by Clark Field in 1941.

Deep, straight-sided basket, 1941
Made by Edith Lewis
Coiled, 8 x 13¼
1948.39.202
Collected by Clark Field in 1941, Gallup
Inter-tribal Ceremonial, Gallup, New
Mexico.

Plaque, 1943
Made by Sak-yon-si
Coiled, 1¾ x 13½
1948.39.367
Collected by Clark Field in 1943,
Shongopavi, Arizona.

Plaque, 1933
Made by Tu Wa Ngai Ni Ma
Coiled, 2¼ x 15
1948.39.371
Collected by Clark Field in 1943.

Cradle with hood, 1943
Made by Nuvangyaoma [Pearl?]
Wicker plaited, 14 x 13 x 28½
1948.39.416
Collected by Clark Field in 1943,
Shipaulovi, Second Mesa, Arizona.

Carrying basket with tumpline, 1943
Made by Tcos-Ngainima Tewahaftewa
Wicker plaited, 22½ x 9½ x 27
1948.39.428
Collected by Clark Field in 1943,
Shongopavi, Arizona.

Plaque, 1943
Made by Mrs. Cecil Calvert
Coiled, 2 x 13¼
1948.39.430
Collected by Clark Field in 1943.

Plaque, c. 1940
Made by Sylvia James
Coiled, 1½ x 13½
1948.39.431
Collected by Clark Field in 1943.

Plaque, 1940
Made by Alice Honumpka
Coiled, 1½ x 12½
1948.39.432
Collected by Clark Field in 1943.

Plaque, c. 1943
Made by Rebecca Starlie
Coiled, 1¼ x 12
1948.39.433
Collected by Clark Field in 1943.

Plaque, 1943
Coiled, ½ x 7
1948.39.434
Collected by Clark Field in 1943.

Plaque, 1943
Coiled, ¾ x 6⅝
1948.39.435
Collected by Clark Field in 1943.

Plaque, 1943
Made by Inmana
Coiled, 2 x 12½
1948.39.444
Collected by Clark Field in 1943.

Bowl, c. 1940
Coiled, 3⅝ x 9⅛
1948.39.469
Collected by Clark Field in 1943,
Shongopavi, Arizona.

Plaque, 1952
Made by Nellie Archie
Coiled, 1¼ x 18
1952.22.12
Collected by Clark Field in 1952,
Shongopavi, Arizona.

Plaque, 1952
Made by Martha Leban
Coiled, 1 x 14½
1952.22.13
Collected by Clark Field in 1952,
Shongopavi, Arizona.

Plaque, c. 1952
Made by Lola Joshongeva
Coiled, 1¾ x 14¾
1952.22.14
Collected by Clark Field in 1952,
Shongopavi, Arizona.

Plaque, c. 1952
Coiled, 1¾ x 11¾
1952.22.15
Collected by Clark Field in 1952.

Southwest Baskets (cont.)

Storage basket with two strap slits, 1952
Coiled, 8¾ x 9½
1953.1.9
Collected by Clark Field in 1952.

Shallow bowl, 1954
Made by Cora Mocta
Wicker plaited, 2 x 12½
1954.15.24
Collected by Clark Field in 1954.

High-shouldered jar, c. 1956
Made by Lola Joshongeva
Coiled, 13 x 17
1956.14.1
Collected by Clark Field in 1956, Gallup
Inter-tribal Ceremonial, Gallup, New
Mexico.

Food basket, c. 1920
Coiled, 8½ x 10½
1966.2.2
Gift of Mr. Charles Oliphant and
Mrs. Burch Mayo from the estate of
Mrs. Carol Oliphant

Plaque, 1965
Made by Martha Leban
Coiled, 2 x 9
1966.4.3
Collected by Clark Field in 1965.

Basket with lid, c. 1900
Coiled, 7½ x 7½
1995.24.221 a,b
Gift of the University of Tulsa,
Ellis Soper Collection

(Third Mesa)
Straight-sided basket, 1936
Wicker plaited, 9 x 12¼
1946.47.18
Collected by Clark Field in 1936.

Deep bowl, c. 1937
Wicker plaited, 9 x 12¾
1948.27.16
Collected by Clark Field in 1937
near Oraibi, Arizona.

Plaque, c. 1937
Wicker plaited, ½ x 13
1948.27.20
Collected by Clark Field in 1937.

Plaque, 1937
Wicker plaited, 1 x 16
1948.27.21
Collected by Clark Field in 1937.

Plaque, 1938
Wicker plaited, 1 x 15½
1948.39.107
Collected by Clark Field in 1938
near Oraibi, Arizona.

Straight-sided basket, 1938
Wicker plaited, 11½ x 14
1948.39.108
Collected by Clark Field in 1938.

Plaque, c. 1940
Wicker plaited, 3/4 x 14½
1948.39.109
Collected by Clark Field in 1948
in Oraibi, Arizona.

Bowl, 1941
Made by Susie Talamyamka
Wicker plaited, 8 x 12
1948.39.200
Collected by Clark Field in 1941, Gallup
Inter-tribal Ceremonial, Gallup, New
Mexico.

Deep, straight-sided basket, c. 1941
Made by Stella Fredericks
Wicker plaited, 14½ x 18¼
1948.39.201
Collected by Clark Field in 1941, Gallup
Inter-tribal Ceremonial, Gallup, New
Mexico.

Carrying basket, c. 1930
Wicker plaited, 13½ x 16 x 8½
1948.39.443
Collected by Clark Field in 1943.

Bread tray, 1944
Wicker and twill plaited, 16 x 13½
1949.4.9
Collected by Clark Field in 1944, Hopi
Reservation, Arizona.

Plaque, c. 1950
Made by Tillie Masayestewa
Wicker plaited, 1/2 x 15½
1950.17.4
Collected by Clark Field in 1950,
Hotevilla, Arizona.

Plaque, c. 1950
Made by Eva Hoyungowa
Wicker plaited, 14 x 14½
1950.17.5
Collected by Clark Field in 1950,
Hotevilla, Arizona.

Deep bowl, c. 1952
Made by Hazel Koyiyumtewa
Wicker plaited, 7½ x 14
1952.22.16
Collected by Clark Field in 1952.

Straight-sided bowl, c. 1952
Made by Anna Fredericks
Wicker plaited, 4½ x 9½
1952.22.17
Collected by Clark Field in 1952.

Plaque, 1954
Made by Maud Burton
Wicker plaited, 1 x 11
1954.15.25
Collected by Clark Field in 1959.

Deep bowl, c. 1910
Wicker plaited, 7¼ x 13
1966.2.3
Gift of Mr. Charles Oliphant and
Mrs. Burch Mayo from the estate of
Mrs. Carol Oliphant

Plaque, 1965
Made by Rachel Loloma
Wicker plaited, 1¼ x 16
1966.4.4
Collected by Clark Field in 1965.

Zuni

Carrying basket for peaches, c. 1900
Wicker plaited, 15 x 12 x 14½
1942.14.1998
Collected by Clark Field in 1947 from
Kelsey's Trading Post, Zuni, New Mexico.

Peach tray (shallow bowl), 1920
Wicker plaited, 3½ x 16¼
1948.39.43
Collected by Clark Field in 1937.

Shallow bowl, c. 1899
Wicker plaited, 3¼ x 12½
1948.39.149
Collected by Clark Field in 1939 from C.
Kelsey, Kelsey's Trading Post, Zuni, New
Mexico.

River Yuman Tribes

Maricopa
Vase, c. 1926
Coiled, 8 x 9½
1942.14.1943
Collected by Clark Field in 1946, Gila
River Reservation, near Phoenix, Arizona.

Shallow bowl, c. 1942
Coiled, 5½ x 17
1942.14.1947
Collected by Clark Field in 1946, Gila
River Reservation, near Phoenix, Arizona.

Upland Yuman Tribes

Havasupai
Shallow bowl, c. 1946
Wicker plaited, 3¼ x 17
1942.14.1949
Collected by Clark Field in 1946, Grand
Canyon, Arizona.

Jar, c. 1900
Twined, 8½ x 7
1948.27.82
Collected by Clark Field in 1937.

Tray, 1938
Made by Louisa
Coiled, 1 x 12
1948.39.112
Collected by Clark Field in 1938, Gallup
Inter-tribal Ceremonial, Gallup, New
Mexico.

Water bottle with loops, c. 1900
Made by Paiya-U-Qua-La
Twined, 11 x 10½
1948.39.417
Collected by Clark Field in 1943, Cataract
Canyon, Arizona.

Water bottle with loops, c. 1900
Made by Paiya-U-Qua-La
Twined, 11 x 10½
1948.39.417
Collected by Clark Field in 1943,
Cataract Canyon, Arizona.

Bowl, c. 1957
Coiled, 1½ x 5½
1957.20.24
Collected by Clark Field in 1957,
Grand Canyon, Arizona.

Shallow bowl, 1958
Twined, 3 x 16¾
1958.19.2
Collected by Clark Field in 1958,
Grand Canyon, Arizona.

Miniature burden basket, c. 1958
Twined, 6¾ x 8½
1958.19.5
Collected by Clark Field in 1958,
Grand Canyon, Arizona.

Hualapai (Walapai)

Deep bowl, c. 1900
Twined, 13 x 16½
1942.11.78
Gift of Mrs. C. C. Bovey

Deep bowl, c. 1910
Twined, 9 x 20
1942.14.1946
Collected by Clark Field in 1946.

Bowl, 1946
Coiled, 3⅛ x 6½
1942.14.1975
Collected by Clark Field in 1946.

Olla-shaped basket, c. 1946
Plain twined, 6 x 5
1942.14.1976
Collected by Clark Field in 1946 on the
Hualapai Reservation near the Grand
Canyon, Arizona.

Tray/shallow bowl, c. 1930
Made by Mamie Mahone
Coiled, 1¼ x 10¼
1942.14.1997
Collected by Clark Field in 1947.

Conical-shaped carrying basket, c. 1927
Made by Mrs. Tim McGee
Twined, 16 x 18
1942.14.2001
Collected by Clark Field in 1947,
Peach Springs, Arizona.

Water bottle, c. 1850
Twined, 15 x 12
1942.14.2002
Collected by Clark Field in 1947,
Peach Springs, Arizona.

[Chiricahua Apache C.F.]
Deep bowl, c. 1915
Twined, 9 x 13½
1947.57.55
Collected by Clark Field in 1936,
Lawton, Oklahoma.

Bowl, c. 1900
Twined, 4½ x 13¾
1948.27.22
Collected by Clark Field in 1937.

Shallow bowl, 1937
Coiled, 2¾ x 11½
1948.27.23
Collected by Clark Field in 1937,
Peach Springs, Arizona.

[Chiricahua Apache C.F.]
Bowl, c. 1939
Twined, 6 x 9
1948.39.148
Collected by Clark Field in 1939,
southwestern Oklahoma.

Tray, c. 1930
Coiled, 1¼ x 11
1950.17.3
Collected by Clark Field in 1950.

Yavapai

Shallow bowl, c. 1940
Coiled, 3 x 12¾
1942.14.1972
Collected by Clark Field in 1946,
Camp Verde, Arizona.

Bowl, c. 1948
Made by Josephine Harrison
Coiled, 4 x 12½
1942.14.2015
Collected by Clark Field in 1948,
Fort McDowell Reservation, Fort
McDowell, Arizona.

Shallow bowl, c. 1940
Made by Kate Joseph
Coiled, 2⅝ x 14
1942.14.2016
Collected by Clark Field in 1942,
Fort McDowell Reservation, Fort
McDowell, Arizona.

Olla, c. 1940
Made by Minnie Stacy
Coiled, 8½ x 6½
1942.14.2027
Collected by Clark Field in 1942,
Fort McDowell Reservation, Fort
McDowell, Arizona.

[San Carlos Apache C.F.]
Shallow bowl, c. 1937
Coiled, 2 x 12⅞
1948.27.69
Collected by Clark Field in 1937.

Shallow bowl, c. 1937
Coiled, 1¾ x 13½
1948.39.46
Collected by Clark Field in 1937 from
R. B. Cregar, Palm Springs, California.

Shallow bowl, c. 1938
Coiled, 2½ x 9½
1948.39.99
Collected by Clark Field in 1938 from
Viola Jimulla, Yavapai Reservation, near
Prescott, Arizona.

Bowl, c. 1900
Made by Minnie Stacy
Coiled, 1½ x 14
1950.17.1
Collected by Clark Field in 1950, Fort
McDowell Reservation, Fort McDowell,
Arizona.

[Western Apache C.F.]
Shallow bowl, c. 1900
Coiled, 4 x 22
1954.15.5
Collected by Clark Field in 1954.

[Western Apache C.F.]
Shallow bowl, c. 1900
Coiled, 4¼ x 21½
1954.15.18
Collected by Clark Field in 1954.

Calfornia Baskets

Achumawi (Pit River)

[Pakamilli C.F.]
Bowl, c. 1937
Plain twined, full-twist overlay, 4½ x 9
1948.27.63
Collected by Clark Field in 1937 from
R. B. Cregar, who had acquired it in the
Shavehead Hat Creek District, California.

Bowl, c. 1937
Plain twined, 6¼ x 12
1948.39.4
Collected by Clark Field in 1937 from the
Fred Harvey Company.

Mortar hopper, c. 1875
Plain twined, 9 x 16
1948.39.419
Collected by Clark Field in 1943.

Burden basket, c. 1951
Plain twined, 17½ x 19
1951.23.11
Collected by Clark Field in 1951.

[Hoopa C.F.]
Large storage basket, c. 1890
Plain twined, full-twist overlay, 27 x 23
1959.2
Collected by Clark Field in 1959.

Bowl, c. 1900
Plain twined, 5½ x 6¼
1995.24.231
Gift of the University of Tulsa,
Ellis Soper Collection

California Baskets (cont.)

Cahuilla

Medium-sized food bowl, c. 1850
Coiled, 5⅞ x 10½
1942.14.1979
Collected by Clark Field in 1947.

Large bowl, c. 1936
Made by Mrs. Casilda Welmas
Coiled, 11 x 22
1948.27.52
Collected by Clark Field in 1937 from
R. B. Cregar, Palm Springs, California.

Bowl, c. 1937
Coiled, 3¼ x 9½ x 10⅜
1948.27.53
Collected by Clark Field in 1937 from
R. B. Cregar, Palm Springs, California.

Tray, c. 1937
Coiled, 4 x 19⅜
1948.27.55
Collected by Clark Field in 1937.

Trinket bowl, c. 1900
Coiled, 1⅝ x 5¼
1948.39.17
Collected by Clark Field in 1937.

Acorn sieve, c. 1937
Plain plaited, 8 x 21
1948.39.42
Collected by Clark Field in 1937.

Large bowl, c. 1900
Made by Susan Arguello [Agreayo C.F.]
Coiled, 8½ x 22
1948.39.138
Collected by Clark Field in 1939.

Grasshopper tray, c. 1939
Coiled, 2½ x 17
1948.39.146
Collected by Clark Field in 1939.

Grasshopper tray, c. 1939
Coiled, 2½ x 17½
1948.39.147
Collected by Clark Field in 1939.

Tray, c. 1940
Made by Dolores Patencio [Delores
Pontencio C.F.]
Coiled, 3 x 16½
1948.39.405
Collected by Clark Field in 1943.

[Chumash C.F.]
Jar with lid, c. 1850
Coiled, 5½ x 10
1950.17.15 a,b
Collected by Clark Field in 1950 from
R. B. Cregar, Palm Springs, California.

Large bowl, c. 1850
Coiled, 5¾ x 20½
1954.15.16
Collected by Clark Field in 1954.

Cupeño

Bowl, c. 1950
Coiled, 6 x 8
1950.17.14
Collected by Clark Field in 1950.

Hupa

Bowl, c. 1937
Plain twined, half-twist overlay, 3⅝ x 6½
1947.57.67
Collected by Clark Field in 1937.

Wastebasket, c. 1937
Open twined and twill plaited, 14¾ x 14½
1948.27.28
Collected by Clark Field in 1937.

Tobacco jar with lid, c. 1937
Plain twined, half-twist overlay, 5⅛ x 6½
1948.27.29 a,b
Collected by Clark Field in 1937.

Bowl, c. 1937
Plain twined, half-twist overlay, 5½ x 7½
1948.27.41
Collected by Clark Field in 1937.

Small bowl, c. 1937
Made by Emma Frank
Plain twined, half-twist overlay, 3½ x 5¾
1948.27.42
Collected by Clark Field in 1937.

Hat, c. 1937
Made by Mrs. Charles Myers
Plain twined, half-twist overlay, 3½ x 6⅝
1948.27.43
Collected by Clark Field in 1937.

Cradle, c. 1937
Made by Mrs. Robinson Shoemaker
Open twined, 8 x 12 x 25½
1948.27.51
Collected by Clark Field in 1937.

Wastepaper basket, c. 1937
Open twined, half-twist overlay,
10⅜ x 10¼
1948.39.11
Collected by Clark Field in 1937.

[Karoc C.F.]
Carrying basket with tumpline, c. 1937
Plain twined, half-twist overlay, 10 x 13¾
1948.39.14
Collected by Clark Field in 1937.

Jump Dance purse, c. 1900
Plain twined, half-twist overlay,
7½ x 4½ x 20
1948.39.387
Collected by Clark Field in 1943, Eureka,
California.

Jump Dance purse, c. 1900
Plain twined, half-twist overlay,
7½ x 4½ x 20
1948.39.388
Collected by Clark Field in 1943, Eureka,
California.

Jump Dance purse, c. 1900
Plain twined, half-twist overlay,
5½ x 4 x 13
1948.39.389
Collected by Clark Field in 1943, Eureka,
California.

[Karoc C.F.]
Large seed storage bowl, c. 1900
Plain twined, half-twist overlay, 11½ x 21
1948.39.396
Collected by Clark Field in 1943,
Weitchpec, California.

Small bowl, c. 1943
Made by Howard Quinby
Plain twined, half-twist overlay, 3¼ x 7
1948.39.409
Collected by Clark Field in 1943, Eureka,
California.

Small bowl, c. 1943
Made by Howard Quinby
Plain twined, half-twist overlay, 3¼ x 6½
1948.39.410
Collected by Clark Field in 1943, Eureka,
California.

Eel trap, c. 1943
Made by Fred Brown
Open twined, 23 x 24
1948.39.411
Collected by Clark Field in 1943, Eureka,
California.

[Klamath C.F.]
Tray, c. 1944
Made by Nellie Griffen
Plain twined and wicker, 1 x 11
1948.39.480
Collected by Clark Field in 1944.

Large storage jar, c. 1890s
Plain twined, 11½ x 12
1951.23.8
Collected by Clark Field in 1951 near
Eureka, California.

Burden basket, c. 1850
Open twined with a band of half-twist
overlay, 17¼ x 11¼
1954.15.22
Collected by Clark Field in 1954 from
Charles B. Knox, Jamestown, New York,
who had acquired it on the Hoopa
Reservation, near Eureka, California.

Minnow scoop, c. 1956
Open twined, 14 x 7½
1956.19.4
Collected by Clark Field in 1956.

Hat, c. 1900
Plain twined, half-twist overlay, 3¾ x 6¾ .
1995.24.240
Gift of the University of Tulsa,
Ellis Soper Collection

Karuk

Bowl, c. 1936
Plain twined, half-twist overlay, 3¼ x 4¼
1946.47.17
Collected by Clark Field in 1936, Hoopa
Valley Agency, California.

Small bowl, c. 1937
Plain twined, half-twist overlay, 3½ x 5¾
1947.57.66
Collected by Clark Field in 1937 from
Mr. Spink at Bacone College, Muskogee,
Oklahoma.

Small bowl, c. 1900
Made by Mrs. Rafey Jones
Plain twined, half-twist overlay, 4 x 6½
1948.27.39
Collected by Clark Field in 1937, Hoopa
Valley Agency, California.

Small bowl, c. 1937
Made by Nettie Reuben
Plain twined, half-twist overlay, 4½ x 6
1948.27.40
Collected by Clark Field in 1937, Hoopa
Valley Agency, California.

Hat, c. 1937
Plain twined, half-twist overlay, 3½ x 6¼
1948.27.44
Collected by Clark Field in 1937 from
Mr. Spink at Bacone College, Muskogee,
Oklahoma.

[Hoopa C.F.]
Mortar hopper, c. 1930
Plain twined, 4¼ x 19½
1948.39.5
Collected by Clark Field in 1937.

[Hoopa C.F.]
Mortar hopper, c. 1900
Plain twined, half-twist overlay, 4¾ x 16⅜
1948.39.44
Collected by Clark Field in 1937.

Cooking bowl, c. 1920
Made by Lizzie Jake
Plain twined, half-twist overlay, 5¼ x 9⅛
1948.39.403
Collected by Clark Field in 1943,
Happy Camp, California.

Cooking bowl, c. 1943
Made by Lizzie Jake
Plain twined, half-twist overlay, 4½ x 8
1948.39.404
Collected by Clark Field in 1943,
Happy Camp, California.

Burial face covering, c. 1948
Plain twined, half-twist overlay, 2½ x 12½
1951.23.9
Collected by Clark Field in 1951.

Bowl, c. 1920
Plain twined, half-twist overlay, 7 x 7½
1995.24.230
Gift of the University of Tulsa,
Ellis Soper Collection

Kumeyaay (Diegueño)

[Cahuilla C.F.]
Grasshopper-gathering jar, c. 1939
Made by Mary Osuna
Coiled, 12½ x 11½
1948.39.150
Collected by Clark Field in 1939.

Bowl, c. 1890s
Coiled, 4 x 13⅜
1950.17.12
Collected by Clark Field in 1950.

[Mission C.F.]
Bowl, c. 1850
Coiled, 5 x 15
1951.23.14
Collected by Clark Field in 1951 from
Charles B. Knox, Jamestown, New York.

Clothes basket, 1952
Made by Mary Osuna
Coiled, 13 x 29 x 40
1953.1.14
Collected by Clark Field in 1952, Santa
Ysabel Reservation, San Diego,
California.

Luiseño

[Kechi C.F.]
Tray, c. 1850
Coiled, 4¼ x 17
1942.14.1978
Collected by Clark Field in 1947.

Large bowl, c. 1900
Coiled, 3⅝ x 12¼
1942.14.2081
Collected by Clark Field in 1948 from
Mary Jamison.

Maidu

Bowl, c. 1870
Coiled, 3½ x 5
1946.47.14
Collected by Clark Field in 1936.

Pack basket, c. 1900
Plain twined, half-twist overlay, 21 x 20½
1948.27.65
Collected by Clark Field in 1937 from
R. B. Cregar, Palm Springs, California.

Large bowl, c. 1890
Plain twined, 6½ x 8½
1995.24.235
Gift of the University of Tulsa,
Ellis Soper Collection

Konkow
Tray, c. 1903
Coiled, 2¼ x 12½
1948.39.126
Collected by Clark Field in 1938 from
Francis L. Zollinger of Tulsa, Oklahoma,
who had acquired it in about 1903.

Bowl, c. 1903
Coiled, 6 x 6½
1948.39.127
Collected by Clark Field in 1938 from
Francis L. Zollinger, Tulsa, Oklahoma,
who had acquired it in about 1903 at
Round Valley, California.

Shallow bowl, c. 1903
Coiled, 6 x 16½
1948.39.128
Collected by Clark Field in 1938 from
Francis L. Zollinger, Tulsa, Oklahoma,
who had acquired it in about 1903 at
Round Valley, California.

Mission

[Pima C.F.]
Cup and saucer, c. 1930
Coiled, 2½ x 5½
1942.14.1744 a,b
Collected by Clark Field in 1942 from
Alice M. Robertson.

[Gabrieleño C.F.]
Burden basket, c. 1850
Coiled, 18 x 25
1942.14.1981
Collected by Clark Field in 1947.

Bowl, c. 1950
Coiled, 5⅞ x 7
1950.17.11
Collected by Clark Field in 1950.

Tray, c. 1950
Coiled, 1½ x 15½
1950.17.13
Collected by Clark Field in 1950.

Oval-shaped bowl, c. 1900
Coiled, 4 x 8½ x 12
1951.18.43
Collected by Clark Field in 1951 from
the Gottschall Collection, Harrisburg,
Pennsylvania.

Rectangular tray, c. 1900
Coiled, 3½ x 9½ x 12
1951.18.44
Collected by Clark Field in 1951 from
the Gottschall Collection, Harrisburg,
Pennsylvania.

Small bowl, c. 1900
Coiled, 2⅞ x 6
1951.18.45
Collected by Clark Field in 1951 from
the Gottschall Collection, Harrisburg,
Pennsylvania.

California Baskets (cont.)

Oval-shaped bowl, c. 1900
Coiled, 6 x 9½ x 13½
1951.18.47
Collected by Clark Field in 1951 from
the Gottschall Collection, Harrisburg,
Pennsylvania.

Miwok

Rectangular bowl, c. 1946
Coiled, 5½ x 10 x 7¾
1942.14.1937
Collected by Clark Field in 1946.

Mush bowl, c. 1900
Coiled, 4¼ x 8¼
1942.14.2110
Collected by Clark Field in 1949 from
the Southwest Museum, Los Angeles,
California.

Mush bowl, c. 1890
Coiled, 5⅜ x 11¾
1942.14.2111
Collected by Clark Field in 1949 from
the Southwest Museum, Los Angeles,
California.

[Maidu C.F.]
Cooking bowl, c. 1900
Coiled, 6¼ x 9¾
1948.39.12
Collected by Clark Field in 1937.

Mono

Bowl, c. 1920
Made by Nellie [and Luis?] Dick
Coiled, 9¼ x 17¾
1947.57.62
Collected by Clark Field in 1937.

Bowl, c. 1937
Coiled, 6⅝ x 13⅜
1948.27.36
Collected by Clark Field in 1937.

[Maidu C.F.]
Winnowing tray, c. 1937
Open twined, 6¾ x 16 x 18½
1948.39.7
Collected by Clark Field in 1937.

[Mono Paiute C.F.]
Winnowing tray, c. 1943
Made by Lean Knisma
Open twined, 6 x 13½ x 15½
1948.39.397
Collected by Clark Field in 1943,
North Fork, California.

[Mono Paiute C.F.]
Seed-parching tray, c. 1943
Made by May Beecher
Close twined, 17¾ x 22 x 6½
1948.39.398
Collected by Clark Field in 1943,
North Fork, California.

[Shoshone C.F.]
Washing bowl, c. 1900
Coiled, 7¼ x 16½
1949.25.9
Collected by Clark Field in 1944.

Pomo

Wedding basket, c. 1890
Coiled, 4½ x 13
1942.14.1881
Collected by Clark Field in 1942
near Ukiah, California.

Food tray, c. 1944
Made by Annie Ramon Gomachu Burke
Wicker, 4¾ x 17½
1942.14.1882
Collected by Clark Field in 1944
near Ukiah, California.

Tray, c. 1920
Wicker, 4½ x 16
1942.14.1883
Collected by Clark Field in 1944
near Ukiah, California.

Tray, c. 1944
Made by Annie Ramon Gomachu Burke
Wicker, 4½ x 18
1942.14.1884
Collected by Clark Field in 1944
near Ukiah, California.

Tray, c. 1890
Made by Mary Arnold
Plain twined and wrap twined, 7½ x 22
1942.14.1885
Collected by Clark Field in 1944,
Ukiah, California.

Fish trap, c. 1944
Made by Annie Ramon Gomachu Burke
Open twined, 39 x 25½
1942.14.1894
Collected by Clark Field in 1944,
Ukiah, California.

Cradle, c. 1944
Made by Clara Williams
Open twined, 7⅛ x 11¾ x 16
1942.14.1895
Collected by Clark Field in 1944,
Ukiah, California.

Miniature cradle, c. 1944
Made by Annie Ramon Gomachu Burke
Open twined, 3/8 x 2½ x 2¼
1942.14.1896
Collected by Clark Field in 1944,
Ukiah, California.

Burden basket, c. 1945
Made by Clara Williams
Open twined and plain-plaited, 13 x 17
1942.14.1897
Collected by Clark Field in 1945,
Ukiah, California.

Beaded bowl, c. 1930
Made by Annie Dick Boone
Coiled, 5¼ x 9½
1942.14.1899
Collected by Clark Field in 1945,
Upper Lake, California.

Feathered bowl, c. 1940
Made by Lydia Anderson Faught
Coiled, 2¼ x 5½
1942.14.1900
Collected by Clark Field in 1945,
Upper Lake, California.

Miniature bowl, c. 1945
Coiled, 3/16 x ¾
1942.14.1902
Collected by Clark Field in 1945,
Lake County, California.

Miniature bowl, c. 1942
Coiled, ⅜ x ½ x ¾
1942.14.1903
Collected by Clark Field in 1945,
Lake County, California.

Feathered bowl, c. 1920
Made by Lydia Anderson Faught
Coiled, 2⅛ x 5
1942.14.1904
Collected by Clark Field in 1945,
Lake County, California.

Seed beater, c. 1930
Made by Annie Ramon Gomachu Burke
Plain plaited, 1½ x 10½ x 19
1942.14.1905
Collected by Clark Field in 1945,
Ukiah, California.

Storage basket, c. 1945
Made by Annie Ramon Gomachu Burke
Plain twined, 6¼ x 11
1942.14.1908
Collected by Clark Field in 1945,
Ukiah, California.

Feathered bowl, c. 1940
Made by Mary John
Coiled, 4¾ x 9½
1942.14.1928
Collected by Clark Field in 1945,
Lakeport, California.

Canoe-shaped bowl, c. 1940
Made by Evelyn Lake Potter
Coiled, 4¼ x 10¼ x 12
1942.14.1929
Collected by Clark Field in 1945,
Ukiah, California.

Gift basket, c. 1908
Coiled, 4½ x 10¾
1942.14.2044
Collected by Clark Field in 1948,
Mendocino, California.

Bowl, c. 1900
Coiled, 2¾ x 5¼
1946.39.3
Gift of Mrs. W. J. Zollinger

Bowl, c. 1900
Coiled, 2 x 4¾
1947.29.10
Gift of H. P. Bowen

Bowl, c. 1936
Coiled, 4 x 6¾
1947.57.57
Collected by Clark Field in 1936, Big
Valley Rancheria, Lakeport, California.

Bowl, c. 1936
Coiled, 4⅜ x 9
1947.57.58
Collected by Clark Field in 1936, Big
Valley Rancheria, Lakeport, California.

Bowl, c. 1937
Coiled, 3½ x 10¼
1947.57.59
Collected by Clark Field in 1937, Big
Valley Rancheria, Lakeport, California

Large bowl, c. 1937
Made by Old Grant
Coiled, 8¾ x 14½
1947.57.60
Collected by Clark Field in 1937.

Large bowl, c. 1937
Made by Lydia Grace Thompson Sleeper
Plain twined, 12½ x 20
1947.57.68
Collected by Clark Field in 1937,
Upper Lake Rancheria, California.

Bowl, c. 1937
Coiled, 5 x 9¼
1947.57.69
Collected by Clark Field in 1937,
Ukiah Rancheria, California.

Feathered bowl, c. 1937
Coiled, 4½ x 8¾
1948.27.11
Collected by Clark Field in 1937,
Robinson Rancheria, Upper Lake,
California.

Feathered bowl, c. 1920
Made by Emma Bateman Anderson
[Mrs. Anderson C.F.]
Coiled, 2 x 4¾
1948.27.12
Collected by Clark Field in 1937,
Robinson Rancheria, Upper Lake,
California.

Feathered bowl, c. 1910
Coiled, 1⅞ x 4¼
1948.27.71
Collected by Clark Field in 1937.

Miniature bowl, c. 1937
Coiled, ½ x 1
1948.39.21
Collected by Clark Field in 1937.

Miniature bowl, c. 1937
Coiled, ⅜ x ⅝ x 9/16
1948.39.22
Collected by Clark Field in 1937.

Feathered bowl, c. 1877
Coiled, 5¼ x 12½
1948.39.37
Collected by Clark Field in 1937.

Beaded bowl, c. 1920
Coiled, 1⅝ x 3¾
1948.39.50
Collected by Clark Field in 1937.

Large bowl, c. 1915
Plain twined, 10 x 11½
1948.39.120
Collected by Clark Field in 1940 in
northern California.

Bowl, c. 1903
Coiled, 9 x 6
1948.39.125
Collected by Clark Field in 1938 from
Francis L. Zollinger of Tulsa, Oklahoma,
who had acquired it in about 1903 at
Round Valley, California.

Burden basket, c. 1903
Plain twined, 21 x 23½
1948.39.129
Collected by Clark Field in 1938 from
Francis L. Zollinger of Tulsa, Oklahoma,
who had acquired it in 1903 at Round
Valley, California.

Miniature bowl, c. 1943
Coiled, 3/16 x ⅜
1948.39.372
Collected by Clark Field in 1943.

Miniature bowl, c. 1943
Coiled, 3/16 x ⅜
1948.39.373
Collected by Clark Field in 1943.

Miniature bowl, c. 1943
Coiled, ¼ x ⅜
1948.39.374
Obtained by Clark Field in 1943.

Miniature bowl, c. 1943
Coiled, ⅛ x ⅜
1948.39.375
Collected by Clark Field in 1943.

Miniature feathered bowl, c. 1944
Coiled, ⅜ x ¾
1949.25.2
Collected by Clark Field in 1944, Lake
County, California.

Miniature feathered bowl, c. 1944
Coiled, ⅜ x ⅜ x ¾
1949.25.3
Collected by Clark Field in 1944, Lake
County, California.

Miniature bowl, c. 1910
Coiled, 5/16 x 9/16 x 2
1949.25.10
Collected by Clark Field in 1944.

Feathered bowl, c. 1944
Made by Lydia Anderson Faught
Coiled, ½ x 1
1949.25.13
Collected by Clark Field in 1944,
Lake County, California.

Miniature feathered bowl, c. 1944
Coiled, ½ x ½ x ¾
1949.29.14
Collected by Clark Field in 1944,
Upper Lake, California.

Burden basket, c. 1944
Made by Annie Ramon Gomachu Burke
Open plaited, 20 x 21
1949.29.19
Collected by Clark Field in 1944,
Ukiah, California.

Feathered bowl, c. 1952
Made by Susie Santiago Billy
[Mrs. Cruz I. Billy C.F.]
Coiled, 3¼ x 8⅜
1952.22.2
Collected by Clark Field in 1952,
Hopland, California.

Miniature bowl, 1952
Made by Elsie Comanche Allen
Coiled, ⅛ x ⅜
1953.1.10
Collected by Clark Field in 1952,
Ukiah, California.

Miniature cradle, c. 1952
Open twined, 2 x 1 x ½
1953.1.11
Collected by Clark Field in 1952.

Food bowl, c. 1952
Made by Mabel McKay
[Mrs. Charlie McKay C.F.]
Coiled, 5¼ x 10½
1953.1.13
Collected by Clark Field in 1952,
Clearlake Oaks, California.

Feathered bowl, c. 1930
Made by Susie Santiago Billy
[Mrs. Cruz I. Billy C.F.]
Coiled, 3½ x 8 x 1.13½
1953.21.8
Collected by Clark Field in 1953,
Hopland, California.

Bowl, c. 1900
Coiled, 5½ x 11½
1995.24.236
Gift of the University of Tulsa,
Ellis Soper Collection

Bowl, c. 1890
Coiled, 4 x 9
1995.24.237
Gift of the University of Tulsa,
Ellis Soper Collection

California Baskets (cont.)

Bowl c. 1890
Coiled, 6½ x 15½ x 19
1995.24.238
Gift of the University of Tulsa,
Ellis Soper Collection

Shasta

Bowl, 1965
Twined, full-twist overlay, 4½ x 8¼
1966.4.6
Collected by Clark Field in 1965,
Klamath Valley, California.

Bowl, c. 1890
Twined, full-twist overlay, 7 x 9
1995.24.234
Gift of the University of Tulsa,
Ellis Soper Collection

Tubatulabal

[Yokut C.F.]
Large bowl, c. 1900
Made by Mary Ann Brazzanovitch
Coiled, 7 x 16
1948.27.30
Collected by Clark Field in 1937,
Bridgeport, California.

Large bowl, c. 1890
Coiled, 7¾ x 19½
1948.27.80
Collected by Clark Field in 1937 from
the Fred Harvey Company, Albuquerque,
New Mexico.

Wailaki

Mortar hopper, c. 1939
Plain twined, 5 x 14½
1948.39.139
Collected by Clark Field in 1939,
Round Valley, California.

Small bowl, c. 1953
Plain twined, 3½ x 5¼
1953.21.1
Collected by Clark Field in 1953,
Covelo, California.

Wiyot

Bowl, c. 1920
Plain twined, half-twist overlay, 5 x 8½
1967.17.1
Collected by Clark Field in 1967.

Yokuts

[Chukchansi C.F.]
Cradle, 1938
Made by Nancy Rogers
Plain plaited and open twined,
9½ x 10½ x 25
1942.14.1944
Collected by Clark Field in 1946 near
Coarsegold, Yosemite Valley, California.

[Chukchansi C.F.]
Mush bowl, 1938
Made by Nancy Rogers
Plain twined, 6⅜ x 10½
1942.14.1945
Collected by Clark Field in 1946, near
Coarsegold, Yosemite Valley, California.

Food bowl, c. 1900
Coiled, 5⅞ x 12
1942.14.1980
Collected by Clark Field in 1947, San
Joaquin Valley, California.

Bowl, c. 1928
Coiled, 5 x 10
1948.29.3
Collected by Clark Field in 1928 from
the Fred Harvey Company, Albuquerque,
New Mexico.

[Pomo C.F.]
Gambling tray, c. 1900
Coiled, 1 x 28
1948.39.130
Collected by Clark Field in 1938 from
Francis L. Zollinger, Tulsa, Oklahoma,
who had acquired it in 1903.

[Mono C.F.]
Oval-shaped bottleneck basket, c. 1900
Coiled, 8 x 10 x 11½
1951.18.49
Collected by Clark Field in 1951 from
the Gottschall Collection, Harrisburg,
Pennsylvania.

[Tulare C.F.]
Food bowl, c. 1957
Coiled, 8½ x 16½
1957.20.25
Collected by Clark Field in 1957, Tulare
County, California.

[Tulare C.F.]
Bottleneck jar, c. 1959
Coiled, 3 x 7½
1959.7.1
Collected by Clark Field in 1959.

Yuki

Bowl, c. 1953
Coiled, 3½ x 5½
1953.21.2
Collected by Clark Field in 1953, Round
Valley, California.

Bowl, c. 1915
Made by Peggy Stone
Coiled, 8¼ x 12½
1956.19.1
Collected by Clark Field in 1956 near
Covelo, Round Valley, California.

Yurok

Bowl, c. 1936
Plain twined, half-twist overlay, 6 x 8½
1946.47.16
Collected by Clark Field in 1936.

[Hupa C.F.]
Tobacco jar with lid, c. 1920
Made by Susie Little
Plain twined, half-twist overlay, 4½ x 4½
1948.27.45 a,b
Collected by Clark Field in 1937.

Small bowl, c. 1943
Made by Susie Little
Plain twined, half-twist overlay, 3½ x 5½
1948.39.383
Collected by Clark Field in 1943,
Eureka, California.

Bowl, c. 1943
Made by Susie Little
Plain twined, half-twist overlay, 5½ x 8
1948.39.384
Collected by Clark Field in 1943,
Eureka, California.

Large bowl, c. 1943
Made by Susie Little
Plain twined, half-twist overlay, 8 x 12½
1948.39.385
Collected by Clark Field in 1943,
Eureka, California.

Cradle, c. 1943
Made by Susie Little
Open twined, 7½ x 27 x 13½
1948.39.386
Collected by Clark Field in 1943,
Eureka, California.

Large bowl, c. 1940
Plain twined, half-twist overlay, 8 x 13
1948.39.390
Collected by Clark Field in 1943,
Eureka, California.

Burden basket, c. 1943
Made by Mrs. Redwood Henry
Open twined, 18 x 22
1948.39.391
Collected by Clark Field in 1943,
Eureka, California.

Open tray, c. 1943
Made by Emma Carpenter
Open twined, 3 x 21½
1948.39.392
Collected by Clark Field in 1943,
Hoopa Valley Agency, Eureka, California.

Open tray, c. 1943
Made by Emma Carpenter
Open twined, 2¾ x 10¾
1948.39.393
Collected by Clark Field in 1943,
Hoopa Valley Agency, Eureka, California.

Bowl, c. 1943
Made by May Ann Ferry
Plain twined, half-twist overlay, 3½ x 6½
1948.39.407
Collected by Clark Field in 1943,
Eureka, California.

Bowl, c. 1943
Made by May Ann Ferry
Plain twined, 3 x 6
1948.39.408
Collected by Clark Field in 1943,
Eureka, California.

Great Basin Baskets

Chemehuevi

Shallow bowl, c. 1930
Made by Mary Snyder
Coiled, 3¼ x 14¾
1942.14.1995
Collected by Clark Field in 1942 from
Birdie B. Brown, Colorado River Indian
Agency, Parker, Arizona.

Shallow bowl, 1948
Made by Mary Snyder
Coiled, 3¾ x 16
1942.14.2014
Collected by Clark Field in 1948.

Large jar, c. 1920
Made by Mary South Hill
Coiled, 11¾ x 11
1948.27.56
Collected by Clark Field in 1937 from
R. B. Cregar, Palm Springs, California.

Globular jar, c. 1930
Coiled, 4½ x 6½
1948.27.57
Collected by Clark Field in 1937 from
R. B. Cregar, Palm Springs, California.

[Paiute C.F.]
Globular jar, c. 1958
Coiled, 5½ x 5¾
1958.19.4
Collected by Clark Field in 1958.

Paiute

Northern

Carrying basket, c. 1890
Twill twined, 23½ x 27
1942.14.1941
Collected by Clark Field in 1946,
Walker River Reservation, Nevada.

Serving bowl, c. 1935
Coiled, 4 x 9¾
1947.57.47
Collected by Clark Field in 1935,
Yosemite Valley, California.

Jar, c. 1937
Coiled, 7 x 8¼
1948.27.59
Collected by Clark Field in 1937 from
R. B. Cregar, Palm Springs, California.

Pointed-bottom water bottle with two
loops, c. 1900
Twill twined, 17 x 14
1948.27.60
Collected by Clark Field in 1937 from
R. B. Cregar, Palm Springs, California.

Small bowl, c. 1937
Coiled and beaded, 2¼ x 4½
1948.39.15
Collected by Clark Field in 1937,
Gallup Inter-tribal Ceremonial,
Gallup, New Mexico.

Small bowl, c. 1930
Coiled and beaded, 2¾ x 5¼
1948.39.16
Collected by Clark Field in 1937.

Bowl, c. 1938
Coiled, 3 x 7
1948.39.69
Collected by Clark Field in 1938.

Baby carrier with hood, c. 1943
Made by Maud Allen
Open plain twined, 13½ x 12½ x 37
1948.39.395
Collected by Clark Field in 1943,
Walker River Reservation, Nevada.

Pointed-bottom water bottle with
two loops, c. 1943
Made by Lorena Thomas
Twill twined, 16½ x 11½
1948.39.406
Collected by Clark Field in 1943,
Walker River Reservation, Nevada.

Doll cradle with hood, c. 1944
Made by Ella Patega
Open diagonal twined, 7½ x 8 x 20
1948.39.482
Collected by Clark Field in 1944,
Pyramid Lake area of Nevada.

Utility tray, c. 1952
Coiled, 4½ x 24
1952.22.3
Collected by Clark Field in 1952 in
Nevada.

Seed jar with loops, c. 1952
Plain twined, 8 x 4½
1952.22.8
Collected by Clark Field in 1952,
Walker River Reservation, Nevada.

Seed-gathering basket with handle,
c. 1952
Close twill twined, 7¼ x 6¾
1952.22.9
Collected by Clark Field in 1952,
Walker River Reservation, Nevada.

[Klamath C.F.]
Dipper with handle, c. 1952
Open plain twined, 10½ x 7¾
1952.22.10
Collected by Clark Field in 1952.

Seed-gathering basket with handle,
c. 1910
Close twill twined, 8 x 7½
1956.19.5
Collected by Clark Field in 1956 in
Nevada.

Pointed-bottom water bottle, c. 1910
Twill twined, 16 x 12
1957.20.23
Collected by Clark Field in 1957 from
Eugenia Gockel, Tulsa, Oklahoma.

Storage basket, c. 1962
Open coiled, 12 x 16
1962.13.4
Collected by Clark Field in 1962 in
Nevada.

Utility basket, c. 1962
Open coiled, 5 x 10
1962.13.5
Collected by Clark Field in 1962 in
Nevada.

[Washoe C.F.]
Small bowl, c. 1950
Coiled and beaded, 2 x 4
1962.13.11
Collected by Clark Field in 1962,
Carson City, Nevada.

[Washoe C.F.]
Miniature bowl, c. 1950
Coiled and beaded, 1¼ x 2⅝
1962.13.12
Collected by Clark Field in 1962,
Carson City, Nevada.

[Washoe C.F.]
Miniature bowl, c. 1950
Coiled and beaded, 1⅜ x 2⅝
1962.13.13
Collected by Clark Field in 1962,
Carson City, Nevada.

[Washoe C.F.]
Miniature bowl, c. 1950
Coiled and beaded, 1¼ x 2½
1962.13.14
Collected by Clark Field in 1962,
Carson City, Nevada.

[Washoe C.F.]
Miniature bowl, c. 1950
Coiled and beaded, 1¼ x 2½
1962.13.15
Collected by Clark Field in 1962,
Carson City, Nevada.

Owens Valley

Cooking basket, c. 1943
Made by Maggie Williams
Open plain twined, 12 x 7½
1948.39.471
Collected by Clark Field in 1943
near Bishop, California.

Great Basin Baskets (cont.)

Boiling basket, c. 1930
Twill twined, 8¼ x 12
1948.39.472
Collected by Clark Field in 1943
near Bishop, California.

Southern

Shallow bowl, c. 1870–80
Coiled, 3¼ x 12⅝
1942.14.1954
Collected by Clark Field in 1946,
San Juan Paiute Strip in southern Utah.

Shallow bowl, c. 1940
Made by daughter of Mamie "Squaw"
Coiled, 3 x 10
1942.14.1989
Collected by Clark Field in 1947 near
Moccasin Agency, Kaibab Reservation,
Arizona.

Utility basket, c. 1947
Coiled, 6¾ x 14½ x 19
1942.14.1990
Collected by Clark Field in 1947,
Moccasin Agency, Kaibab Reservation,
Arizona.

Utility basket, c. 1947
Made by Mable Yellow Jacket
Open coiled, 7¼ x 19 x 20
1942.14.1991
Collected by Clark Field in 1947, Shivwits
Reservation, near Saint George, Utah.

Utilitarian tray, c. 1940
Made by Tappie George
Coiled, 3 x 11½ x 13
1942.14.1992
Collected by Clark Field in 1947, Shivwits
Reservation, near Saint George, Utah.

Large seed-gathering basket, c. 1920
Made by Mary Ann People
Close twill twined, 15 x 14¼
1942.14.1999
Collected by Clark Field in 1947,
Moapa River Indian Reservation, Nevada.

Carrying basket, c.1925
Made by Polly O. Viette
Open plain twined, 16½ x 16½
1942.14.2000
Collected by Clark Field in 1947,
Moapa River Indian Reservation, Nevada.

Baby carrier, c. 1947
Open plain twined, 9 x 9 x 32½
1942.14.2008
Collected by Clark Field in 1947
near Moapa, Nevada.

Bowl, c. 1920
Coiled, 4⅜ x 8¼
1948.39.113
Collected by Clark Field in 1938,
Moapa River Indian Reservation, Nevada.

Winnowing-parching tray, c. 1938
Open twined, 3 x 14½ x 19¼
1948.39.114
Collected by Clark Field in 1938,
Moapa River Indian Reservation, Nevada.

Water bottle with two loops, c. 1900
Coiled, 15 x 13
1948.39.203
Collected by Clark Field in 1941 in
southwestern Colorado.

Winnowing tray, c. 1900
Open plain twined, 3½ x 21¼ x 24¼
1957.16.15
Gift of Mrs. John Leavell

Carrying basket, c. 1910
Plain twined, 12 x 14¾
1995.24.227
Gift of the University of Tulsa,
Ellis Soper Collection

Navajo-style wedding tray, 1900
Coiled, 3½ x 15
1995.24.228
Gift of the University of Tulsa,
Ellis Soper Collection

Panamint Shoshone

[Paiute C.F.]
Bowl, c. 1937
Made by Rosie Nobles
Coiled, 3½ x 7¾
1948.27.15
Collected by Clark Field in 1937 at
the Gallup Inter-tribal Ceremonial,
Gallup, New Mexico.

[Paiute C.F.]
Necked jar, c. 1930
Coiled, 5⅜ x 7
1948.27.62
Collected by Clark Field in 1937 from
R.B. Cregar, Palm Springs, California.

Bowl, c. 1937
Made by Mamie Gregory
Coiled, 4 x 8½
1948.27.72
Collected by Clark Field in 1937.

Bowl, c. 1890
Made by Molly Hansen
Coiled, 4¼ x 8⅜
1948.39.485
Collected by Clark Field in 1944,
Death Valley, California.

Food bowl, c. 1890
Made by Molly Hansen
Coiled, 5 x 8¼
1949.4.3
Collected by Clark Field in 1944,
Death Valley, California.

Bowl, c.1910
Made by Sarah Hunter
Coiled, 8¼ x 23½
1949.4.5
Collected by Clark Field in 1944,
Death Valley, California.

Ute

Southern

[Navajo C.F.]
Navajo-style wedding tray, c. 1937
Coiled, 4 x 15¼
1948.27.24
Collected by Clark Field in 1937.

[Jicarilla Apache C.F.]
Water bottle with two loops, c.1900
Coiled, 11¼ x 8½
1948.39.2
Collected by Clark Field in 1937.

Water bottle with handle, c. 1942
Coiled, 13½ x 8½
1948.39.305
Collected by Clark Field in 1942 from
Werner Helms, Towaoc, Colorado.

Navajo-style wedding tray, c. 1942
Coiled, 3¾ x 15
1948.39.306
Collected by Clark Field in 1942 from
Werner Helms, Towaoc, Colorado.

Cradle, c. 1943
Made by Clardy Ute
Open twined and wrap twined,
34½ x 14 x 12
1948.39.429
Collected by Clark Field in 1943, Ute
Mountain Reservation, Towaoc, Colorado.

Utility basket with handles, c. 1940s
Coiled, 12½ x 20
1950.17.18
Collected by Clark Field in 1950, Ute
Mountain Reservation, Towaoc, Colorado.

[Paiute C.F.]
Navajo-style wedding tray, c. 1952
Coiled, 3½ x 15½
1952.22.1
Collected by Clark Field in 1952, Ute
Mountain Reservation, Towaoc, Colorado.

[Paiute C.F.]
Navajo-style wedding bowl, c. 1950
Coiled, 2¾ x 10¼
1953.1.2
Collected by Clark Field in 1952, Ute
Mountain Reservation, Towaoc, Colorado.

[Paiute C.F.]
Navajo-style wedding bowl, c. 1900
Coiled, 3 x 11
1953.1.3
Collected by Clark Field in 1952, Ute
Mountain Reservation, Towaoc, Colorado.

[Paiute C.F.]
Navajo-style wedding tray, c. 1952
Coiled, 3 x 14½
1953.1.4
Collected by Clark Field in 1952, Ute
Mountain Reservation, Towaoc, Colorado.

[Paiute C.F.]
Navajo-style wedding tray, 1952
Coiled, 3 x 13½
1953.1.5
Collected by Clark Field in 1952.

Navajo-style wedding tray, 1952
Made by Medra Wells
Coiled, 3 x 14½
1953.1.6
Collected by Clark Field in 1952, Ute
Mountain Reservation, Towaoc, Colorado.

[Navajo C.F.]
Miniature Navajo-style wedding tray,
c. 1950
Coiled, ¾ x 3¾
1962.13.6
Collected by Clark Field in 1962,
Shonto, Arizona.

[Navajo C.F.]
Miniature Navajo-style wedding tray,
c. 1962
Coiled, ¼ x 4⅛
1962.13.7
Collected by Clark Field in 1962,
Shonto, Arizona.

[Navajo C.F.]
Miniature Navajo-style wedding bowl,
c. 1950
Coiled, 1⅜ x 4¼ :
1962.13.8
Collected by Clark Field in 1962,
Shonto, Arizona.

[Navajo C.F.]
Miniature Navajo-style wedding bowl,
c. 1962
Coiled, ¾ x 3½
1962.13.9
Collected by Clark Field in 1962,
Shonto, Arizona.

[Navajo C.F.]
Miniature Navajo-style wedding bowl,
c. 1962
Coiled, ⅞ x 3
1962.13.10
Collected by Clark Field in 1962,
Shonto, Arizona.

Water bottle with horsehair handles,
c. 1900
Coiled, 13 x 10
1995.24.222
Gift of the University of Tulsa,
Ellis Soper Collection

Washoe

Degikup, c. 1918
Made by Louisa Keyser (Dat So La Lee)
Coiled, 13 x 16¼
1942.14.1909
Collected by Clark Field in 1945,
presumably from Margaret Cohn, The
Cohn Emporium, Carson City, Nevada.

Deep bowl, c. 1937
Made by Susie John
Coiled, 5½ x 10
1948.27.13
Collected by Clark Field in 1937,
Carson City, Nevada.

Degikup-style bowl, c. 1915
Made by Maggie James [?]
Coiled, 3½ x 8
1948.27.33
Collected by Clark Field in 1937,
Woodfords, California.

Degikup-style bowl, c. 1937
Coiled, 4¾ x 7
1948.27.34
Collected by Clark Field in 1937.

Utility basket with two handles, c. 1937
Twill twined, 10⅛ x 16
1948.27.37
Collected by Clark Field in 1937,
Carson Indian Agency, Stewart, Nevada.

Degikup-style basket with lid, c. 1937
Open coiled, 8 x 11
1948.39.18 a,b
Collected by Clark Field in 1937.

Gathering basket, c. 1944
Made by Maggie Mayo James
Open twill twined, 26 x 22½
1948.39.473
Collected by Clark Field in 1944 in
western Nevada.

Miniature cradle, 1944
Made by Katie Dressler
Open twill twined, 8 x 7 x 19
1948.39.481
Collected by Clark Field in 1944.

Western Shoshone

Baby carrier, 1964
Made by Marie Tala Hash
Open twined, 12 x 13 x 31½
1964.24.7
Collected by Clark Field in 1964 in
Nevada.

Plateau Baskets

Chilcotin

[Klikitat C.F.]
Pack basket, c. 1890
Coiled with imbricated overlay,
8 x 12½ x 9¼
1948.39.86
Collected by Clark Field in 1938 from the
estate of Henry B. Spencer, Sacramento,
California.

Klamath

Bowl, c. 1900
Twined, full-twist overlay, 5½ x 8
1942.14.1745
Collected by Clark Field in 1942 [?] from
Alice M. Robertson.

Hat, c. 1900
Plain twined, full-twist overlay, 3¾ x 7
1946.39.1
Gift of Mrs. W. J. Zollinger

Hat, c. 1900
Plain twined, full-twist overlay, 4 x 7½
1947.53.3
Gift of Mrs. B. P. Walkey

Bowl, c. 1900
Twined, full-twist overlay, 3¼ x 7½
1947.57.61
Collected by Clark Field in 1937.

Hat, c. 1900
Plain twined, half-twist overlay, 3 x 6
1948.30.2
Gift of Mrs. Elizabeth Putnam

[Modoc Klamath C.F.]
Wallet, c. 1890
Plain twined, full-twist overlay and lattice
twined, 8½ x 12
1948.39.355
Collected by Clark Field in 1941 from
Frank G. Speck, who had acquired it from
the Gottschall Collection, Harrisburg,
Pennsylvania.

[Modoc Klamath C.F.]
Wallet, c. 1890
Plain twined, 9 x 7
1948.39.356
Collected by Clark Field in 1943 from
Frank G. Speck, who had acquired it from
the Gottschall Collection, Harrisburg,
Pennsylvania.

Parching tray, c. 1890
Made by Sarah Weeks
Plain twined, 2 x 24
1948.39.420
Collected by Clark Field in 1943.

Parching tray, c. 1890
Made by Sarah Weeks [?]
Plain twined, ⅛ x 24
1948.39.421
Collected by Clark Field in 1943.

Plateau Baskets (cont.)

Gambling tray, c. 1900
Made by Wynona
Twined, half-twist overlay, ⅛ x 15½
1948.39.445
Collected by Clark Field in 1943, possibly at the Klamath Agency, Oregon.

Basketry doll [male], c. 1943
Made by Carrie Jackson
Twined, full-twist overlay, 7¾ x 3¼ x 2
1948.39.446
Collected by Clark Field in 1943, possibly at the Klamath Agency, Oregon.

Basketry doll [female], c. 1943
Made by Carrie Jackson
Twined, full-twist overlay, 7 x 3 x 2
1948.39.447
Collected by Clark Field in 1943, possibly at the Klamath Agency, Oregon.

Bowl, c. 1943
Made by Carrie Jackson
Twined, full-twist overlay, 4¾ x 7
1948.39.474
Collected by Clark Field in 1943.

Gambling tray, 1944
Plain and diagonal twined, ⅛ x 25
1949.4.4
Collected by Clark Field in 1944.

Quiver, 1943
Made by Lizzie Kirk
Twined, full-twist overlay, 19 x 6
1949.4.7
Collected by Clark Field in 1944.

Storage basket, c. 1875
Open twined, 11 x 16
1949.4.8
Collected by Clark Field in 1944.

Oval-shaped carrying basket with handle, c. 1900
Plain and full-turn twined, 6 x 9 x 11½
1949.29.12
Collected by Clark Field in 1952.

Hat, 1951
Open twined, 9 x 20
1951.23.10
Gift of Clark Field in 1951

Baby carrier, c. 1952
Open twined, parallel and crossed warp, 4 x 13 x 27
1952.22.4
Collected by Clark Field in 1952.

Klikitat

Berry basket, c. 1873
Coiled with imbricated overlay, 8¾ x 8
1942.14.2069
Collected by Clark Field in 1948, Yakima Reservation, Washington.

Jar, c. 1940
Coiled, 6 x 5½
1942.14.2070
Collected by Clark Field in 1948, Yakima Reservation, Washington.

Household basket, c. 1900
Coiled with imbricated overlay, 5 x 7
1942.14.2088
Collected by Clark Field in 1948, Yakima Reservation, Washington.

Berry basket, c. 1837
Coiled with imbricated overlay, 8¾ x 11¼ x 7¾
1948.27.75
Collected by Clark Field in 1937.

Oval-shaped berry basket, c. 1930
Coiled with imbricated overlay, 5½ x 5 x 6¾
1948.39.28
Collected by Clark Field in 1937.

Oval-shaped berry basket, c. 1838
Coiled with imbricated overlay, 5½ x 7¼ x 7½
1948.39.83
Collected by Clark Field in 1938.

Gathering basket, c. 1838
Coiled with imbricated overlay, 5½ x 7 x 7¾
1948.39.85
Collected by Clark Field in 1938.

Gathering basket, c. 1920
Coiled with imbricated overlay, 13½ x 12¼
1948.39.176
Collected by Clark Field in 1940.

Berry basket, c. 1890
Coiled with imbricated overlay, 13 x 12½
1948.39.440
Collected by Clark Field in 1943 from the Washington State Museum, Seattle.

Kootenai

Carrying basket, c. 1900
Made by Mary Hewankosu
Coiled with imbricated overlay, 7¼ x 7½ x 11½
1961.16.1
Collected by Clark Field in 1961.

Lillooet

Berry basket with handles, c. 1900
Coiled with imbricated overlay, 6¼ x 7 x 14¼
1947.19.585
Roberta Campbell Lawson Collection, gift of Mr. and Mrs. Edward C. Lawson

Pack basket, c. 1937
Coiled with imbricated overlay, 13½ x 21 x 17
1948.27.61
Collected by Clark Field in 1937 from R. B. Cregar, Palm Springs, California.

Pack basket, 1937
Coiled with beaded overlay, 12¾ x 17 x 15
1948.39.40
Collected by Clark Field in 1937, Thompson River, British Columbia and Washington.

Pack basket, c. 1900
Coiled with beaded overlay, 12⅞ x 18 x 14⅝
1948.39.87
Collected by Clark Field in 1938 from R. B. Cregar, Palm Springs, California, who presumably had acquired it in western British Columbia.

Modoc

Small bowl, c. 1934
Made by Mary Chiloquin
Plain twined, full-twist overlay, 3 x 5½
1947.57.44
Collected by Clark Field in 1938 from Alice Marriott of the Indian Arts and Crafts Board, Oklahoma City, Oklahoma.

Woman's cap, c. 1900
Plain twined, full-twist overlay, 4½ x 8¼
1948.39.121
Collected by Clark Field in 1938 from Francis L. Zollinger, who had acquired it in about 1903 at Round Valley, California.

Unfinished bowl, c. 1939
Made by Mary Chiloquin
Plain twined, 4 x 7½
1948.39.366
Collected by Clark Field in 1943 from Alice Marriott.

Bowl, 1944
Made by Minnie Shiffower
Plain twined, 4½ x 6
1948.39.475
Collected by Clark Field in 1944, presumably at Chiloquin, Oregon.

Storage basket, 1944
Made by Sarah Riddle
Plain twined, full-twist overlay, 5¾ x 10
1948.39.476
Collected by Clark Field in 1944 in Oregon.

Bowl, c. 1940
Made by Maggie Jacob
Plain twined, full-twist overlay, 5¼ x 9
1948.39.477
Collected by Clark Field in 1943, Chiloquin, Oregon.

Hat, c. 1944
Made by Jennie Clinton
Plain twined, 4 x 6½
1948.39.479
Collected by Clark Field in 1944, Chiloquin, Oregon.

Shallow bowl, 1944
Made by Dollie Lavor
Open twined, 3½ x 14½
1949.25.5
Collected by Clark Field in 1944,
Chiloquin, Oregon.

Nez Perce

Bag, c. 1900
Plain twined, false embroidery, 10¾ x 8½
1942.14.1712
Collected by Clark Field in 1942.

Bag, c. 1900
Plain twined, false embroidery, 11⅜ x 10
1942.14.1713
Collected by Clark Field in 1942.

Bag, c. 1910
Plain twined, false embroidery,
17¾ x 13¾
1942.14.1714
Collected by Clark Field in 1942.

Bag, c. 1900
Plain twined, false embroidery,
23¾ x 17¾
1942.14.1715
Collected by Clark Field in 1942.

[Klikitat C.F.]
Bag, c. 1900
Plain twined, false embroidery, 20 x 13
1942.14.2059
Collected by Clark Field in 1948, Yakima
Reservation, Washington.

Bag, c. 1948
Plain twined, false embroidery, 17 x 14
1942.14.2062
Collected by Clark Field in 1948, Lapwai
Reservation, near Lewiston, Idaho.

Bag, c. 1900
Plain twined, false embroidery, 17 x 13
1947.19.227
Roberta Campbell Lawson Collection,
gift of Mr. and Mrs. Edward C. Lawson

Bag, 1900
Plain twined, false embroidery, 7 x 6
1947.19.228
Roberta Campbell Lawson Collection,
gift of Mr. and Mrs. Edward C. Lawson

Bag, c. 1900
Plain twined, false embroidery, 18 x 12½
1947.19.229
Roberta Campbell Lawson Collection,
gift of Mr. and Mrs. Edward C. Lawson

Bag, c. 1910
Plain twined, false embroidery,
17¼ x 13⅛
1947.19.230
Roberta Campbell Lawson Collection,
gift of Mr. and Mrs. Edward C. Lawson

Bag, c. 1910
Plain twined, false embroidery, 25 x 19
1947.19.231
Roberta Campbell Lawson Collection,
gift of Mr. and Mrs. Edward C. Lawson

Bag, c. 1900
Plain twined, false embroidery, 22 x 16
1947.19.545
Roberta Campbell Lawson Collection,
gift of Mr. and Mrs. Edward C. Lawson

Bag, c. 1900
Plain twined, false embroidery,
20½ x 16¼
1947.19.546
Roberta Campbell Lawson Collection,
gift of Mr. and Mrs. Edward C. Lawson

Bag, c. 1787
Plain twined, false embroidery,
20½ x 15¼
1948.27.18
Collected by Clark Field in 1937.

Bag, c. 1900
Plain twined, false embroidery, 21½ x 15
1952.1.2
Gift of Mrs. W. D. Godfrey Sr.

Woman's hat, c. 1880
Wrap twined with overlay, 6¼ x 7
1984.2.37
Gift of Mr. and Mrs. Kenneth Siebel

Bag, c. 1900
Plain twined, false embroidery, 29 x 18
1995.24.225
Gift of the University of Tulsa,
Ellis Soper Collection

Bag, c. 1910
Plain twined, false embroidery, 10¼ x 8¾
1995.25.103
Gift of the University of Tulsa,
Bright Roddy Collection

Salish

Fraser River

Cradle, c. 1925
Coiled with imbricated overlay,
5¼ x 11 x 27
1942.14.1923
Collected by Clark Field in 1945.

Tray with two handles, c. 1937
Coiled with imbricated overlay, 2¼ x 16¼
1948.39.45
Collected by Clark Field in 1937.

Carrying basket with loops, c. 1937
Coiled with imbricated overlay,
9¾ x 12 x 15
1948.39.93
Collected by Clark Field in 1937.

Deep bowl, c. 1938
Coiled with imbricated overlay, 7⅝ x 8½
1948.39.94
Collected by Clark Field in 1938.

Thompson River

Storage basket, c. 1750
Coiled with imbricated overlay,
13¾ x 19 x 21½
1942.14.2072
Collected by Clark Field in 1942 in British
Columbia.

Gathering basket, c. 1900
Coiled with imbricated overlay, 9 x 13
1947.30.2
Gift of Yaffe Kimball

Storage basket, c. 1890
Coiled with imbricated overlay,
7¾ x 10 x 12¾
1948.27.76
Collected by Clark Field in 1937.

Storage basket with lid, c. 1890
Coiled with imbricated overlay, 9½ x 11
1948.39.81 a,b
Collected by Clark Field in 1938 from
the estate of Henry B. Spencer,
Sacramento, California.

Deep bowl, c. 1890
Coiled with beaded and imbricated
overlay, 4⅞ x 6⅞
1948.39.84
Collected by Clark Field in 1938 from
the estate of Henry B. Spencer,
Sacramento, California.

Storage basket, c. 1890
Coiled with imbricated overlay,
13½ x 15 x 20
1948.39.88
Collected by Clark Field in 1938 from
the estate of Henry B. Spencer,
Sacramento, California.

Berry basket, c. 1944
Coiled with imbricated overlay, 9½ x 9½
1948.39.478
Collected by Clark Field in 1944, Warm
Springs Reservation, Warm Springs,
Oregon.

Umatilla

Bag, c. 1875
Made by Anna Wannassee's mother
Plain twined, false embroidery, 8¼ x 8¼
1942.14.2061
Collected by Clark Field in 1948.

Bag, c. 1837
Plain twined, false embroidery, 17 x 13½
1948.27.31
Collected by Clark Field in 1937.

[Wasco C.F.]
Bag, c. 1937
Plain twined, false embroidery, 15¼ x 11
1948.39.52
Collected by Clark Field in 1937.

Plateau Baskets (cont.)

Wishram

Bag, c. 1929
Wrap twined, 9 x 6½
1948.39.441
Collected by Clark Field in 1943 from
the Washington State Museum, Seattle,
which had acquired it in 1929.

Yakima

Hat, c.1848
Wrap twined, 7½ x 7½
1942.14.2054
Collected by Clark Field in 1948.

Bag, c. 1910
Plain twined, false embroidery, 7½ x 7½
1942.14.2056
Collected by Clark Field in 1948,
Yakima Reservation, Washington.

Bag, c. 1875
Plain twined, false embroidery, 11 x 9⅜
1942.14.2057
Collected by Clark Field in 1942,
Yakima Reservation, Washington.

Bag, c. 1890
Plain twined, 19¾ x 9
1942.14.2058
Collected by Clark Field in 1948,
Yakima Reservation, Washington.

[Umatilla C.F.]
Berry basket, c. 1875
Coiled with imbricated overlay, 8⅜ x 9¾
1942.14.2092
Collected by Clark Field in 1948 near
Pendleton, Oregon.

Gathering basket, c. 1940
Coiled with imbricated overlay,
16⅜ x 14½
1948.39.369
Collected by Clark Field in 1943, Yakima
Reservation, Toppenish, Washington.

Gathering basket, c. 1940
Coiled with imbricated overlay,
14⅞ x 14½
1948.39.370
Collected by Clark Field in 1943, Yakima
Reservation, Toppenish, Washington.

Carrying basket, c. 1890
Coiled with imbricated overlay,
16 x 12 x 16
1966.3
Gift of William V. Hanks

Northwest Coast Baskets

Chehalis (Lower)

Oval berry basket, c. 1948
Coiled with imbrication, 6¾ x 7¼ x 13
1942.14.2080
Collected by Clark Field in 1948, Oakville,
Washington.

Oblong cooking basket, c. 1943
Made by Susie Williams
Coiled with imbrication, 9½ x 10½ x 13½
1948.39.376
Collected by Clark Field in 1943,
Montesano, Washington.

Market basket with handle, c. 1943
Made by Susie Williams
Plain twined and plaited, 7⅝ x 7¾ x 13⅜
1948.39.377
Collected by Clark Field in 1943,
Montesano, Washington.

Container with lid, c. 1943
Made by Susie Williams
Plain twined, half-twist overlay, 17 x 13
1948.39.378 a,b
Collected by Clark Field in 1943,
Montesano, Washington.

Market basket with handle, c. 1943
Made by Susie Williams
Plain twined, half-twist overlay,
7¾ x 9½ x 14½
1948.39.379
Collected by Clark Field in 1943,
Montesano, Washington.

Clallam

Clam-gathering basket, c. 1948
Diagonal twined, 11 x 14½
1942.14.2066
Collected by Clark Field in 1948,
Sequim, Washington.

Square utility basket, c. 1875
Made by Julie Barkhausen
Twill plaited, 9½ x 14½ x 15½
1942.14.2085
Collected by Clark Field in 1948.

Deep bowl, c. 1948
Plain twined, half-twist overlay, 9 x 11
1942.14.2089
Collected by Clark Field in 1948,
Sequim, Washington.

Oval cooking basket, c. 1937
Coiled with imbrication,
3½ x w 15½ x 18
1948.39.39
Collected by Clark Field in 1937.

Berry basket, c. 1939
Coiled with imbrication, 10 x 9 x 10
1948.39.137
Collected by Clark Field in 1939,
Puget Sound, Washington.

Clatsop

Wallet with handles, c. 1910
Made by Jennie [?]
Twined, 5½ x 7 x 1½
1951.23.7
Collected by Clark Field in 1951,
Grande Ronde Reservation, Oregon.

Haida

Hat, c. 1930
Plain twined, 7½ x 15½
1942.14.1955
Collected by Clark Field in 1946.

Bucket with two handles, c. 1946
Open diagonal twined and plain twined,
false embroidery, 11¾ x 13¼
1942.14.1956
Collected by Clark Field in 1946.

Hat, c. 1900
Plain twined, 8 x 13½
1948.39.9
Collected by Clark Field in 1937.

Cylindrical basket, c. 1937
Plain twined, false embroidery, 3¾ x 5½
1948.39.49
Collected by Clark Field in 1937,
Queen Charlotte Islands, British
Columbia.

Round basket with lid, c. 1880
Plain twined and plaited, 4 x 7
1984.2.43 a,b
Gift of Mr. and Mrs. Kenneth Siebel

Kwakwaka'wakw (Kwakiutl)

Hat, c. 1900
Plain twined, 7 x 10
1942.11.76
Gift of Mrs. C. C. Bovey

[Koskimo C.F.]
Round clam basket, c. 1890
Plain plaited, 6 x 6½ x 10
1948.39.353
Collected by Clark Field in 1941 from
Frank G. Speck, who had acquired it from
the Gottschall Collection, Harrisburg,
Pennsylvania.

[Koskimo C.F.]
Round clam basket, c. 1890
Plain plaited, 8½ x 7½ x 10½
1948.39.354
Collected by Clark Field in 1943 from
Frank G. Speck, who had acquired it from
the Gottschall Collection, Harrisburg,
Pennsylvania.

Lummi

Small rectangular basket, c. 1900
Made by Mrs. John Salomaen
Coiled with imbrication, 6½ x 8¼ x 9
1942.14.2087
Collected by Clark Field in 1948,
Lummi Reservation, near Bellingham,
Washington.

Wastepaper basket, c. 1948
Coiled with Imbrication, 7 x 10½
1942.14.2094
Collected by Clark Field in 1948,
Lummi Reservation, near Bellingham,
Washington.

Makah

Unfinished miniature basket, c. 1948
Wrap twined and plaited, ⅞ x 2¼ x 2
1942.14.2045
Collected by Clark Field in 1948,
Neah Bay, Washington.

Trinket basket, c. 1948
Wrap twined and plaited, 4 x 5¾
1942.14.2083
Collected by Clark Field in 1948,
Neah Bay, Washington.

Carrying basket, c. 1900
Made by Ada Markington
Open twined, 12½ x 14 x 20
1942.14.2091
Collected by Clark Field in 1948,
Neah Bay, Washington.

Trinket basket, c. 1936
Oval wrap twined and plaited,
2¾ x 3¾ x 5⅜
1947.57.41
Collected by Clark Field in 1936.

Round basket with lid, c. 1937
Wrap twined and plaited, 2⅜ x 3¼
1948.39.20 a,b
Collected by Clark Field in 1937,
Neah Bay, Washington.

Oval basket, c. 1912
Wrap twined and plaited, 4¼ x 7 x 10
1948.39.29
Collected by Clark Field in 1937.

Oval trinket basket, c. 1900
Wrap twined and plaited, 3¾ x 5 x 7⅞
1948.39.71
Collected by Clark Field in 1938,
Neah Bay, Washington.

Oval trinket basket, c. 1938
Wrap twined and plaited, 2¼ x 3½ x 5½
1948.39.72
Collected by Clark Field in 1938.

Round trinket basket, c. 1938
Wrap twined and plaited, 2¾ x 4
1948.39.73
Collected by Clark Field in 1938,
Neah Bay, Washington.

Globular-shaped trinket basket, c. 1938
Wrap twined and plaited, 2¼ x 4¼
1948.39.74
Collected by Clark Field in 1938.

Round trinket basket with lid, c. 1938
Wrap twined and plaited, 2⅝ x 3¾
1948.39.75 a,b
Collected by Clark Field in 1938.

Round trinket basket with lid, c. 1938
Wrap twined, 2⅝ x 6¾
1948.39.76
Collected by Clark Field in 1938.

Round trinket basket with lid, c. 1938
Wrap twined and plaited, 4 x 4
1948.39.77 a,b
Collected by Clark Field in 1938.

Round trinket basket with lid, c. 1938
Wrap twined and plaited, 3¼ x 5¼
1948.39.78 a,b
Collected by Clark Field in 1938,
Neah Bay, Washington.

Round trinket basket with lid, c. 1938
Wrap twined and plaited, 3¼ x 4½
1948.39.79 a,b
Collected by Clark Field in 1938.

Round trinket basket, c. 1938
Wrap twined and plaited, 2⅝ x 4¼
1948.39.80
Collected by Clark Field in 1938.

[Quatsino C.F.]
Pocket basket, c. 1930
Plain twined and plaited, 3½ x 2¼ x 6½
1948.39.240
Collected by Clark Field in 1941 from
Frank G. Speck, Department of
Anthropology, University of Pennsylvania.

Round trinket basket with lid, c. 1925
Wrap twined and plaited, 2½ x 4⅜
1950.2.8 a,b
Collected by Clark Field in 1950 from
Francis L. Zollinger, Tulsa,
Oklahoma.

Basket with lid, c. 1920
Wrap twined and plaited, 2¼ x 4½
1995.24.239 a,b
Gift of the University of Tulsa,
Ellis Soper Collection

Round trinket basket with lid, c. 1930
Wrap twined and plaited, 1¾ x 2⅝
1999.7.1 a,b
Gift of Rita Willis

Round trinket basket with lid, c. 1930
Wrap twined and plaited, 1¾ x 2⅞
1999.7.2 a,b
Gift of Rita Willis

Trinket basket with lid, c. 1930
Wrap twined and plaited, 2 x 2⅝
1999.7.3 a,b
Gift of Rita Willis

Trinket basket with lid, c. 1930
Wrap twined and plaited, 3 x 3⅛
1999.7.4 a,b
Gift of Rita Willis

Trinket basket with lid, c. 1930
Wrap twined and plaited, 2½ x 4¼ x 3½
1999.7.5 a,b
Gift of Rita Willis

Makah/Nootka

Trinket basket with lid, c. 1930
Wrap twined and plaited, 6¼ x 6½
1999.7.6 a,b
Gift of Rita Willis

Trinkit basket with lid, c. 1930
Wrap twined and plaited, 5⅝ x 5⅜
1999.7.7 a,b
Gift of Rita Willis

Muckleshoot

Cooking basket, c. 1910
Made by Matilda Settle
Coiled with imbrication, 11 x 9½ x 13½
1942.14.2073
Collected by Clark Field in 1948,
southeast of Auburn, Washington.

Nisqualli

Oval cooking basket, c. 1850
Coiled with imbrication, 12 x 10 x 15
1942.14.2074
Collected by Clark Field in 1948 near
Olympia, Washington.

Nooksack

Household basket, c. 1910
Made by Xwienlia-hompkin, mother of
Lois George
Plain and twill plaited, 12½ x 19½ x 22
1942.14.2084
Collected by Clark Field in 1948 near
Everson, Washington.

Carrying basket, c. 1818
Made by the great-grandmother of
Northbert Charles
Coiled with imbrication, 12 x 13 x 17
1942.14.2097
Collected by Clark Field in 1948 from
Northbert Charles, who was living in
Clearwater, Oklahoma, at the time.

Nuu-chah-nulth (Nootka)

Hat, c. 1900
Plain twined, 5¼ x 14¼
1948.39.8
Collected by Clark Field in 1937 from the
Fred Harvey Company.

Rectangular bowl, c. 1920
Plaited and plain twined, 3 1/2 x 6 1/2
1948.39.239
Collected by Clark Field in 1941 from
Frank G. Speck.

Bowl, c. 1930
Plaited, 5¾ x 8¼
1999.7.8
Gift of Rita Willis

Puyallup

Round storage basket, c. 1840
Plain twined with overlay, 12 x 13
1951.23.6
Collected by Clark Field in 1951,
Puyallup, Washington.

Quileute

Round berry basket, c. 1943
Made by Elsie Payne
Plain twined with overlay, 9½ x 11¼
1948.39.412
Collected by Clark Field in 1943, Quileute
Reservation, La Push, Washington.

Northwest Coast Baskets (cont.)

Storage basket, c. 1943
Made by Mrs. Roy Black
Twill plaited, 11½ x 17½
1948.39.413
Collected by Clark Field in 1943, Quileute Reservation, La Push, Washington.

Cradle and bonnet, c. 1943
Made by Beatrice Hobucket
Combination of wrap twined and plain plaited, 4 x 13 x 19 , hood 7½ x 8¾
1948.39.414 a,b
Collected by Clark Field in 1943, Quileute Reservation, La Push, Washington.

Carrying basket with loop handles and tumpline, c. 1943
Made by Elsie Payne
Open wrap twined, 14¾ x 18¼ x 23
1948.39.415
Collected by Clark Field in 1943, Quileute Reservation, La Push, Washington.

Quinault

Carrying basket with loops, c. 1940
Coiled with imbrication, 6½ x 6¼
1942.14.2071
Collected by Clark Field in 1948, Washington state.

Bowl, c. 1948
Plain twined with overlay, 5¾ x 9
1942.14.2093
Collected by Clark Field in 1948.

Clam basket, c. 1900
Open twined 12½ x 16 x w 10
1948.39.41
Collected by Clark Field in 1937, Quinault, Washington.

Round trinket basket, c. 1943
Open twined, 4½ x 6
1948.39.470
Collected by Clark Field in 1943, Quinault River, Washington.

Salish (Coast)

Bucket, c. 1938
Plain twined with overlay, 7¼ x 10
1948.39.70
Collected by Clark Field in 1938, Puget Sound, Washington.

Siletz

Bowl, c. 1920
Plain twined, half-twist overlay, 6 x 10
1948.30.3
Gift of Mrs. Elizabeth Putnam

Bowl, c. 1943
Plain twined, half-twist overlay, 5 x 9
1948.39.427
Collected by Clark Field in 1943 from Mrs. Simmons, Salem, Oregon.

Skagit

Carrying basket with loops, c. 1900
Made by Mary Anne Shelton
Coiled, 8 x 7½ x 10¾
1942.14.2096
Collected by Clark Field in 1948, La Conner, Washington.

Snohomish

Carrying basket with loops, c. 1848
Made by Sarah Heck
Coiled with imbrication, 8½ x 9 x 12
1942.14.2086
Collected by Clark Field in 1948, Olympic Peninsula, Washington state.

Wallet, c. 1890
Plain twined, 5½ x at rim 6.
1947.19.276
Roberta Campbell Lawson Collection, gift of Mr. and Mrs. Edward C. Lawson

Snoqualmie

Market basket with handles, c. 1948
Plain twined and plain plaited,
8¾ x 13½ x 8
1942.14.2065
Collected by Clark Field in 1948, Snoqualmie Reservation, Washington.

Rectangular berry basket with loops, c. 1900
Made by Martha Bagley McDavit
Coiled with imbrication, 9 x 11¼ x 13
1942.14.2077
Collected by Clark Field in 1948.

Small berry basket, c. 1900
Made by Mollie Bagley McDavit
Open twined and plaited, 5 x 7 x 8½
1942.14.2078
Collected by Clark Field in 1948.

Bowl, 1948
Made by Martha Bagley McDavit
Plain twined, 4 x 6
1942.14.2082
Collected by Clark Field in 1948 from the weaver.

Suquamish

Berry basket with loops, c. 1925
Made by Mary George
Coiled with imbrication, 11⅛ x 8¾ x 11
1942.14.2076
Collected by Clark Field in 1948, Marysville, Washington.

Swinomish

Rectangular berry basket, c. 1930
Made by Mrs. Jimmie Jones
Coiled with imbrication, 13 x 13¼ x 15¾
1942.14.2075
Collected by Clark Field in 1948 near La Conner, Washington.

Household basket, c. 1930
Made by Mrs. Jimmie Jones
Twill plaited, 8 x 15 x 20
1942.14.2090
Collected by Clark Field in 1948, La Conner, Washington.

Tlingit

Cylindrical basket, c. 1945
Plain twined, false embroidery, 5½ x 7¾
1942.14.1926
Collected by Clark Field in 1945.

Cylindrical basket, c. 1945
Plain twined, false embroidery, 5 x 7
1942.14.1927
Collected by Clark Field in 1945.

Cylindrical basket, c. 1911
Plain twined, false embroidery, 6¾ x 8
1942.14.1931
Collected by Clark Field in 1946. This basket was originally from the area of Sitka, Alaska.

Bowl, c. 1948
Plain twined, 5 x 13½
1942.14.2050
Collected by Clark Field in 1948, Ketchikan, Alaska.

Cylindrical basket, c. 1900
Plain twined, false embroidery, 7¼ x 8½
1942.14.2051
Collected by Clark Field in 1948.

Cooking basket with two loops, c. 1920
Plain twined, 8 x dia 10
1942.14.2052
Collected by Clark Field in 1948, Ketchikan, Alaska.

Large cylindrical basket, c. 1900
Plain twined, false embroidery, 11¼ x 13
1942.14.2053
Collected by Clark Field in 1948, Ketchikan, Alaska.

Folding basket, c. 1930
Plain twined, 7 x 21
1942.14.2060
Collected by Clark Field in 1948, Ketchikan, Alaska.

Miniature crab trap, c. 1942
Open twined, 23½ x 8
1942.14.2063
Collected by Clark Field in 1948, Ketchikan, Alaska.

Cylindrical basket, c. 1948
Plain twined, false embroidery, 8 x 8½
1942.14.2102
Collected by Clark Field in 1948, Ketchikan, Alaska.

Cylindrical basket, c. 1920
Plain twined, false embroidery, 7 x 6 x 8
1942.14.2103
Collected by Clark Field in 1948, Ketchikan, Alaska.

Cylindrical basket, c. 1948
Plain twined, false embroidery, 6½ x 7
1942.14.2104
Collected by Clark Field in 1948,
Ketchikan, Alaska.

Cylindrical basket, c. 1948
Plain twined, false embroidery, 5¾ x 7
1942.14.2105
Collected by Clark Field in 1948,
Ketchikan, Alaska.

Cylindrical basket, c. 1920
Plain twined, false embroidery, 7¾ x 8½
1942.14.2106
Collected by Clark Field in 1948,
Lynn Canal, Alaska.

Rattle-top basket, c. 1930
Plain twined, false embroidery, 4½ x 6¼
1946.47.15 a,b
Collected by Clark Field in 1936.

Cylndrical basket , c. 1880
Plain twined, false embroidery, 7 x 7
1947.29.13
Gift of H. P. Bowen

[Haida C.F.]
Trinket basket with lid, c. 1937
Plain twined, false embroidery, 2 x 3⅛
1948.39.23 a,b
Collected by Clark Field in 1937.

[Yakutat C.F.]
Cylindrical basket, c. 1937
Plain twined, false embroidery, 5 x 5¾
1948.39.48
Collected by Clark Field in 1937,
Yakutat Bay, Alaska.

[Yakutat C.F.]
Cylindrical basket, c. 1920
Plain twined, false embroidery, 5¾ x 6¼
1948.39.53
Collected by Clark Field in 1937 from
the Indian Arts and Crafts Board.

[Haida C.F.]
Round basket with lid, c. 1937
Plain twined, false embroidery, 4 x 9⅞
1948.39.57 a,b
Collected by Clark Field in 1937,
Hydaburg, Alaska.

Trinket basket with lid, c. 1850
Plain twined, 4 x 6
1948.39.62 a,b
Collected by Clark Field in 1938 from the
estate of Henry B. Spencer, Sacramento,
California.

Rattle-top basket with a lid, c. 1890
Plain twined, false embroidery, 2½ x 4⅜
1948.39.63 a,b
Collected by Clark Field in 1938 from the
estate of Henry B. Spencer, Sacramento,
California.

[Yakutat C.F.]
Cylindrical basket, c. 1850
Plain twined, false embroidery, 4¼ x 5¼
1948.39.64
Collected by Clark Field in 1938 from the
estate of Henry B. Spencer, Sacramento,
California.

[Yakutat C.F.]
Cylindrical basket, c. 1900
Plain twined, false embroidery, 5 x 6¼
1948.39.65
Collected by Clark Field in 1938.

Berry basket with loops. c. 1880
Plain twined, 7¾ x 7½
1948.39.442
Collected by Clark Field in 1943 from the
Washington State Museum, Seattle.

[Washoe C.F.]
Small cylindrical case, c. 1880
Plain twined, false embroidery,
1½ x 2 x 5⅛
1953.1.1 a,b
Collected by Clark Field in 1951 from
Mrs. Henry J. English, granddaughter of
missionary Henry Stoever.

Rattle-top basket, c. 1890
Open and closed plain twined, false
embroidery, 5½ x 6
1984.2.44 a,b
Gift of Mr. and Mrs. Kenneth Siebel

Cylindrical basket, c. 1880
Plain twined, false embroidery, 7 x 7½
1995.24.223
Gift of the University of Tulsa,
Ellis Soper Collection

Cylindrical basket, c. 1880
Plain twined, false embroidery, 8 x 10
1995.24.232
Gift of the University of Tulsa,
Ellis Soper Collection

Cylindrical basket, c. 1900
Plain twined, 6½ x 7½
1995.24.233
Gift of the University of Tulsa,
Ellis Soper Collection

Tsimshian

Small rectangular basket with handles,
c. 1947
Plaited, 6¼ x 6½ x 4½
1942.14.1988
Collected by Clark Field in 1947 from the
School of American Research, Santa Fe,
New Mexico.

Trinket basket with lid, c. 1920
Plain twined, false embroidery, 3 x 4½
1942.14.2049 a,b
Collected by Clark Field in 1948,
Metlakatla, Alaska.

Market basket with two handles, c. 1948
Plaited, 11 x 7¼ x 13
1942.14.2064
Collected by Clark Field in 1948.

Twana (Skokomish)

Oval-shaped bowl, c. 1948
Coiled with imbrication, 3¾ x 12 x 9¾
1942.14.2079
Collected by Clark Field in 1948,
Hood Canal, Puget Sound, Washington.

Carrying basket with loops, c. 1948
Open twined and plaited, 9 x 10 x 13½
1942.14.2095
Collected by Clark Field in 1948,
Hood Canal, Puget Sound, Washington.

Wallet, c. 1900
Plain twined, half-twist overlay, 12¼ x 13
1948.39.136
Collected by Clark Field in 1939 near
Puget Sound, Washington.

Wallet, c. 1950
Plain twined, 8⅞ x 9
1949.29.11
Collected by Clark Field in 1952,
Olympic Peninsula, Washington.

Wallet, c. 1950
Plain twined, 12⅜ x 12
1953.1.15
Collected by Clark Field in 1952,
Olympic Peninsula, Washington.

Wallet, c. 1950
Plain twined, 9½ x 9
1953.1.16
Collected by Clark Field in 1952, Olympic
Peninsula, Washington.

Arctic Baskets

Aluet

Trinket basket, c. 1900
Closed twined, false embroidery, 5½ x 6
1942.14.1924
Collected by Clark Field in 1942.

[Attu C.F.]
Trinket basket with lid, c. 1900
Open and closed twined, false
embroidery, 2 x 3½
1942.14.2046 a,b
Collected by Clark Field in 1942.

[Attu C.F.]
Two-piece wallet, c. 1948
Open and closed twined, false
embroidery, 5 x 1¾
1942.14.2048 a,b
Collected by Clark Field in 1948.

Storage basket, c. 1948
Open twined, false embroidery, 12½ x 15
1942.14.2099
Collected by Clark Field in 1948.

Arctic Baskets (cont.)

Basket with handle, c. 1900
Closed twined, false embroidery, 5½ x 6
1942.14.2100
Collected by Clark Field in 1942.

Trinket basket, c. 1948
Closed twined, false embroidery, 5½ x 5½
1942.14.2101
Collected by Clark Field in 1948.

[Attu C.F.]
Pack bag, c. 1880
Open twined, false embroidery, 12 x 18
1948.39.10
Collected by Clark Field in 1937.

Trinket basket with lid, c. 1937
Closed twined, false embroidery, 4½ x 3⅞
1948.39.51 a,b
Collected by Clark Field in 1937.

Trinket basket with lid, c. 1890
Closed twined, false embroidery, 7 x 5½
1948.39.59 a,b
Collected by Clark Field in 1937 from the
estate of Henry B. Spencer, Sacramento,
California.

Cylindrical basket with handle, c. 1858
Closed twined, false embroidery, 5½ x 5⅜
1948.39.60
Collected by Clark Field in 1942.

Trinket basket with lid, c. 1938
Closed twined, false embroidery, 3¾ x 4¼
1948.39.61 a,b
Collected by Clark Field in 1938.

Storage basket, c. 1900
Open twined, false embroidery, 12 x 15
1948.39.348
Collected by Clark Field in 1942 from
George Chick of Kelseyville, California.

Storage basket, c. 1900
Open twined, false embroidery, 10 x 12½
1948.39.349
Collected by Clark Field in 1942 from
George Chick of Kelseyville, California.

Storage basket, c. 1900
Open twined, false embroidery, 10½ x 13
1948.39.350
Collected by Clark Field in 1942 from
George Chick of Kelseyville, California.

Covered bottle with lid, c. 1902
Open and closed twined, false
embroidery, 12¼ x 3
1955.16.7 a,b
Collected by Clark Field in 1955 from Mr.
and Mrs. Melvin T. Boice, Akron, Ohio,
who had bought it in Dutch Harbor,
Alaska, in 1902.

Inuit (Eskimo)

Labrador Inuit

Trinket basket with lid, 1936
Coiled, 3 x 3⅛
1946.47.12 a,b
Collected by Clark Field in 1936.

Bowl, c. 1920
Coiled, 4¼ x 10
1948.39.32
Collected by Clark Field in 1937.

Bowl, c. 1930
Coiled, 3¼ x 6
1948.39.303
Collected by Clark Field in 1942 from
Frank G. Speck, who presumably had
acquired it at Grenfell Mission, Saint
Anthony, Newfoundland, Canada, in
1933.

Bowl, c. 1920
Coiled, 3 x 7½
1948.39.418
Collected by Clark Field in 1943 from
Frank G. Speck, who presumably had
acquired it at Grenfell Mission, Saint
Anthony, Newfoundland, Canada.

Mainland Southwest Alaska Eskimo

Trinket basket with lid, c. 1930
Coiled, 4 x 5½
1942.14.2047 a,b
Collected by Clark Field in 1948, Hooper
Town Bay, Alaska.

Storage basket, c. 1948
Coiled, 10¾ x 13
1942.14.2055
Collected by Clark Field in 1948,
Hooper Town Bay, Alaska.

Trinket basket with lid, c. 1930
Coiled, 4½ x 4
1942.14.2098 a,b
Collected by Clark Field in 1948, Hooper
Town Bay, Alaska.

Yupik
Tray with one loop handle, c. 1945
Coiled, 2½ x 11
1942.14.1932
Collected by Clark Field in 1946. This
basket was originally from Nelson Island,
Alaska, near the mouth of the Kuskokwim
River.

Tray with one loop handle, c. 1945
Coiled, 2½ x 10
1942.14.1933
Collected by Clark Field in 1946. This
basket was originally from Nelson Island,
Alaska, near the mouth of the Kuskokwim
River.

Flange basket with lid, c. 1938
Coiled, 9½ x 9
1948.39.96 a,b
Collected by Clark Field in 1938 through
the Indian Arts and Crafts Board, Juneau,
Alaska.

North Alaska Coast Inuit

Inupiat
Trinket basket with lid, c. 1941
Made by Abe P. Simmonds
Coiled, 3¼ x 3¾
1942.14.1910 a,b
Collected by Clark Field in 1942.

Trinket basket with lid, c. 1930
Coiled, 3¾ x 4¾
1942.14.1930 a,b
Collected by Clark Field in 1946. This
basket was originally from Point Barrow,
Alaska.

Eastern Subarctic Baskets

Attikamek (Tête de Boule)

Mokok, c. 1920
Sewn birchbark, 6¾ x 8¼
1948.39.267 a,b
Collected by Clark Field in 1942 from
Frank G. Speck.

Saulteaux

Mokok, c. 1910
Made by Mrs. John Keefer
Sewn birchbark, 9 x 9 x 11
1948.39.270 a,b
Collected by Clark Field in 1942 from
Frank G. Speck, who had acquired it from
Mrs. John Keefer of the Little Grand
Rapids Band, Berens River District,
Manitoba, Canada, in 1933.

Western Subartic Baskets

Chipewyan

[Cree C.F.]
Dish with cover, c. 1941
Sewn birchbark, 3 x 8⅛
1948.39.228 a,b
Collected by Clark Field in 1941 from
Frank G. Speck who acquired it at Portage
la Loche, Saskatchewan, Canada.

[Cree C.F.]
Mokok, c. 1941
Birchbark, 7¼ x 10½
1948.39.230 a,b
Collected by Clark Field in 1941 from
Frank G. Speck who acquired it at Portage
la Loche, Saskatchewan, Canada.

Cree (Western Woods)

Mokok, 1941
Sewn birchbark, 7½ x 7
1948.39.229 a,b
Collected by Clark Field in 1941 from
Frank G. Speck, who had acquired it at
Portage la Loche, Saskatchewan, Canada.

Gwich'in Dene (Loucheux)

Basketry cradle, c. 1945
Sewn birchbark, 9 x 9 x 15
1942.14.1911
Collected by Clark Field in 1951. This
basket was from the Yukon River Valley.

Dish, c. 1945
Sewn birchbark, 3¼ x 6¼ x 7
1942.14.1912
Collected by Clark Field in 1945. This
basket was from the Yukon River Valley.

Koyukon

[Yukon C.F.]
Storage basket with lid, c. 1920
Coiled, 14½ x 13
1942.14.2068 a,b
Collected by Clark Field in 1948.

Prairie Baskets

Osage

Mat or wrapper, c. 1860
Plaited, 18½ x 21½
1942.14.1698
Collected by Clark Field in 1942.

Bag, c. 1900
Open twined, 12½ x 10½
1995.25.21
Gift of the University of Tulsa,
Bright Roddy Collection

Mat, c. 1850
Twill twined, 48 x 24
1995.25.23
Gift of the University of Tulsa,
Bright Roddy Collection

Mat, c. 1850
Twill twined, 54½ x 24
1995.25.24
Gift of the University of Tulsa,
Bright Roddy Collection

Mat, c. 1860
Twill twined, 54¼ x 23½
1995.25.25
Gift of the University of Tulsa,
Bright Roddy Collection

Mat, c. 1860,
Twill twined, 55 x 23
1995.25.26
Gift of the University of Tulsa,
Bright Roddy Collection

Plains Baskets

Chippewa (Plains Ojibwa)

Oval potato basket, c. 1954
Wicker plaited, 4 x 14
1954.15.23
Collected by Clark Field in 1954, Turtle
Mountain Reservation, North Dakota.

[Sioux C.F.]
Basket with handle, c. 1954
Wicker plaited, 12 x 13
1955.16.2
Collected by Clark Field in 1954, Fort
Totten, Devils Lake (Spirit Lake)
Reservation, North Dakota.

Mandan

Burden basket, c. 1920
Made by Waheenee (Bird Woman)
Twill plaited, 12½ x 11¾
1950.17.17
Collected by Clark Field in 1950.

Pawnee

Gambling tray with eight plum-pit dice,
c. 1870
Made by Rhonda Knifechief's mother
Coiled, 2 x 9¼
1948.39.133
Collected by Clark Field in 1939, Pawnee,
Oklahoma.

Cheyenne

Gambling tray, c. 1940
Made by Laty Osage
Coiled, 4¼ x 17
1948.39.261
Collected by Clark Field in 1942 from
Laty Osage, Longdale, Blaine County,
Oklahoma.

Cheyenne/Arapaho

Gambling tray with six fruit-pit dice,
c. 1880
Made by Old Lady Bald Eagle
Coiled, 2⅞ x 8¼
1948.39.98 a-k
Collected by Clark Field in 1938,
Oklahoma.

Northeast Baskets

Abenaki

[Ottawa C.F.]
Flowerpot container, c. 1945
Plain plaited, 7 x 6½
1942.14.1963
Collected by Clark Field in 1946.

Fancy workbasket with two handles,
c. 1910
Plaited, 4¼ x 10¼
1948.39.249
Collected by Clark Field in 1941 from
Frank G. Speck.

Storage basket, c. 1860
Wicker plaited, 8 x 14
1948.39.250
Collected by Clark Field in 1941 from
Frank G. Speck.

Trinket basket with handle, c. 1870
Plain plaited, 3¾ x 4½
1948.39.307
Collected by Clark Field in 1942 from
Frank G. Speck.

Wastepaper basket, c. 1900
Made by Joseph Lola (Joseph Laurent)
Plain plaited, 9 x 8
1948.39.308
Collected by Clark Field in 1942 from
Frank G. Speck.

Cayuga

Hominy basket, c. 1920
Twill plaited, 9½ x 10 x 10
1942.14.1886
Collected by Clark Field in 1944 from
Frank G. Speck.

Miniature splint basket with handle,
c. 1945
Made by Tueved Jo'Wes
Plain plaited, 2 x 3 x 4
1942.14.1906
Collected by Clark Field in 1945 from
Frank G. Speck.

Miniature berry basket with handle,
c. 1945
Made by Tueved Jo'Wes
Plain plaited, 4 x 4½
1942.14.1907
Collected by Clark Field in 1945.

Miniature basket with handle, c. 1940
Made by wife of Niagwanigaa (Little Bear)
Plain plaited, 1 x 1
1942.14.1983
Collected by Clark Field in 1947.

Hominy washing basket with handle,
1942
Plain plaited, 6¼¼ x 6½
1948.39.269
Collected by Clark Field in 1942 from
Frank G. Speck.

Miniature basket with handle, 1942
Made by Kaihnes
Plain plaited, 2¾ x 2¾
1948.39.272
Collected by Clark Field in 1942 from
Frank G. Speck.

[Oneida C.F.]
Workbasket, c. 1930
Made by Mary Swamp
Plain plaited, 6 x 12½
1954.15.8
Collected by Clark Field in 1954,
presumably from Nellie Swamp of
Tulsa, Oklahoma, Mary Swamp's
daughter-in-law.

Northeast Baskets (cont.)

Croatoan

Storage basket, c. 1963
Twill plaited, 10 x 15½
1963.16.11
Collected by Clark Field in 1963.

Delaware

Storage basket with lid, c. 1900
Plain plaited, 10¼ x 8 x 8
1947.19.235 a,b
Roberta Campbell Lawson Collection,
gift of Mr. and Mrs. Edward Lawson.

(Munsee Branch)
Square to round hominy basket, c. 1860s
Made by Eliza Jackson Fall Leaf
Twill plaited, 8½ x 11
1948.39.131
Collected by Clark Field in 1938 in
Oklahoma.

Huron

Card case, c. 1870
Sewn and embroidered birchbark,
3¼ x 2 x ½
1942.14.2009 a,b
Collected by Clark Field in 1947 from
Frank G. Speck.

Card case, c. 1861
Sewn and embroidered birchbark,
4 x 2⅝ x ¾
1948.39.243 a,b
Collected by Clark Field in 1941 from
Frank G. Speck.

[Passamaquoddy C.F.]
Hexagonal box, c. 1880
Sewn and embroidered birchbark, 3 x 4⅝
1948.39.268 a,b
Collected by Clark Field in 1942 from
Frank G. Speck.

Thimble holder, c. 1944
Made by Gros Louis
Plain plaited, 1 x 1
1949.25.8
Collected by Clark Field in 1944 from
Frank G. Speck.

Iroquois

Oval-shaped basket with handle, c. 1950
Plain plaited, 5¾ x 4¼
1954.15.7
Collected by Clark Field in 1961.

Maliseet

Cylindrical feather basket, c. 1920
Open plain plaited, 33 x 13½
1942.14.1936
Collected by Clark Field in 1946.

Sewing basket with lid, c. 1900
Combination of plain plaited, wart, and
curlicues, 4½ x 6½ x 6½
1948.39.309 a,b
Collected by Clark Field in 1942.

Rectangular basket with lid, c. 1940
Made by Susan Paul
Plain plaited, 5½ x 8½ x 5½
1948.39.331 a,b
Collected by Clark Field in 1942 from
Frank G. Speck, who had acquired it from
the Gottschall Collection, Harrisburg,
Pennsylvania.

Micmac

Farm basket with handle, c. 1940
Made by the family of Steve Barlow
Plain plaited, 8 x 17 x 12½
1942.14.2003
Collected by Clark Field in 1947.

Yankee-style basket with handle, c. 1940
Made by the family of Steve Barlow
Plain plaited, 13 x 13
1942.14.2004
Collected by Clark Field in 1947 from
Frank G. Speck.

Rectangular quilled box with lid,
c. 1860–1880
Sewn birchbark, 4 x 7 x 5¾
1948.39.241 a,b
Collected by Clark Field in 1941 from
Frank G. Speck.

Melon/gizzard basket with handle,
c. 1940
Plain plaited, 8¾ x 14 x 14
1948.39.328
Collected by Clark Field in 1942 from
Frank G. Speck.

Round quilled box with lid, c. 1865
Sewn birchbark, 3 x 3¾
1949.29.15 a,b
Collected by Clark Field in 1944 from
Frank G. Speck.

Mohawk

Rectangular shopping basket with
handle, c. 1940
Made by John Sana
Plain plaited, 9 x 16¼ x 11
1942.14.1984
Collected by Clark Field in 1947.

Candy basket with lid, c. 1930
Plain plaited, 2¼ x 5¼
1947.19.577 a,b
Roberta Campbell Lawson Collection,
gift of Mr. and Mrs. Edward C. Lawson

Round farm basket, c. 1900
Plain plaited, 12 x 15½
1948.39.314
Collected by Clark Field in 1942 from
Frank G. Speck.

Farm basket with two handles, c. 1875
Plain plaited, 7½ x 21
1948.39.315
Collected by Clark Field in 1942 from
Frank G. Speck.

Yankee-style basket with two handles,
c. 1875
Plain plaited, 9½ x 19
1948.39.316
Collected by Clark Field in 1942 from
Frank G. Speck.

[Oneida C.F.]
Arm basket with lid, c. 1954
Made by Ida Baird
Plain plaited, 2¼ x 9¼
1954.15.9 a,b
Collected by Clark Field in 1954 from
Nellie Swamp of Tulsa, Oklahoma, Ida
Baird's daughter.

Mohegan

Mohegan/Nianti
Cheese basket, c. 1850
Hexagonal plaited, 5⅞ x 12½ x 10
1948.39.251
Collected by Clark Field in 1941,
presumably from Frank G. Speck.

Round storage basket with lid, c. 1800
Made by Lucy Tecomwass
Plain plaited, 11½ x 11½
1948.39.255 a,b
Collected by Clark Field in 1941 from
Frank G. Speck.

Rectangular open basket, c. 1810
Made by Lucy Tecomwass
Plain plaited, 11 x 17 x 13
1948.39.256
Collected by Clark Field in 1941 from
Frank G. Speck.

Montauk

Round basket with lid, c. 1940s
Made by Florence Tokuson
Plain plaited, 3 x 5¾
1948.39.293 a,b
Collected by Clark Field in 1942 from
Frank G. Speck.

Yankee-style workbasket, c. 1900
Made by Naoma Hannabel
Plain plaited, 6 x 7 1/2 ,
1948.39.347
Collected by Clark Field in 1942.

Yankee-style basket with two handles,
c. 1880s
Plain plaited, 5 x 15
1948.39.438
Collected by Clark Field in 1943 from
Frank G. Speck, who had acquired it from
Nathaniel Dominy, Long Island, New York.

Nanticoke

Basket section, n.d.
Plain plaited, 7½ x 5½
1942.14.2024
Collected by Clark Field in 1948.

[Nanticoke-Delaware C.F.]
Yankee-style basket with handle, 1942
Plain plaited, 11¼ x 11½
1948.39.259
Collected by Clark Field in 1942 from
Frank G. Speck.

Eel trap, c. 1868
Made by Topsey Morris
Plain plaited, 20 x 8
1948.39.271
Collected by Clark Field in 1942 from
Frank G. Speck.

Grain-measuring basket, c. 1862
Plain plaited, 3½ x 6
1948.39.294
Collected by Clark Field in 1942 from
Frank G. Speck.

Produce basket, c. 1880–1900
Made by Catherine Street
Plain plaited, 11½ x 11
1948.39.346
Collected by Clark Field in 1942 from
Frank G. Speck, who had acquired it from
Ashbury Thompson.

Eel trap with lid, c. 1900
Made by Elwood Wright
Plain plaited, 22 x 8
1948.39.437 a,b
Collected by Clark Field in 1943.

Natick

[Pequot C.F.]
Square storage basket with lid, c. 1850
Plain plaited, 11¼ x 11¼
1948.39.257 a,b
Collected by Clark Field in 1941 from
Frank G. Speck.

[Pequot C.F.]
Rectangular storage basket with lid,
c. 1850
Plain plaited, 12 x 18½
1948.39.258 a,b
Collected by Clark Field in 1941 from
Frank G. Speck.

Rectangular storage basket, c. 1830
Plain plaited, 11½ x 17 x 13½
1948.39.298
Collected by Clark Field in 1942 from
Frank G. Speck.

[Pennacook C.F.]
Square storage basket, c. 1840–1860
Plain plaited, 6 x 8½ x 8½
1948.39.311
Collected by Clark Field in 1942 from
Frank G. Speck.

[Pennacook C.F.]
Square storage basket with lid, c. 1835
Plain plaited, 8½ x 10½ x 10½
1948.39.322 a,b
Collected by Clark Field in 1942 from
Frank G. Speck.

[Pennacook C.F.]
Rectangular storage basket, c. 1835
Plain plaited, 6 x 13½ x 10½
1948.39.323
Collected by Clark Field in 1942 from
Frank G. Speck.

Niantic

[Mohegan C.F.]
Egg basket, c. 1850
Made by Mercy Nonesuch Matthews
Plain plaited, 4 x 7 x 6
1948.39.253
Collected by Clark Field in 1941 from
Frank G. Speck.

Oblong storage basket, c. 1820–1840
Made by Mercy Nonesuch Matthews [?]
Plain plaited, 7 x 9½ x 8¼
1948.39.254
Collected by Clark Field in 1941 from
Frank G. Speck.

Oneida

Round workbasket, c. 1936
Made by Mrs. Isaac Claus
Plain plaited, 4½ x 7½
1948.39.260
Collected by Clark Field in 1942 from
Frank G. Speck.

Passamaquoddy

Sieve, c. 1890
Open hexagonal plaited, 4½ x 8
1942.14.1919
Collected by Clark Field in 1941.

Melon basket with handle, c. 1920
Plain plaited, 6 x 13¼
1942.14.1985
Collected by Clark Field in 1947.

Wallet with lid, c. 1928
Plain twined, 1⅝ x 7
1948.39.332 a,b
Collected by Clark Field in 1942 from
Frank G. Speck, who had acquired it from
the Socktomah family in Eastport, Maine.

Round straight-sided fancy basket,
c. 1900
Plain plaited, 4 x 5
1949.25.11
Collected by Clark Field in 1944 from
Frank G. Speck.

Fancy basket with two handles, c. 1900
Plain plaited, 12¾ x 11¾
1949.25.12
Collected by Clark Field in 1944 from
Frank G. Speck.

Pennacook

Rinsing basket with two handles, c. 1835
Open hexagonal plaited, 6 x 11 x 11
1948.39.310
Collected by Clark Field in 1942 from
Frank G. Speck.

Round storage basket with lid, c. 1835
Plain plaited, 14½ x 18¼
1948.39.320 a,b
Collected by Clark Field in 1942 from
Frank G. Speck.

Round storage basket, c. 1835
Plain plaited, 10½ x 17½
1948.39.321
Collected by Clark Field in 1942 from
Frank G. Speck.

Small round basket, c. 1835
Plain plaited, 6 x 10 x 10
1948.39.324
Collected by Clark Field in 1942 from
Frank G. Speck.

Round storage basket with lid, c. 1840
Plain plaited, 9¾ x 16
1948.39.341 a,b
Collected by Clark Field in 1942 from
R. S. Speck, brother of Frank G. Speck.

Penobscot

Melon basket with handle, c. 1900
Made by Katlyn Paul
Plain plaited, 6 x 10 x 5½
1942.14.1918
Collected by Clark Field in the early 1940s
from Frank G. Speck.

Pack basket with hide harness, c. 1920
Plain plaited, 21 x 13½
1942.14.1935
Collected by Clark Field in 1946.

Pie basket with handle, c. 1900
Plain plaited, 4½ x 8¼
1942.14.1942
Collected by Clark Field in 1946.

Trinket basket with lid, c. 1936
Plain plaited, 1½ x 3⅜
1946.47.13 a,b
Collected by Clark Field in 1936.

Trinket basket with lid, c. 1931
Plain plaited, 2⅝ x 4⅛ x 4¼
1948.32.2 a,b
Gift of Frances Kinkead

Sewing basket with lid and handle,
c. 1925
Plain plaited, 4 x 10½
1948.39.56 a,b
Collected by Clark Field in 1937.

Sewing basket with lid and handle,
c. 1890
Made by Mrs. Sebat Ladi
Plain plaited, 7 x 7½
1948.39.245 a,b
Collected by Clark Field in 1941 from
Frank G. Speck.

Workbasket with two handles, c. 1870
Made by Mrs. Sebat Ladi
Plain plaited, 5¼ x 11¾
1948.39.246
Collected by Clark Field in 1941 from
Frank G. Speck.

Northeast Baskets (cont.)

Storage basket with lid, c. 1860s
Plain plaited, 7¼ x 12½ with lid
1948.39.247 a,b
Collected by Clark Field in 1941 from
Frank G. Speck.

Storage basket, c. 1860–1880
Plain plaited, 12½ x 15½
1948.39.248
Collected by Clark Field in 1941 from
Frank G. Speck.

[Nipmuck C.F.]
Round basket with handle, c. 1860–1880
Plain plaited, 10 x 13
1948.39.252
Collected by Clark Field in 1941 from
Frank G. Speck.

Storage basket, c. 1900
Twill plaited, 12 x 14
1948.39.265
Collected by Clark Field in 1942 from
Frank G. Speck.

[Pennacook C.F.]
Small square storage basket,
c. 1840–1880
Plain plaited, 4½ x 6¼
1948.39.312
Collected by Clark Field in 1942 from
Frank G. Speck.

Miniature basket with lid and handle,
c. 1840
Open hexagonal plaited, 2⅝ x 5 with
handle; lid ½ x 3½
1948.39.330 a,b
Collected by Clark Field in 1942 from
R. S. Speck, Rockport, Maine.

Miniature melon basket with handle,
c. 1942
Plain plaited, 2 x 4½ x 2¾
1948.39.334
Collected by Clark Field in 1942 from
Frank G. Speck.

Colander with two handles, c. 1841
Open hexagonal plaited, 3½ x 11¾
1948.39.335
Collected by Clark Field in 1942 from
Frank G. Speck.

Shallow gathering basket with two
handles, c. 1880
Plain plaited, 4½ x 16
1948.39.338
Collected by Clark Field in 1942 from
Frank G. Speck.

Storage basket, c. 1860
Plain plaited, 14½ x 16
1948.39.339
Collected by Clark Field in 1942 from
R. S. Speck.

Storage basket with lid, c. 1860
Diagonal plaited, 12½ x 16½
1948.39.340 a,b
Collected by Clark Field in 1942 from
R. S. Speck.

Round storage basket with lid, c. 1840
Plain plaited, 9¾ x 16
1948.39.341 a,b
Collected by Clark Field in 1942 from
R.S. Speck.

Trinket basket with lid, c. 1900
Plain plaited, 2¾ x 4½
1949.25.4 a,b
Collected by Clark Field in 1944 from
Frank G. Speck.

Rappahannock

Fish bag with two handles, c. 1920
Made by Susie Nelson
Knotted, 12 x 18
1948.39.262
Collected by Clark Field in 1942 from
Frank G. Speck.

Gizzard basket, c. 1900
Made by Bob Nelson
Plain plaited, 9⅝ x 21¼
1948.39.264
Collected by Clark Field in 1942 from
Frank G. Speck.

Egg basket, c. 1942
Made by Susie Nelson
Wicker plaited, 6 x 10½
1948.39.273
Collected by Clark Field in 1942 from
Frank G. Speck.

Miniature basket with handle, 1942
Made by Lizzie Nelson
Coiled and sewn, 2⅛ x 3½
1948.39.301
Collected by Clark Field in 1942 from
Frank G. Speck.

Small square basket with handle, c. 1942
Plain plaited, 4 x 6 x 6½
1948.39.302
Collected by Clark Field in 1942 from
Frank G. Speck.

[Arosaguntacook C.F.]
Half-melon basket with handle, c. 1880
Plain plaited, 6 x 10
1948.39.327
Collected by Clark Field in 1942 from
Frank G. Speck.

Melon basket with handle, c. 1900
Plain plaited, 12 x 18 x 22
1957.16.14
Gift of Mrs. John Leavell

Schaghticoke

Miniature basket with handle, c. 1942
Made by Frank Coggswell
Plain plaited, 2½ x 2½
1948.39.333
Collected by Clark Field in 1942 from
Frank G. Speck.

Seneca

Round basket with handle, c. 1900
Made by Dwight Jimerson
Plain plaited, 6½ x 13½
1942.14.1958
Collected by Clark Field in 1946.

Hulling basket, c. 1890
Twill plaited, 11 x 11½
1947.57.37
Collected by Clark Field in 1936.

Utilitarian basket with handle, c. 1937
Made by Susie Bearskin
Plain plaited, 11 x 11¾ x 7
1948.27.77
Collected by Clark Field in 1937.

Carrying basket, c. 1937
Made by Susan Bearskin
Plain plaited, 13 x 20
1948.27.78
Collected by Clark Field in 1937.

Utilitarian basket, c. 1937
Made by Susan Bearskin
Plain plaited, 4½ x 6½
1948.27.79
Collected by Clark Field in 1937.

Shinnecock

Melon/gizzard basket with handle,
c. 1900
Made by Wickham Cuffee
Plain plaited, 4¾ x 7½
1948.39.295
Collected by Clark Field in 1942 from
Frank G. Speck, who had acquired it from
Wickham Cuffee's daughter.

Round bailed workbasket with handle,
c. 1893
Made by the David Kellis Family
Plain plaited, 8 x 11
1948.39.439
Collected by Clark Field in 1943 from
Frank G. Speck, who had acquired it from
the David Kellis family, Long Island, New
York.

Fish trap with lid, c. 1890
Plain plaited, 22½ x 9½
1948.39.448 a,b
Collected by Clark Field in 1943 from
Frank G. Speck.

Low rectangular basket with handles, c. 1890
Made by the David Kellis Family
Plain plaited, 7 x 21½ x 15
1948.39.449
Collected by Clark Field in 1943 from Frank G. Speck, who had acquired it from the David Kellis family, Long Island, New York.

Yankee-style basket, c. 1890
Made by the David Kellis Family
Plain plaited, 4¾ x 10 x 9
1948.39.450
Collected by Clark Field in 1943 from Frank G. Speck, who had acquired it from the David Kellis family, Long Island, New York.

Yankee-style basket, c. 1890
Made by the David Kellis Family
Plain plaited, 7 x 12 x 14
1948.39.451
Collected by Clark Field in 1943 from Frank G. Speck, who had acquired it from the David Kellis family, Long Island, New York.

Yankee-style basket, c. 1890
Made by the David Kellis Family
Plain plaited, 9 x 11½
1948.39.452
Collected by Clark Field in 1943 from Frank G. Speck, who had acquired it from the David Kellis family, Long Island, New York.

Yankee-style basket with handle, c. 1890
Made by the David Kellis Family
Plain plaited, 10½ x 8½
1948.39.453
Collected by Clark Field in 1943 from Frank G. Speck, who had acquired it from the David Kellis family, Long Island, New York.

Yankee-style basket, c. 1900
Made by the David Kellis Family
Plain plaited, 5 x 7
1948.39.454
Collected by Clark Field in 1943 from Frank G. Speck, who had acquired it from the David Kellis family, Long Island, New York.

Yankee-style basket, c. 1890
Made by the David Kellis Family
Plain plaited, 4 x 5¾
1948.39.455
Collected by Clark Field in 1943 from Frank G. Speck, who had acquired it from the David Kellis family, Long Island, New York.

Rectangular basket with handle, c. 1890
Made by the David Kellis Family
Plain plaited, 4½ x 4½ x 3½
1948.39.456
Collected by Clark Field in 1943 from Frank G. Speck, who had acquired it from the David Kellis family, Long Island, New York.

Square basket, c. 1890
Made by the David Kellis Family
Plain plaited, 3¾ x 4½ x 4
1948.39.457
Collected by Clark Field in 1943 from Frank G. Speck, who had acquired it from the David Kellis family, Long Island, New York.

Round storage basket, c. 1890
Made by the David Kellis Family
Plain plaited, 6¼ x 8
1948.39.458
Collected by Clark Field in 1943 from Frank G. Speck, who had acquired it from the David Kellis family, Long Island, New York.

Yankee-style basket, c. 1920
Made by the David Kellis Family
Plain plaited, 5¼ x 9
1948.39.459
Collected by Clark Field in 1943 from Frank G. Speck, who had acquired it from the David Kellis family, Long Island, New York.

Workbasket with two handles, c. 1880–1900
Made by the David Kellis Family
Plain plaited, 6 x 14
1948.39.460
Collected by Clark Field in 1943 from Frank G. Speck, who had acquired it from the David Kellis family, Long Island, New York.

Fish-carrying basket, c. 1890
Made by the David Kellis Family
Plain plaited, 12 x 10½ x depth 7
1948.39.461
Collected by Clark Field in 1943 from Frank G. Speck, who had acquired it from the David Kellis family, Long Island, New York.

Workbasket with handle, c. 1890
Made by the David Kellis Family
Plain plaited, 5½ x 29¾ x 14
1948.39.462
Collected by Clark Field in 1943 from Frank G. Speck, who had acquired it from the David Kellis family, Long Island, New York.

Yankee-style basket with handle, c. 1890
Made by the David Kellis Family
Plain plaited, 7⅜ x 10¼
1948.39.463
Collected by Clark Field in 1943 from Frank G. Speck, who had acquired it from the David Kellis family, Long Island, New York.

Yankee-style basket with handle, c. 1890
Made by the David Kellis Family
Plain plaited, 8 x 11½
1948.39.464
Collected by Clark Field in 1943 from Frank G. Speck, who had acquired it from the David Kellis family, Long Island, New York.

Workbasket with lid and handle, c. 1890
Made by the David Kellis Family
Plain plaited, 11 x 10
1948.39.465
Collected by Clark Field in 1943 from Frank G. Speck, who had acquired it from the David Kellis family, Long Island, New York.

Tuscarora

Utilitarian basket, c. 1935
Plain plaited, 3½ x 9
1948.39.313
Collected by Clark Field in 1942 from Frank G. Speck, who had acquired it from R. R. Corbin, Newburgh, New York.

Tutelo-Saponi

Gizzard basket with handle, c. 1920
Plain plaited, 9 x 21½ x 16½
1948.39.590
Collected by Clark Field in 1942 from Frank G. Speck.

Wampanoag

(Mashpee)
Clothes hamper with lid, c. 1940
Plain plaited and open coiled, 13 x 13½
1942.14.1957 a,b
Collected by Clark Field in 1946, Cape Cod, Massachusetts.

(Mashpee)
Utility basket, c. 1880
Plain plaited, 6 x 7
1948.39.304
Collected by Clark Field in 1942 from Frank G. Speck.

Basket with handle, c. 1870
Made by Zerviah Gould Mitchell
Plain plaited, 7 x 9½
1948.39.319
Collected by Clark Field in 1942 from Mrs. Burnham, who had acquired it from the Spaulding family of Ipswich, Massachusetts.

Northeast Baskets (cont.)

Miniature storage basket with lid and
handle, c. 1870
Made by Emma Mitchell Safford
Plain plaited, 4½ x 4½
1948.39.325
Collected by Clark Field in 1942 from
Frank G. Speck.

Miniature basket with handle, c. 1870
Made by Emma Mitchell Safford
Plain plaited, 1¾ x 2⅛
1948.39.329
Collected by Clark Field in 1942 from
Frank G. Speck.

Sewing basket with handle and lid,
c. 1870
Made by Zerviah Gould Mitchell
Plain plaited, 8 x 9
1949.25.7 a,b
Collected by Clark Field in 1944 from
Mrs. Burnham, who had acquired it from
the Spaulding family of Ipswich,
Massachusetts.

Great Lakes

Algonquin

Carrying basket, c. 1941
Made by Paul Bras Coupe Commada
Etched and sewn birchbark, 15 x 9½
1948.39.232
Collected by Clark Field in 1941 from
Frank G. Speck.

Round storage container with lid, 1943
Etched and sewn birchbark, 15 x 16½
1948.39.381 a,b
Collected by Clark Field in 1943.

Storage basket with lid, c. 1943
Etched and sewn birchbark, 7½ x 10½
1948.39.382 a,b
Collected by Clark Field in 1943.

Round storage basket with lid, c. 1943
Etched and sewn birchbark, 9 x 20¾
1948.39.401 a,b
Collected by Clark Field in 1943.

Fishing creel with lid, c. 1943
Etched and sewn birchbark,
10 x 10½ x 8½
1948.39.423 a,b
Collected by Clark Field in 1943.

La Barriere Band
Round basket with lid, c. 1900–1940
Etched and sewn birchbark, 9 x 10½
1948.39.402 a,b
Collected by Clark Field in 1943.

River Desert Band
Small rectangular basket, c. 1914
Plain plaited, 3 x 1.6 x 4¾
1948.39.231
Collected by Clark Field in 1941 from
Frank G. Speck.

Fishing creel with lid, c. 1941
Made by Mary Buckshot
Etched and sewn birchbark, 12 x 12
1948.39.233 a,b
Collected by Clark Field in 1941 from
Frank G. Speck.

Barrel-shaped basket, c. 1943
Made by Mrs. Pierre Djako
Sewn birchbark, 33 x 37
1948.39.380
Collected by Clark Field in 1943.

Feather basket with lid, c. 1943
Made by Mrs. Michelle Buckshot
Plain plaited, 28 x 17
1948.39.399 a,b
Collected by Clark Field in 1943.

Round basket with lid, c. 1943
Made by Mrs. Michelle Buckshot
Etched and sewn birchbark, 18 x 18
1948.39.400 a,b
Collected by Clark Field in 1943.

Bucket basket with lid, c. 1920
Etched and sewn birchbark, 20 x 22
1948.39.422 a,b
Collected by Clark Field in 1943.

Ho-Chunk (Winnebago)

Basket with handle, c. 1900
Plain plaited, 8 x 11
1948.39.182
Collected by Clark Field in 1940 near
Minocqua, Wisconsin.

[Menominee C.F.]
Square to round basket with swing
handle, c. 1952
Plain plaited, 10¼ x 11¼ x 11
1953.1.12
Collected by Clark Field in 1952 near
Antigo, Wisconsin.

Kickapoo

Rectangular storage basket with handle
and lid, 1940
Plain plaited and wrap twined,
5½ x 8¼ x 5½
1942.14.1890 a,b
Collected by Clark Field in 1944 from
Alice Marriott, Indian Arts and Crafts
Board, who had acquired it in Muzquiz,
Coahuila, Mexico.

Square basket with handle, 1940
Plain plaited and twined, 3½ x 3 x 4½
1942.14.1891
Collected by Clark Field in 1942 from
Alice Marriott, who had acquired it in
Muzquiz, Coahuila, Mexico.

Miniature basket with handle, c. 1940
Plain plaited and twined, 2¼ x 2½ x 2¾
1942.14.1892
Collected by Clark Field in 1944 from
Alice Marriott, who had acquired it in
Muzquiz, Coahuila, Mexico.

Shopper with two loop handles
Plain plaited and twined, 13 x 13½ x 6
1942.14.2114
Collected by Clark Field in 1949, Nuevo
Laredo, Coahuila, Mexico.

Square basket with handle, c. 1937
Made by Mush-Qua-To-Quah
Plain plaited and wrap twined, 5½ x 5½
1948.27.47
Collected by Clark Field in 1937.

Square basket with handle, c. 1930
Made by Mush-Qua-To-Quah
Plain plaited and twined, 4 x 4 x 6
1948.27.48
Collected by Clark Field in 1937.

Square to round basket with handle,
c. 1937
Made by Mush-Qua-To-Quah
Twined, 7½ x 4¼
1948.27.49
Collected by Clark Field in 1937.

Rectangular to oval basket with handle,
c. 1847
Made by Ah-Ko-The
Plain plaited and twined, 6 x 12
1948.27.50
Collected by Clark Field in 1937.

Menominee

Pail with handle, c. 1940
Sewn birchbark, 7 x 7½
1948.39.280
Collected by Clark Field in 1942 in
Wisconsin from a Menominee man
named Piegion.

Ojibwa (Chippewa)

Water bucket with handle, c. 1900
Sewn birchbark, 12 x 11
1942.14.1934
Collected by Clark Field in 1946 in
Michigan.

Bag, c. 1900
Twined, 12 x 9¾, handle: 25½ x ⁹⁄₁₆
1947.19.232
Roberta Campbell Lawson Collection,
gift of Mr. and Mrs. Edward C. Lawson

Round basket with lid, c. 1930
Plain twined, 2½ x 6¾
1947.19.575 a,b
Roberta Campbell Lawson Collection,
gift of Mr. and Mrs. Edward C. Lawson

Round quilled birchbark box with lid,
c. 1938
Made by Mrs. Sky Eagle
Sewn birchbark, 3½ x 8⅞
1948.39.104 a,b
Collected by Clark Field in 1938 from
R. B. Cregar, Palm Springs, California.

Rice storage basket, c. 1900
Sewn birchbark, 14¾ x 12½ x 17
1948.39.122
Collected by Clark Field in 1938 from
T. J. Darby, Tulsa, Oklahoma.

Maple-sugar container, c. 1935
Made by John Whitefish (A-De-Ka-Maig)
Sewn birchbark, 10 x 17 x 10
1948.39.177
Collected by Clark Field in 1940.

Maple-sugar storage basket, c. 1930
Made by John Whitefish (A-De-Ka-Maig)
Sewn birchbark, 12¼ x 18
1948.39.178
Collected by Clark Field in 1940.

Rice-winnowing tray, c. 1900
Sewn birchbark, 8½ x 30⅝
1948.39.180
Collected by Clark Field in 1941.

Rice-winnowing tray, c. 1900
Sewn birchbark, 5 x 25
1948.39.181
Collected by Clark Field in 1940.

Dish, c. 1930
Sewn birchbark, 3 x 10¾ x 7½
1948.39.227
Collected by Clark Field in 1941 from
Frank G. Speck.

Trinket basket, c. 1940
Sewn birchbark, 4 x 3 ¾ x 5½
1948.39.242
Collected by Clark Field in 1941 from
Frank G. Speck.

Maple-sugar container, c. 1900
Sewn birchbark, 9½ x 12 x 9
1948.39.244
Collected by Clark Field in 1941 from
Frank G. Speck.

Maple-sugar container, c. 1940
Sewn birchbark, 8½ x 11½ x 6
1948.39.263
Collected by Clark Field in 1942 from
Frank G. Speck.

Round quilled birchbark box with lid,
c. 1875
Sewn birchbark, 2¾ x 5⅜
1948.39.343 a,b
Collected by Clark Field in 1942 from
Frank G. Speck, who had acquired it from
the Gottschall Collection, Harrisburg,
Pennsylvania.

Trinket box with lid, c. 1875
Made by Mrs. Leri Joe
Sewn birchbark, 3½ x 6¾ .
1948.39.344 a,b
Collected by Clark Field in 1942 from
Frank G. Speck, who had acquired it from
the Gottschall Collection.

Trinket basket, c. 1930
Coiled and sewn, 2 x 6¾
1948.39.351
Collected by Clark Field in 1941 from
Frank G. Speck.

Trinket basket with lid, c. 1940
Coiled and sewn birchbark, 2½ x 5½ x 3½
1948.39.352 a,b
Collected by Clark Field in 1941 from
Frank G. Speck.

Oval trinket box with lid, c. 1943
Sewn birchbark, 4¼ x 4 x 6
1948.39.466 a,b
Collected by Clark Field in 1943.

Round quilled birchbark box with lid,
c. 1943
Sewn birchbark, 2½ x 3½
1948.39.467 a,b
Collected by Clark Field in 1943.

Maple-sugar container, 1962
Sewn birchbark, 8 x 10
1963.16.7
Collected by Clark Field in 1962.

Trinket basket with lid, 1962
Coiled, 1¾ x 3¾
1963.16.8 a,b
Collected by Clark Field in 1962.

Trinket basket, c. 1940
Coiled, 4 x 6
1963.16.9 a,b
Collected by Clark Field in 1962.

Round workbasket, 1962
Plain plaited, 3¾ x 8
1963.16.19
Collected by Clark Field in 1962.

Square workbasket, c. 1962
Plain plaited, 4½ x 8½ x 8½
1963.16.20
Collected by Clark Field in 1962.

Basket, c. 1930
Coiled, 3¾ x 5
1995.24.48 a,b
Gift of the University of Tulsa,
Ellis Soper Collection

Ottawa

Rectangular to oval basket with handle,
c. 1900
Made by Charles Shugnaby
Twill plaited, 9 x 18 x 10
1942.14.1960
Collected by Clark Field in 1946 from
Frank G. Speck.

Household basket, c. 1930
Twill plaited, 9 x 9
1942.14.1961
Collected by Clark Field in 1946 from
Frank G. Speck.

Fancy trinket basket with two handles,
c. 1930
Made by Ottina Petosley
Plain plaited and braided, 2½ x 5½
1942.14.1964
Collected by Clark Field in 1942.

Fancy trinket basket with lid, c. 1945
Coiled and sewn, 3½ x 5½
1942.14.1965 a,b
Collected by Clark Field in 1946 in
Harbor Springs, Michigan.

Maple-sugar basket with two handles,
c. 1885
Sewn, 10 1/2 x 9 x 13½
1948.39.205
Collected by Clark Field in 1941 at the
northern point of the Michigan Peninsula.

Maple-sugar collection basket,
c. 1920–1940
Sewn, 11 x 10¾
1948.39.206
Collected by Clark Field in 1941 at the
northern point of the Michigan Peninsula.

Pack bag, c. 1866
Twined, 12½ x 18
1948.39.207
Collected by Clark Field in 1941 at the
northern point of the Michigan Peninsula.

Salt container, 1926
Sewn, 3 x 3½
1949.29.16
Collected by Clark Field in 1944.

Round quilled birchbark box with lid,
1964
Sewn birchbark, 2½ x 8⅛
1964.24.6 a,b
Collected by Clark Field in 1964.

Potawatomi

Rectangular box, c. 1880
Coiled and sewn birchbark, 2½ x 5 x 6½
1948.39.326
Collected by Clark Field in 1942 at
Walpole Island, Perry Sound, Ontario,
Canada.

[Ottowa Potawatomie C.F.]
Trinket box with lid, c. 1875
Coiled and sewn birchbark, 3½ x 6¼ x 3¾
1948.39.345
Collected by Clark Field in 1942 from
Frank G. Speck.

Utility basket with handle, c. 1952
Plain-plaited, 8 x 17½ x 8½
1953.1.21
Collected by Clark Field in 1952.

Great Lakes Baskets (cont.)

[Menominee C.F.]
Bowl, c. 1945
Coiled, 2 x 6¼
1955.16.5
Collected by Clark Field in 1955 from Royal Hassrick, formerly with the Indian Arts and Crafts Board, Denver, Colorado.

[Menominee C.F.]
Square quilled box with lid, c. 1962
Sewn birchbark, 2½ x 3¼ x 4¼
1963.16.10
Collected by Clark Field in 1962.

Sac and Fox

Bag, c. 1900
Open twined, 11½ x 13
1948.27.17
Collected by Clark Field in 1937 in Oklahoma.

Bag, c. 1900
Twined, 15½ x 19
1948.27.38
Collected by Clark Field in 1937 from Mrs. O. D. Lewis at the Shawnee Agency, Oklahoma, who had acquired it from Was-Ko-Nee-A-Mesh-Ko-Kee, a Sac and Fox.

Bag, c. 1870
Twined, h 5¼ x 7¾
1995.25.115
Gift of the University of Tulsa, Bright Roddy Collection.

Southeast Baskets

Biloxi

Basket with handle, c. 1964
Made by Mrs. Joe (Rose Jackson) Pierite
Plain and twill plaited, 6 x 6½
1964.24.8
Collected by Clark Field in 1964 near Marksville, Louisiana.

Catawba

Fish trap, 1890
Made by Henry Saunders
Plain plaited, 64 x 18
1948.39.234
Collected by Clark Field in 1941 from Frank G. Speck.

Cherokee

North Carolina (Eastern Band)
Miniature gizzard-shaped basket with handle, c. 1942
Wicker plaited, 1¼ x 2⅜
1942.14.1898
Collected by Clark Field in 1945 in Cherokee, North Carolina.

Gizzard-shaped basket with handle, c. 1940s
Wicker plaited, 7 x 11 x 13
1942.14.1917
Collected by Clark Field in the 1940s in North Carolina.

[Ottawa C.F.]
Sieve with two handles, c. 1930
Wicker and twill plaited, 9½ x 4¾
1942.14.1962
Collected by Clark Field in 1946 from Frank G. Speck.

Basket, c. 1920–1940
Wicker and twill plaited, 13¼ x 10½
1947.19.576
Roberta Campbell Lawson Collection, gift of Mr. and Mrs. Edward C. Lawson

Storage basket, c. 1943
Wicker plaited, 20 x 14
1948.27.364
Collected by Clark Field in 1943 from Frank G. Speck.

Winnowing basket, c. 1931
Twill plaited, 5½ x 15 x 14½
1948.32.1
Gift of Miss Elizabeth Kinkead

Carrying basket, c. 1941
Made by Nancy Bradley
Wicker and twill plaited; 12 x 12
1948.39.191
Collected by Clark Field in 1941 from C. T. Lloyd of the Cherokee Inn, Cherokee, North Carolina.

Basket with handle, c. 1941
Made by Nancy Bradley
Twill plaited, 8½ x 10½
1948.39.192
Collected by Clark Field in 1941 from C. T. Lloyd of the Cherokee Inn, Cherokee, North Carolina.

Small square basket, c. 1941
Made by Nancy Bradley
Twill-plaited double weave, 4½ x 8
1948.39.193
Collected by Clark Field in 1941 from C. T. Lloyd of the Cherokee Inn, Cherokee, North Carolina.

Square basket, c. 1941
Made by Nancy Bradley
Twill plaited, 7½ x 17
1948.39.195
Collected by Clark Field in 1941 in Cherokee, North Carolina.

Burden basket, 1941
Made by Nancy Bradley
Twill plaited, 18½ x 20½
1948.39.196
Collected by Clark Field in 1941 from C. T. Lloyd of the Cherokee Inn, Cherokee, North Carolina.

Storage basket, c. 1941
Made by Nancy Bradley
Twill plaited, 18 x 18
1948.39.197
Collected by Clark Field in 1941 from C. T. Lloyd of the Cherokee Inn, Cherokee, North Carolina.

Carrying basket, c. 1941
Made by Nancy Bradley
Twill plaited, 19 x 18
1948.39.198
Collected by Clark Field in 1941 from C. T. Lloyd of the Cherokee Inn, Cherokee, North Carolina.

Sifter, c. 1890
Wicker plaited, 2½ x 5 x 5
1948.39.216
Collected by Clark Field in 1941 from Frank G. Speck, who had acquired it from West Long in North Carolina.

Square basket, c. 1922
Twill-plaited double weave, 3½ 5¼ x 8
1948.39.217
Collected by Clark Field in 1941 from Frank G. Speck.

Square basket, c. 1940
Made by Sally Toinuta
Wicker plaited, 4 x 11¼ x 10
1948.39.218
Collected by Clark Field in 1941 from Frank G. Speck.

Catch basket, c. 1900
Twill plaited, 4½ x 11 x 13
1948.39.219
Collected by Clark Field in 1941 from Frank G. Speck, who had acquired it from West Long in North Carolina.

Burden basket, c. 1941
Made by Katie Loossie [Lossiah?]
Twill plaited, 17 x 20
1948.39.220
Collected by Clark Field in 1941 from Frank G. Speck.

Storage basket, 1942
Made by Jennie Walkingstick
Plain plaited, 13½ x 14
1948.39.277
Collected by Clark Field in 1942 from C. T. Lloyd of the Cherokee Inn, Cherokee, North Carolina.

Storage basket with two handles, c. 1942
Made by Nancy Bradley
Wicker plaited, 15½ x 12½
1948.39.278
Collected by Clark Field in 1942 from C. T. Lloyd of the Cherokee Inn, Cherokee, North Carolina.

Miniature basket with handle, c. 1942
Wicker plaited, 2 x 2
1948.39.279
Collected by Clark Field in 1942 from
Frank G. Speck, who had acquired it in
North Carolina.

Trinket basket with lid, 1942
Wicker plaited, 5 x 8
1948.39.281 a,b
Collected by Clark Field in 1942 from
Frank G. Speck.

Trinket basket, c. 1942
Plain and wicker plaited, 7½ x 8¾
1948.39.282 a,b
Collected by Clark Field in 1942 from
Frank G. Speck.

Quiver for arrows and darts, 1942
Twill-plaited, 18½ x 4½
1948.39.283
Collected by Clark Field in 1942 from
Frank G. Speck, who had acquired it in
North Carolina.

Miniature basket with handle, c. 1934
Coiled, 1½ x 3
1948.39.296
Collected by Clark Field in 1942 from
Frank G. Speck.

Bowl, c. 1940
Wicker, 2¾ x 5¾
1948.39.359
Collected by Clark Field in 1943 from
Frank G. Speck.

Round basket, c. 1880
Wicker plaited, 6 x 11
1948.39.360
Collected by Clark Field in 1941 from
Frank G. Speck, who had acquired it
from Mary George in North Carolina.

Globular-shaped basket, c. 1943
Wicker, 6½ x 8
1948.39.361
Collected by Clark Field in 1943 from
Frank G. Speck, who had acquired it in
North Carolina.

Gizzard-shaped basket with handle,
c. 1943
Wicker plaited, 8 x 14
1948.39.365
Collected by Clark Field in 1943 from
Frank G. Speck, who had acquired it in
the Smoky Mountains area of North
Carolina.

Basket with handle, c. 1944
Wicker plaited, 6 x 12
1948.39.484
Collected by Clark Field in 1944 in
Cherokee, North Carolina.

Straight-sided basket, c. 1944
Twill plaited, 3¼ x 5½
1949.4.6
Collected by Clark Field in 1944 in
Cherokee, North Carolina.

Gizzard-shaped basket with handle,
c. 1835
Wicker plaited, 5 x 7 x 8½
1994.4
Gift of Ray Trotter

Oklahoma (Cherokee Nation)
Cradle, c. 1930
Wicker plaited, 7 x 12¼ x 30
1942.14.1893
Collected by Clark Field in 1944 from
Chief J. B. Milam, Cherokee Nation, in
Kenwood, Oklahoma.

Basket with two handles, c. 1941
Made by Lucy Mouse
Wicker plaited, 13½ x 17½
1942.14.1920
Collected by Clark Field in 1941 in
Kenwood, Oklahoma.

Basket with handle, 1936
Wicker plaited, 8 x 11¼
1946.47.1
Collected by Clark Field in 1936 near
Kenwood, Oklahoma.

Vase, c. 1936
Wicker plaited, 7 x 6
1946.47.2
Collected by Clark Field in 1936,
presumably from the Kenwood Cherokee
School in Kenwood, Oklahoma.

Storage basket, 1936
Wicker and twill plaited, 10¼ x 16
1946.47.4
Collected by Clark Field in 1936 in
Oklahoma.

Basket with two handles, 1936
Wicker plaited, 3¾ x 10
1946.47.5
Collected by Clark Field in 1936 in
Eucha, Oklahoma.

Oval basket, c. 1936
Wicker plaited, 5¼ x 8½ x 13½
1946.47.6
Collected by Clark Field in 1936 in
Eucha, Oklahoma.

Tray, c. 1940
Made by Lucy Spade Wolf
Wicker plaited, 3 x 11½
1946.47.8
Collected by Clark Field in 1940 in
Oklahoma.

Sifter, c. 1936
Wicker plaited, 4¼ x 8 x 8½
1946.47.9
Collected by Clark Field in 1936 in
Oklahoma.

Sifter, c. 1890
Wicker plaited 5¾ x 14½
1946.47.11
Collected by Clark Field in 1936 at
Fort Gibson, Oklahoma.

Basket with handle, c. 1920
Wicker, 7½ x 7¼
1947.19.581
Roberta Campbell Lawson Collection,
gift of Mr. and Mrs. Edward C. Lawson

Openwork fruit basket, c. 1936
Wicker plaited, 7 x 13
1947.57.33
Collected by Clark Field in 1936 in
Oklahoma.

Small sewing basket, c. 1938
Wicker plaited, 3¼ x 7½
1947.57.42
Collected by Clark Field in 1938.

Vase, c. 1936
Wicker, 10¾ x 7
1947.57.43
Collected by Clark Field in 1936 near
Tahlequah, Oklahoma.

Sewing basket, 1936
Wicker plaited, 3¼ x 10
1947.57.46
Collected by Clark Field in 1936.

Wastebasket, c. 1936
Wicker, 7¾ x 8¾
1947.57.48
Collected by Clark Field in 1936 in Eucha,
Oklahoma.

Sewing basket, c. 1936
Wicker plaited, 4½ x 10
1947.57.51
Collected by Clark Field in 1936 in
Eucha, Oklahoma.

Basket with handle, 1936
Wicker plaited, 10¾ x 12⅛
1947.57.54
Collected by Clark Field in 1936 in
Kenwood, Oklahoma.

Basket with two handles, lid with handle,
1936
Wicker plaited, 9½ x 12
1947.57.56 a,b
Collected by Clark Field in 1936.

Storage basket, 1937
Made by Eliza Padgett
Wicker plaited, 16 x 13½
1948.27.14
Collected by Clark Field in 1937 in
Stilwell, Oklahoma.

Basket with handle, c. 1937
Wicker plaited, 6 x 9½
1948.39.30
Collected by Clark Field in 1937 in
Eucha, Oklahoma.

Sewing basket, 1937
Wicker plaited, 6½ x 11½
1948.39.31
Collected by Clark Field in 1937 in
Eucha, Oklahoma.

Southeast Baskets (cont.)

Sifter, c. 1937
Made by Susie Soldier Glory
Twill plaited, 5 x 10½
1948.39.54
Collected by Clark Field in 1937 in
Kenwood, Oklahoma.

Storage basket, c. 1940
Made by Sallie Lacy
Plain plaited, 21 x 18
1948.39.67
Collected by Clark Field in 1940 near
Kenwood, Oklahoma.

Basket with handle, 1940
Made by Lucy Spade Wolf
Plain and wicker plaited, 7¼ x 14
1948.39.68
Collected by Clark Field in 1940 near
Kenwood, Oklahoma.

Basket with handle, 1940
Made by Nancy Sixkiller
Wicker plaited, 7½ x 9½
1948.39.162
Collected by Clark Field in 1940 in
Oklahoma.

Sifter, c. 1940
Twill plaited, 5½ x 11
1948.39.163
Collected by Clark Field in 1940 near
Eucha, Oklahoma.

Egg basket with handle, 1940
Wicker plaited, 5½ x 9
1948.39.164
Collected by Clark Field in 1940 in
Eucha, Oklahoma.

Egg basket with handle, 1940
Wicker plaited, 5¼ x 9¼
1948.39.165
Collected by Clark Field in 1940 in
Eucha, Oklahoma.

Fruit basket, 1940
Wicker plaited, 7 x 12½
1948.39.166
Collected by Clark Field in 1940 in
Eucha, Oklahoma.

Basket with handle, c. 1940
Made by Susie Soldier Glory
Wicker plaited, 5 x 10
1948.39.168
Collected by Clark Field in 1940 near
Eucha, Oklahoma.

Openwork fruit basket, 1940
Wicker plaited, 4 x 7½
1948.39.169
Collected by Clark Field in 1940 in
Eucha, Oklahoma.

Basketry bowl, c. 1940
Wicker plaited, 4½ x 9
1948.39.170
Collected by Clark Field in 1940 in
Eucha, Oklahoma.

Basket with handle, 1940
Made by Lucy Spade Wolf
Wicker plaited, 8½ x 14
1948.39.171
Collected by Clark Field in 1940 near
Kenwood, Oklahoma.

Basket with lid and handles, 1940
Made by Lucy Spade Wolf
Wicker plaited, 17½ x 19
1948.39.172 a,b
Collected by Clark Field in 1940 near
Kenwood, Oklahoma.

Basket with lid and handles, 1940
Made by Sallie Lacy
Wicker plaited, 18½ x 18
1948.39.173 a,b
Collected by Clark Field in 1940 near
Kenwood, Oklahoma.

Storage basket with two handles,
lid with handle, 1940
Made by Lucy Spade Wolf
Wicker plaited, 18 x 17
1948.39.175 a,b
Collected by Clark Field in 1940 in
Oklahoma.

Basket with handle, c. 1941
Made by Nancy Wildcat
(Mrs. Ward Coachmen)
Twill plaited, 6¾ x 11½
1948.39.187
Collected by Clark Field in 1941 near
Gore, Oklahoma.

Sifter, c. 1941
Made by Nancy Wildcat
(Mrs. Ward Coachmen)
Twill plaited, 5 x 16 x 15½
1948.39.188
Collected by Clark Field in 1941 near
Gore, Oklahoma.

Catch basket, c. 1941
Made by Nancy Wildcat
(Mrs. Ward Coachmen)
Twill plaited, 5½ x 21
1948.39.189
Collected by Clark Field in 1941 near
Gore, Oklahoma.

Rectangular shallow basket, c. 1941
Made by Fannie Jumper
Wicker plaited, 2¾ x 13 x 11½
1948.39.204
Collected by Clark Field in 1941 in
Jay, Oklahoma.

Basket with handle, 1900
Made by Donna Spade
Wicker plaited, 9 x 11
1948.39.300
Collected by Clark Field in 1942 near
Kenwood, Oklahoma.

Gizzard-shaped basket with handle,
c. 1952
Wicker plaited, 6 x 9½ x 9
1952.22.5
Collected by Clark Field in 1952 in
Tahlequah, Oklahoma.

Chickahominy

Trinket basket with handle, c. 1948
Wicker plaited, 2½ x 7
1942.14.2023
Collected by Clark Field in 1948 from
Frank G. Speck, who had acquired it near
Powhatan, Virginia.

Gizzard-shaped basket, c. 1870
Wicker plaited, 6¼ x 14 x 12
1948.39.284
Obtained by Clark Field in 1942 from
Frank G. Speck, who had acquired it in
Virginia.

Farm basket with handle, c. 1942
Made by wife of Chief Bradley
Plain plaited, 5 x 11 x 8
1948.39.342
Collected by Clark Field in 1942 from
Frank G. Speck, who had acquired it in
Virginia.

Chitimacha

Basket with lid, c. 1938
Twill plaited, 7⅛ x 8¼
1948.39.89 a,b
Collected by Clark Field in 1938 from a
Chitimacha Indian in Charenton, near
Grand Lake, Louisiana.

Box with lid, c. 1938
Twill plaited, 4 x 3½
1948.39.90 a,b
Collected by Clark Field in 1938 from a
Chitimacha Indian in Charenton, near
Grand Lake, Louisiana.

Bowl, c. 1938
Twill plaited, 4¾ x 11½
1948.39.91
Collected by Clark Field in 1938 from a
Chitimacha Indian in Charenton, near
Grand Lake, Louisiana.

Straight-sided basket, 1938
Made by Zelia Marcotte
Twill plaited, 13¾ x 11
1948.39.92
Collected by Clark Field in 1938 from a
Chitimacha Indian in Charenton, near
Grand Lake, Louisiana.

Rectangular basket, c. 1938
Made by Pauline Paul
Twill plaited, 6½ x 6 x 9
1948.39.97 a,b
Collected by Clark Field in 1938 in
Louisiana.

Bowl, c. 1890
Twill plaited, 5½ x 10
1972.14
Gift of Mrs. Charles E. Mangold

Choctaw

Louisiana

Basket with handle, c. 1941
Twill plaited, 6 x 8½
1948.39.210
Collected by Clark Field in 1941.

Basket with handle, 1942
Made by Marellia Johnson
Twill plaited, 9 x 6
1948.39.289
Collected by Clark Field in 1942 in
Bayou LaComb, Louisiana.

Elbow-shaped basket, c. 1942
Made by Marellia Johnson
Twill plaited, 15 x 14
1948.39.290
Collected by Clark Field in 1942 in
Bayou LaComb, Louisiana.

Basket with two handles, 1942
Made by Marellia Johnson
Wicker and twill plaited, 14½ x 17 x 9
1948.39.291
Collected by Clark Field in 1942 in
Bayou LaComb, Louisiana.

Mississippi

Hamper with handles and lid, 1942
Twill plaited, 24½ x 20
1942.14.1880 a,b
Collected by Clark Field in 1942,
presumably in Mississippi.

Envelope basket, c. 1936
Twill plaited, 12¼ x 6 x 3
1946.47.3
Collected by Clark Field in 1936.

Berry basket with lid and handle, c. 1817
Wicker and twill plaited, 9½ x 10 x 10
1948.39.58
Collected by Clark Field in 1937 from
F. Antle in Sulphur, Oklahoma, who had
acquired it from Gordon Hawkins, whose
mother's family brought it from Mississippi
(1838–1842).

Basket with handle, c. 1942
Wicker and twill plaited, 4½ x 5½
1948.39.286
Collected by Clark Field in 1942 in
Neshoba County, Mississippi.

Wall pocket basket with handle, 1942
Twill plaited, 7 x 4½ x 7½
1948.39.287
Collected by Clark Field in 1942 in
Neshoba County, Mississippi.

Basket with handle, c. 1942
Twill plaited, 8¾ x 12¼
1948.39.288
Collected by Clark Field in 1942 in
Neshoba County, Mississippi.

Oklahoma

Elbow basket, c. 1936
Twill plaited, 12½ x 16 x 4
1946.47.20
Collected by Clark Field in 1936 in
Oklahoma.

Workbasket, 1936
Twill plaited, 6 x 9½
1947.57.35
Collected by Clark Field in 1936 in
Oklahoma.

Winnowing basket, 1936
Twill plaited, 5½ x 14¼
1947.57.38
Collected by Clark Field in 1936 in
Oklahoma.

Sifter, c. 1936
Twill plaited, 5¼ x 14 x 14
1947.57.39
Collected by Clark Field in 1936 in
Oklahoma.

Catch basket, 1936
Twill plaited, 7 x 17 x 21
1947.57.40
Collected by Clark Field in 1936 in
Oklahoma.

Basket with handle, c. 1936
Plain and twill plaited, 7 x 8
1947.57.53
Collected by Clark Field in 1936 in
Oklahoma.

Basket with handle, 1937
Made by Fannie Battiest
(Mrs. Willis Wesley)
Twill plaited, 14 x 12
1948.39.26
Collected by Clark Field in 1937 near
Broken Bow, Oklahoma.

Basket with handle, 1937
Made by Jane Brandy
Twill plaited, 7 x 8
1948.39.27
Collected by Clark Field in 1937 in
Oklahoma.

Three-sided basket with handle, c. 1937
Twill plaited, 8 x 13 x 13
1948.39.38
Collected by Clark Field in 1937 in
southern Oklahoma.

Basket with handle, 1940
Made by Fannie Battiest
(Mrs. Willis Wesley)
Plain and twill plaited, 7 x 11
1948.39.151
Collected by Clark Field in 1940 in
Oklahoma.

Heart basket with handle, 1940
Made by Fannie Battiest
(Mrs. Willis Wesley)
Twill plaited, 8 x 10½ x 4½
1948.39.152
Collected by Clark Field in 1940 in
Oklahoma.

Square tray, c. 1940
Made by Fannie Battiest
(Mrs. Willis Wesley)
Twill plaited, 5 x 15 x 16
1948.39.153
Collected by Clark Field in 1940 near
Idabel, Oklahoma.

Basket with handle, c. 1940
Made by Jane Brandy
Wicker and twill plaited, 8 x 11
1948.39.154
Collected by Clark Field in 1940 near
Idabel, Oklahoma.

Square tray, c. 1940
Made by Jane Brandy
Twill plaited, 7 x 11
1948.39.155
Collected by Clark Field in 1940 near
Idabel, Oklahoma.

Tray, c. 1940
Made by Fannie Battiest
(Mrs. Willis Wesley)
Twill plaited, 2½ x 9¼ x 10
1948.39.156
Collected by Clark Field in 1940 near
Broken Bow, Oklahoma.

Square tray, c. 1940
Made by Fannie Battiest
(Mrs. Willis Wesley)
Twill plaited, 2¾ x 9 x 10
1948.39.157
Collected by Clark Field in 1940 near
Broken Bow, Oklahoma.

Square tray, c. 1940
Made by Fannie Battiest
(Mrs. Willis Wesley)
Twill plaited, 2½ x 9 10
1948.39.158
Collected by Clark Field in 1940 in
Oklahoma.

Rectangular tray, c. 1940
Made by Fannie Battiest
(Mrs. Willis Wesley)
Twill plaited, 3¾ x 11 x 13
1948.39.159
Collected by Clark Field in 1940 near
Broken Bow, Oklahoma.

Southeast Baskets (cont.)

Square tray, 1940
Made by Fannie Battiest
(Mrs. Willis Wesley)
Twill plaited, 4 x 14 x 12
1948.39.160
Collected by Clark Field in 1940 near
Broken Bow, Oklahoma.

Tray, 1940
Made by Fannie Battiest
(Mrs. Willis Wesley)
Twill plaited, 4 x 12 x 13½
1948.39.161
Collected by Clark Field in 1940 near
Broken Bow, Oklahoma.

Basket with two handles, 1939
Made by Jane Brandy
Plain and twill plaited, 15½ x 16
1948.39.174
Collected by Clark Field in 1941 near
Idabel, Oklahoma.

Basket with handle, 1941
Plain and twill plaited, 7½ x 6½ x 7¼
1948.39.209
Collected by Clark Field in 1941 in
Oklahoma.

Square basket, 1942
Made by Fannie Battiest
(Mrs. Willis Wesley)
Twill plaited, 5 x 14½ x 15
1948.39.292
Collected by Clark Field in 1942 near
Broken Bow, Oklahoma.

Coushatta (Koasati/Alibamu)

Louisiana

Basket with handle, before 1936
Made by Cinsie Abbey
Twill plaited, 5½ x 7 x 7
1948.39.208
Collected by Clark Field in 1941 in
Elton, Louisiana.

Basket with lid, c. 1936
Made by Fanny Puucho
Coiled, 2¼ x 4¼
1948.39.266 a,b
Collected by Clark Field in 1942 from
Frank G. Speck, who probably had
acquired it in Allen Parish, Louisiana.

Texas

Basket with handle, before 1947
Coiled, 2¾ x 4½
1947.19.578
Roberta Campell Lawson Collection,
gift of Mr. and Mrs. Edward C. Lawson

Sieve, c. 1939
Twill plaited, 3½ x 12
1948.39.134
Collected by Clark Field in 1939 from
J. E. Farley, Indian agent, Livingston,
Texas.

Hanging shelf basket, c. 1900
Twill plaited, 22 x 11
1948.39.135
Collected by Clark Field in 1939 from
J. E. Farley, Indian agent, Livingston,
Texas.

Winnowing basket, c. 1941
Twill plaited, 3 x 13½ x 9¾
1948.39.235
Collected by Clark Field in 1941 from
J. E. Farley, Indian agent, Livingston,
Texas.

Sieve, c. 1941
Plain plaited, 3 x 12 x 12½
1948.39.236
Collected by Clark Field in 1941 from
J. E. Farley, Indian agent, Livingston,
Texas.

Basket with two handles, c. 1941
Twill plaited, 3 x 9 x 13
1948.39.237
Collected by Clark Field in 1941 from
J. E. Farley, Indian agent, Livingston,
Texas.

Basket with lid, c. 1941
Coiled, 8 x 10
1948.39.238 a,b
Collected by Clark Field in 1941 in Texas.

Wall pocket basket, 1963
Made by Maggie Poncho
Twill plaited, 9 x 8 x 7
1963.16.12
Collected by Clark Field in 1963 in
Livingston, Texas.

Basket with double handle, c. 1962
Made by Maggie Poncho
Plain and twill plaited, 6 x 11 x 11½
1963.16.13
Collected by Clark Field in 1962 in
Livingston, Texas.

Basket with handle, 1963
Made by Mrs. Joe Langley
Twill plaited, 8 x 14
1963.16.14
Collected by Clark Field in 1963 in
Livingston, Texas.

Turkey-shaped trinket basket, 1962
Made by Maggie Poncho
Coiled, 8 x 8 x 10
1963.16.18 a,b
Collected by Clark Field in 1962 in
Livingston, Texas.

Alligator-shaped trinket basket, 1962
Made by Maggie Poncho
Coiled, 3½ x 3½ x 14½
1963.16.22 a,b
Collected by Clark Field in 1963 in
Livingston, Texas.

Turtle-shaped basket, 1963
Coiled, 5 x 9½ x 5¼
1964.24.1 a,b
Collected by Clark Field in 1963 in
Livingston, Texas.

Frog-shaped basket, 1963
Made by Maggie Poncho
Coiled, 4¼ x 5 x 9½
1964.24.2 a,b
Collected by Clark Field in 1963 in
Livingston, Texas.

Armadillo-shaped trinket basket, c. 1963
Made by Maggie Poncho
Coiled, '4 x 4 x 9
1964.24.3 a,b
Collected by Clark Field in 1963 in
Livingston, Texas.

Basket with lid, c. 1967
Plain plaited, 7 x 10½
1967.17.2 a,b
Collected by Clark Field in 1967.

Owl-shaped trinket basket, c. 1967
Coiled, 8¾ x 4
1967.17.4 a,b
Collected by Clark Field in 1967.

Creek

Oklahoma

Wall pocket, before 1947
Twill plaited, 10 x 11
1947.19.270
Roberta Campbell Lawson Collection,
gift of Mr. and Mrs. Edward C. Lawson

Winnowing basket, c. 1940
Twill plaited, 5 x 22
1948.39.183
Collected by Clark Field in 1940 from
Rhoda Hawkins in Stidham, Oklahoma.

Square basket, c. 1930
Twill plaited, 3½ x 11½ x 11½
1948.39.184
Collected by Clark Field in 1941 from
Rhoda Hawkins in Stidham, Oklahoma.

Square basket, 1941
Made by Winey Deere
Twill plaited, 8½ x 14
1948.39.221
Collected by Clark Field in 1941 from
Winey Deere near Cromwell, Oklahoma.

Winnowing basket, 1941
Made by Winey Deere
Twill plaited, 6½ x 21 x 21½
1948.39.222
Collected by Clark Field in 1941 from
Winey Deere near Cromwell, Oklahoma.

Catch basket, 1941
Made by Winey Deere
Twill plaited, 4½ x 18 x 17
1948.39.223
Collected by Clark Field in 1941 from
Winey Deere near Cromwell, Oklahoma.

Sifter, 1941
Made by Winey Deere
Twill plaited, 5 x 17½ x 17½
1948.39.224
Collected by Clark Field in 1941 from
Winey Deere near Cromwell, Oklahoma.

Sifter, c. 1941
Made by Winey Deere
Twill plaited, 5¼ x 16
1948.39.225
Collected by Clark Field in 1941 from
Winey Deere near Cromwell, Oklahoma.

Houma

Basket with handle, c. 1941
Made by Mrs. David Billiot
Wicker plaited, 5½ x 7
1948.39.211
Collected by Clark Field in 1941 in
Golden Meadow, Louisana.

Basket with handle, c. 1941
Made by Mrs. David Billiot
Coiled, 5½ x 7 x 9
1948.39.212
Collected by Clark Field in 1941 in
Golden Meadow, Louisiana.

Basket with lid and handles, c. 1942
Made by David Billiot
Wicker plaited, 12 x 8½
1948.39.274 a,b
Collected by Clark Field in 1942 from
Frank G. Speck.

Basket with handle, c. 1942
Made by Leona Billiot
Wicker plaited, 3½ x 6 x 7
1948.39.285
Collected by Clark Field in 1942 in
Louisiana.

Basket with handle, c. 1942
Wicker plaited, 4¾ x 6 x 9½
1948.39.297
Collected by Clark Field in 1942 from
Frank G. Speck.

Sewing basket, c. 1943
Made by Anthony Billiot
Wicker plaited, 4½ x 7½ x 11
1948.39.368
Collected by Clark Field in 1943 from
Frank G. Speck.

Monacan

Basket with handle, 1964
Made by Virginia Branham
Plain plaited, 6½ x 17 x 11¾
1964.24.4
Collected by Clark Field in 1964 in
Amherst, Virginia.

Natchez

Sifter, c. 1937
Made by Wat Sam
Twill plaited, 3½ x 14½
1947.57.63
Collected by Clark Field in 1937 near
Braggs, Oklahoma.

Tray, c. 1937
Made by Wat Sam
Twilled, 3¼ x 14¼
1947.57.64
Collected by Clark Field in 1937 near
Braggs, Oklahoma.

Seminole

Sifter, 1941
Twill plaited, 2¾ x 13½ x 14
1948.39.226
Collected by Clark Field in 1941 from
Frank G. Speck, who had acquired it in
Florida.

Square basket, c. 1942
Twill plaited, 7 x 7½ x 11
1948.39.275
Collected by Clark Field in 1942 from Mrs.
William Boehmer of the Brighton Indian
Day School, Brighton, Florida.

Sifter, 1942
Twill plaited, 3 x 18 x 18 in
1948.39.276
Collected by Clark Field in 1942 from Mrs.
William Boehmer of the Brighton Indian
Day School, Brighton, Florida.

Catch basket, 1942
Twill plaited, 4½ x 20½ x 20
1948.39.299
Collected by Clark Field in 1942 from Mrs.
William Boehmer of the Brighton Indian
Day School, Brighton, Florida.

Storage basket, c. 1943
Made by Annie Tommie
Twill plaited, 14½ x 14 x 18½
1948.39.358
Collected by Clark Field in 1943 from
Dorothy Field Maxwell, who had acquired
it near Miami, Florida.

Basket with lid, c. 1930
Coiled, 3½ x 7
1950.17.16 a,b
Collected by Clark Field in 1950 from
Francis L. Zollinger, Tulsa, Oklahoma

Bread tray, 1955
Plain plaited, 2¾ x 11¾ x 1½
1955.16.6
Collected by Clark Field in 1955,
Seminole Reservation, Florida.

Carrying basket, 1961
Twill plaited, 16 x 19
1961.16.4
Collected by Clark Field in 1961 in
Hollywood, Florida.

Tunica

Rectangular basket, 1952
Twill plaited, 7½ x 18½ x 20
1953.1.7
Collected by Clark Field in 1952 from Mr.
L. A. Cayer, superintendent of schools in
Marksville, Louisiana.

Basket with handle, 1952
Twill plaited, 10 x 14½ x 16
1953.1.8
Collected by Clark Field in 1952 from Mr.
L. A. Cayer, superintendent of schools in
Marksville, Louisiana.

Yuchi

Sifter, c. 1875
Made by George Fulsom
Twill plaited, 3 x 10½ x 12
1962.13.2
Collected by Clark Field in 1962 from
Johnson Tiger, the maker's grandson, in
Kellyville, Oklahoma.

Sifter, c. 1875
Made by Fannie Fulsom
Twill plaited, 3½ x 12 x 12
1962.13.3
Collected by Clark Field in 1962 from
Johnson Tiger, the maker's grandson, in
Kellyville, Oklahoma.

European-American

Basket with handle, 1948
Made by Frank G. Speck as a
demonstration piece.
Wicker plaited, 2½ x 3½ x 4¼
1942.14.2022
Collected by Clark Field in 1948 from
Frank G. Speck.

Aniline dye—a synthetic dye or coloring agent introduced to North American native peoples in the mid-1800s.

Base—the bottom of a basket, which can be flat, rounded, concave, convex, or pointed.

Basket—a container or receptacle, the structure of which is usually woven or sewn and commonly consists of plant materials such as shoots, roots, stems, leaves, bark, grasses, and vines.

Basketry—a general term that refers to both the process and techniques of basketmaking and the finished basket.

Beading—a decorative overlay technique usually used on coiled basketry. The structural stitching is used to bind a strip of bark or pliable colored splint to the outer surface of the foundation.

Block stamp—a decorative printing technique in which dyes or paints are applied to the surface of a basket by using a carved potato, block, or other stamp.

Boiling basket, or cooking basket—an impermeable basket in which water and hot stones are placed to boil or cook food.

Bottleneck basket—a basket with a globular body, sharp shoulder, and narrow neck.

Bundle—a bunch of grass shoots, plant stems, or other fine materials used as a foundation in some coiled baskets.

Burden basket, or pack basket—a large carrying basket. The shape varies culturally and regionally and includes plaited and twined rectangular and conical forms.

Coiling—a technique in which a continuous spiraling foundation is sewn together by whipstitchlike sewing or binding.

Crossed warp—type of open-twined or plaited basketwork in which two sets of warp elements cross each other at an oblique angle, often producing an X configuration.

Culture area—a geographic region in which various distinct native peoples live, all of whom share comparable but not identical cultural characteristics.

Decoration—ornamentation on basketry.

Designs—patterns and motifs that use line, shape, size, space, texture, color, balance, rhythm, and proportion to create order and beauty that contribute to the overall aesthetic effect of a basket's design.

Diagonal twining—type of twining in which a pair of weft elements cross each other between each unit of two or more warp elements, thus creating a diagonal column of twists that rises to the right or left.

Embroidery—decoration added to a basket after its structural completion, using such materials as moose hair, porcupine quills, and worsted and silk yarns and threads.

Etching—a decorative technique in which the surface of the birchbark is scraped away to reveal the darker underlayers of bark, thus creating a decorative two-toned pattern.

Fag end—the end of a sewing splint on the work surface of a coiled basket that marks the place where a new element begins and an old one ends.

False braid—appearance of three-ply braidwork at the rim of a basket, created with a single splint that has been woven backward and forward on itself.

False embroidery—a decorative technique used on plain-twined baskets in which a single strand of material, such as a splint or grass stem, is wrapped around the outer surface of the weft elements during the weaving process. False embroidery stitches slant in the *opposite* direction from weft-element stitches and resemble half-twist overlay, in that they do not show on the inner surface of a basket.

Featherwork—decoration of basketry by incorporating feathers into the structure of the basket during sewing or weaving.

Finish—the finished edge, selvage, or rim of a basket in which the warp elements are turned down or bound.

Form—three-dimensional shape. A basket can be deep with rounded, globular, or flaring sidewalls (such as a bowl or hat), or it can be flat or slightly concave (such as a plaque or tray).

Foundation—the inner core or structure of a basket.

Function, or use—the cultural role of a specific basket or basket form.

Geometric—a specific type of design in which regular lines, angles, and curves predominate.

Herringbone finish—specific type of rim finish; braidwork that appears to be three-ply at the rim of a coiled basket, actually made by weaving a single splint backward and forward on itself, similar to a false braid.

Imbrication—a decorative overlay technique used on coiled basketry, in which a splint or thin strip of bark or grass is folded regularly back and forth on itself along the outer surface of the foundation and is caught under selected stitches and bound to the foundation, thus creating an overlapping appearance.

Interlocking stitches—in coiling, the foundation is bound together by looping or sewing stitches through those of a preceding coil.

Lattice twining—type of twining which uses four structural elements: one rigid warp element, one rigid weft element, and two flexible weft strands. The rigid weft crosses the warp element at right angles on the outer surface and is held in place with the two flexible weft strands, which twine around the rigid elements. This method resembles plain-twined stitches on the inner surface and coiling stitches on the outer surface.

Moving end—the end of a splint or rod in a coiled basket, which is present on the surface and is clipped off or folded under stitches on the reverse surface.

Natural dye—any dye obtained from various plants, insects, minerals, etc., and which is not classified as a paint, pigment, or aniline dye.

Overlay—decorative method using materials that differ in color and texture, incorporated by laying the strand against the surface of the structural weft in twining and plaiting. By using the two paired weft elements with the decorative overlay weft strand always facing outside, the weaver produces half-twist overlay, in which the design appears only on the outer surface of the twined basket. When the paired overlay and structural weft elements are twisted on each other, thus creating full-twist overlay, the design will appear on both the outer and inner surfaces of the basket.

Pattern—a planned, often repeating decorative design, which usually can be broken down into more basic elements, or motifs.

Plain plaiting, or checkerwork—a weaving technique in which the warp and weft elements are usually indistinguishable from each other because they are often of equal size and flexibility.

Plain twining—type of twining which has a pair of weft elements that cross each other between each warp unit and lie vertically above the weft twists.

Plaiting—basketry in which the warp and weft, both usually of equal pliability and width, are interwoven at right angles to each other.

Quillwork—a decorative technique that incorporates porcupine (or occasionally bird) quills in the structure of a basket.

Rattle lid—a basket lid in which small stones are enclosed in a double thickness of basketry fabric.

Ring basket—a twill-plaited basket with a circular or oval wooden or metal rim support.

Rod—a long, straight shoot or stem of a woody plant that is both thin and round. It is used as a weaving or sewing material, particularly in coiled basketry.

Seed beater—a device used for beating seeds from grasses into a tray or burden basket.

Sewing—technique used in the creation of coiled basketry. The foundation of a coiled basket is attached to the preceding coil with a splint that is used to bind the foundation with whipstitching.

Splint—a pliable sewing material that wraps around the foundation material in coiled baskets or around the warp in twined baskets.

Start—the point at which the construction of a coiled or twined basket begins, usually in the center of the basket base. Starts may be plaited, stitched, nonintersecting, or intersecting warp elements.

Stitches—the individual sewing elements in coiled basketry that hold the coils of a basket together.

Storage basket—round or squared trunklike container used for storing household possessions.

Strand—one of two or more weft elements or stitching elements used in basket weaving.

Stylized—a specific type of design in which an object being portrayed is standardized with a motif that falls between naturalistic and representational.

Swabbing—a technique for painting splints, used particularly on plaited splint basketry.

Tobacco basket—a cylindrical or globular basket, often lidded or closed with a drawstring, used for storing tobacco.

Trinket basket—a small or medium-sized vessel, often lidded, used for holding or storing small items or trinkets.

Tumpline—a strap that goes across the forehead or chest to support a basket carried on the back.

Twill plaiting, or diagonal plaiting—a variant of plaiting in which the warp and weft elements pass over and under each other in intervals other than over one, under one. By varying the interval used, this technique produces decorative structural patterns such as diamonds and meanders.

Twining—basketry made with vertical warp elements and two or more horizontal weft elements that are crossed between warp units. Twining has many variations, and rows of twining can be placed in either open spacing (spaced apart) or closed spacing (close together).

Wallet—a soft, flexible bag or basket, often with a drawstring to close the mouth of the bag.

Warp—the foundation of the basket. The warp element is usually more rigid and stronger than the weft elements, which run lengthwise or vertically in basketry.

Water bottle, or water jar—a watertight container with a constricted neck, used for holding water.

Weft—the sewing or twining material.

Wicker plaiting, or wickerwork—a variant of plaiting in which the warp elements are rigid, round, and rodlike. A single weft element is usually used to interweave the warp elements.

Winnowing basket—a container or tray for sifting or separating grains and seeds from chaff.

Wrap twining—type of twining which uses three structural elements: one rigid warp element, one rigid weft element, and one flexible weft strand. The rigid warp and weft elements are crossed at right angles and are then bound with the flexible weft strand.

REFERENCES CITED

Abel-Vidor, Suzanne, Dot Brovarney, and Susan Billy. *Remember Your Relations: The Elsie Allen Baskets, Family & Friends.* Grace Hudson Museum, City of Ukiah, and Oakland Museum of California, Berkeley: Heyde Books, 1996.

Allen, Elsie. *Pomo Basketmaking: A Supreme Art for the Weaver.* Rev. ed. Happy Camp, California: Naturegraph Publishers, Inc., 1972.

Arreola, Paul. "George Wharton James and the Indians," *Masterkey* 60:1 (1986).

Bailey, Garrick A., ed. *The Osage and the Invisible World from the Works of Francis La Flesche.* Norman: University of Oklahoma Press, 1995.

Bailey, A. Garrick, and Roberta Glenn Bailey. *A History of the Navajos: The Reservation Years.* Santa Fe, New Mexico: School of American Research Press, 1986.

Bardwell, Kathryn. "The Case for an Aboriginal Origin of Northeast Indian Woodsplint Basketry," *Man in the Northeast* 31:49–67 (1986).

Baskets: Red Willow and Birchbark, An Exhibition, January 21 to March 22, 1990. Rapid City, South Dakota: U.S. Department of the Interior, Indian Arts and Crafts Board, Sioux Indian Museum and Crafts Center, 1990.

Basso, Keith H. "Western Apache." In *Handbook of North American Indians.* Vol. 10. Edited by Alfonso Ortiz. Washington, D.C.: Smithsonian Institution, 1983, 462–488.

Bates, Craig D. "Hechenu Pulaka: The Changing Role of Baskets in a Northern Miwok Family." In *Native American Basketry of Central California.* Riverside, California: Riverside Museum Press, 1986, 50–61.

Bates, Craig D., and Martha J. Lee. *Tradition and Innovation: A Basket History of the Indians of the Yosemite–Mono Lake Area.* Yosemite National Park, California: Yosemite Association, 1990.

———. "Chukchansi Yokuts and Southern Miwok Weavers of Yosemite National Park," *American Indian Art Magazine* 18(3): 44–51 (1993).

Benedict, Salli. "Mohawk Indian Basketry," *American Indian Basketry Magazine* 3(1):10–16 (1983).

Benedict, Salli, and Judy Lauersons. *Teionkwahontasen: Basketmakers of Akwesasne.* Hogansburg, New York: The Akwesasne Museum, 1983.

Berlo, Janet Catherine, ed. *The Early Years of Native American Art History.* Seattle: University of Washington Press, 1992.

Bernstein, Bruce. "Panamint Shoshone Coiled Basketry: A Definition of Style," *American Indian Art Magazine* 4(4):68–74 (1979).

Boas, Franz. "Ethnology of the Kwakiutl (Based on Data Collected by George Hunt)." 2 pts. *35th Annual Report of the Bureau of American Ethnology for the Years 1913–1914.* Washington, D.C.: 1921, 43–1481.

Bowen, Thomas. "Seri Basketry: A Comparative View," *The Kiva* 38:3–4 (1973).

Brasser, Ted J. "The Coastal Algonkians: People of the First Frontiers." In *North American Indians in Historical Perspective.* Edited by Eleanor Leacock and Nancy O. Luri. New York: Random House, 1971, 64–91.

———. "A Basketful of Indian Culture Change," National Museum of Man, Mercury Series, Canadian Ethnology Service 22. Ottawa, Ontario: National Museums of Canada, 1975.

Brody, J.J. *Pueblo Indian Painting: Tradition and Modernism in New Mexico, 1900–1930.* Santa Fe, New Mexico: School of American Research Press, 1997a.

———. Interview by Lydia L. Wyckoff, Albuquerque, New Mexico, tape recording, March 1997b.

Butler, Eva L. "Some Early Indian Basket Makers of Southern New England." In *Eastern Algonkian Block-Stamp Decoration: A New World Original or an Acculturated Art*, by Frank G. Speck. Research Series No. 1. Trenton: Archaeological Society of New Jersey, 1947, 35–54.

Bushnell, David I. Jr. "The Choctaw of Bayou LaComb, St. Tammany Parish, Louisiana." *Bureau of American Ethnology Bulletin 48.* Washington, D.C.: Smithsonian Institution, 1909.

Cain, Thomas. Foreword. In *The Basket Weavers of Arizona*, by Bert Robinson. Albuquerque: University of New Mexico Press, 1991.

Cain, William C., and Justin F. Farmer. "Materials, Techniques, and Styles." In *Rods, Bundles, & Stitches: A Century of Southern California Indian Basketry.* Edited by Raul L. Lopez and Christopher L. Moser. Riverside, California: Riverside Museum Press, 1981, 82–111.

Callender, Charles, Richard K. Pope, and Susan M. Pope. "Kickapoo." In *Handbook of North American Indians.* Vol. 15. Edited by B.G. Trigger. Washington, D.C.: Smithsonian Institution, 1978, 656–667.

Carse, Mary Rowell. "The Mohawk Iroquois." *Bulletin of the Archaeological Society of Connecticut* 23:3–53 (1949).

Chatters, James C. "Environment." In *Handbook of North American Indians.* Vol. 12. Edited by Deward E. Walker Jr. Washington, D.C.: Smithsonian Institution, 1998, 29–48.

Christian, Emma Ervin. "Memories of my Childhood Days in the Choctaw Nation," *Chronicles of Oklahoma* 9(2) (1931).

Church, Robert M. Foreword. In *The Clark Field American Indian Pottery and Basket Collection.* Tulsa, Oklahoma: Philbrook Art Center, 1952.

Coe, Ralph T. *Lost and Found Traditions: Native American Art 1965–85.* Seattle: University of Washington Press and American Federation of Arts, 1986.

Cohodas, Marvin. "Dat so la lee's Basketry Design," *American Indian Art Magazine* 1(4):22–31 (1976).

———. "Lena Frank Dick: An Outstanding Washoe Basket Weaver," *American Indian Art Magazine* 4(4):32–41, 90 (1979a).

———. *Degikup: Washoe Fancy Basketry, 1895–1935.* Vancouver: Fine Arts Gallery, University of British Columbia, 1979b.

————. "Sarah Mayo and her Contemporaries: Representative Designs in Washoe Basketry," *American Indian Art Magazine* 6(4):52–59 (1981).

————. "Washoe Basketry," *American Indian Basketry and Other Native Arts* 12:4–40 (1983).

————. "Washoe Innovators and their Patrons." In *The Art of the American Indian: Native Traditions in Transition*. Edited by Edwin L. Wade. New York: Hudson Hills Press, 1986, 203–220.

————. "Louisa Keyser and the Cohns: Mythmaking and Basket Making in the American West." In *The Early Years of Native American Art History*. Edited by Janet Catherine Berlo. Seattle: University of Washington Press, 1992.

Cole, Douglas. *Captured Heritage: The Scramble for Northwest Coast Artifacts*. Seattle: University of Washington Press, 1985.

Colton, Harold S. *Hopi Kachina Dolls, with a Key to their Identification*. Albuquerque: University of New Mexico Press, 1959.

Conkey, Laura E., Ethel Boissevain, and Ives Goddard. "Indians of Southern New England and Long Island: Late Period." In *Handbook of North American Indians*. Vol. 15. Edited by B.G. Trigger. Washington, D.C.: Smithsonian Institution, 1978, 177–189.

Conn, Richard G., and Mary Dodds Schlick. "Basketry." In *Handbook of North American Indians*. Vol. 12. Edited by Deward E. Walker Jr. Washington, D.C.: Smithsonian Institution, 1998, 600–609.

Curtis, W. Conway. "Basketry of the Pautatucks and Scatacooks," *The Southern Workman* 33(7):385-390 (1904).

Dalrymple, Larry. *Indian Basketmakers of California and the Great Basin*. Santa Fe: Museum of New Mexico Press, 2000.

Davis, E.H. "Indian Basketry," manuscript, National Archives Branch, Laguna Niguel, California, 1935.

Dawson, Lawrence. "California Indian Basketry." Seminar presented September 23–25, 1983, at Sacramento State University. Class notes in possession of Suzanne Griset.

Day, Gordon M. "Western Abenaki." In *Handbook of North American Indians*. Vol. 15. Edited by B.G. Trigger. Washington, D.C.: Smithsonian Institution, 1978, 148–159.

Day, Gordon M., and Bruce G. Trigger. "Algonquin." In *Handbook of North American Indians*. Vol. 15. Edited by B.G. Trigger. Washington, D.C.: Smithsonian Institution, 1978, 792–797.

D'Azevedo, Warren L. Introduction. In *Handbook of North American Indians*. Vol. 11. Edited by Warren L. D'Azevedo. Washington, D.C.: Smithsonian Institution, 1986a, 1–14.

————. "Washoe." In *Handbook of North American Indians*. Vol. 11. Edited by Warren L. D'Azevedo. Washington, D.C.: Smithsonian Institution, 1986b, 466–498.

Deagan, Kathleen. "Afro-American and Native American Traditions in Florida Basketry." In *Florida Basketry: Continuity and Change*. White Springs, Florida: Florida Folklife Program, 1981.

Dean, Marie, and Antoine Billiot. "Palmetto and Spanish Moss Weaving," *American Indian Crafts and Culture* 8(2): 14–17 (1974).

Densmore, Frances. "Chippewa Customs." *Bureau of American Ethnology Bulletin 86*. Washington, D.C.: Smithsonian Institution, 1929.

————. "Seminole Music." *Bureau of American Ethnology Bulletin 161*. Washington, D.C.: Smithsonian Institution, 1956.

Department of Indian Affairs and Northern Development. *A Report of the Government of Canada*, 2000.

DeWald, Terry. *The Papago Indians and their Basketry*. Tucson, Arizona: Terry DeWald, 1979.

Dittmore, Diane, and Cathy Notarnicola. "Anonymous Was a Weaver: In Search of Turn-of-the-Century Western Apache/Yavapai Basketry Artists," *American Indian Art Magazine* 24(3): 54–65 (1999).

Dockstader, Frederick J. *Indian Art in America*. Greenwich, Connecticut: New York Graphic Society, 1962.

Douglas, Frederic H. "Three Creek Baskets." In *Material Culture Notes*. Compiled by Norman Feder. Denver, Colorado: Denver Art Museum, 1969. Rev. ed. of the original publication of 1941.

Downs, Dorothy. "Contemporary Florida Indian Patchwork and Baskets," *American Indian Art Magazine* 15(4): 56–63 (1990).

————. *Art of the Florida Seminole and Miccosukee Indians*. Gainesville: University of Florida Press, 1995.

Drake, Allene, and Lyle Wilson. "Eulachon: A Fish to Cure Humanity." *Museum Note*, No. 32. Vancouver: University of British Columbia Museum of Anthropology, n.d.

Driver, Harold E. *Indians of North America*. 2nd ed. Chicago, Illinois: University of Chicago Press, 1969.

Duff, Wilson. *The Indian History of British Columbia*. Vol. 1: *The Impact of the White Man*. Anthropology in British Columbia. Memoirs 5. Victoria, 1964.

Duggan, Betty J., and Brett H. Riggs. "Studies in Cherokee Basketry." *Occasional Paper* No. 9. Knoxville: University of Tennessee, the Frank H. McClung Museum, 1991.

Eckstrom, Fanny Hardy. *The Handicrafts of the Modern Indian of Maine*. Bulletin 3. Bar Harbor, Maine: Robert Abbe Museum, 1932.

Eiseley, Loren. *All the Strange Hours: The Excavation of a Life*. New York: Charles Scribner's Sons, 1975.

Eisenhart, Linda L. "Hupa, Karok, and Yurok Basketry." In *The Art of Native American Basketry: A Living Legacy*. Edited by Frank W. Porter III. *Contributions to the Study of Anthropology*, No. 5. New York: Greenwood Press, 1990.

Ellis, Florence Hawley, and Mary Walpole. "Possible Pueblo, Navajo, and Jicarilla Basketry Relationships," *El Palacio* 66:6 (1959).

Emmons, George T. "The Basketry of the Tlingit." *Memoirs of the American Museum of Natural History* 8(2):229–277 (1903).

Ewers, John C. *Murals in the Round: Painted Tipis of the Kiowa and Kiowa-Apache Indians*. Washington, D.C.: Smithsonian Institution, 1978.

Feder, Norman. *Long Island Indian Culture*, Leaflet 50. Denver, Colorado: Denver Art Museum, 1932.

Feest, Christian F. "North Carolina Algonquians." In *Handbook of North American Indians*. Vol. 15. Edited by B.G. Trigger. Washington, D.C.: Smithsonian Institution, 1978, 271–281.

Fewkes, J. Walters. "Hopi Katchinas." *21st Annual Report of the Bureau of American Ethnology*. Washington, D.C., 1903.

Field, Clark. "Fine Root Runner Basketry among the Oklahoma Cherokee Indian." Bulletin No. 1. Tulsa, Oklahoma: Philbrook Art Center, 1943.

————. Letter to Frank G. Speck, April 2, 1946. Philadelphia: American Philosophical Society Library, Frank G. Speck Papers, 572.97, Sp. 3, Box 30.

————. Letter to Frank G. Speck, May 12, 1947. Philadelphia: American Philosophical Society Library, Frank G. Speck Papers, 572.97, Sp. 3, Box 30.

————. *The Clark Field American Indian Pottery and Basket Collection*. Tulsa, Oklahoma: Philbrook Art Center, 1952.

————. Autobiography. In *The Art and the Romance of Indian Basketry*. Tulsa, Oklahoma: Philbrook Art Center, 1964.

————. Letter to Dorothy Field Maxwell, August 25, 1967. Albuquerque: Maxwell Museum, University of New Mexico, 1967.

————. "Pima Basketry," *The Arizona Archaeologist* 4 (1969).

Field, Dorothy. "The Inter-tribal Indian Ceremonial." *Smoke Signals*, No. 17. Washington, D.C.: Indian Arts and Crafts Board, United States Department of the Interior, 1955.

Fields of Clover: Larry Dawson's Thirty-eight Years with the Lowie Museum Collections. Exhibit brochure, Lowie Museum of Anthropology, University of California, Berkeley, n.d.

Fontana, Bernard L. "Pima and Papago: Introduction." In *Handbook of North American Indians*. Vol. 10. Edited by Alfonso Ortiz. Washington, D.C.: Smithsonian Institution, 1983, 125–136.

Foreman, Carolyn Thomas. *Cherokee Weaving and Basketry*. Muskogee, Oklahoma: The Star Printery, 1948.

Fowler, Catherine S., and Lawrence E. Dawson. "Ethnographic Basketry." In *Handbook of North American Indians*. Vol. 11. Edited by Warren L. D'Azevedo. Washington, D.C.: Smithsonian Institution, 1986, 705–737.

Freeman, Milton M.R. "Arctic Ecosystems." In *Handbook of North American Indians*. Vol. 5. Edited by D. Damas. Washington, D.C.: Smithsonian Institution, 1984, 36–48.

Gardner, James S. "General Environment." In *Handbook of North American Indians*. Vol. 6. Edited by J. Helm. Washington, D.C.: Smithsonian Institution, 1981, 5–14.

Gillespie, Beryl C. "Major Fauna in the Traditional Economy." In *Handbook of North American Indians*. Vol. 6. Edited by J. Helm. Washington, D.C.: Smithsonian Institution, 1981, 15–18.

Goble, Danney. *Tulsa! Biography of the American City*. Tulsa, Oklahoma: Council Oak Books, 1997.

Gogol, John M. "Cornhusk Bags and Hats of the Columbia Plateau Indians," *American Indian Basketry Magazine* 3(2):4–17 (1980a).

————. "Rose Frank Shows How to Weave a Nez Perce Cornhusk Bag," *American Indian Basketry Magazine* 1(2):22–30 (1980b).

————. "The Golden Decade of Collecting Indian Basketry," *American Indian Basketry* 5(1):12–29 (1985).

Goodwin, Grenville. "The Social Divisions and Economic Life of the Western Apache," *American Anthropologist* 37:1 (1935).

Gordon, Joleen. "Micmac Indian Basketry." In *The Art of Native American Basketry: A Living Legacy*. Edited by F. W. Porter III. Westport, Connecticut: Greenwood Press, 1990, 17–44.

Gregory, Hiram F., and Clarence H. Webb. "Chitimacha Basketry." In *Basketry of Southeastern Indians*. Edited by Marshall Gettys. Idabel, Oklahoma: Museum of the Red River, 1984, 43–50.

Guy, Hubert. "The Rattlesnake Basket," *American Indian Art Magazine* 1(3): 66–70, 74, 78 (1976).

Haberland, Wolfgang. *The Art of North America*. New York: Crown Publishers, Inc., 1964.

Hackenberg, Robert A. "Pima and Papago Ecological Adaptations." In *Handbook of North American Indians*. Vol. 10. Edited by Alfonso Ortiz. Washington, D.C.: Smithsonian Institution, 1983, 161–177.

Haeberlin, Hermann K., James A. Teit, and Helen H. Roberts. "Coiled Basketry in British Columbia and Surrounding Region." *41st Annual Report of the Bureau of American Ethnology for 1919–1924*. Washington, D.C., 1928, 119–484.

Hail, Barbara A., and Kate C. Duncan. *Out of the North: The Subarctic Collection of the Haffenreffer Museum of Anthropology*. Bristol, Rhode Island: Haffenreffer Museum of Anthropology, Brown University, 1989.

Halbert, H.S. "The Indians in Mississippi and their Schools." In *Biannual Report of the Superintendent of Public Education to the Legislature of Mississippi for the Scholastic Years 1893–1894 and 1894–1895*. Jackson, Mississippi, 1896, 534–545.

Harper, Kimball T. "Historical Environments." In *Handbook of North American Indians*. Vol. 11. Edited by Warren D'Azevedo. Washington, D.C.: Smithsonian Institution, 1986, 31–50.

Harrington, John P. "Tobacco among the Karuk Indians of California." *Bureau of American Ethnology Bulletin 94*. Washington, D.C.: Smithsonian Institution, 1932.

Harrington, Mark Raymond. "Vestiges of Material Culture among the Canadian Delawares," *American Anthropologist* 10:408–417 (1908).

Hart, Robert G. "Judging at the Inter-tribal Indian Ceremonial." *Smoke Signals*, No. 17. Washington, D.C.: Indian Arts and Crafts Board, United States Department of the Interior, 1955.

Hartman, Russell. Letter to Suzanne Griset, April 20, 2000. Anthropology Department, California Academy of Sciences, San Francisco.

Hauptman, Laurence M. *The Iroquois and the New Deal*. Syracuse, New York: Syracuse University Press, 1981.

Heizer, Robert. "The Archaeology of Central California: The Early Horizon," *University of California Archaeological Records* 12(1):1–84 (1949).

————. Introduction. In *Handbook of North American Indians*. Vol. 8. Edited by Robert F. Heizer. Washington, D.C.: Smithsonian Institution, 1978a, 1–5.

Heizer, Robert F., editor. *Handbook of North American Indians*. Vol. 8. Washington, D.C.: Smithsonian Institution, 1978b.

Heizer, Robert F., and Karen N. Nissen. *The Human Sources of California Ethnography*. Archaeological Research Facility, Department of Anthropology, University of California, Berkeley, 1973.

Helm, June, Edgar S. Rogers, and James G.E. Smith. "Intercultural Relations and Cultural Change in the Shield and Mackenzie Borderlands." In *Handbook of North American Indians*. Vol. 6. Edited by J. Helm. Washington, D.C.: Smithsonian Institution, 1981, 146–157.

Herold, Joyce. "Havasupai Basketry: Theme and Variation," *American Indian Art Magazine* 4:4 (1979).

Hill, Sarah H. *Weaving New Worlds: Southeastern Cherokee Women and their Basketry*. Chapel Hill: University of North Carolina Press, 1997.

Hoig, Stan. *The Battle of the Washita: The Sheridan-Custer Indian Campaign of 1867–69*. Lincoln: University of Nebraska Press, 1976.

Holm, Bill. *Northwest Coast Indian Art: An Analysis of Form*. Monograph No. 1. Seattle: Thomas Burke Memorial Washington State Museum, 1965.

———. "Art." In *Handbook of North American Indians*. Vol. 7. Edited by Wayne Suttles. Washington, D.C.: Smithsonian Institution, 1990, 602–632.

Howard, James. *Oklahoma Seminole Medicine, Magic and Religion*. Norman: University of Oklahoma Press, 1984.

Howard, Kathleen L., and Diana F. Pardue. *Inventing the Southwest: The Fred Harvey Company and Native American Art*. Flagstaff, Arizona: Northland Publishing, 1996.

Hudson, Charles. *The Southeastern Indians*. Knoxville: University of Tennessee Press, 1976.

Hudson, Travis. Letter to Isabel McIntosh, Indian Department, Philbrook Art Center, Tulsa, Oklahoma, March 21, 1980.

———. "Early Russian-Collected California Ethnographic Objects in European Museums." *American Indian Art Magazine*. 9(4): 30–37 (1984).

Hulings, Norman M. Letter to Rene d'Harnoncourt, February 21, 1942. Norman: University of Oklahoma, Western History Collection, Marriott Collection, Box 15, File 6, 1942.

Humphrey, Donald G. "A Necessary Balance," *Greater Tulsa*, September 5, 1963.

Hunter, Donald G. "Coushatta Basketry in the Rand Collection," *Florida Anthropologist* 28(1): 27–37 (1975).

Indian Pioneer History, Works Progress Administration. Oklahoma City: Division of Archives and Manuscripts, Oklahoma Historical Society. Interview with Andrew Riley, vol. 42. Interview with Harvey Williams, vol. 67. Interview with Mary Baker, vol. 99. Interview with Dorothy Field Morgan, vol. 108, 1937.

Jacobsen, William H. Jr. "Washoe Language." In *Handbook of North American Indians*. Vol. 11. Edited by Warren L. D'Azevedo. Washington, D.C.: Smithsonian Institution, 1986, 107–112.

James, George Wharton. *Indian Basketry*. Pasadena, California: privately printed, 4th ed. 1902. Reprint, New York: Dover Publications, 1972.

Johannsen, Christina B., and John P. Ferguson, eds. *Iroquois Arts: A Directory of a People and their Work*. Warnerville, New York: Association for the Advancement of Native North American Arts and Crafts, 1983.

Johnson, John W. *Life of John W. Johnson*. Biddeford, Maine, 1861. Reprint, *The Garland Library of Narratives of North American Indian Captivities*. Vol. 111. Series edited by Wilcomb E. Washburn. New York: Garland, 1977.

Kehoe, Alice Beck. *North American Indians: A Comprehensive Account*. Englewood Cliffs, New Jersey: Prentice-Hall, Inc., 1992.

Kent, Kate Peck. *Navajo Weaving: Three Centuries of Change*. Santa Fe, New Mexico: School of American Research Press, 1985.

Kinkade, M. Dale, William W. Elmendorf, Bruce Rigsby, and Haruo Aoki. "Languages." In *Handbook of North American Indians*. Vol. 12. Edited by Deward E. Walker Jr. Washington, D.C.: Smithsonian Institution, 1998, 49–72.

Kroeber, Alfred Louis. "Handbook of California Indians." *Bureau of American Ethnology Bulletin No. 78*. Washington, D.C.: Smithsonian Institution, 1925.

———. "Native Culture of the Southwest." *University of California Publications in American Archaeology and Ethnology* 33 (1928).

———. "The Patwin and their Neighbors." *University of California Publications in American Archaeology and Ethnology* 29(4):253–423 (1932).

———. "Culture Element Distributions III," *Area and Climax* 37(3):101–116 (1936).

———. "Cultural and Natural Areas of Native North America." *University of California Publications in American Archaeology and Ethnology* 38:1–242 (1939).

Laforet, Andrea. "Tsimshian Basketry." In *The Tsimshian: Images of the Past, Views for the Present*. Edited by Margaret Sequin. Vancouver: University of British Columbia Press, 1984, 215–280.

———. Unpublished field notes, 1999.

Lantis, Margaret. "Aleut." In *Handbook of North American Indians*. Vol. 5. Edited by D. Damas. Washington, D.C.: Smithsonian Institution, 1984, 161–184.

Latta, Frank. *Handbook of Yokuts Indians*. Santa Cruz, California: Bear Flag Publications, 1977.

Lee, Molly. *Baleen Basketry of the North Alaska Eskimo*. Barrow, Alaska: North Slope Borough Planning Department, 1983.

Lester, Joan A. *We're Still Here: Art of Indian New England*. Boston: The Children's Museum, 1987a.

———. "'We Didn't Make Fancy Baskets Until We Were Discovered': Fancy-Basket Making in Maine." In *A Key into the Language of Woodsplint Baskets*. Edited by Ann McMullen and Russell G. Handsman. Washington, Connecticut: American Indian Archaeological Institute, 1987b, 38–59.

——— *History on Birchbark: The Art of Tomah Joseph, Passamaquoddy*. Bristol, Rhode Island: Haffenreffer Museum of Anthropology, Brown University, 1993.

Liljeblad, Sven, and Catherine S. Fowler. "Owens Valley Paiute." In *Handbook of North American Indians*. Vol. 11. Edited by Warren L. D'Azevedo. Washington, D.C.: Smithsonian Institution, 1986, 412–434.

Lismer, Marjorie. *Seneca Splint Basketry*. Ohsweken, Ontario: Iroqrafts, 1982. Originally published by the U.S. Bureau of Indian Affairs, Indian Handcraft Pamphlet No. 4, Washington, D.C., 1941.

Lobb, Allan. *Indian Baskets of the Pacific Northwest and Alaska*. Portland, Oregon: Graphic Arts Center Publishing Co., 1990.

Lopez, Raul L., and Christopher L. Moser, eds. *Rods, Bundles, & Stitches: A Century of Southern California Indian Basketry*. Riverside, California: Riverside Museum Press, 1981.

Lurie, Nancy Oestreich. "Winnebago." In *Handbook of North American Indians*. Vol. 15. Edited by B.G. Trigger. Washington, D.C.: Smithsonian Institution, 1978, 690–707.

Lyford, Carrie A. *Ojibwa Crafts*. Stevens Point, Wisconsin: R. Schneider, Publishers, 1982.

Mack, Joanne M. "Changes in Cahuilla Coiled Basketry." In *The Art of Native American Basketry: A Living Legacy*. Edited by Frank W. Porter III. *Contributions to the Study of Anthropology*, No. 5. Westport, Connecticut: Greenwood Press, 1990, 227–240.

MacNair, Peter L., Alan L. Hoover, and Kevin Neary. *The Legacy: Continuing Traditions of Canadian Northwest Coast Indian Art*. Victoria: British Columbia Provincial Museum, 1980.

Marriott, Alice L. Letter to Rene d'Harnoncourt, November 26, 1937. Norman: University of Oklahoma, Western History Collection, Marriott Collection, Box 15, File 5, 1937a.

———. Letter to Dorothy Field Morgan, December 4, 1937. Norman: University of Oklahoma, Western History Collection, Marriott Collection, Box 17, File 11–17, 1937b.

———. Letter to Dorothy Field Morgan, February 11, 1938. Norman: University of Oklahoma, Western History Collection, Marriott Collection, Box 17, File 11–17, 1938a.

———. Letter to Dorothy Field Morgan, February 23, 1938. Norman: University of Oklahoma, Western History Collection, Marriott Collection, Box 17, File 11–17, 1938b.

———. Letter to Dorothy Field Morgan, April 22, 1938. Norman: University of Oklahoma, Western History Collection, Marriott Collection, Box 17, File 11–17, 1938c.

Mason, Otis Tufton. "Aboriginal American Basketry: Studies in Textile Art without Machinery." *Annual Report of the U.S. National Museum for 1902*. Vol. 1:171–784; Vol. 2:1–248. Washington, D.C., 1904.

McBride, Bunny. *Our Lives in our Hands: Micmac Indian Basketmakers*. Gardiner, Maine: Tilbury House, 1990.

McCormack, Ann. "Interview with Nettie Jackson (Klikitat), Basket Weaver (1991)." In *A Song to the Creator: Traditional Arts of Native American Women of the Plateau*. Edited by Lillian A. Ackerman. Norman: University of Oklahoma Press, 1996a, 61.

———. "Interview with Rose Frank (Nez Perce), Cornhusk Weaver (1991)." In *A Song to the Creator: Traditional Arts of Native American Women of the Plateau*. Edited by Lillian A. Ackerman. Norman: University of Oklahoma Press, 1996b, 65.

McDermott, John Francis, ed. *Tixier's Travels on the Osage Prairie*. Norman: University of Oklahoma Press, 1940.

McFeat, Tom. "Space and Work in Maliseet Basket Making." In *A Key into the Language of Woodsplint Baskets*. Edited by Ann McMullen and Russell G. Handsman. Washington, Connecticut: American Indian Archaeological Institute, 1987, 60–73.

McGreevy, Susan Brown. "Translating Tradition: Contemporary Basketry Art." In *Translating Tradition: Basketry Arts of the San Juan Paiutes*. Santa Fe, New Mexico: Wheelwright Museum of the American Indian, 1985.

McGuire, Thomas. "Walapai." In *Handbook of North American Indians*. Vol. 10. Edited by Alfonso Ortiz. Washington, D.C.: Smithsonian Institution Press, 1983, 25–37.

McLendon, Sally. "Pomo Basket Weavers in the University of Pennsylvania Museum Collection," *Expedition* 40(1): 34–47 (1998).

McMullen, Ann. "Looking for People in Woodsplint Basketry Decoration." In *A Key into the Language of Woodsplint Baskets*. Edited by Ann McMullen and Russell G. Handsman. Washington, Connecticut: American Indian Archaeological Institute, 1987, 102–123.

———. "Many Motives: Change in Northeastern Native Basket Making." In *The Art of Native American Basketry: A Living Legacy*. Edited by Frank W. Porter III. Westport, Connecticut: Greenwood Press, 1990, 45–78.

———. "Talking through Baskets: Meaning, Production and Identity in the Northeast Woodlands." In *Basketmakers: Meaning and Form in Native American Baskets*. Edited by Linda Mowat, Howard Morphy, and Penny Dransart. Oxford, England: Pitt Rivers Museum, 1992, 18–35.

———. "Native Basketry, Basketry Styles, and Changing Group Identity in Southern New England." In *Algonkians of New England: Past and Present. Annual Proceedings of the Dublin Seminar for New England Folklife, 1991*. Edited by Peter Benes. Boston University and Dublin Seminar for New England Folklife, 1994, 76–88.

———. "Under the Bridge: Woodsplint Basketry and the Identification of Hidden Native Communities in Historic New England." Paper read at the Annual Meeting of the American Society for Ethnohistory, at Kalamazoo, Michigan. 1995.

———. "Culture by Design: Native Identity, Historiography, and the Reclamation of Tradition in Twentieth-century Southeastern New England." Ph.D. diss. in anthropology, Brown University. Ann Arbor, Michigan: University Microfilms, 1996.

McMullen, Ann, and Russell G. Handsman, eds. *A Key into the Language of Woodsplint Baskets*. Washington, Connecticut: American Indian Archaeological Institute, 1987.

Medford, Claude. "Coushatta Baskets and Basketmakers." In *Basketry of Southeastern Indians*. Edited by Marshall Gettys. Idabel, Oklahoma: Museum of the Red River, 1984, 51–56.

Merrill, Ruth Earl. "Plants Used in Basketry by the California Indians." *University of California Publications in American Archaeology and Ethnology* 29(13):215–244 (1928).

Miller, Lynette. "Basketry Styles of the Plateau Region." In *A Song to the Creator: Traditional Arts of Native American Women of the Plateau*. Edited by Lillian A. Ackerman. Norman: University of Oklahoma Press, 1996, 41–54.

Miller, Wick R. "Numic Languages." In *Handbook of North American Indians*. Vol. 11. Edited by Warren L. D'Azevedo. Washington, D.C.: Smithsonian Institution, 1986, 98–106.

Morgan, Dorothy Field. Letter to Alice L. Marriott, December 3, 1937. Norman: University of Oklahoma, Western History Collection, Marriott Collection, Box 17, File 11–17, 1937.

———. Letter to Alice L. Marriott, January 8, 1938. Norman: University of Oklahoma, Western History Collection, Marriott Collection, Box 17, File 11–17, 1938.

Morissonneau, Christian. "Huron of Lorette." In *Handbook of North American Indians*. Vol. 15. Edited by B.G. Trigger. Washington, D.C.: Smithsonian Institution, 1978, 389–393.

Morris, E.H., and R.F. Burgh. "Anasazi Basketry." *Publications in Anthropology and Archaeology*. Vol. 533. Washington, D.C.: Carnegie Institution of Washington, 1941.

Moser, Christopher L. *Native American Basketry of Central California*. Riverside, California: Riverside Museum Press, 1986.

———. *Native American Basketry of Southern California*. Riverside, California: Riverside Museum Press, 1993.

Moser, Edward. "Seri Basketry," *The Kiva* 38:3–4 (1973).

Newcomb, William W. Jr. "The Culture and Acculturation of the Delaware Indians." *Anthropological Papers*, No. 10. Ann Arbor, Michigan: Museum of Anthropology, University of Michigan, 1956.

Oklahoma State Capitol, Guthrie, Oklahoma Territory, July 11, 1901; July 12, 1901.

Olmstead, David L., and Omer C. Stewart. "Achumawi." In *Handbook of North American Indians*. Vol. 8. Edited by Robert F. Heizer. Washington, D.C.: Smithsonian Institution, 1978, 225–235.

O'Neale, Lila M. "Yurok-Karok Basket Weavers." *University of California Publications in American Archaeology and Ethnology* 32(1) (1932).

Opler, Morris E. "Chiricahua Apache." In *Handbook of North American Indians*. Vol. 10. Edited by Alfonso Ortiz. Washington, D.C.: Smithsonian Institution, 1983a, 401–418.

———. "Mescalero Apache." In *Handbook of the North American Indian*. Vol. 10. Edited by Alfonso Ortiz. Washington, D.C.: Smithsonian Institution, 1983b, 419–439.

Patencio, Francisco. *Stories and Legends of the Palm Springs Indians as Told to Margaret Boynton*. Edited by Margaret Boynton. Los Angeles: *Times-Mirror* Press, 1943.

Pelletier, Gaby. *Abenaki Basketry*. National Museum of Man, Canadian Ethnology Service, Mercury Series 85, 1982.

Peri, David W., and Scott M. Patterson. "The Basket Is in the Roots: That's Where It Begins," *Journal of California Anthropology* 3(2):17–32 (1976).

Petty, Ethel. Letter to Alice L. Marriott, August 31, 1938. Norman: University of Oklahoma, Western History Collection, Marriott Collection, Box 17, File 12, 1938a.

———. Letter to Clark Field, September 7, 1938. Norman: University of Oklahoma, Western History Collection, Marriott Collection, Box 17, File 12, 1938b.

———. Letter to Alice L. Marriott, September 16, 1938. Norman: University of Oklahoma Western History Collection, Marriott Collection, Box 17, File 12, 1938c.

———. Letter to Alice L. Marriott, September 20, 1938. Norman: University of Oklahoma, Western History Collection, Marriott Collection, Box 17, File 12, 1938d.

Pierite, Joseph A. "Present Day Crafts of the Tunica and Biloxi Tribes of Louisiana," *American Indian Crafts and Culture* 8(3) (1974).

Pilles, Peter. "Yavapai Archaeology." Paper read at Southern Arizona Protohistoric Conference, Arizona State University, Tempe, 1979.

Polanich, Judith Kessler. "Mono Basketry: Migration and Change." Ph.D. diss., Department of Anthropology, University of California, Davis, 1994.

Pratt, Wayne. Foreword. In *The Basket Weavers of Arizona*, by Bert Robinson. Albuquerque: University of New Mexico Press, 1954, xiii–xiv.

Ream, Mary Ann. "Indian Exhibits at Philbrook Art Center," *Chronicles of Oklahoma* 21(1): 70–73 (1943).

Ritzenthaler, Robert. *Woodland Indians of the Western Great Lakes*. Prospect Heights, Illinois: Waveland Press, 1991.

Robinson, Bert. *The Basket Weavers of Arizona*. Albuquerque: University of New Mexico Press, 1954.

Rogers, Edward S., and James G.E. Smith. "Environment and Culture in the Shield and MacKenzie Borderlands." In *Handbook of North American Indians*. Vol. 6. Edited by J. Helm. Washington, D.C.: Smithsonian Institution, 1981, 130–145.

Rowland, Russell L. Letter to Alice Marriott, September 6, 1938. Norman: University of Oklahoma, Western History Collection, Marriott Collection, Box 17, File 11–17, 1938a.

———. Letter to Alice Marriott, September 10, 1938. Norman: University of Oklahoma, Western History Collection, Marriott Collection, Box 17, File 11–17, 1938b.

Sanipass, Mary Ann. *Baskadegan: Basket Making Step-By-Step*. Madawaska, Maine: Saint John Valley Publishing Company, 1990.

Schlick, Mary D. "Ojibwa/Chippewa Basketry: A Search for Basketmakers," *American Indian Basketry* 3 (3): 15–18 (1983).

———. *Columbia River Basketry: Gift of the Ancestors, Gift of the Earth*. Seattle: University of Washington Press, 1994.

Schoolcraft, Henry R. *Information Respecting the History, Condition, and Prospects of the Indian Tribes of the United States*. Philadelphia: Lippencott, Grambo Co., 1853.

Schneider, Mary Jane. "An Investigation into the Origin of Arikara, Hidatsa, and Mandan Twilled Basketry," *Plains Anthropologist* 29(106) (1984).

Schrader, Robert Fay. *The Indian Arts and Crafts Board: An Aspect of New Deal Indian Policy.* Albuquerque: University of New Mexico Press, 1983.

Schroeder, Albert H. "An Archaeological Survey of the Painted Rocks Reservoir, Western Arizona," *The Kiva* 27:1 (1961).

———. "A Brief History of the Yavapai of the Middle Verde Valley," *Plateau* 24:3 (1952).

Shipley, William F. "Native Languages of California." In *Handbook of North American Indians.* Vol. 8. Edited by Robert F. Heizer. Washington, D.C.: Smithsonian Institution, 1978, 80–90.

Smith, Anne M. Cooke. Ethnography of the Northern Ute. *Museum of New Mexico Papers in Anthropology* 17. Santa Fe, 1974.

Smith, Gerald A., and Christopher L. Moser. "The Sundry Uses of Basketry." In *Rods, Bundles, & Stitches: A Century of Southern California Indian Basketry.* Edited by Raul L. Lopez and Christopher L. Moser. Riverside, California: Riverside Museum Press, 1981, 52–81.

Southside Times, Tulsa, Oklahoma, July 26, 1962.

Speck, Frank G. "Notes on the Mohegan and Niantic Indians." In *The Indians of Greater New York and the Lower Hudson.* Edited by C. Wissler. *Anthropological Papers of the American Museum of Natural History* 3, 1909, 183–210.

———. "Decorative Art of the Indians of Connecticut." *Anthropological Series 10, Memoirs of the Canadian Geological Survey 75.* Ottawa, Ontario: Department of Mines, 1915a.

———. "The Nanticoke Community of Delaware." *Contributions from the Museum of the American Indian, Heye Foundation* 2(4):1–43 (1915b).

———. "The Rappahannock Indians of Virginia," *Indian Notes and Monographs* 5(3) (1925).

———. "River Desert Indians of Quebec," *Indian Notes* 4:240–252 (1927).

———. Foreword. In *Fine Root Runner Basketry among the Oklahoma Cherokee Indian.* Bulletin No. 1. Tulsa, Oklahoma: Philbrook Art Center, 1943.

———. "The Iroquois: A Study in Cultural Evolution." *Cranbrook Institute of Science Bulletin 23.* Bloomfield Hills, Michigan, 1945.

———. *Catawba Hunting, Trapping and Fishing.* Joint Publication No. 2. Philadelphia: Museum of the University of Pennsylvania and the Philadelphia Anthropological Society, 1946.

———. *Eastern Algonkian Block-Stamp Decoration: A New World Original or an Acculturated Art.* Research Series No. 1. Trenton: Archaeological Society of New Jersey, 1947.

Spencer, Robert F., Jesse D. Jennings, et al. *The Native Americans: Ethnology and Backgrounds of the North American Indians.* 2nd ed. New York: Harper and Row, 1977.

Spicer, Edward H. *Cycles of Conquest: The Impact of Spain, Mexico, and the United States on the Indian of the Southwest, 1533–1960.* Tucson: University of Arizona Press, 1962.

Stager, John K., and Robert J. McSkimming. "Physical Environment." In *Handbook of North American Indians.* Vol. 5. Edited by D. Damas. Washington, D.C.: Smithsonian Institution, 1984, 27–35.

Steinbring, Jack H. "Saulteaux of Lake Winnipeg." In *Handbook of North American Indians.* Vol. 6. Edited by J. Helm. Washington, D.C.: Smithsonian Institution, 1981, 244–255.

Steward, Julian H. "Ethnography of the Owens Valley Paiute." In *University of California Publications in American Archeology and Ethnology* 33(3): 233–350 (1933).

Strong, William D. "Aboriginal Society of Southern California." *University of California Publications in American Archaeology and Ethnology* 26(1):1–348 (1929).

Swanton, John R. "The Indians of the Southeastern United States." *Bureau of American Ethnology Bulletin 137.* Washington, D.C.: Smithsonian Institution, 1946.

Tantaquidgeon, Gladys. "Notes on the Gay Head Indians of Massachusetts," *Indian Notes* 7(1):1–26 (1930).

Taylor, J. Garth. "Historical Ethnography of the Labrador Coast." In *Handbook of North American Indians.* Vol. 5. Edited by D. Damas. Washington, D.C.: Smithsonian Institution, 1984, 508–521.

Thompson, Gerald E. *The Army and the Navajo: The Bosque Redondo Reservation Experiment, 1863–68.* Tucson: University of Arizona Press, 1976.

Tiller, Veronica E. "Jicarilla Apache." In *Handbook of North American Indians.* Vol. 10. Edited by Alfonso Ortiz. Washington, D.C.: Smithsonian Institution, 1983, 440–461.

Tschopik, Harry Jr. "Navajo Basketry: A Study of Cultural Change," *American Anthropologist* 42(3):444–462 (1940).

Tulsa Daily World, October 2, 1938; January 19, 1941; February 15, 1942; October 15, 1942; July 18, 1943; March 17, 1947; June 20, 1948; October 17, 1954; December 7, 1955; October 8, 1957; January 26, 1958; February 1, 1963; January 7, 1964; September 7, 1965.

Tulsa Tribune, October 13, 1939; July 20, 1942; July 30, 1942; January 19, 1944; July 1, 1946; September 17, 1950; July 28, 1955; December 19, 1956; August 22, 1962; July 25, 1965; December 22, 1967; December 3, 1971.

Turnbaugh, Sarah Peabody, and William A. Turnbaugh. *Indian Baskets.* Atglen, Pennsylvania: Schiffer Publishing Ltd., 1986, and 1997.

Waddell, Jack O. "The Place of the Cactus Wine Ritual in the Papago Indian Ecosystem." In *The Realm of Extra-human Ideas and Actions.* Chicago: 9th International Congress of Anthropological and Ethnological Science, 1973.

Walker, Deward E. Jr. Introduction. In *Handbook of North American Indians.* Vol. 12. Edited by Deward E. Walker Jr. Washington, D.C.: Smithsonian Institution, 1998, 1–7.

Wallis, Michael. *Route 66: The Mother Road.* New York: St. Martin's Press, 1990.

———. *Beyond the Hills: The Journey of Waite Phillips.* Trackmaker Series. Oklahoma City: Oklahoma Heritage Association, 1995.

Watkins, John A. "The Choctaws in Mississippi," *American Antiquarian and Oriental Journal* 16(2):69–77 (1894).

REFERENCES CITED

Waugh, F. W. "Iroquois Foods and Food Preparation." *Geological Survey Memoir 86, No. 12,* Anthropology Series. Ottawa, Ontario: Department of Mines, 1916. Reprint, Oshweken, Ontario: Iroqrafts, 1973.

Weltfish, Gene. "Prehistoric North American Basketry Techniques and Modern Distributions," *American Anthropologist* 32:3 (1930a).

———. "Coiled Gambling Baskets of the Pawnee and Other Plains Tribes," *Indian Notes* 7(3) (1930b).

———. *The Lost Universe: Pawnee Life and Culture.* Lincoln: University of Nebraska Press, 1965.

White, Marion E., William E. Englebrecht, and Elizabeth Tooker. "Cayuga." In *Handbook of North American Indians.* Vol. 15. Edited by B.G. Trigger. Washington, D.C.: Smithsonian Institution, 1978, 500–504.

Whiteford, Andrew Hunter. *Southwest Indian Baskets: Their History and Their Makers.* Santa Fe, New Mexico: School of American Research Press, 1988.

Whitehead, Ruth Holmes. *Elitekey: Micmac Material Culture from 1600 A.D. to the Present.* Halifax: The Novia Scotia Museum, 1980.

———. *Micmac Quillwork.* Halifax: The Nova Scotia Museum, 1982.

Wiengrad, Dilys Pegler. *Through Time, Across Continents: A Hundred Years of Archaeology and Anthropology at the University Museum.* Philadelphia: University of Pennsylvania, 1993.

Wilson, G.L. "The Hidatsa Earth Lodge." *Anthropological Papers* No. 33, American Museum of Natural History, 1934.

Wissler, Clark. *The American Indian.* New York: Macmillan, 1938.

Witherspoon, Gary. "Navajo Social Organization." In *Handbook of North American Indians.* Vol. 10. Edited by Alfonso Ortiz. Washington, D.C.: Smithsonian Institution, 1983, 524–535.

Wood, W. R. "An Interpretation of Mandan Culture History." River Basin Surveys Papers No. 39. *Bureau of American Ethnology Bulletin No. 198,* 1967.

Woodbury, Anthony C. "Eskimo and Aleut Languages." In *Handbook of North American Indians.* Vol. 5. Edited by D. Damas. Washington, D.C.: Smithsonian Institution, 1984, 49–63.

Wright, Barton. *Hopi Material Culture: Artifacts Gathered by H. R. Voth in the Fred Harvey Collection.* Flagstaff, Arizona: Northland Press and the Heard Museum, 1979.

Wyatt, David. "Thompson." In *Handbook of North American Indians.* Vol. 12. Edited by Deward E. Walker Jr. Washington, D.C.: Smithsonian Institution, 1998, 191–202.

Wyckoff, Lydia L. *Designs and Factions: Politics, Religion and Ceramics on the Hopi Third Mesa.* Albuquerque: University of New Mexico Press, 1990.

Wyckoff, Lydia L., ed. *Visions and Voices: Native American Painting from The Philbrook Museum of Art.* Albuquerque: University of New Mexico Press, 1996.

Wyckoff, Lydia L., and Curtis Zunigha. "Delaware: Honoring the Past and Preparing for the Future," *Native Peoples* (Spring 1994).

REFERENCES CITED